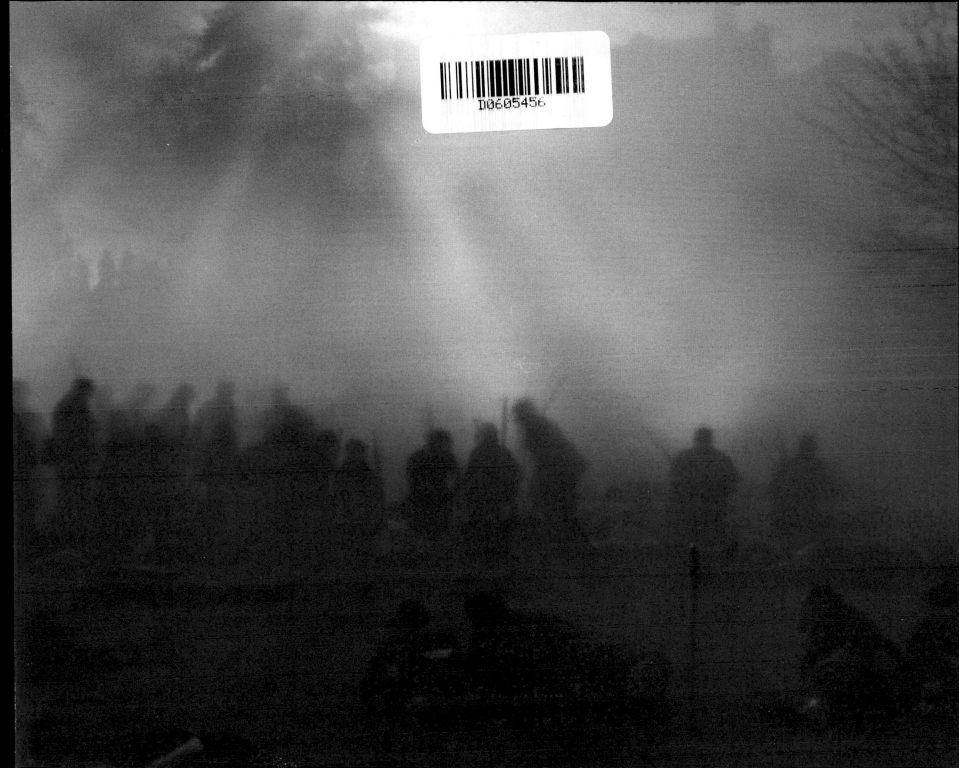

ECHOES OF THE

CIVIL WAR

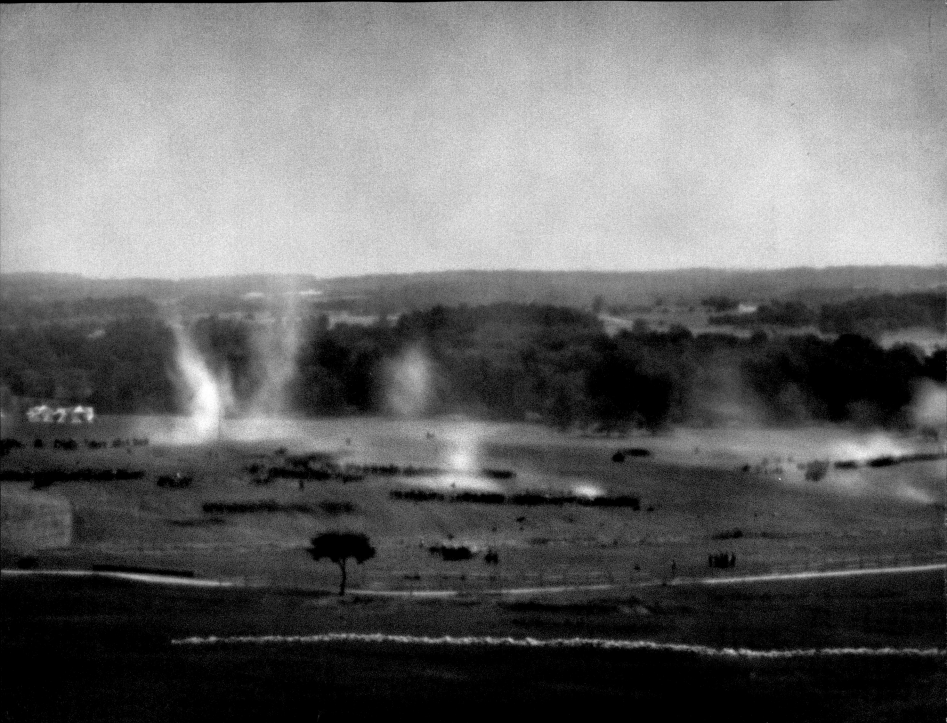

ECHOES OF THE
CIVIL WAR

CAPTURING BATTLEFIELDS THROUGH A PINHOLE CAMERA

MICHAEL FALCO

The Countryman Press
A division of W. W. Norton & Company
Independent Publishers Since 1923

For information about permission to reproduce selections from this book, write to
Permissions, The Countryman Press, 500 Fifth Avenue, New York, NY 10110

For information about special discounts for bulk purchaces, please contact
W. W. Norton Special sales at specialsales@wwnorton.com or 800-233-4830

Book design by Lissi Sigillo
Manufacturing by RR Donnelley, Shenzhen
Production manager: Devon Zahn

Library of Congress Cataloging-in-Publication Data

Names: Falco, Michael, author, photographer.
Title: Echoes of the Civil War : Capturing Battlefields Through a Pinhole
 Camera / Michael Falco.
Description: New York, NY : The Countryman Press, 2016.
Identifiers: LCCN 2016016510 | ISBN 9781581573800 (hardcover)
Subjects: LCSH: United States—History—Civil War,
 1861-1865—Battlefields—Pictorial works. | United States—History—Civil
 War, 1861-1865—Anniversaries, etc.—Pictorial works. | Historical
 reenactments—United States—Pictorial works. | Photography, Pinhole.
Classification: LCC E641 .F35 2016 | DDC 973.7—dc23 LC record available
at https://lccn.loc.gov/2016016510

The Countryman Press
www.countrymanpress.com

A division of W. W. Norton & Company, Inc.
500 Fifth Avenue, New York, NY 10110
www.wwnorton.com

10 9 8 7 6 5 4 3 2 1

This book is dedicated to my mom,
Constance Mary Falco.

Contents

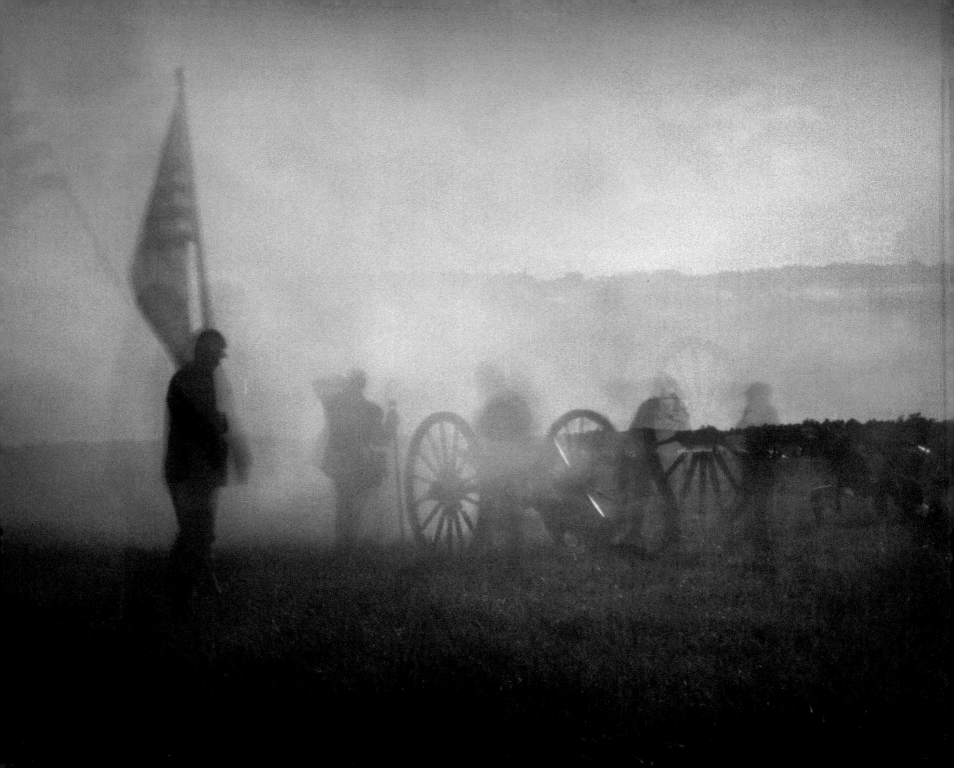

Introduction

This book describes a four-year, battlefield-to-battlefield journey along the anniversary tracks of the American Civil War. The arduous and exhilarating trek crossed landscapes that remain, preserved by virtue of their terrible history, very much as they were 150 years ago—oases from modernity, as pristine and scarred as the great war left them, hallowed and haunting. The past is present on these battlefields.

The images in the book were created with large-format pinhole cameras—handmade wooden boxes with no lens, no viewfinder, and no shutter—that would have seemed primitive even at the time of the Civil War, but that, in uncanny ways, turned out to be the perfect devices for this project.

The camera's tiny, fixed aperture creates a canvas where details are obscured. The minuscule amount of light entering the camera requires a long exposure time that pushes the images into the ambiguous terrain between landscape and dreamscape. Wind blows, leaves rustle, clouds move, the earth turns. The pinhole photograph breathes with space and time.

Soldiers' journals and memoirs describe the battlefields as dreamlike, and that is how they appear through the patient eye of the pinhole camera. Time is stretched and, ultimately, upended. The images invite lingering contemplation.

The book is also a photographic chronicle of the legion of dedicated reenactors, impeccably attired and historically attuned, who recreated scenes at one battlefield anniversary after another, heightening the eerie déjà vu of this expedition of commemoration.

I had not expected, setting out, that these living historians would figure importantly in this project. But, on my very first battlefield visit, to Manassas, Virginia, for the 150th anniversary of the Battle of Bull Run, I encountered a band of Virginians portraying the units in which their great-great grandfathers had fought a century and a half before. I marveled at the remarkable nexus of people, place, and history that was unfolding before my eyes.

The impressions of these reenactors—so many descended (like those Virginians at Manassas) from the very soldiers whose uniforms they wear—brought a dimension of verisimilitude and narrative drive to the project and, through the prism of the pinhole, emerged not as documentations of people involved in play

Gunners at Gettysburg

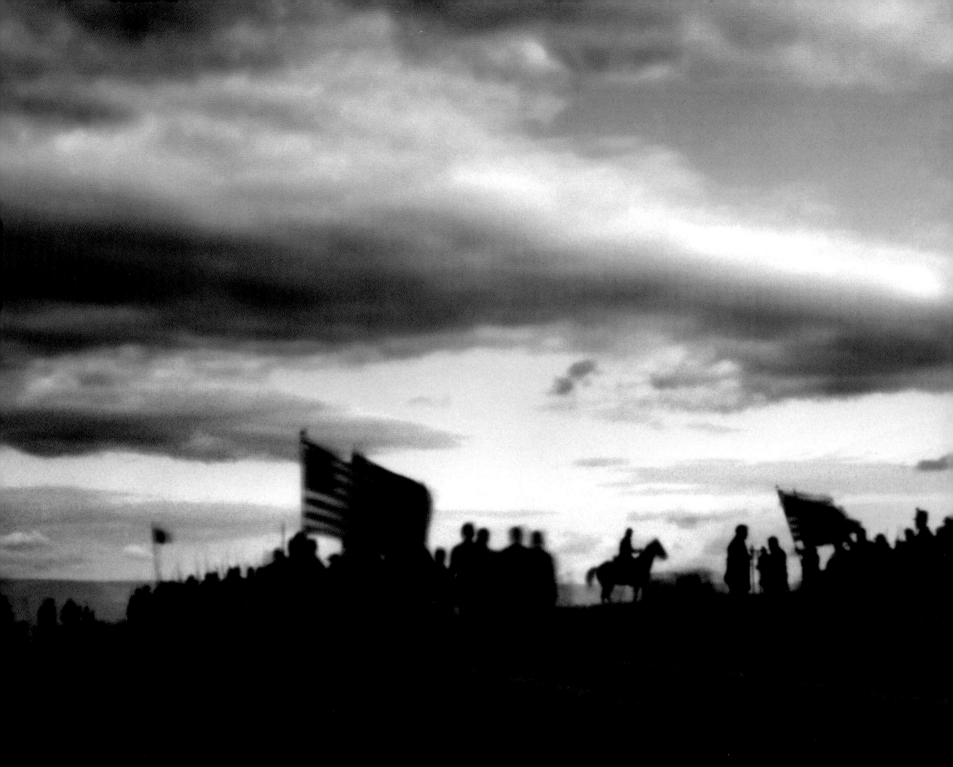

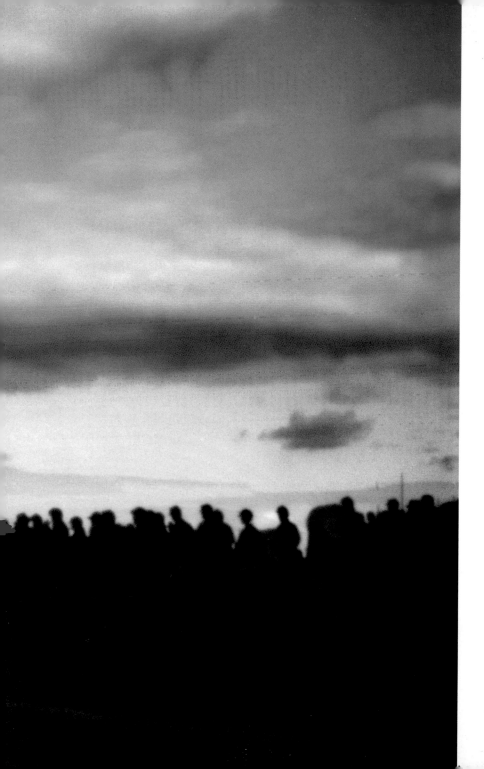

acting or costume drama, but as ghostly evocations of the spirits that hang over these fields.

It was not too long before I found myself becoming one of them, a Civil War photographer arriving with his primitive wooden box camera on these fields of battle, squinting into a pin-hole, seeing before me timeless, epic landscapes, and the terrible, transitory struggle that left them sacred ground.

I would also be following in the footsteps of Civil War photographers. I certainly had an easier time than some of the famous chroniclers of the war, like Matthew Brady and Alexander Gardner. Nineteenth-century photography required a mobile darkroom and also required that the images be processed in the field. The equipment was cumbersome, the process delicate. Although I'd be using a camera even more rudimentary than Brady's, my use of modern film stock made the work easier to accomplish. The other advantage I had, that Brady and Gardner didn't, was that thankfully there would be no lead flying in the air as I worked.

This was, for me, a personal odyssey along the length and breadth of America's deepest wound. I trust the images here will evoke the wonder, the awe, and, ultimately, the peace I found on my pilgrimage through this consecrated domain.

Cedar Creek Battlefield, Virginia

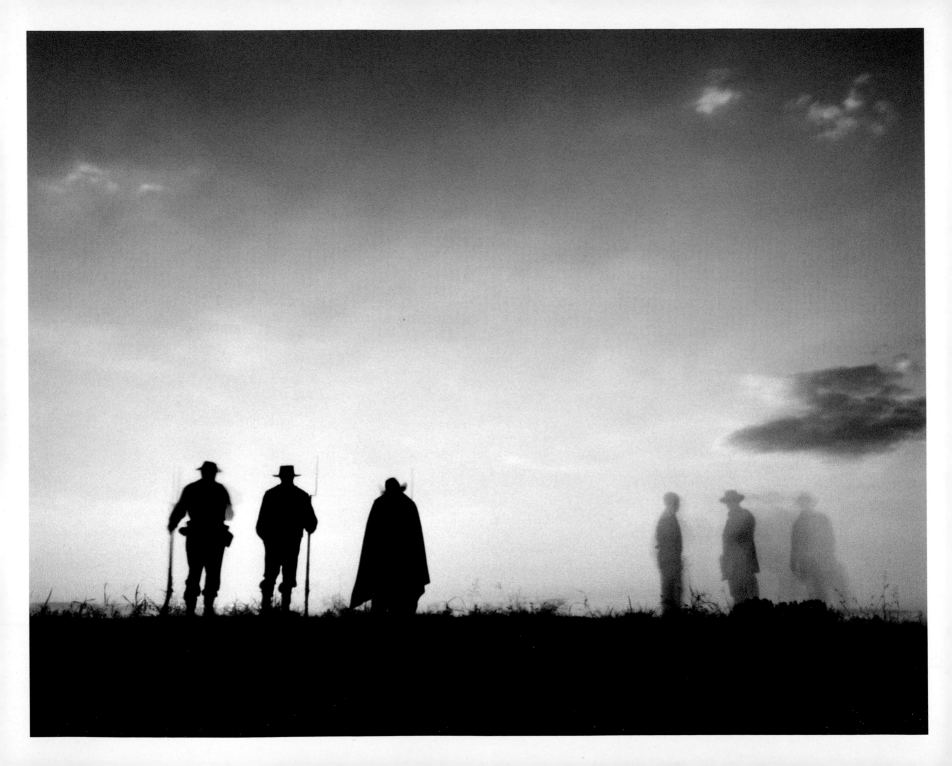

The Pinhole Camera

A number of years ago, after years of shooting exclusively digital, I felt I needed to slow down as a photographer. I wanted to trade, at least occasionally, the ease, precision and instant gratification of digital photography for something that required me to spend more time with the subject—to really immerse myself in the meaning and composition of each frame.

I was missing the mystery of photography, the magic that happens in the box. I wanted to put some of the guesswork and intuition back into my image making. This led me to the pinhole camera. To shoot with a pinhole camera is, quite literally, to get back to basics.

What I did not anticipate is that stripping back to this most basic method of shooting would somehow yield images that also seemed more elemental. I soon realized these simple cameras had a remarkable capability for rendering landscapes. The cameras somehow looked deeper into the subjects, and I actually found myself experiencing these landscapes and the photographic process in a deeper way.

Battlefield at Raymond, Mississippi

The pinhole camera has no "lens," per se. The tiny fixed aperture creates a soft infinite focal plane, allowing the "feeling" of the landscape to come through. Where digital photography is like good nonfiction, sharp and detailed, pinhole photography somehow has the profound emotional honesty, the subjective truth of a great novel. Each image carries with it a story, or many different stories.

The Journey

These discoveries with the pinhole camera happened to coincide with a subject that had been an interest of mine since childhood: the American Civil War. In 2009, as the 150th anniversary of the war approached, I inadvertently tumbled down the rabbit hole of Civil War history. My only desire, after reading a small library's worth of this material, was to visit the war's battlefields. And I would bring the pinhole camera.

Each trip along this journey, each battlefield, was preceded by a good deal of research. After consuming a number of books

on the subject, I would arrive at each location with a detailed shot list of images I hoped to find along the way. The shot list became my logistical map, but often the list would lead me to unexpected discoveries.

On a typical day, I would shoot anywhere from 30 to 50 images, changing film in a portable darkroom in my car or hotel room. At night, when the pinhole camera became impossible to work with, I would spend the evening loading film for the following day, writing in my project journal, and mapping out the next day's journey.

With the pinhole camera, Cartier-Bresson's instructive phrase—*the decisive moment*, referring to the fraction of a second in which a photo should be taken—turns into the decisive minute or minutes. Patience is the greatest virtue when working with these rudimentary cameras.

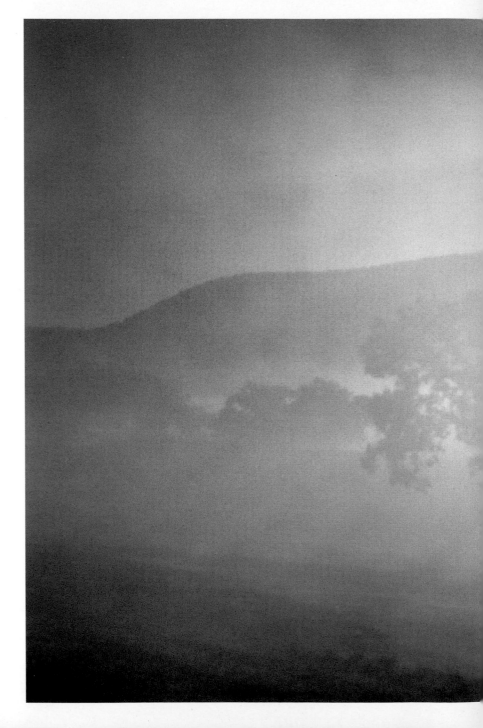

McLemore's Cove, Chickamauga, Georgia

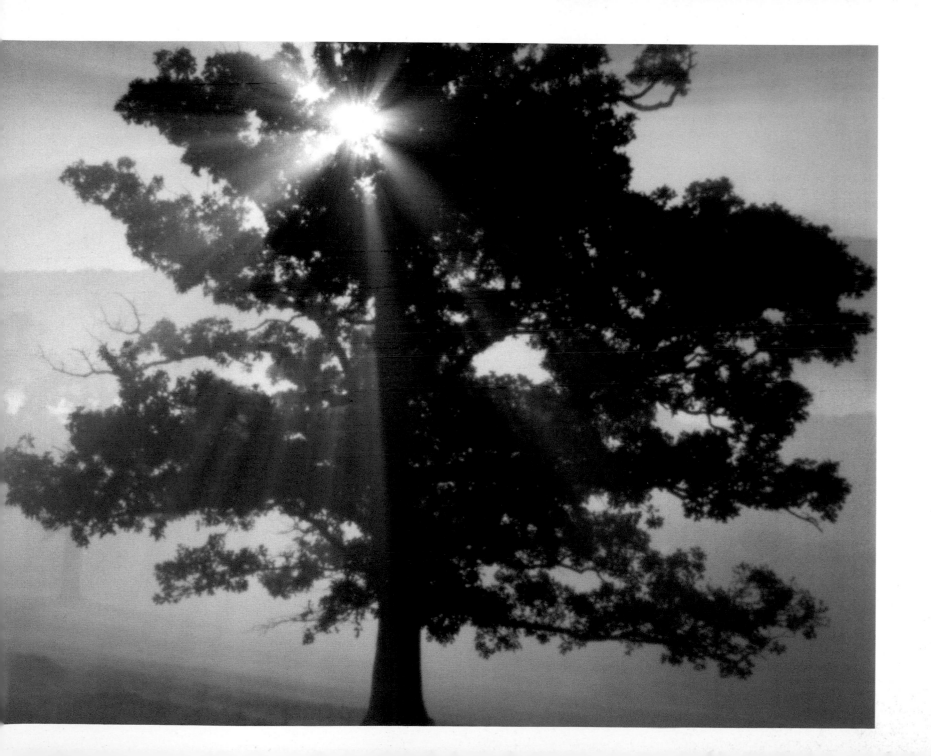

Bull Run

On July 21, 1861, the opposing armies of the American Civil War first met, just 30 miles southwest of Washington, DC. It was the first major battle of the Civil War, known in the North as the Battle of Bull Run—the name of the creek that bisected the battlefield—and known in the South, which preferred place names to geographic features in identifying battles, such as the Battle of Manassas.

Both armies believed that this would be the decisive battle of the war, putting a quick end, one way or another, to the question of secession. With its proximity to Washington, Manassas drew spectators, who made the trek into the Virginia countryside to bear witness to history. They were drawn by an excited curiosity about the war now upon them and propelled by the likelihood that if they didn't take advantage of the opportunity now, the war might be over before they had another chance.

They were also somewhat naive about what could go wrong. They came in carriages and on horseback. There were senators and congressmen, journalists and common folks, ladies with their opera glasses, packing picnic lunches for the excursion—and champagne to celebrate its all-but-certain outcome. They would have front-row seats for what they expected to be a swift coup de grâce by superior federal forces that would quickly crush the reckless folly of secession.

After the victory, on to take the Confederate capitol in Richmond. Or, in the Confederate imagination, it would be just the reverse—victory and then on to Washington.

Rickett's Guns, Manassas Battlefield

Neither was to be.

Union forces had the early advantage but were ultimately routed by the Confederates, issuing for the first time their blood-curdling "rebel yell" on the command of Brigadier General Thomas Jonathan Jackson.

"Reserve your fire until they come within 50 yards. Then fire and give them the bayonet. And when you charge, yell like furies."

Jackson would become the stuff of legend that day.

"There is Jackson standing like a stone wall. Let us determine to die here, and we will conquer. Rally behind the Virginians," said Confederate General Barnard Bee, summoning his faltering troops to glory just moments before his own mortal wounding.

Conquer they did.

It was, in the mocking terms of the Southern press, the Great Skedaddle. Adding insult to injury, the Union's voyeuristic camp followers found themselves stampeded by the helter skelter retreat of their heroes, trampling any hopes for a quick end to the conflict.

It was the bloodiest battle on American soil to that date, and a harbinger of the far greater carnage to come. Altogether, the Union lost about 460 men killed, 1,125 wounded, and 1,310 captured or missing. The Confederate losses came to 390 killed, 1,580 wounded, but only 13 missing.

"Today will be known as Black Monday," wrote a Northern diarist by the name of George Templeton Strong. "We are utterly and disgracefully routed, beaten, whipped by secessionists."

Notable among the spectators at Bull Run was Mathew Brady, the most famous photographer of his day. His greatest fame would come as the pioneering visual chronicler of the war. He made his way to Manassas with his horse-drawn mobile

Henry House, Manassas Battlefield

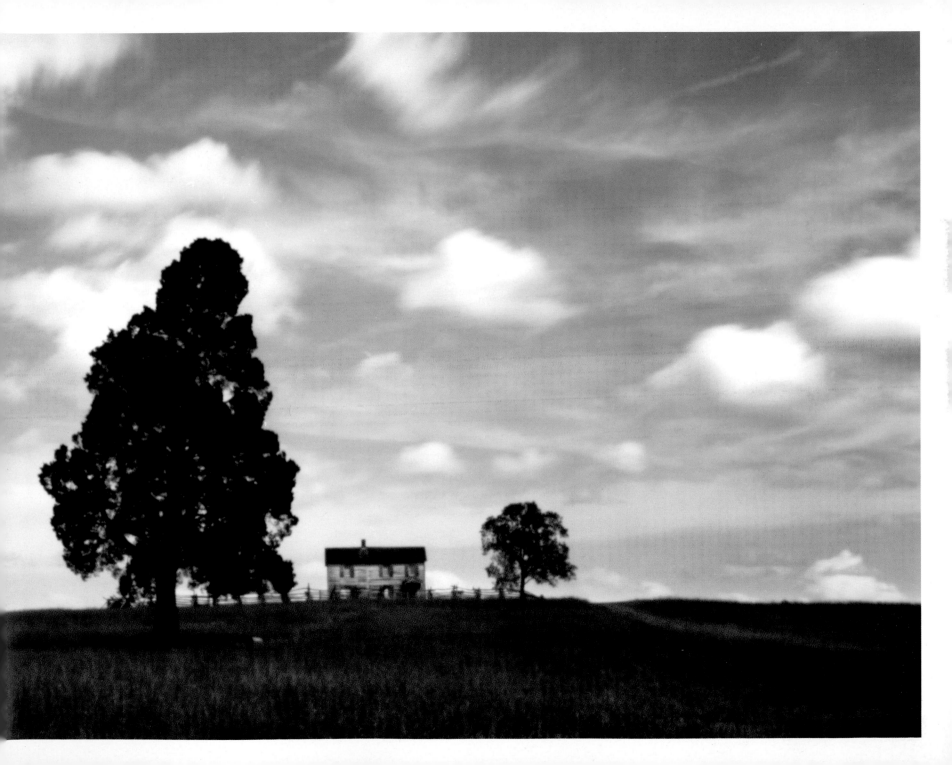

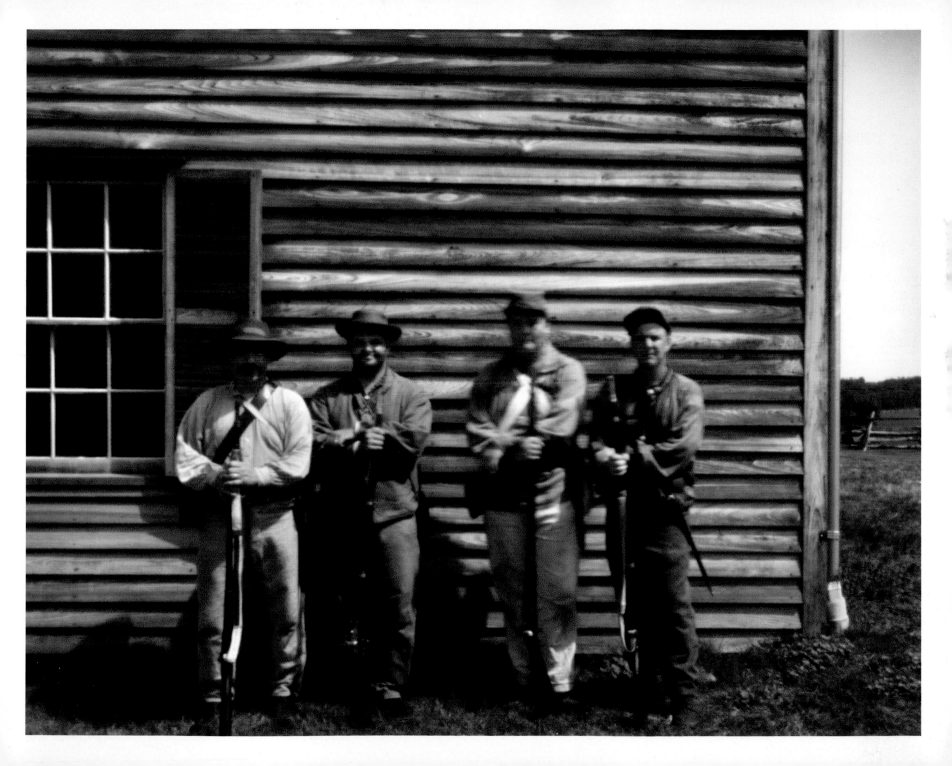

darkroom, following what he would describe as an irresistible sense of mission. While accounts suggest that Brady made some images that day, none survive. For Brady, though, his experience impressed upon him the difficulties that would lie ahead. He would never again try to shoot in the throes of battle. But the experience also instilled in him the historic imperative to press forward with his mission, ultimately enlisting more than 20 other men to help him record the war, on as grand and sweeping a scale as possible.

———— >‹ ————

Bull Run was my shakedown battle.

It was the place at which my exhilarated daydreaming about embarking on this project came face-to-face with the practical rigors of what I was embarking upon, and all in the smothering heat of a Southern summer.

Heat stroke claimed its share of victims at Bull Run, and 150 years later, hiking the battlefield with three cumbersome pinhole cameras slung over my shoulder, I felt empathetic with the challenges those soldiers endured. This was going to be a long, arduous, and sweaty slog, not for the faint of heart.

In the mid-nineteenth century, Manassas Junction was a small town with rolling farmland and an important rail link. Today, Manassas bears the scars of exurban modernity—a cluttered landscape of strip malls, fast food restaurants and crawling traffic. But the battlefield remains much as it was, and I set out to record images of the pristine landscape while following the course of the battle.

After watching the sunrise on Henry Hill, the focal point of the battle, I made my way down to Bull Run Creek to see where Union troops first crossed on the morning of July 21.

The creek looks as it did in the nineteenth century: slow-moving, 30–40 feet across, with somewhat steep banks. It presented a serious obstacle to the Union troops. Union engineers sought areas along the creek that could be forded. I photographed one of those: the Farm Ford.

An old stone bridge, crossing the creek near the Warrenton Turnpike, now Lee's Highway, Rte. 29, was the retreat route for many Union soldiers. Destroyed after the Battle of Second Manassas in August 1862, the old stone bridge was rebuilt in 1886 and remains intact today.

I moved on, following the course of the day's battle, eventually ending up near the visitor's center at the Henry House. At the time of the battle, this was home to Judith Carter Henry. In her mid-80s and bedridden, she refused to leave her home as the battle unfolded around her. Confederate snipers claimed the house for its vantage point, drawing Union cannon fire. The shelling killed the old woman, the battle's first civilian casualty.

The remains of the house—picked over for souvenirs—were burned to the ground at the Second Battle of Bull Run, but the home was subsequently reconstructed. It was at Henry House that I met a group of "living historians," talking to visitors about the battle as part of a National Park Service program. They were, in common parlance, reenactors. But the roles they were playing were in their DNA. They were all descendants of Virginia troops who fought at Manassas. We talked for a while, and I took their

Bull Run Creek, Manassas Battlefield

picture. At the time, and in my mind, they were a mere aside—a very interesting curiosity.

Returning home and looking over the images I had taken on my maiden outing, I was pleased with what I saw. It confirmed that I was onto something, that the pinhole camera had captured beautifully what I had seen in my mind's eye. There, in the images of the battlefield, was the quiet, haunting beauty inherent in these landscapes.

But they were maybe a little too quiet. My eye kept returning to the images of those reenactors, flesh of the flesh who fought that day, bestowed with timelessness by the long time exposures of the pinhole camera. Together with the landscapes, they completed the picture. And these reenactors were on precisely the same schedule I was—arriving at each battle site on or around its 150th anniversary.

It was a moment of revelation. From here on, I would be setting my sights both on the battlefields themselves and the battle reenactments that would be occurring on each anniversary across the sesquicentennial. It was here at Manassas, on the 150th anniversary of the first major battle of the Civil War, that I realized my project in full.

Stone House, Manassas Battlefield

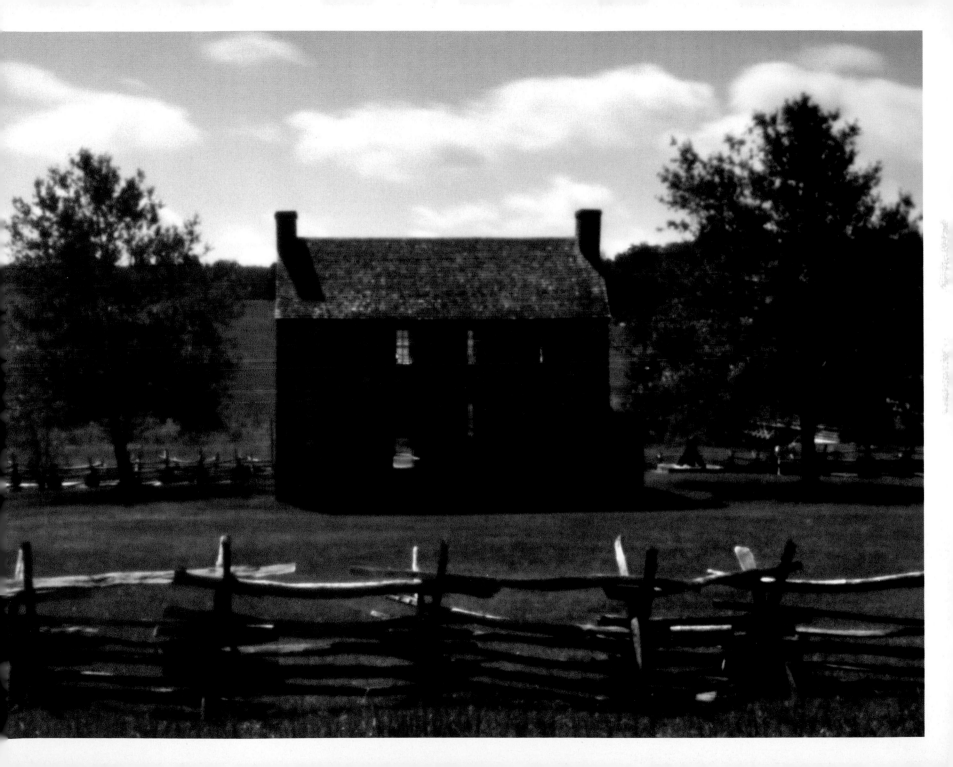

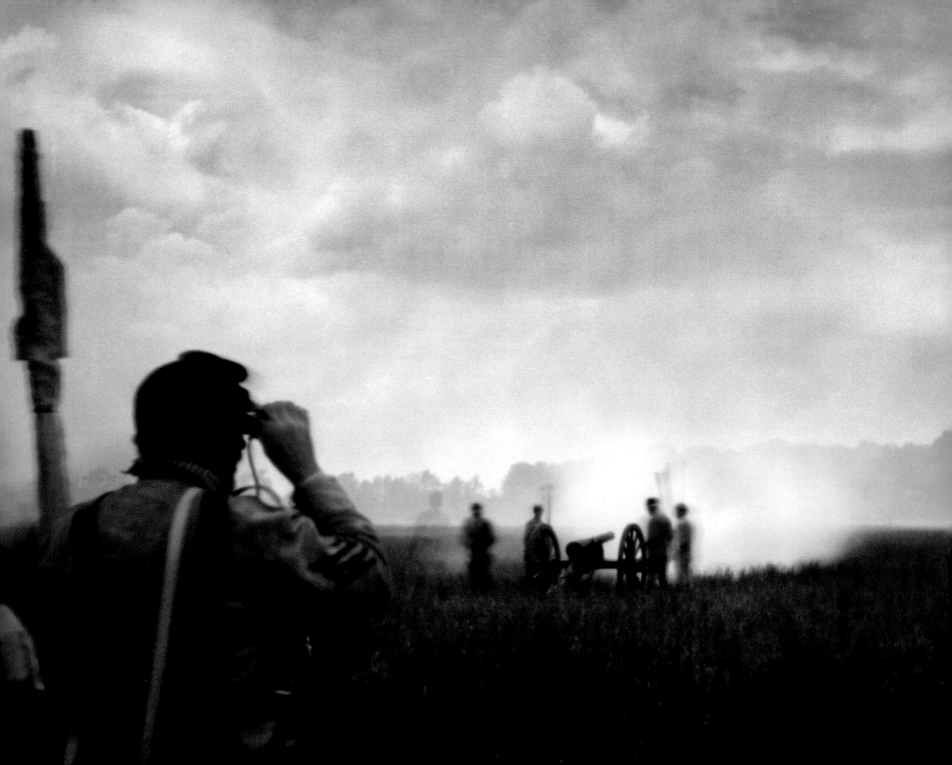

Shiloh

Walking a trail along the Tennessee River on the National Battlefield at Shiloh in 2012, I noticed something curious and out of place on the ground. Picking it up, I realized I was holding the shattered remains of an artillery shell fired during the battle here, exactly 150 years ago, in 1862. My hands were shaking as I held the rusted fragment and considered the trajectory of time and history that left that deadly piece of shrapnel here in this spot.

But perhaps it's not so surprising that relics from the Battle of Shiloh are still surfacing today. By April 7, 1862, the fields and forests around Shiloh were blanketed with the dead. Altogether, 23,746 soldiers were killed, wounded or captured, more than in all of America's previous wars combined. When news of the enormous toll reached the public, a collective hush descended on the land. The grievous sense of loss was all the greater because the battle was inconclusive. Despite the enormous price paid, the only certain outcome was that the war would go on.

"When it was over, the nation—two nations as it were, for the moment—convulsed, horrified, at the results," author Winston Groom wrote on the 2012 anniversary. "A great battle had indeed been anticipated; at stake was control of the Mississippi River Valley, which would likely decide who won the war. But the Battle of Shiloh was not the outcome that anyone wanted.

"Beyond the grisly statistics, Americans north and south of the Mason-Dixon line were suddenly confronted with the sobering fact that Shiloh hadn't been the decisive battle-to-end-all-battles; there was no crushing victory—only death and carnage on a scale previously unimaginable. The casualty figures at Shiloh were five

times greater than its only major predecessor engagement, the Battle of Bull Run, and people were left with the shocking apprehension that more, and perhaps many more, such confrontations were in store before the thing was settled."

I arrived at Shiloh, Tennessee, on the 150th anniversary of the famous battle prepared to explore the battleground and attend my first reenactment. The landscape, then as now, is pastoral farmland broken by pristine forests, with myriad creeks cutting through, creating deep ravines on their way to the Tennessee River.

In early 1862, Ulysses S. Grant disembarked his soldiers at Pittsburg Landing—Grant's name for the Battle of Shiloh—and bivouacked his army along the shores of the river, intent on marching the soldiers twenty miles inland to Corinth, Mississippi, a vital railroad hub for the Confederacy, linking the western states in rebellion to their sister states in the South. Capturing that crossroads could be a crippling blow to the Confederacy.

Unbeknownst to Grant, a large Confederate force was gathering at Corinth, intent on driving the Yankee invaders from the state. In the predawn hours of April 6, 1862, 45,000 Confederate soldiers emerged from the woods, surprising Grant's sleeping army of 65,000—mostly green troops utterly untested in battle—and sending the unnerved Federal soldiers scurrying for safety.

Leading the Confederates that day was General Albert Sydney Johnston, who had been named by his friend Jefferson Davis to be a full general and commander of the Western Department for the Confederacy. While marshaling his troops astride his horse, Johnston was stuck in the right leg. (It may have been friendly fire.) Apparently unaware of the seriousness of the wound, he bled to death, becoming the highest-ranking officer killed in combat in the Civil War, or any war since.

The Union troops escaped a complete rout as hungry Confederates paused to plunder the abandoned Union encampment. Overnight, Federal reinforcements arrived: the Army of the Ohio under the command of Maj. Gen. Don Carlos Buell. Ferrying across the Tennessee River, they then had to make their way through the tens of thousands of panicked young Union recruits who had sought refuge from the battle on the banks of the Tennessee.

Buell's arrival would turn the tide. On April 7, Grant led his reinforced army back across the fields and forests of Shiloh, sending the Rebels in retreat to Corinth, the city to which, within the month, the Union Army would lay siege.

The terrain contributed to the chaos and carnage at Shiloh, and the many losses, amid the confusion, contributed to friendly fire. This was wilderness fighting in dense primal forest, after all, occasionally interrupted by open cultivated fields.

In his memoir of life as a soldier in the First Tennessee Regiment, private Sam Watkins vividly recalled Shiloh, the regiment's first major engagement, as a kind of "dream."

Tennessee River, Shiloh National Battlefield

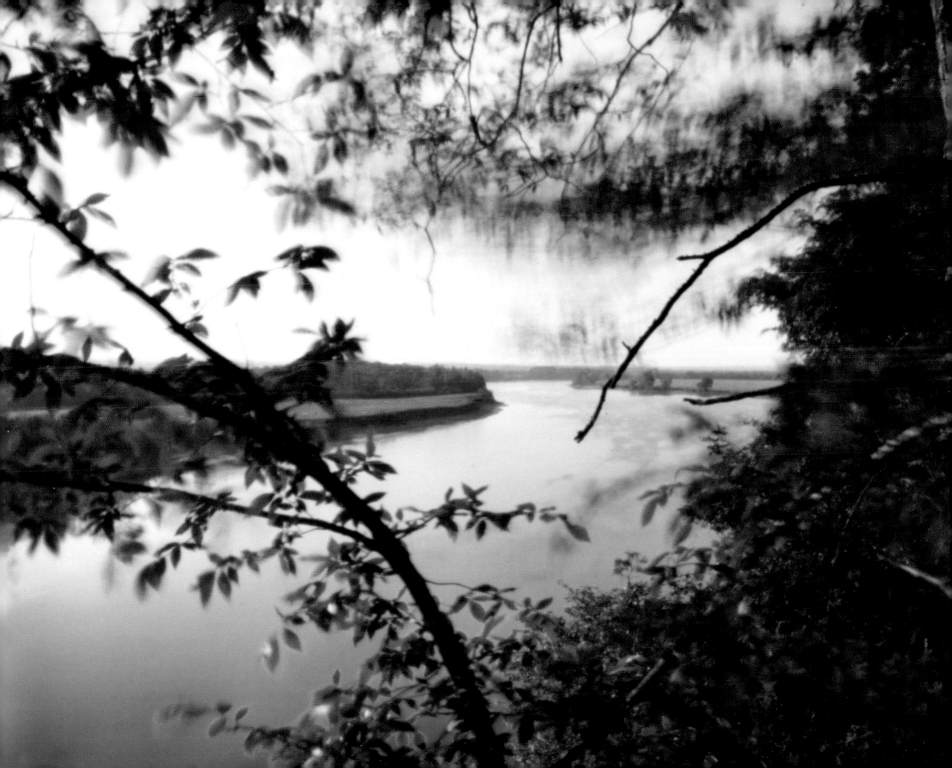

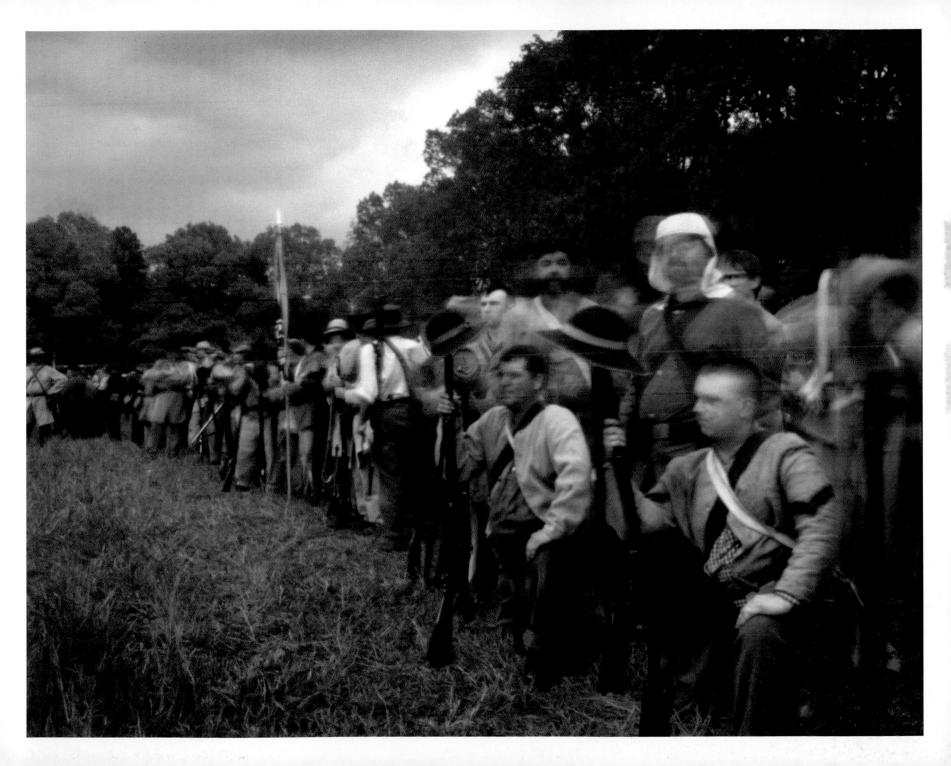

> 66 *I must confess that I never realized the 'pomp and circumstance' of the thing called glorious war until I saw this. Men were lying in every conceivable position; the dead lying with their eyes wide open, the wounded begging piteously for help, and some waving their hats and shouting to us to go forward. It all seemed to me a dream."*
>
> —Private Sam Watkins, First Tennessee Regiment

PREVIOUS: *Pittsburg Landing, Shiloh, Tennessee (left); reenactment at Michie, Tennessee (right)*
LEFT: *Sunken Road, Shiloh National Battlefield*

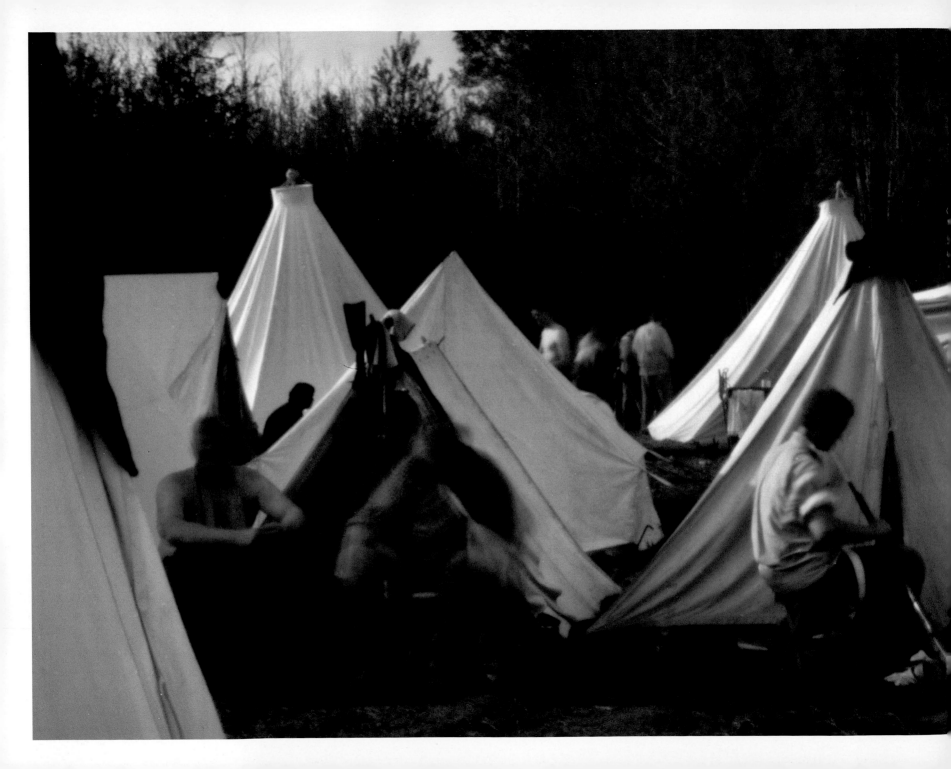

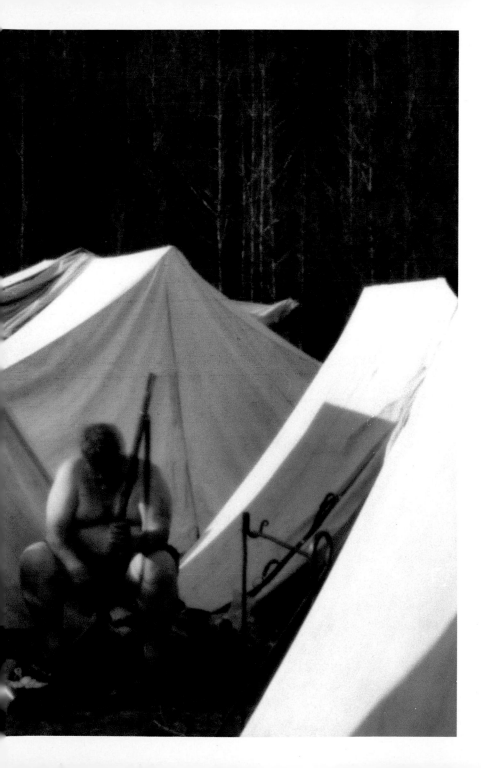

As the sun rose on the 150th anniversary, I stood in Fraley Field, where the first shots were fired upon Union soldiers on reconnaissance by Confederates hidden in the tree line. As the rising sun sent golden rays of light slanting across the landscape, I felt a chill run up my spine.

Could any of those soldiers in Fraley Field, North or South, have known what lay ahead?

The battle on April 6 wasn't a complete rout. Union troops dug in along an old Sunken Road, and held it long enough to stall Confederate momentum. Late in the day, after numerous Confederate attacks, the Southerners turned sixty artillery pieces situated on Duncan Hill toward the Sunken Road to pummel the hunkered-down Union troops. Wounded Federals, sent to the rear, found their way blocked by circling Rebel forces, and returned to the fighting. Two thousand troops were eventually captured, but their fierce resistance helped save the Union Army at Shiloh. The Sunken Road would come to be known Bloody Lane, or the Hornet's Nest—for the buzzing sound of the whizzing bullets.

On a steep bluff overlooking the Tennessee River, ceremonial mounds still rise up in the forest, the remains of a thousand-year-old Native American village. The forest seems untouched by time, a Garden of Eden. The rising sun reflects on the wake of a black snake slithering through the watery clay pit dug a millennium ago. It was from one of the Indian mounds that Confederate Cavalry commander Nathan Bedford Forrest caught a glimpse of Grant's crucial reinforcements arriving by steamboat.

Nearby is another consequential battlefield feature: the Dill Branch Ravine, into which Union troops poured in their confused

Reenactors in camp, Michie, Tennessee

retreat from the surprise Confederate assault. Many Federals were shot down as they slogged their way across the deep creek to the safety of Union guns on the other side of the ravine. But the steep, flooded ravine also ultimately ended the Confederate attack.

Hiking the ravine in 2012, it was easy to see how a battlefield feature like this could determine the outcome. I slipped and fell a number of times negotiating the slick muddy floor and walls of the gorge. A local I chatted with before descending into the ravine suggested I look out for poisonous snakes.

For the sesquicentennial anniversary, thousands of reenactors from around the country camped on farmland secured for the event just a mile or so from Shiloh National Battlefield. This was my first real plunge into the world of reenactments, and the painstaking lengths to which these living historians would go to create the impression that they were nineteenth-century soldiers—and then live in it—astonished me.

The Southern reenactors seemed especially dedicated to authenticity, to the point that I initially found them slightly intimidating. After skirting the unsmiling men on horseback with their long straggly beards, bristling with weaponry and fitted into their greasy butternut uniforms, I eventually approached with the pinhole camera for a closer look. With a big smile, the leader of this roughneck band called me "Mr. Brady" and asked if I would like to take a photograph of them.

I was instantly put at ease and began to see these gentlemen as their twenty-first-century selves. Although convincingly dressed in the likeness of their Confederate forefathers, they were—the rest of the year—truck drivers, mechanical engineers, and construction managers.

Marching through the Tennessee wilderness alongside what were now hundreds of these Southern reenactors, one of the crew began to sing the old wartime tune "Dixie" with the entire company of soldiers joining in.

Railroad, Corinth, Mississippi

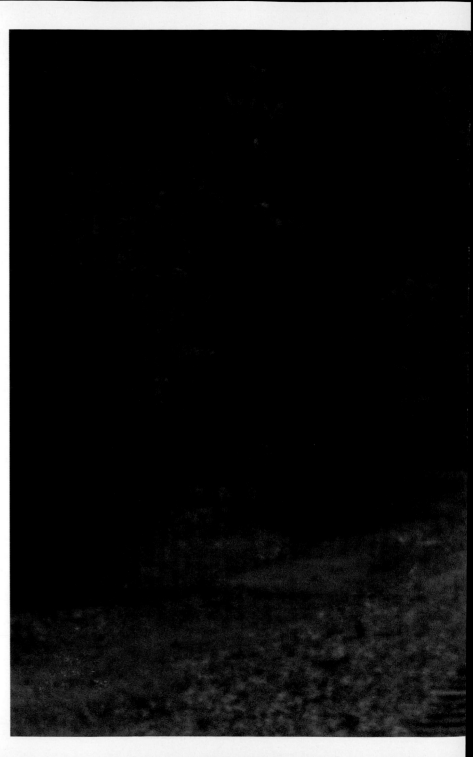

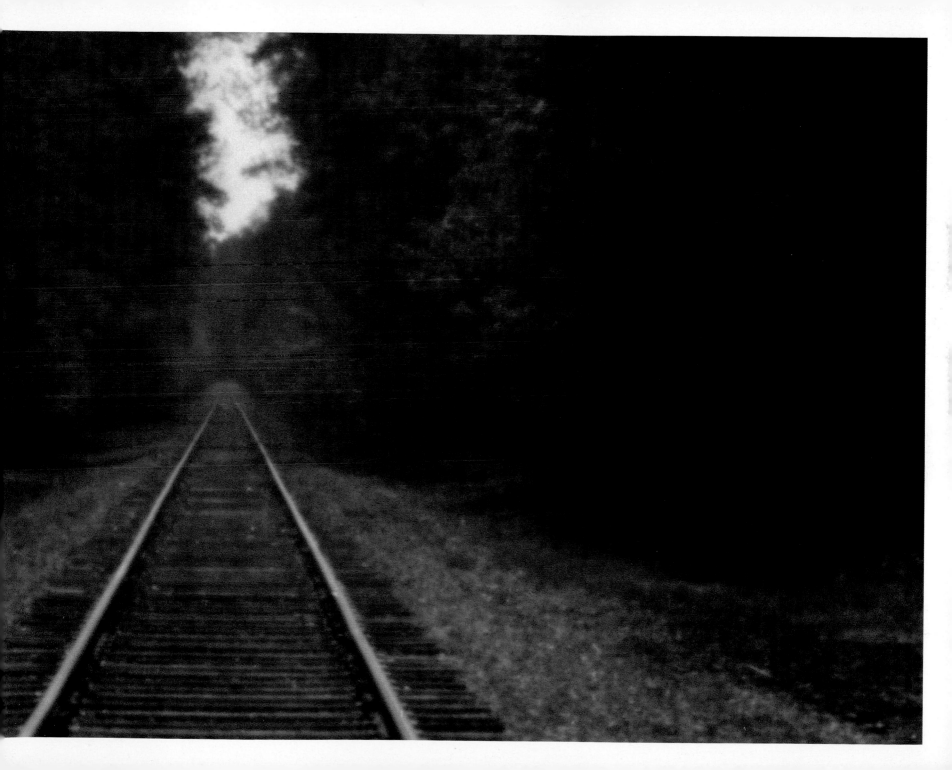

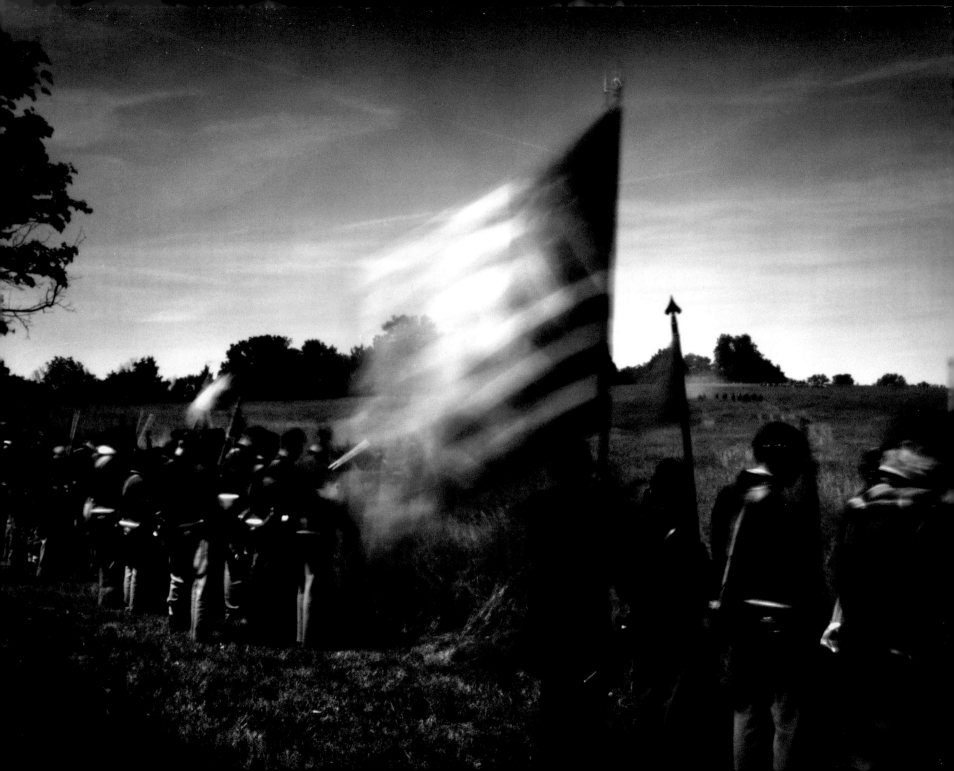

Shenandoah Valley 1862

Now, as in the days of the Civil War, Virginia's Shenandoah Valley is one of the most breathtakingly beautiful places in America. Stretching 150 miles from Harper's Ferry to Lexington and framed by the Blue Ridge and Appalachian Mountains, the Shenandoah Valley points like a spear, northeastward, toward Washington. From the outset of the war, the Union saw it very much in those menacing terms.

For the Confederacy, the strategic importance of the Valley was not just its location. This area was "the granary of the Confederacy." The Confederate forces depended on it to feed its armies and supply its cavalry with horses. Moreover, in its bucolic splendor, the Valley was close to the heart of the Confederacy in

every sense: a source of emotional and spiritual sustenance, and, in the spring of 1862, a font of inspiring dispatches, with Stonewall Jackson "performing prodigies of valor in the Valley," in the contemporaneous description of Judith McGuire, a war refugee living in Richmond.

The Shenandoah Valley was also, for me, a scene of personal tactical maneuvering. Here, I sought to infiltrate a battlefield—in the midst of a reenactment—dressed, as best as I could muster, in the period dress of a nineteenth-century photographer. It was not an easy mission. But after my experience photographing the reenactment at Shiloh, I knew I could not shoot from the outskirts of the action if I wanted to successfully execute this project. It was imperative that I be on the field, in the thick of the action.

Battlefield at New Market, Virginia

In 1862, Union forces entered the valley with 50,000 soldiers, intent on laying claim to this fertile region, but they were stopped cold in a series of engagements with troops commanded by Jackson, the Confederacy's most feared general. Before the war, Jackson lived in Lexington, teaching artillery tactics at Virginia Military Institute. He knew the region well. It was his home turf.

Dispatched to defend the Valley, Jackson's familiarity with the region was buttressed by Jedediah Hotchkiss, historically remembered as the most famous cartographer and topographer of the Civil War. Born to a prominent New York family—his mother was cousin to Harriet Beecher Stowe, the abolitionist author of *Uncle Tom's Cabin*—Jed Hotchkiss had first come to Virginia in 1847 as a young man on an extended walking tour of the Valley, a sojourn that led to his being hired as a tutor, and ultimately founding his own school, while also teaching himself map-making.

Hotchkiss thought secession a mistake, but joined the war effort anyway. When Jackson encountered him, he gave him this command: "I want you to make me a map of the Valley, from Harpers Ferry to Lexington, showing all the points of offense and defense in those places." Those detailed maps, delineating every road and mountain gap in the Valley, proved indispensable to Jackson, enabling him to exploit the secrets of the terrain to outfox and surprise a Union Army effectively on foreign soil.

The stakes were enormous. As Jackson famously put it, "If this Valley is lost, Virginia is lost." Although he was defeated in the Battle of Kernstown near Winchester on March 23, 1862, Jackson regrouped his smaller force of 17,000 troops near New Market and began his grand strategy to outmaneuver and defeat the Union forces sent to subdue him.

Signal Knob, Front Royal, Virginia

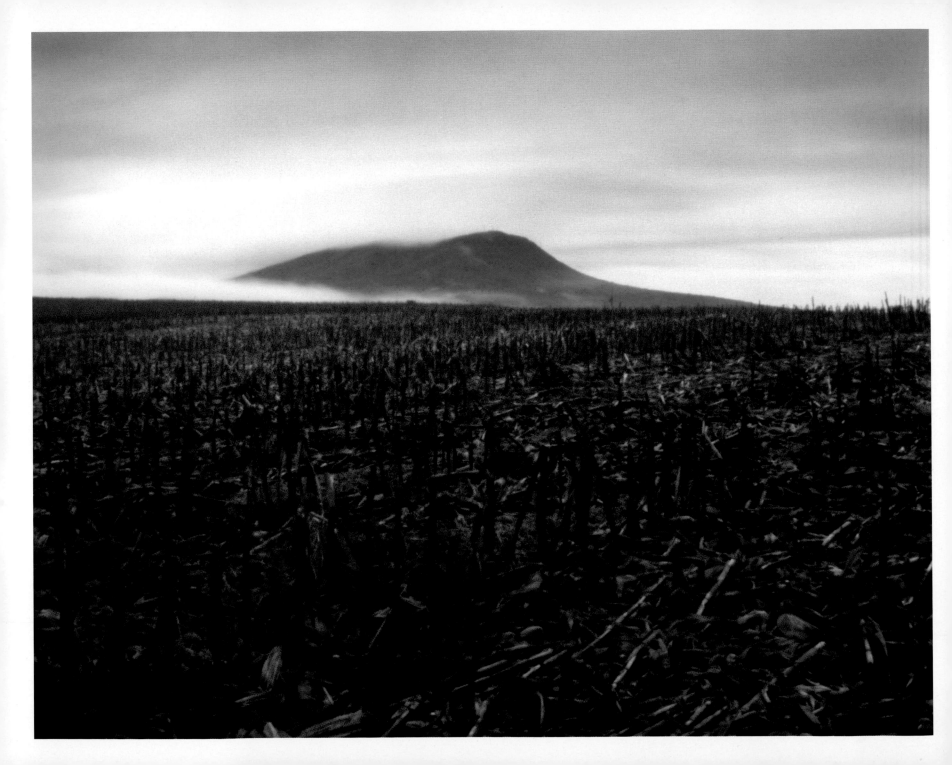

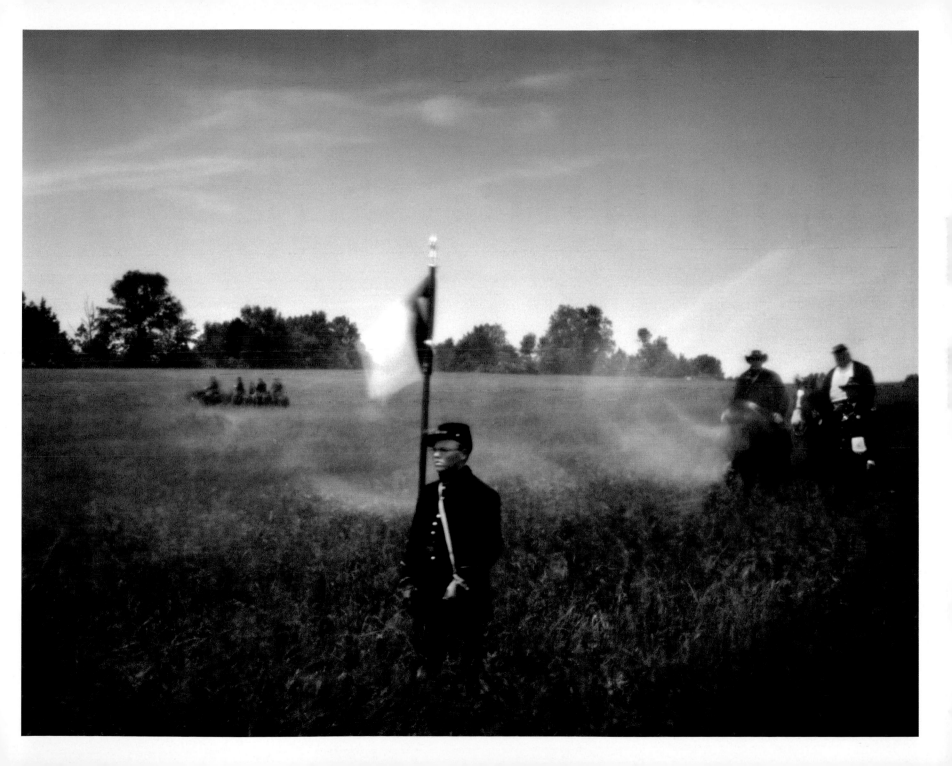

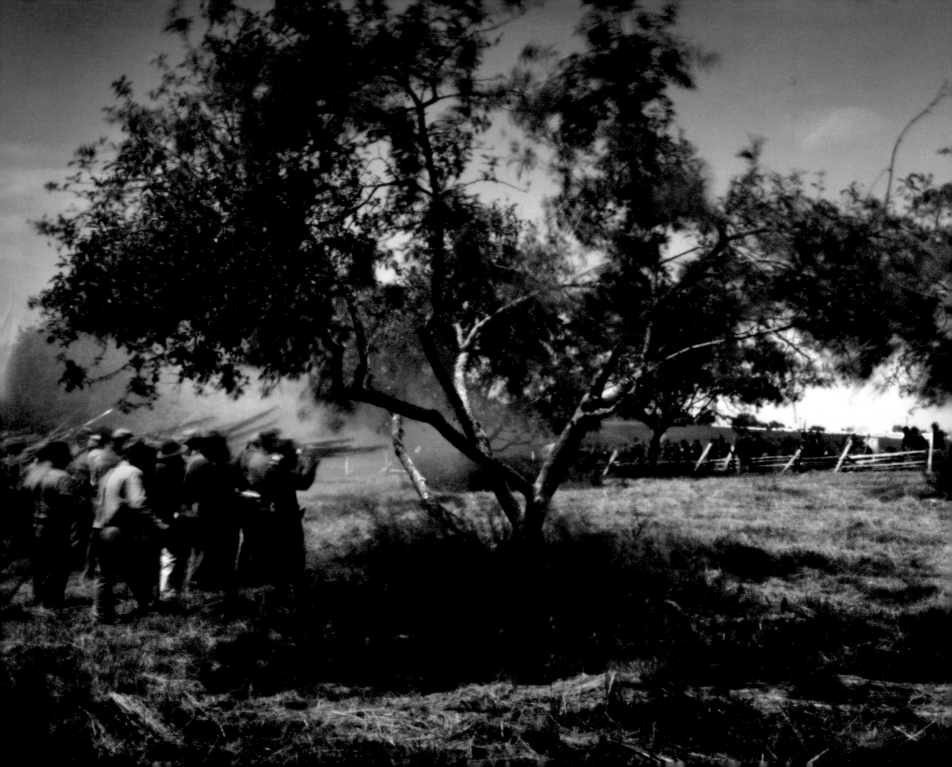

From April to June 1862, in battles at Winchester, McDowell, Cross Keys, and Port Republic, the Confederates bested Union armies twice their size. Jackson's textbook campaign of "surprise and maneuver" in the Valley made him an international celebrity. With his success turning back the Union troops, Jackson was free in late June 1862 to march his army out of the Valley to the aid of General Robert E. Lee fighting on the Virginia Peninsula against a Union Army bent for Richmond.

I visited the battlefields at Cross Keys and Port Republic during a torrential downpour. When the weather cleared, rolling farms appeared, along with the ever-present Massanutten Mountain east of Harrisonburg. A vital lookout point during the war, Massanutten looms over the landscape.

In the Luray Valley on my way to the small town of New Market, I came across an old barn, daylight filtering through gaping, jagged holes. In my imagination, it had been shelled in battle. This is not actually very likely, but the past seemed so present here, in a place where both armies marched and encountered one another. In Virginia, every nook and cranny of the landscape bears the scars of war.

In 1862, Jackson encamped his army here to refit after the Battle of Kernstown. The rolling farmland adjacent to the old Valley Pike has been well preserved and looks much like it did 150 years ago. The Bushong Farm still sits on the site and is open to visitors today. An old orchard behind the farmhouse is still dropping apples like those gobbled up by the armies during the war.

New Market is one of a number of Civil War battlefields in the country administered by a private organization. Reenactments are traditionally not allowed on National Park Service battlefields out of respect for "hallowed ground." But, on privately held battlefields, reenactments are a prized way to raise money, and reenactors have the rare privilege of fighting on the actual soil where a battle was originally fought and not some nearby substitute.

New Market would be my reenacting debut, and I arrived dressed in the guise of a nineteenth-century photographer. I was not greeted with open arms. The organizers were used to photographers trying to gain access to the battlefield during reenactments, something they do not look upon with favor. But surely I was different, I thought. Really. I just needed to persuade them.

PREVIOUS: *Massanutten Mountain, Cross Keys, Virginia (left); reenactment at New Market, Virginia (right)*

LEFT: *Orchard on the Bushong Farm, New Market, Virginia*

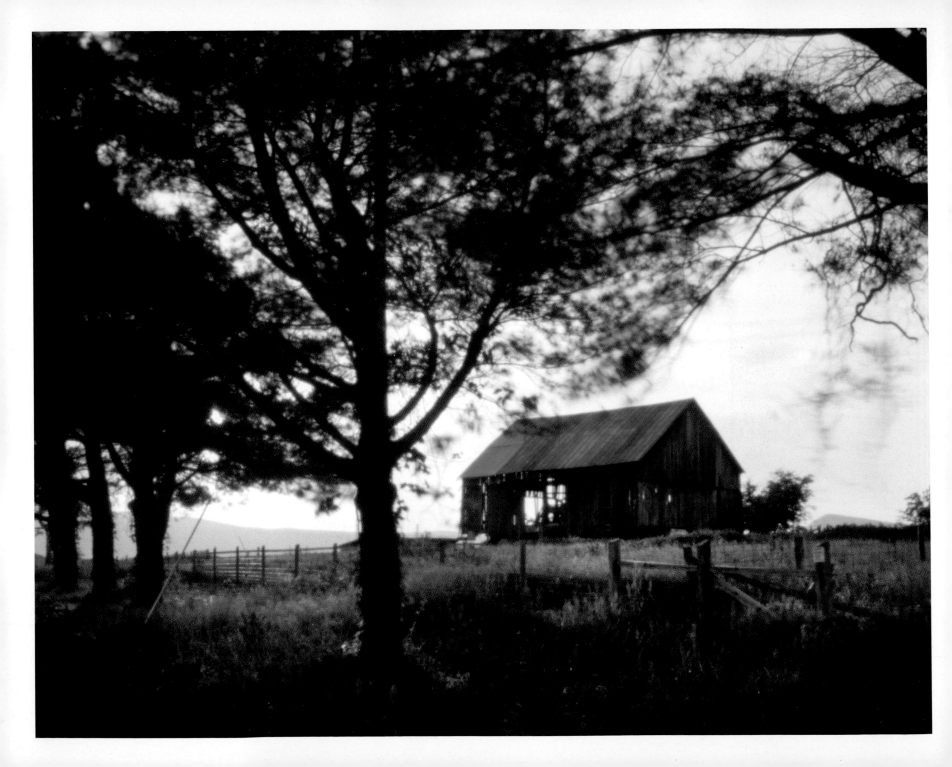

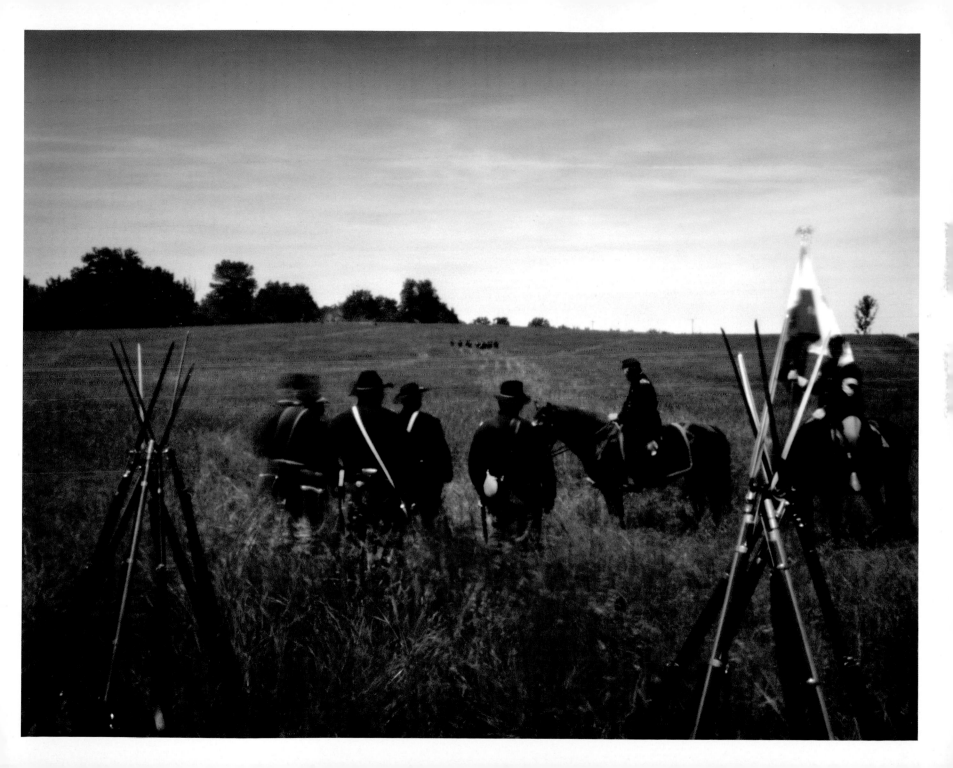

At New Market, I showed them the pinhole cameras. I showed them pinhole images from Shiloh. I met Ron Paul, a local Vietnam veteran and longtime reenactor who was the event organizer. Overcoming his skepticism, Paul gave me some advice. He suggested that I embed with a unit—and get some better clothes. So I went to the sutler's village—where merchants, then and now, would typically set up shop by the encampment and sell their wares—and bought a more believable period straw hat.

In my 20 years as a photojournalist, my modus operandi was always to be as inconspicuous as possible: to be invisible, to disappear. Now here I was in costume, worrying about which hat to wear. But I had come to realize that only by embracing the role of a period photographer could I blend into the unfolding scene and do what I was here to do.

It would be an ongoing challenge, as "the war" progressed. But, having gained access to the battlefield for the first time at New Market, I now had to confront the difficulty of using the cumbersome pinhole cameras, with their long exposure times, amid the bedlam of the fast-moving battle scenes.

Battlefield at New Market, Virginia

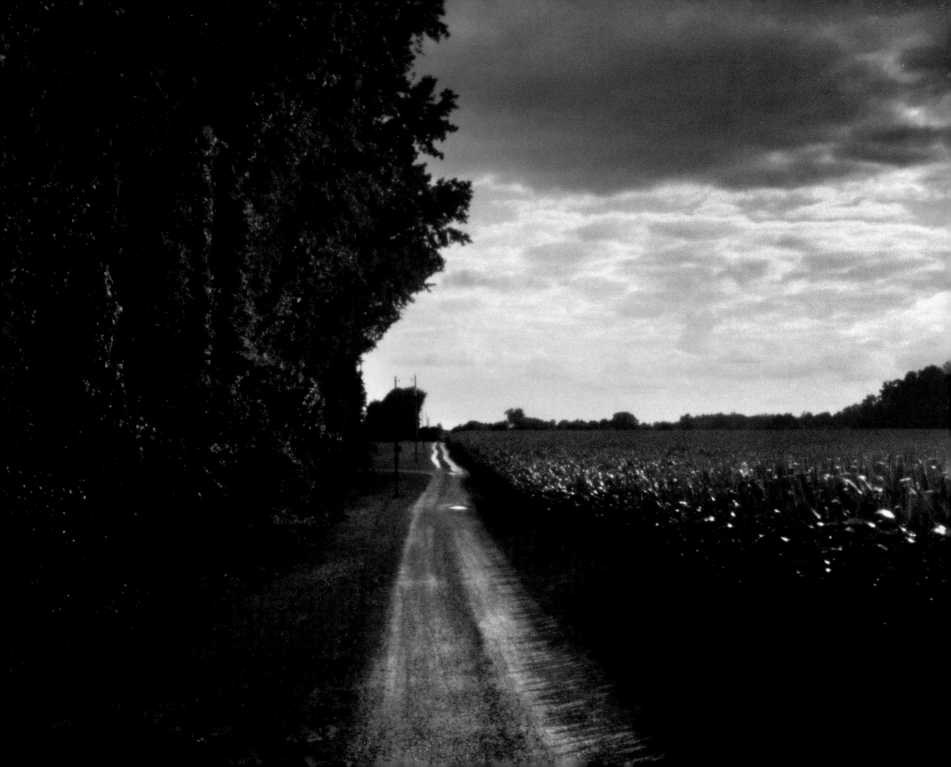

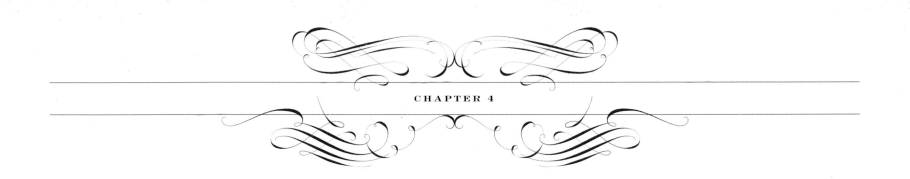

Seven Days Battles

The rolling landscape between the Chickahominy and the James Rivers near Richmond, Virginia, can sometimes appear to be a vast swamp. The spring of 1862 was the rainiest in recorded history in Virginia, and both Union and Confederate troops would fight six major battles in just seven days, slogging through this soggy terrain.

The two sides fought over the space around Richmond throughout the war; worn-down trenches and earthworks still dot the landscape amid its small farms. In early 1862, General George B. McClellan marched the 100,000-man Army of the Potomac up the Virginia Peninsula, intent on capturing Richmond.

In May, after gaining control of the Port of Norfolk, Union ironclads had made their way up the James River ahead of McClellan's troops, intent on bombarding the Rebel Capital. But

the city's Confederate defenders had sunk ships in the river to obstruct the ironclads' progress, and they were manning the guns high upon Drewry's Bluff to further deter such an attack. Stalled by the sunken hulks, the Union ironclads turned back. The Army of the Potomac would have no choice but to march and fight their way to Richmond.

For the first time, the Confederates were under the command of Robert E. Lee, who had assumed the reins after General Joseph E. Johnston was wounded at the Battle of Seven Pines. A former superintendent of West Point, Lee was highly regarded. He was considered the most experienced soldier in the country.

Lee, who had served the first year of the war as an advisor to Jefferson Davis, was ordered to stop McClellan's advance. Defending the Confederate Capital was the top priority and,

Gaines' Mill Battlefield, Virginia

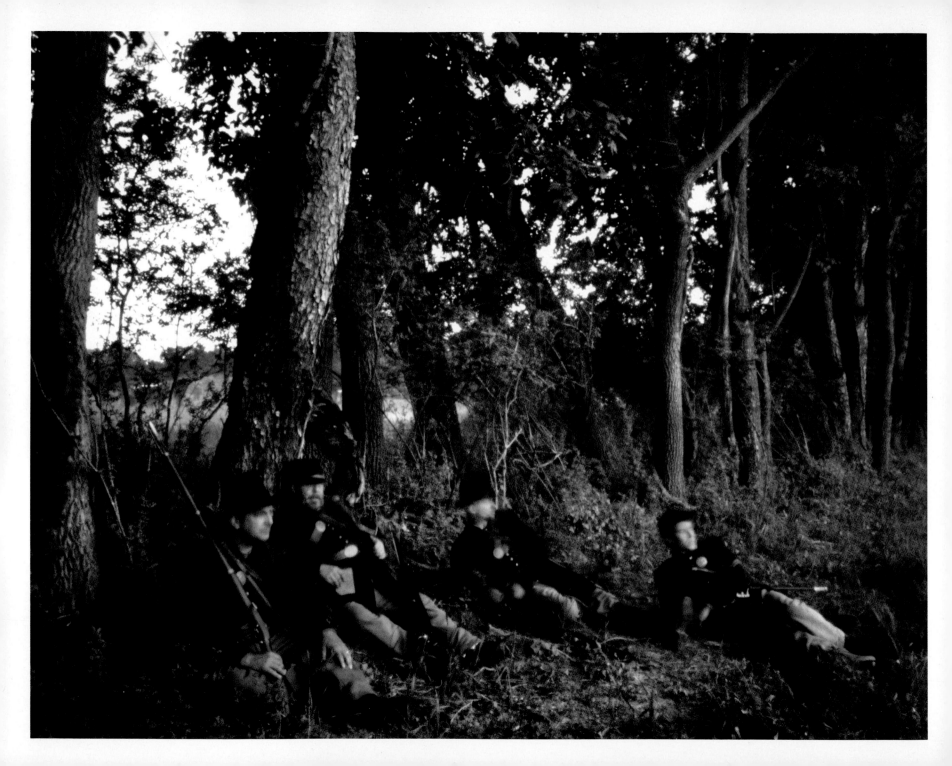

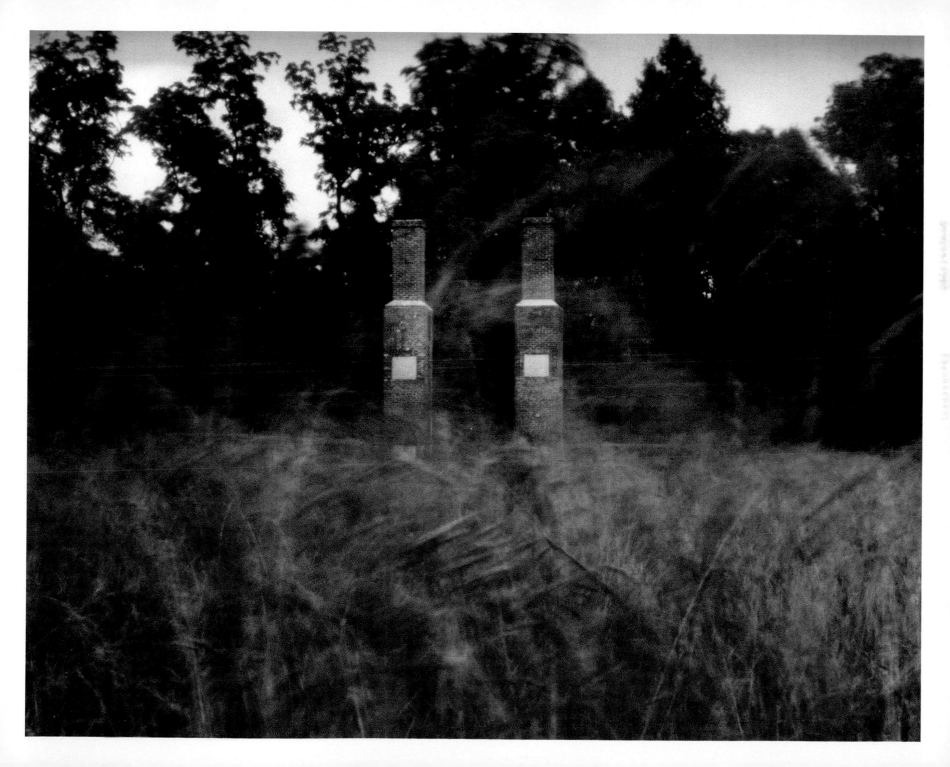

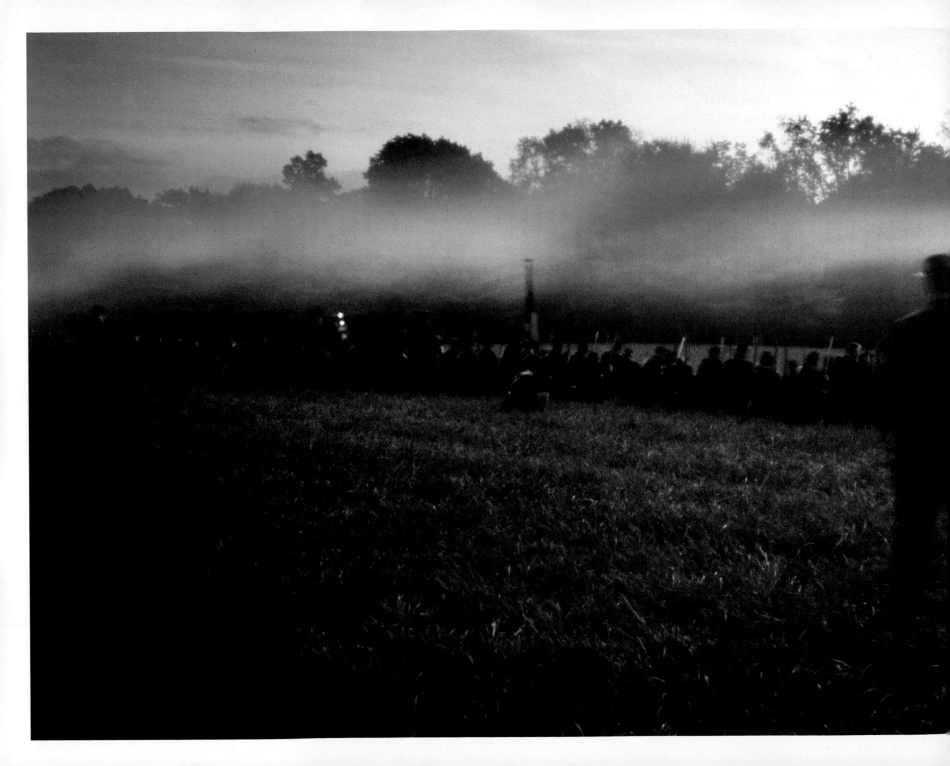

outnumbered, as he would be during much of the war, General Lee went on the offensive. The Army of the Potomac was on the doorstep of victory, less than ten miles from Richmond, when Lee's troops stopped them at Oak Grove.

Over the next seven days, the two armies would clash in a series of battles that pushed the Union Army back on its heels. Battles at Beaver Dam Creek, Gaines' Mill, Savage Station, Glendale, White Oak Swamp, and Malvern Hill would enable Lee to drive the superior Union forces back down the peninsula. There had been a brutal cost: 35,000 casualties on both sides. But Richmond, and the Confederate cause, had been saved. The momentum of the war had been reversed. McClellan had been unnerved by Lee's confident aggression. The war would go on.

Hiking along Beaver Dam Creek in 2012, taking in the swampy landscape with its dense vegetation, I wondered how the armies fought here at all. The black waters seemed menacing, and the random tussles of swamp grass, like stepping stones, seemed the only sure footing in the morass.

The Battlefield at Gaines' Mill today looks much as it did 150 years ago. The old Gaines' farmhouse still sits on the site, its now-quiet fields delineated by cross-rail fences. Union guns sit arrayed, pointing toward a stand of trees. On June 27, in the forest opposite the Gaines' farm, the trickling Boatswain Creek created a ravine in the dense forest that hid Lee's attacking force. To stand behind the Union guns, knowing what was to come on that day, remains intimidating even today. That evening the Union gunners were startled by an eerie wail emanating from the forest. It was the Rebel Yell.

One feels the same dread at Malvern Hill. In this last battle of the Seven Days Campaign, Union guns were arrayed along the summit—as they are today—with a clear view of the tree line

Gun smoke, Elizabethtown, Pennsylvania

a quarter mile away. There, they waited for the Confederates, who had taken up position in the forest near Willis Church, to launch what would prove to be a devastatingly costly attempt to take the hill.

Two chimneys are all that remain of the church, now called the Parsonage Ruins. The doomed assault on Malvern Hill would cost the Confederates more than 5,000 casualties in less than an hour.

"It was not war," wrote Confederate General D.H. Hill, whose brigades suffered appalling losses. "It was murder."

It has been described as Lee's greatest mistake. And yet, in the aftermath of the Confederate defeat at Malvern Hill, McClellan withdrew, Richmond was safe, and, it seemed, the tide of the war had turned.

Coinciding with the 150th anniversary of the Seven Days Battles, I attended a reenactment held in Elizabethtown, Pennsylvania. Organized by the Southern Division, a group of dedicated living historians, reenactors from around the country gathered in this small Pennsylvania town to commemorate the Confederate success in the Seven Days Battles.

Known as "campaigners," the reenactors of the Southern Division are a hardcore lot. They take the hobby of reenacting to heights I had not previously witnessed.

Photographing them was a revelation.

Upon my arrival, I was asked to present myself to the Confederate commander at sunrise the next morning to be embedded with a unit I would follow over the weekend. Per instructions, I arrived as the sun's first rays illuminated the farm that would serve as the field of battle. There I was stopped by a Confederate sentry.

"Who goes there?"

Taken aback, I explained to the sentry that I was there to see the commander, that he was expecting me. The sentry led me to his sergeant, who in turn led me to his captain. The captain directed me to the camp adjunct. He looked me up and down, asked if I was a Union spy, then he dutifully scribbled a pass so I could enter the camp.

I'm not sure what would have happened if they had determined I was a spy. In any event, I was embedded with reenactors of the 1st Virginia Regiment. I would march with them into battle over the weekend.

This was my second reenactment, and I was learning the difference between mainstream reenacting, which is mostly for the benefit of the spectators, and campaigning, which is all about the campaigners. In Elizabethtown, of the three battle scenarios the campaigners were reenacting, only one was open to public viewing. The campaigners are meticulous about accuracy. They sew their own uniforms and knapsacks, and they try to remain in "first person," living as a nineteenth-century soldier at all times throughout the weekend. They skewered beef on a bayonet, roasting it on an open fire. It was delicious.

At dusk, just before the battle began, I watched and listened as a group of Confederate reenactors, in the colorful Zouave uniforms of the Louisiana Tigers, prepared in the day's waning light. Their commanding officer offered a dramatic reading from *Harper's Weekly*, dated June 1862, recounting the depredations being suffered by the people of occupied New Orleans, recently captured and under the command of Union General Benjamin Butler of Massachusetts.

Gaines' Mill Farm, Virginia

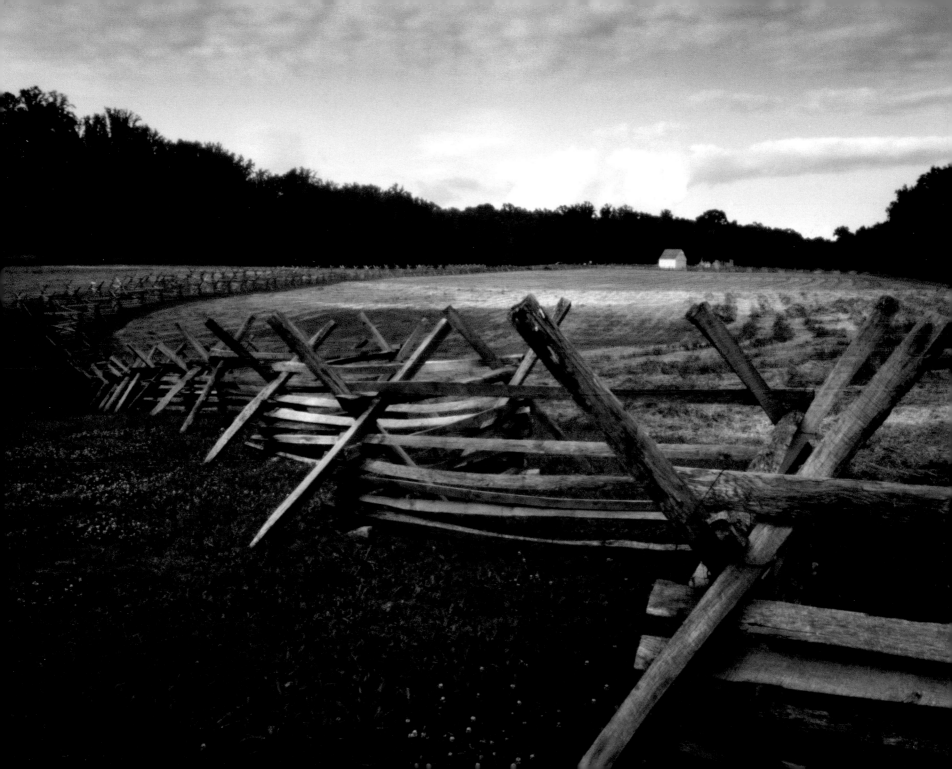

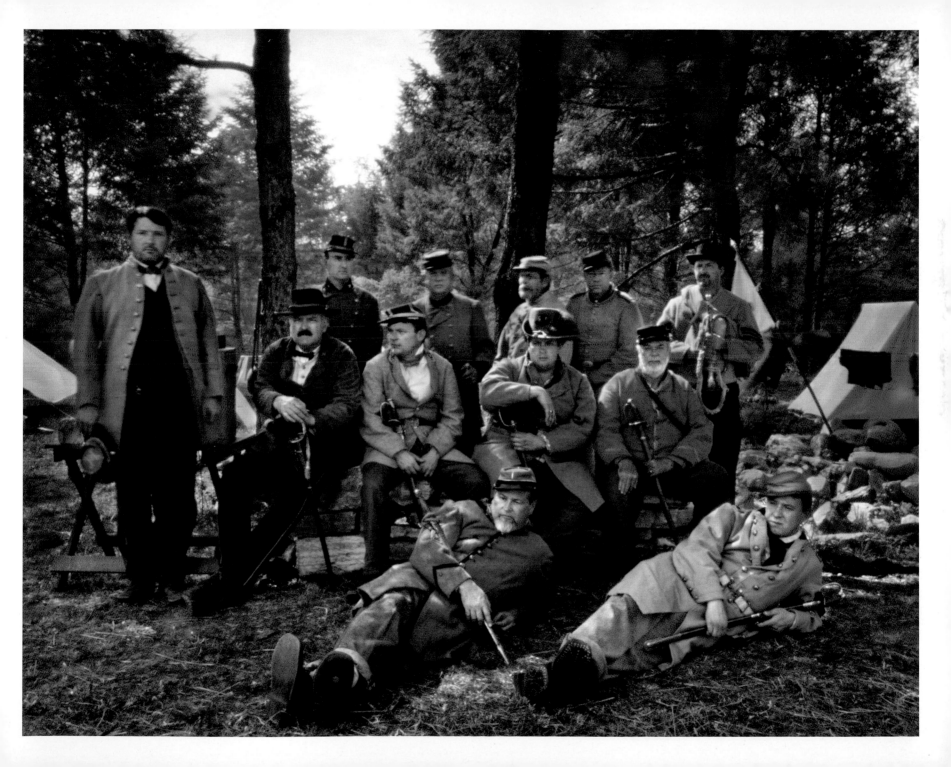

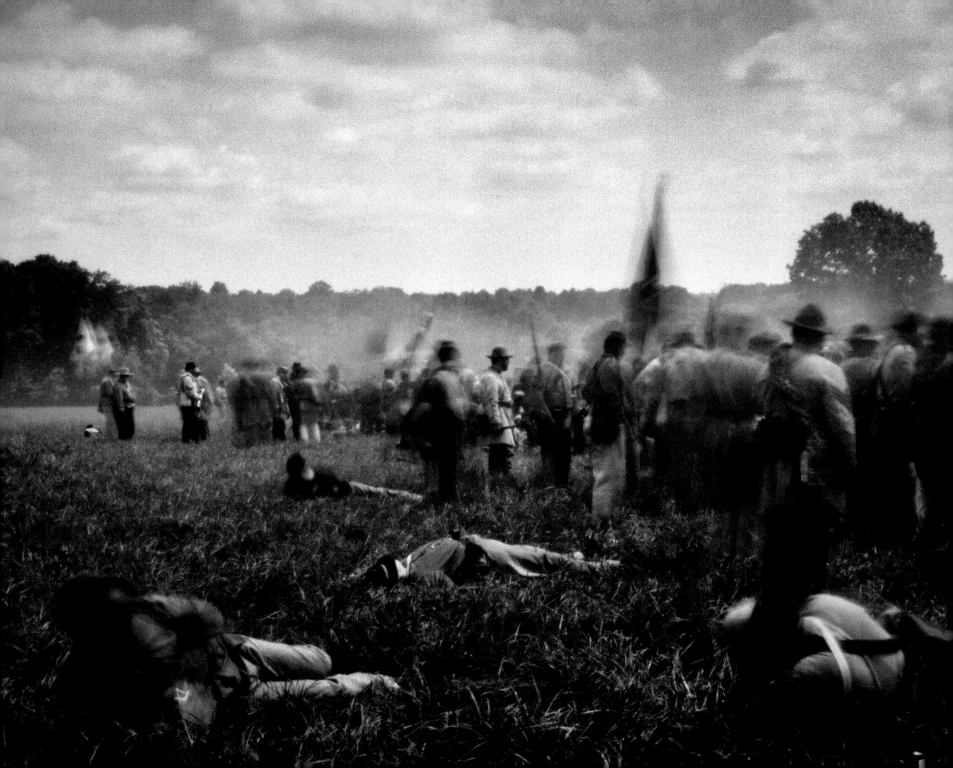

It was Butler, dubbed "the Beast," who, in response to the rudeness local women showed his troops, had issued a decree that any female who insulted a Union soldier by word or deed could be regarded as "a woman of the town plying her avocation."

Listening, I noticed that some of the reenactors—these men who had traded emails with patterns for the uniforms they would sew themselves—were crying, tears streaming down their cheeks. Others called out, "Down with the Union," and "Kill Lincoln."

Leaving the forest to view the battle from the Union perspective, I was back on what now seemed familiar terrain: standing alongside Union guns lined up in an open field, staring out at a dark, forbidding forest. As dusk descended, that unearthly Rebel Yell rose from the forest and the Confederates came rushing from under cover, screaming at the top of their lungs, sending a collective shiver through me and my Union comrades.

You could feel the concussive impact of the shattering cannon blasts. Gun smoke drifted in huge clouds across the meadow. I reunited with the Louisiana Tigers as they charged, shrieking, their faces now powder stained, rifles leveled, crashing headlong into and over me and the Union line in their scripted victory.

The fighting ended. Silence descended on the field.

The following day, for the reenactment of the Battle of Glendale, an Iraq war veteran serving with the First Virginia Regiment was asked to read from a memoir of a Confederate who served in the Seven Days Battles.

"Duck, load, fire, and repeat," was the order of the day, then, and now.

At the mainstream reenactments, long battle lines of soldiers would stand shoulder to shoulder and trade shots across an open field, but it was rare to see a reenactor fall "wounded."

That was not the case in Elizabethtown. Before each reenactment, unit officers handed out scraps of paper to each reenactor assigning them their fate: "belly wound," "leg wound," "dead on the field."

I followed the First Virginia Regiment as it marched in formation toward the Union position, just over a rise in the open field. As we cleared the rise, there before us, not 100 feet away, was a stunning line of hundreds of Union reenactors behind a cross-rail fence, their guns trained on us. All at once, they unleashed a devastating volley of musketry upon us. I watched, stunned, as the entire line of Confederate reenactors surrounding me dropped to the ground, "dead and wounded."

I was the only one left standing. I had received no scrap of paper.

Seeing all these men fall in a heap around me, my weekend comrades screaming and writhing on the ground, was deeply affecting, even heartrending. I had experienced a profound "period moment." A "period rush." Their performance had shaken me to my core.

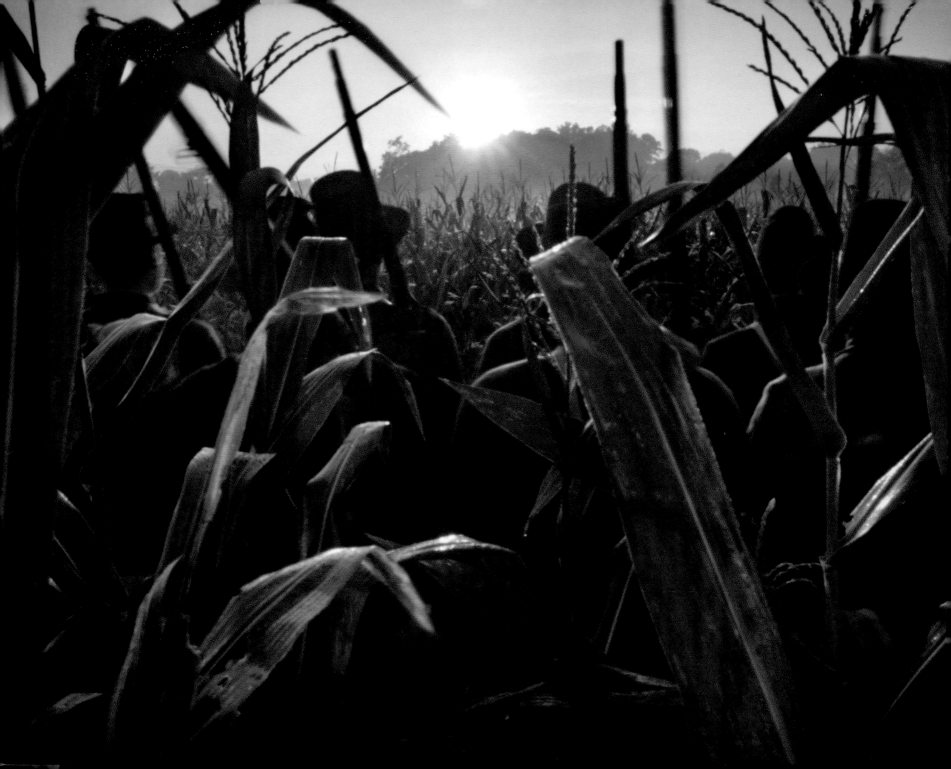

Antietam

orning fog filled the hollows in the Maryland countryside in the predawn hours of Sept 17, 2012. I had arrived at the Antietam battlefield, along with thousands of other Americans keen on seeing the sunrise over the battleground's infamous cornfield.

One hundred fifty years ago, the Union and Confederate armies met here and fought for 18 straight hours. At day's end, 23,000 dead and wounded covered the fields and lay along the creek outside of Sharpsburg, Maryland. The slaughter at Antietam still marks September 17, 1862, as the bloodiest day in American history.

On the morning of the sesquicentennial, the fog mixed with gun smoke as reenactors marched through the cornfield, firing their rifles in a skirmish line to commemorate the commence-

ment of the fighting. The reenactors got a small taste of the fog of war among the tall stalks, as gun smoke shrouded the cornfield, hiding the belligerents from one another as they exchanged fire in the morning air.

In early September 1862, Robert E. Lee led his 55,000 rebel soldiers across the Potomac River, entering the border state of Maryland intent on taking the war north. Fresh off their recent victories, Lee was determined to stay on the offense and, on the march and on the rise, gather new recruits along their way in Maryland, a state with sharply divided loyalties.

With its large plantations along the Atlantic Coast, Maryland was one of four slave states—the others were Delaware, Kentucky, and Missouri—not to join the secession. Maryland saw the first casualties of the Civil War. A week after shots were fired on

Black Hats in the Cornfield, Antietam Battlefield

Fort Sumter, soldiers from the 6th Massachusetts Regiment were changing trains in Baltimore on their way to Washington when they found themselves having to fight their way through a secessionist mob. Four soldiers and twelve rioters were killed.

Fearing that Lee's advance threatened Washington, Union Gen. George McClellan rushed to meet him with an overwhelming force of 75,000 soldiers. The two armies clashed outside the town of Sharpsburg, near the Dunker Church, among the pristine rows of corn still unharvested. By the morning of September 17, the cornfield was in ruins, flattened by the marching armies and matted with casualties: 9,000 dead and wounded soldiers, blue and gray.

Lieutenant Colonel Rufus Dawes, 23, led the soldiers of the Wisconsin 6th Volunteers. They had already earned the sobriquet the Iron Brigade, bestowed by General McClellan as he watched them scale and secure the heights of South Mountain in an engagement a few miles away in a prelude to the Battle of Antietam. That morning, Dawes guided his men into the blinding gun smoke of the cornfield, describing the terrible confusion as they encountered the determined rebels:

"There was, on the part of the men, great hysterical excitement, eagerness to go forward, and a reckless disregard of life, of every thing but victory. Every body tears cartridges, loads, passes guns, or shoots. Men are falling in their places or running back into the corn. The soldier who is shooting is furious in his energy."

Dawes, the grandson of William Dawes, who rode with Paul Revere to warn that the British were coming, had, within days of Fort Sumter, begun to raise a company lest "someone would get ahead and crush the rebellion before I get there."

Now, here he was, in the middle of the most terrible fighting of the war.

Again and again, hour after hour, by charges and countercharges, this portion of the field was lost and recovered, until the

green corn that grow upon it looked as if it had been struck by a storm of bloody hail."

The battle would continue throughout the day, moving across the undulating hills and cultivated farmland that still defines what may be America's most beautiful battlefield.

After the slaughter in the cornfield, the fighting moved onto the Sunken Road, a deep, rutted country lane that bisects the battlefield. Confederate troops occupied the road, piling up fence rails to fortify their position, then waited for the enemy to attack.

When it came, Gen John Gordon, the Confederate commander at the Sunken Road, watched in awe as wave after wave of Union troops were felled as they made their assault on the dug-in rebels, dying in heaps: "As we stood looking upon that brilliant pageant, I thought, if I did not say, 'What a pity to spoil with bullets such a scene of martial beauty!'"

Gordon, who had developed a reputation for a kind of magical invulnerability, was shot five times by Federal rifles. The last blow laid him low that day, though, miraculously, he would live on to play an important role in battles to come.

At great cost, the Union forces finally overwhelmed and uprooted the Confederates on the Sunken Road, rechristening it, due to their troop sacrifices, the Bloody Lane. The final clash of the two armies would occur a few miles further south, at a stone bridge spanning Antietam Creek. It is known now as Burnside's Bridge, named for the Union General who fought his way across it, capturing the crossing.

Union troops assaulted and routed the Confederates defending the opposite bank and then moved to the hills surrounding Sharpsburg to outflank Lee. Pressed by this overwhelming assault, Lee and the Confederates were only saved from annihilation by the timely arrival of Gen. A.P Hill's troops, who had force-marched his men 17 grueling miles to the battlefield that morning and entered the fray at the last possible moment, to turn back Burnside's assault.

The fighting ended on Sept 17, 1862, as darkness fell. The battle was so devastating to both armies that, although they remained in position the following day, the fighting at Antietam was over. On the evening of September 18th, Lee marched his Army back into Virginia, bloodied but still intact.

·———— >‹ ————·

Antietam—or the Battle of Sharpsburg, as it was known in the South—was seared into historical memory because of its awful, unprecedented toll. But the particular locales—the Cornfield, the Sunken Road, Burnside's Bridge—were also forever imprinted on the American mind thanks to the presence, amid the grizzly aftermath on the battlefield, of Alexander Gardner, a Scotsman. Gardner was among the more than 20 photographers working for Mathew Brady in his path-breaking work recording the war on film. Scarcely a month after the battle, Brady presented an exhibit in New York, "The Dead of Antietam," featuring more than 70 of Gardner's images, many of them stereo photographs.

For the first time, Americans in great numbers were able to see a battlefield laid waste by war, and in 3D. In much the way that TV brought the Vietnam War into America's living rooms, "The Dead of Antietam," a century earlier, brought the Civil War home.

As *The New York Times* wrote in October 1862, "Mr. Brady has done something to bring home to us the terrible reality and earnestness of war. If he has not brought bodies and laid them in our dooryards and along the streets, he has done something very like it.

"At the door of his gallery hangs a little placard, 'The Dead of Antietam.' Crowds of people are constantly going up the stairs;

PREVIOUS: *Dunker Church, Antietam (left); Mumma's Farm, Antietam (right)*

follow them, and you find them bending over photographic views of that fearful battle-field, taken immediately after the action. Of all objects of horror one would think the battle-field should stand preeminent, that it should bear away the palm of repulsiveness. But, on the contrary, there is a terrible fascination about it that draws one near these pictures, and makes him loth to leave them."

Those battlefield sites are well preserved today. Visitors can walk the Sunken Road, cross Burnside's Bridge, and get the same visceral view that confronted the soldiers in 1862. For the 150th anniversary, the National Park Service, which administers the battlefield, arranged for a small contingent of reenactors in the uniforms of the Wisconsin 6th to skirmish in the cornfield, adding gun smoke to the morning mist. A sulfurous pall enveloped the soldiers as they disappeared into the haze amongst the cornrows.

Photographing these men as the sun rose over this cornfield, a place so common but so historic, was the first of many spine-tingling moments on my journey. Hiking the fields opposite the Sunken Road, you still get an eerie feeling as you reach the minor summit and find yourself just a hundred feet from the cross-rail fences that still line the old country lane. The memoirs of soldiers, both for the North and the South, describe this precise landscape, and how it hid the Union attackers until the very last moment. Reaching that summit in the field and seeing the Sunken Road so close at hand took my breath away.

Burnside's Bridge, Antietam

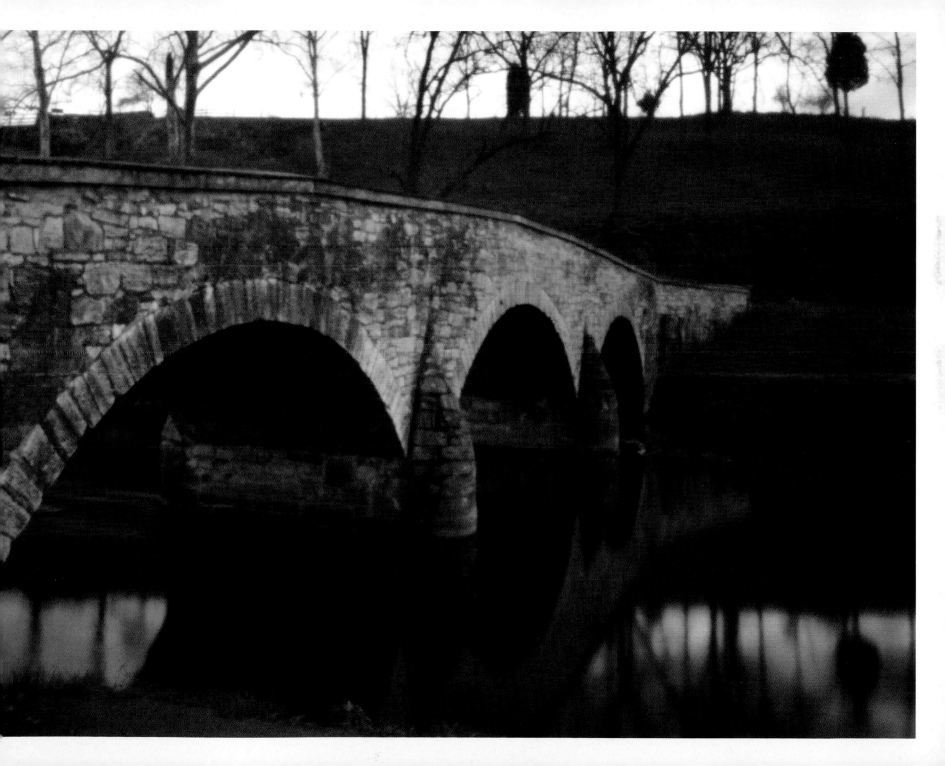

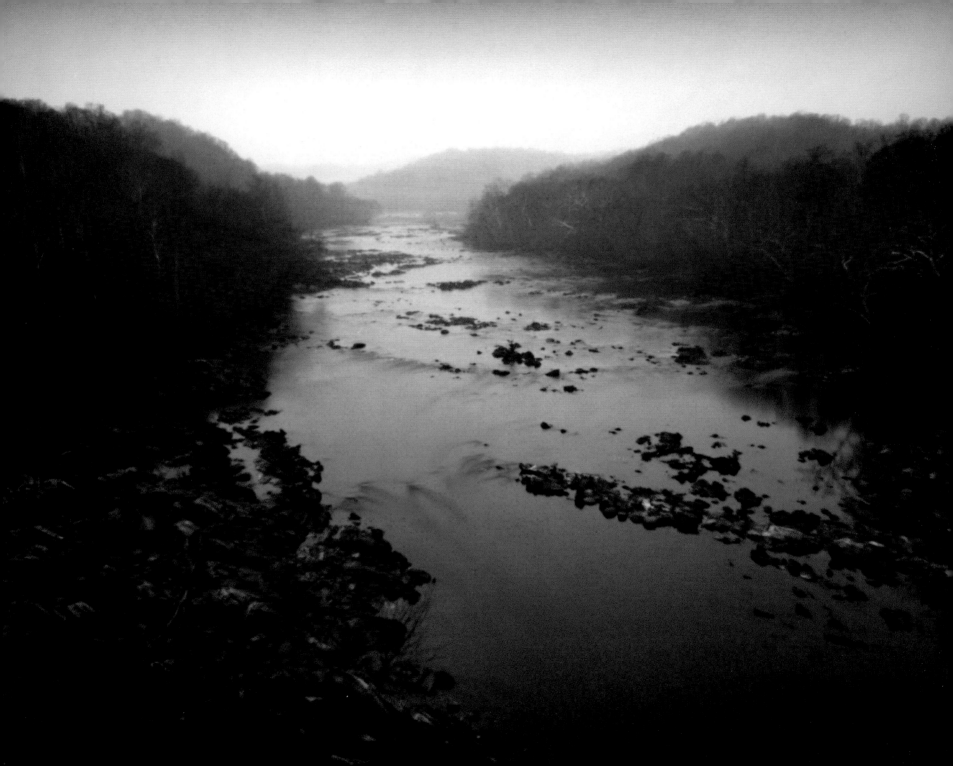

Fredericksburg

On the 150th anniversary of the Battle of Fredericksburg, the Rappahannock River was running swift and cold, much as it did in the winter of 1862. It was the second winter of war, and President Lincoln, frustrated with Major General George McClellan's excessive caution commanding the Army of the Potomac, had relieved McClellan and sent him home to New Jersey to "await further orders," replacing him with Major General Ambrose Burnside.

Burnside's plan was to take Fredericksburg and then the great, elusive prize of Richmond, the Confederate capital. Burnside marched his Army to the north bank of the Rappahannock, opposite Fredericksburg, arriving well ahead of Robert E. Lee's defenders.

For the moment, Fredericksburg appeared ripe and vulnerable. But first, Burnside had to get his men across the river. The pontoon bridges he had ordered were a week late in arriving, their progress slowed by rain and mud. When they arrived and his men began to try to install them, they were slowed yet again by the menace of rebel sharpshooters.

It would be two more weeks before Burnside's army would cross the Rappahanock. By the time the fighting commenced, Lee was there in force. More troops were assembled at Fredericksburg, blue and gray, than were assembled at any engagement in the Civil War, including Gettysburg.

During the long pause before crossing the river, Lee and 75,000 Confederate soldiers were able to barricade Fredericksburg,

Rappahannock River, Fredericksburg, Virginia

settling in on the opposite bank of the Rappahannock, entrenching themselves in the city and especially along the ridge above, called Marye's Heights, lining up for miles following the tracks of the Richmond, Fredericksburg and Potomac Railroad, ending where the tracks turned south at Prospect Hill, opposite Slaughter Pen Farm.

In Fredericksburg itself, Confederate soldiers took up positions in the buildings and along the city's wharf. Artillery were placed along the heights, subjecting any attack to deadly enfilading fire. Lee's lieutenants promised him they could repel any attack mounted by the Federals.

On December 11, fog shrouding the river, Union engineers began to assemble the pontoon bridges. To protect his men, Burnside ordered his phalanx of 220 cannons to bombard the city, the first such salvo fired against any American city. The citizens of Fredericksburg were forced to flee the city proper and find refuge behind Confederate lines along the heights south of the city. But even after crossing the river and emptying—and looting—the city, the Army of the Potomac was stopped in its tracks by the Confederate defenders assembled behind a low stone wall on Marye's Heights.

On December 13, the Federals attacked the heights in successive waves—14 in all—each surge decimated by the Confederates above, 8,000 Union casualties lost to the slaughter.

Fire on the Rappahannock

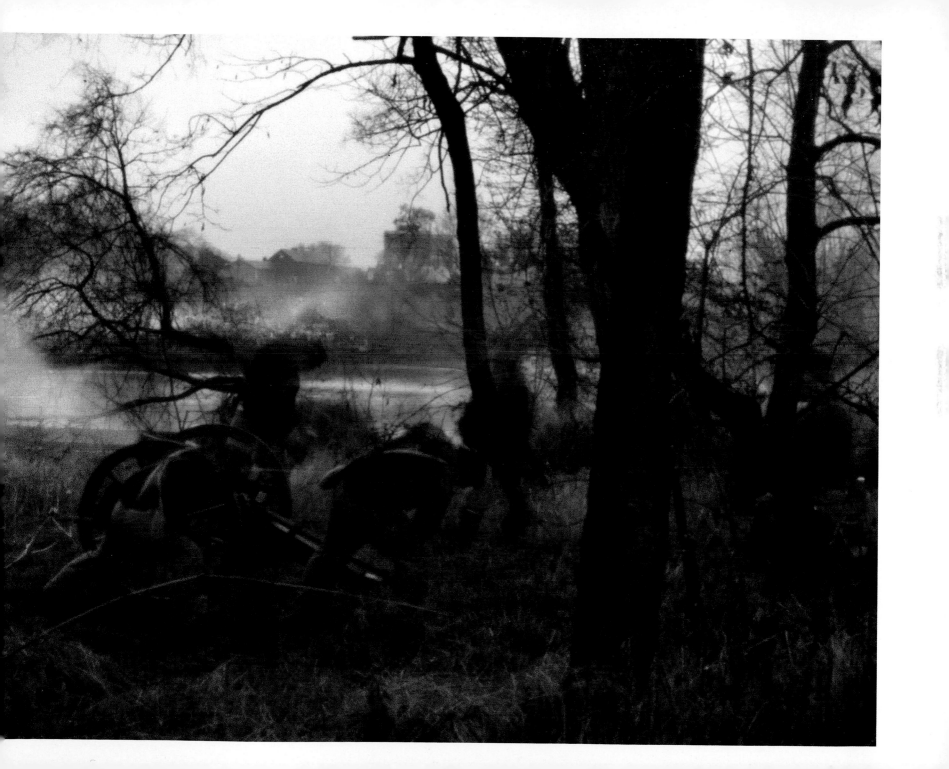

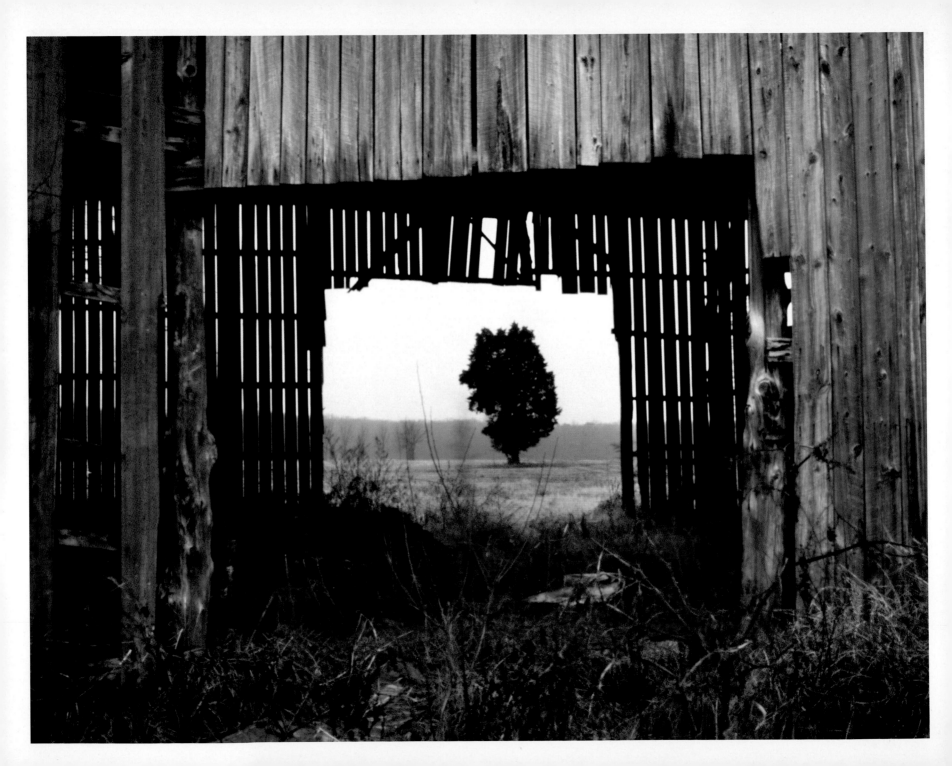

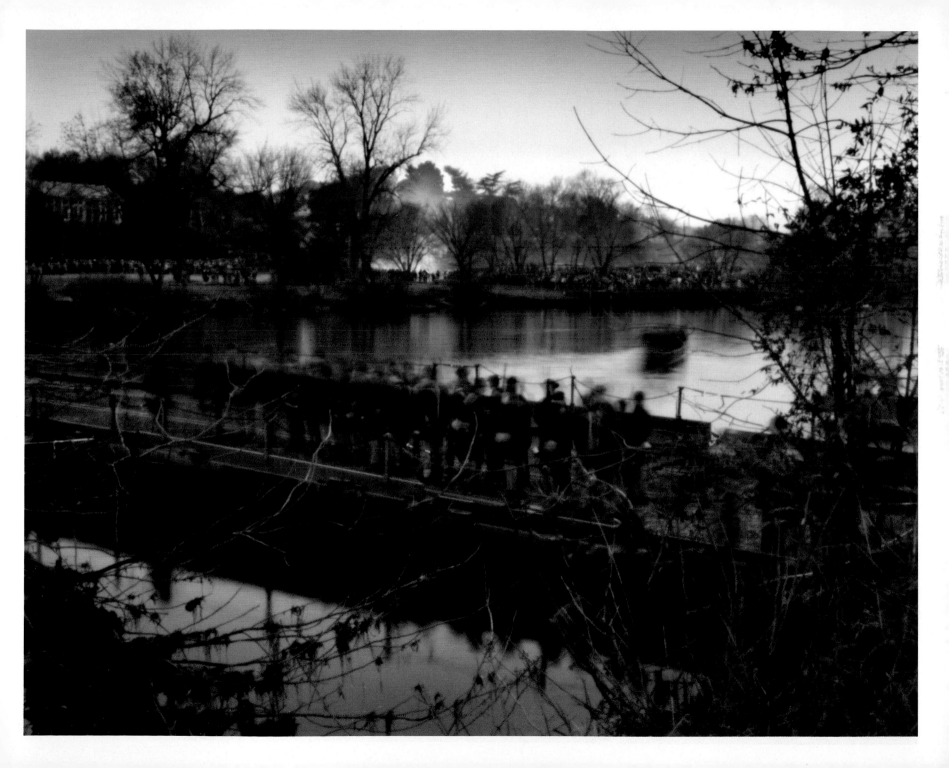

"It is well that war is so terrible," said Lee, surveying the scene, "or we should grow too fond of it."

Altogether, the Union Army suffered 12,000 casualties in their futile attempt to dislodge the Confederates at Fredericksburg. After two days, Burnside relented, marching his Army back across the Rappahannock, and retreated to Washington. Lincoln would need to find a new general.

In 2012, reenactors from across the country gathered at Fredericksburg to commemorate the battle. The reenactors, with help from the US Army Corps of Engineers, erected a pontoon bridge near the site of one of the three original river crossings, with plans to enter the city just as the troops had in 1862.

I had the privilege of embedding with reenactors in the impression of the Union's 69th New York Regiment, the Irish Brigade, which suffered more combat dead in the war than any regiment save two—the First Vermont Brigade and the Iron Brigade. At Fredericksburg, 545 of the brigade's 1,200 men were killed or wounded. Most of the survivors would lose their lives at Gettysburg.

I followed these reenactors over the pontoon bridge as they fought their way across the river and into the city. Like real battles, the reenactments are carefully planned, but even with planning, things don't always go exactly the way they are supposed to go. The pontoon bridge erected by the Army Corps of Engineers was about eight feet too short. Everyone making the crossing had to decide on the spot whether to take off or leave on their shoes before taking the plunge for the last few feet through the freezing waters of the Rappahannock.

Slaughter Pen Farm, Fredericksburg, Virginia

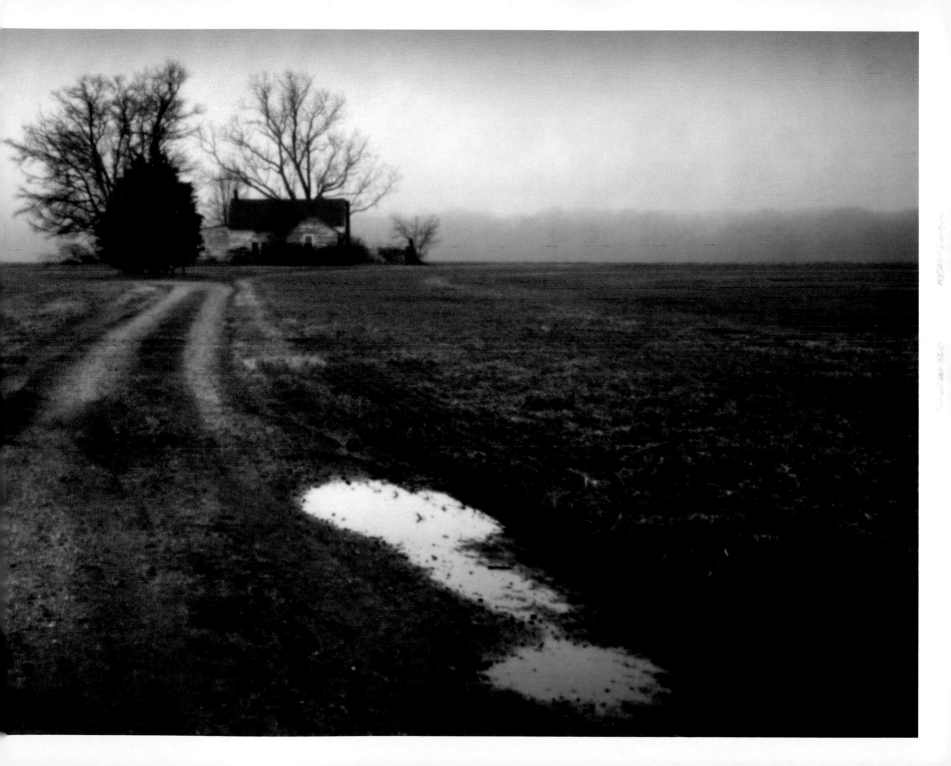

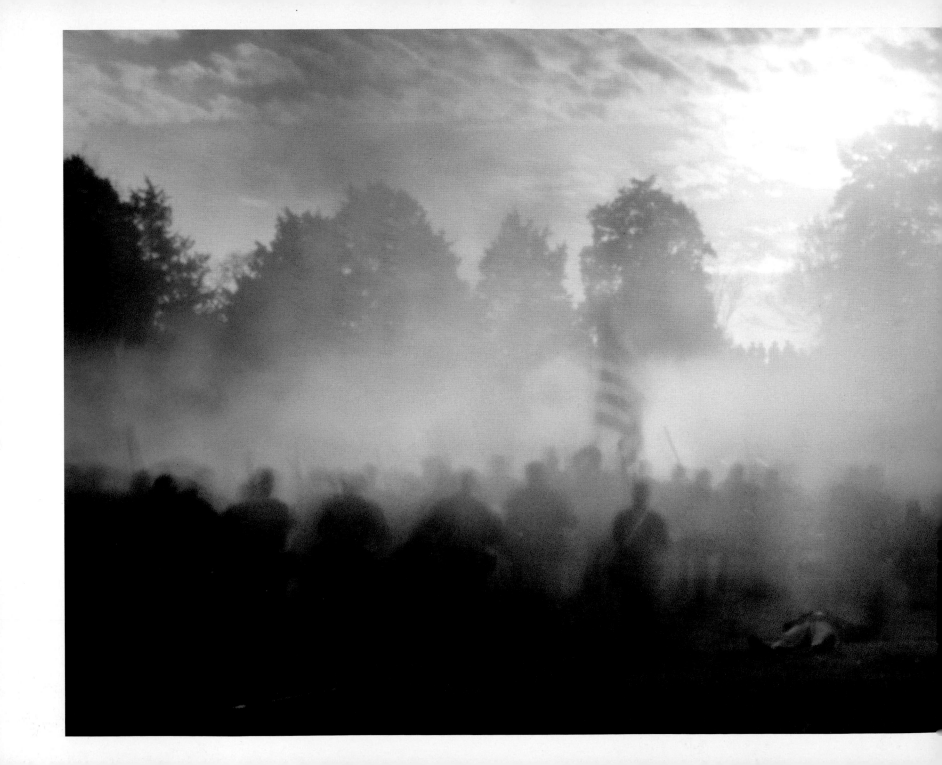

66 *There can be nothing more puzzling than to describe the feelings of a man in battle. To march steadily up to the mouths of a hundred cannons while they pour out fire and smoke . . . is horrible beyond description."*

—Erskine Church, 27th Connecticut

Reenactment at Fredericksburg

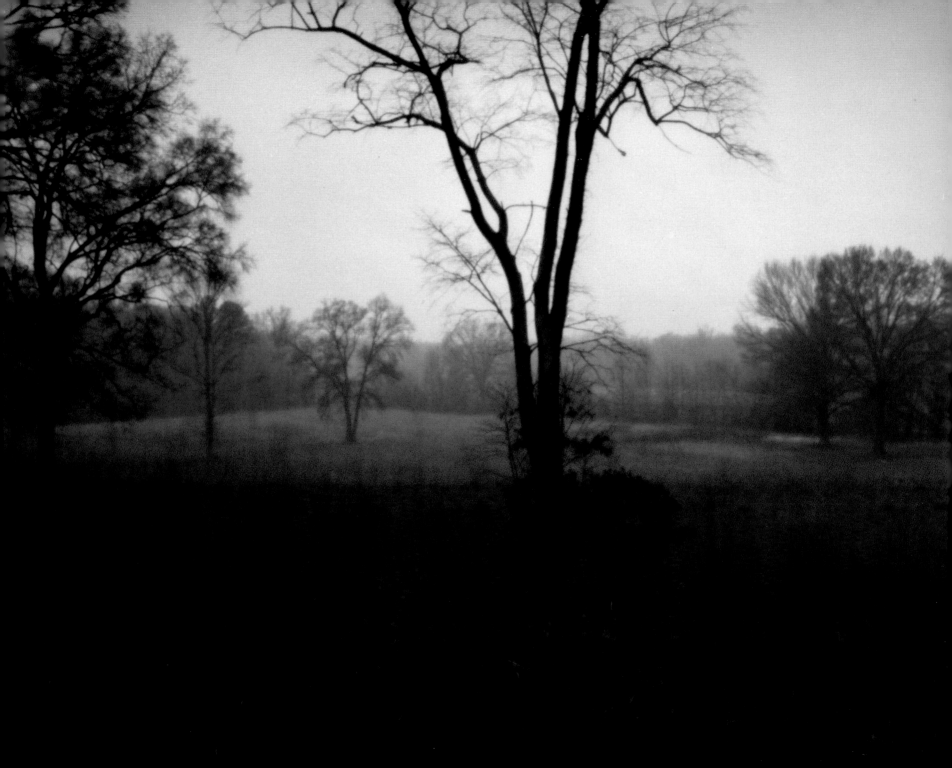

Fredericksburg still retains much of its Civil War character today. Eighteenth- and nineteenth-century buildings dominate the streetscape near the old city wharf, where reenactors, their boots wet from the river crossing, marched up cobblestone streets, "fighting" their way toward the heights. Many citizens of modern-day Fredericksburg gathered to watch the crossing of the Rappahannock, lining the city streets, dressed in period garb, pelting the advancing Union reenactors with jeers and cries of "Yankee go home!"

At Marye's Heights, reenactors had erected a 100-foot long painted plywood structure on Trench Hill to replicate the stone wall. Wave after wave of Union reenactors marched toward the wall and into the line of fire, disappearing into the gun smoke, backlit by the afternoon light. Just as it was 150 years ago, their bodies piled up along the wall in a performance of ghastly verisimilitude.

As the spectacle ended, dueling bugles joined in a somber, elegant Taps. When the reenactment was over, the Union reenactors reanimated, picking themselves up and approaching the faux stone wall to shake hands with their mock foes.

Afterward, I spoke with Mark McNierney, an experienced reenactor, who, with his long blonde hair, goatee and mustache, took the impression of one of the many Union officers leading troops to their demise at Marye's Heights. He talked about the dream-like quality of leading his troops in a charge on the stone wall, how he dramatically fell, his sword flying through the air, and then twisted on the ground, as if pierced by a bullet.

The following day at dawn, I visited the Slaughter Pen Farm on the southern portion of the Fredericksburg Battlefield, and opposite Prospect Hill, the scene of intense fighting on Dec. 13. Confederate trenches, dug to defend the hilltop, remain. Stonewall Jackson commanded the 35,000 Confederates fighting on Prospect Hill. They were securely entrenched, commanding the high ground. Federal troops made headway but were ultimately pushed back and pinned down along the railroad embankment.

The morning was foggy and overcast with a light drizzle of rain, just as it was in 1862. The wide-open fields of the farm were quiet in the soft morning light. A train whistle broke the silence as a mile-long freight train rolled across the landscape. With great contentment, I photographed the barren battlefield in winter, its stark, leafless trees cloaked in mist, somber and strangely beautiful.

Prospect Hill, Fredericksburg, Virginia

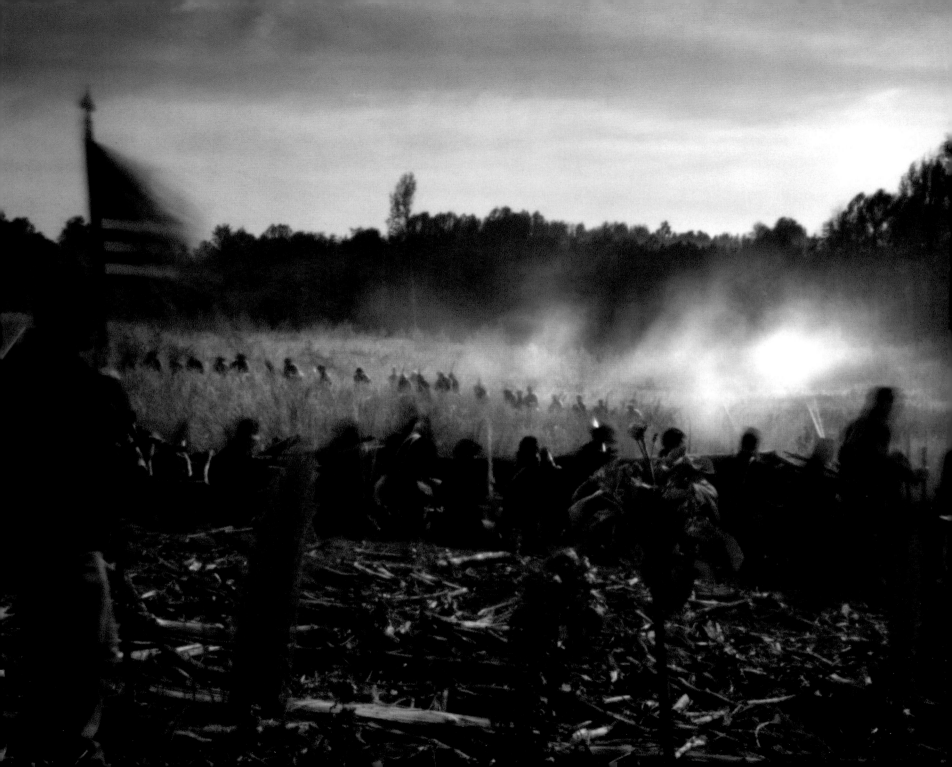

Chancellorsville

More than any other battle, Chancellorsville would demonstrate the strategic brilliance of Robert E. Lee and Stonewall Jackson. It would embolden Lee to take the war north to Gettysburg, even as it would deal a crushing blow to the psyche of the South with the death of Jackson, tragically felled by the friendly fire of his own troops. In retrospect, with its hero's death, the Confederacy's best days on the field of battle were behind it.

At the time of the Civil War, Chancellorsville was simply a crossroads along the Orange Turnpike ten miles west of Fredericksburg, named for the Chancellor family home, a sometime inn for travelers. There were also a few hardscrabble farms alongside a 70-square-mile tract of thick and brambly woodland known as the Wilderness.

The voracious appetite of iron foundries for wood had thinned the forest. The battle traversed a tangled landscape of second-growth woodlands, thick with vegetation, and impenetrable groves of wrist-size saplings. The forest floor, dense with dried leaves and twigs, was a virtual tinderbox that caught fire during the battle; the fire consumed everything in its path and made the battlefield all the more hellish.

General Joseph Hooker—"Fighting Joe," as he was called—led the Union offensive in the spring of 1863, having replaced General Burnside as Commander of the Army of the Potomac after the disaster at Fredericksburg. Hooker devised an offensive which, he promised President Lincoln, would lead to one of two outcomes: Either Lee's army would ingloriously flee the field, or the army would be destroyed.

Skirmish at Chancellorsville, Virginia

"My plans are perfect," said Hooker, "and when I start to carry them out, may God have mercy on General Lee, for I will have none."

"The hen is the wisest of all the animals in creation, because it never cackles until after the egg," said Lincoln, accustomed to the ultimately empty boasts of his commanders.

Lincoln was right to be skeptical. Despite the Union Army's two-to-one superiority in troops—130,000 to Lee's 60,000—and Hooker's success in moving his massive force across two major rivers into position alongside the rear and flank of his enemy, the Army of the Potomac was stopped in its tracks by the Confederates. Lee's army, wintering near Fredericksburg, marched west to meet Hooker, bringing the Union offensive to a standstill. Lee's aggressiveness led Hooker to pull his troops back around his headquarters at the Chancellor House, where he ordered them to dig in, ceding the initiative to Lee.

But many of Hooker's troops remained out in the Wilderness, exposed and vulnerable, when, just a few miles from the Chancellor House, Lee and Jackson sat together on discarded Federal hardtack boxes around a small campfire. Facing the longest odds of the war, they were plotting their strategy for vanquishing their more powerful enemy, when J.E.B. Stuart arrived with word from his scouts that the Union's right flank was "hanging in the air" unprotected. Jackson proposed to Lee that he take 30,000 of his troops, which was half of Lee's army, and make

Fairview, Chancellorsville Battlefield

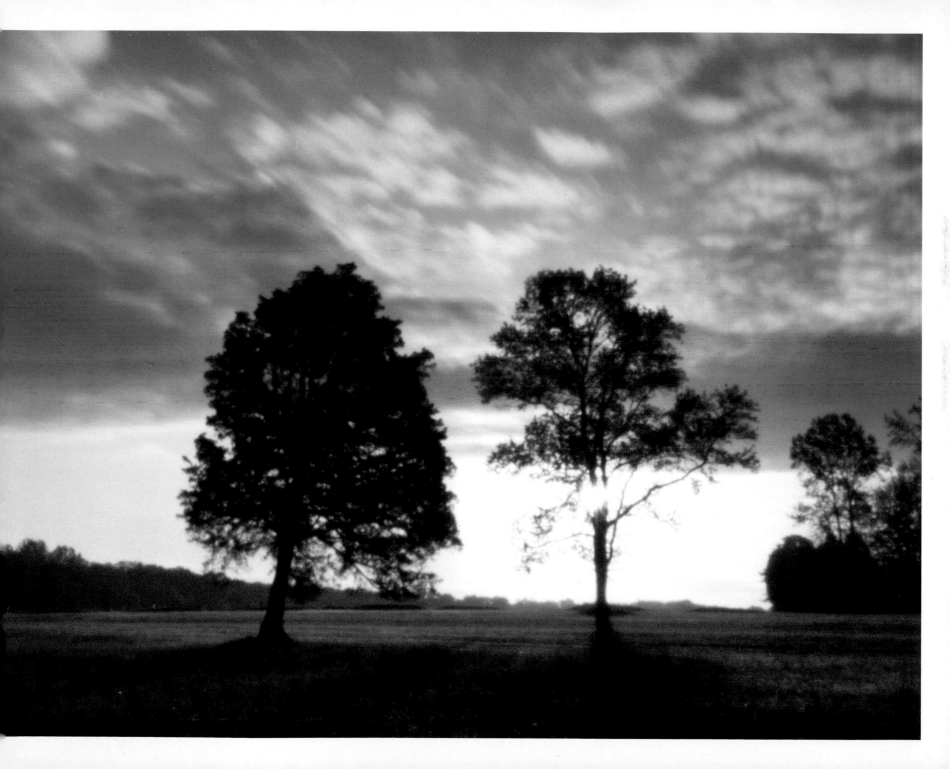

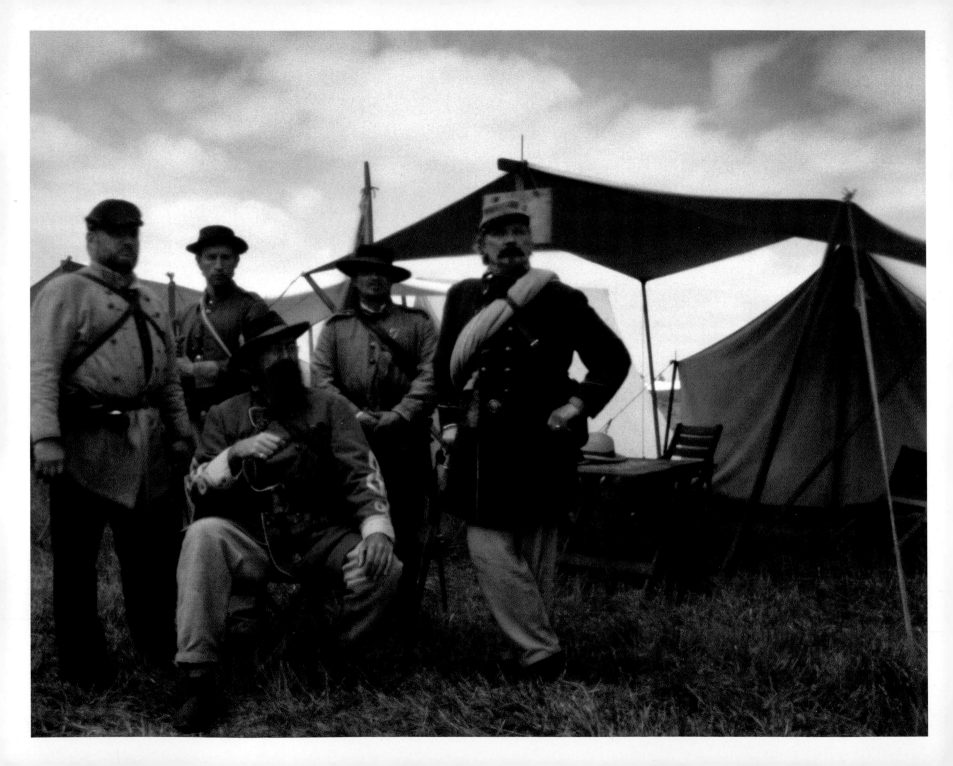

a surprise assault on the exposed right flank and obliterate the Union force. The idea defied military logic, because it would leave Lee weakened and vulnerable if Hooker attacked, but, with confidence in Hooker's timidity and Jackson's boldness, Lee took the gamble.

The key for Jackson would be to maintain the element of surprise; his famous twelve-mile march through the Wilderness is a masterpiece of stealth and misdirection. Along the route, one still finds the ruins of Catherine's Furnace, dedicated in the war years to the manufacture of weaponry, and Poplar Run, a small creek that offered Jackson's troops their last drink of water that day.

A local guide led the Confederates though winding backcountry roads until they arrived within sight of the Federals. Determined to launch the attack before he lost the light, Jackson gave the signal as soon he had enough of his troops amassed.

The first sign the Union's Eleventh Corps had that something was amiss came as deer and rabbits came bounding from the woods ahead of 20,000 Confederates crushing the brush underfoot. Then came the sound of bugles and what Lt. Octavius L. Wiggins of the 37th North Carolina Regiment described as "that inimitable, unearthly, indescribable Rebel Yell from the throats of twenty thousand veteran soldiers." Completely surprised, the Federals ran for their lives.

"I would have done the same thing and so would you and I reckon the Devil himself would have run with Jackson in his rear," Wiggins wrote.

For three brutal hours, the Confederates gave chase, with many Union soldiers running right past Hooker's headquarters at the Chancellor House. It was nearly a complete rout, though fresh Union troops and artillery finally slowed a juggernaut that only the approaching darkness would bring to a halt. But Jackson, furious at the prospect of nightfall depriving him of his chance to finish off his enemy, rode ahead with eight horsemen under the light of a full moon to devise a plan to press the attack, if not by night than by first light.

Hearing the sounds of spades and axes, Jackson knew the Union troops were digging in and there would be no final victory that night. Riding back toward Confederate lines, Jackson and his party came under fire from members of the 18th North Carolina Regiment, who mistook the men for Union cavalry.

Jackson was struck three times. He was taken to nearby Ellwood Manor, where his left arm was amputated, and then he was transported to a plantation 27 miles away, where he died of pneumonia eight days later. Jackson's arm was buried at Ellwood Manor, where the gravestone reads, "ARM OF STONEWALL JACKSON MAY 3, 1863."

Upscale gated communities today surround the Wilderness, but enough of the region has been preserved to give a sense of what it looked like in 1863. Cannons still line both the high open plateau at Hazel Grove—which Hooker, in a strategic blunder had ceded—and Fairview Hill, the scene, on May 3, 1865, of the most intense artillery duel of the battle, between more than 40

NEXT: *Scene of the flank attack, Chancellorsville*

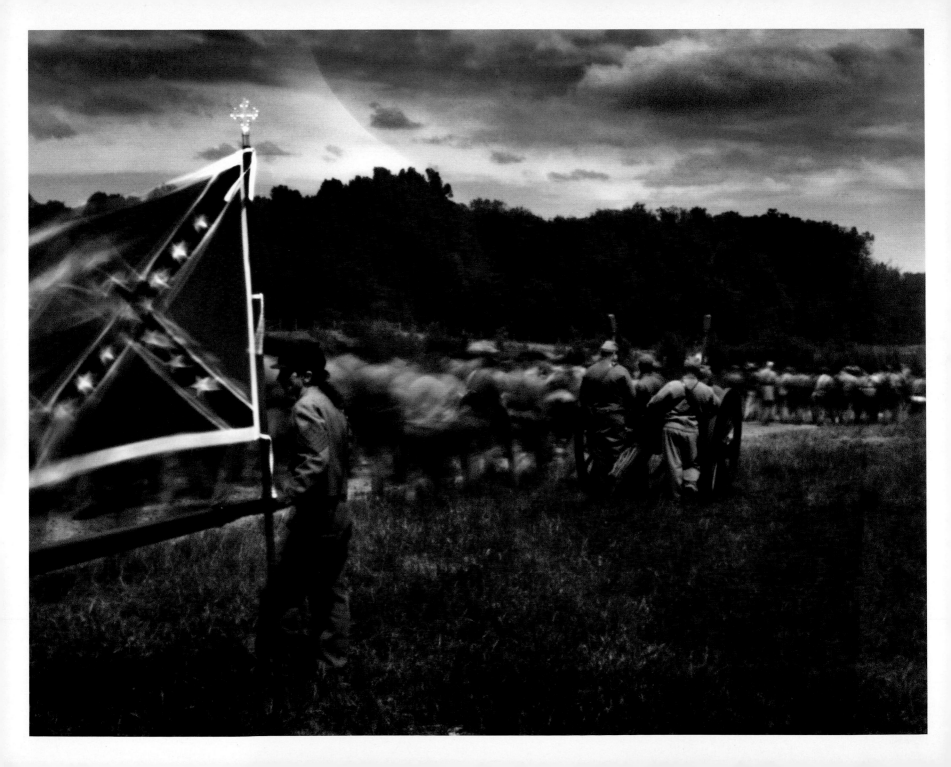

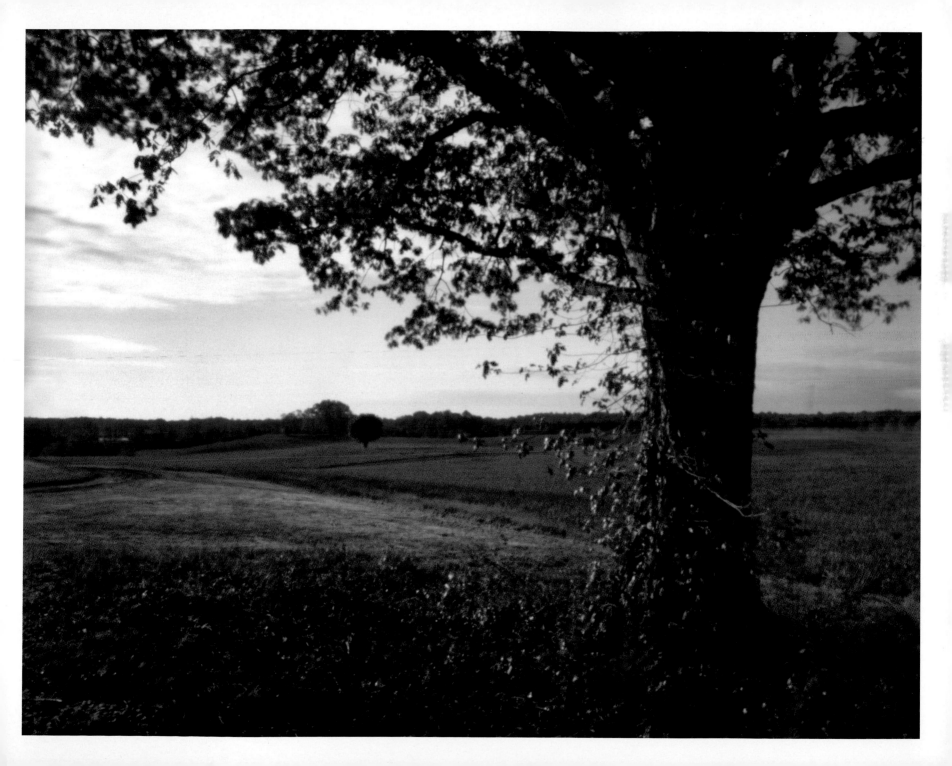

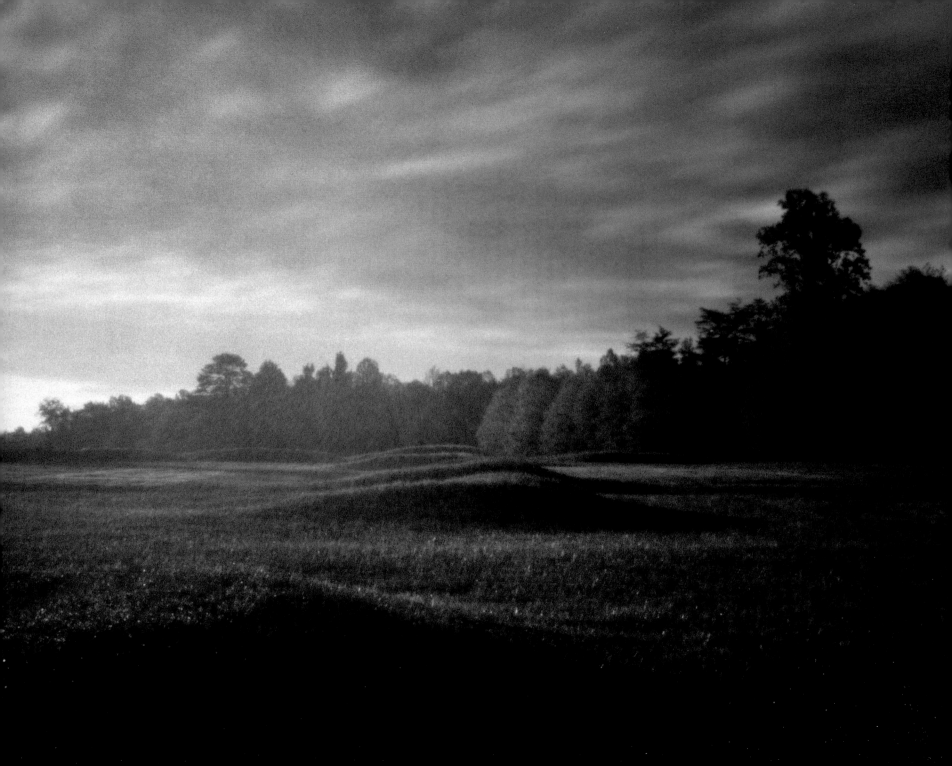

Confederate cannons at Hazel Grove and 34 Union cannons at Fairview. After four hours of bombardment, the Federals withdrew from Fairview.

Walking at dawn between Hazel Grove and Fairview, watching the warm light crawl across the landscape, the silence only disturbed by the singing of birds, it is easy to see why gaining the high ground at Hazel Grove proved so decisive. From Hazel Grove, the Confederates could shell the clearing where Hooker was headquartered and actually fell Hooker himself, when a cannonball struck a wood pillar at Chancellor House that the general was leaning on.

The Union Army was, for all practical purposes, left leaderless. It would fall to Hooker's subordinates to lead the Army of the Potomac, which had arrived at Chancellorsville with such bravado, in retreat across the Rappahannock and back to Washington.

Chancellorsville was, to that date, the bloodiest battle of the Civil War, with 17,000 Union and 13,000 Confederate casualties—a tremendous victory for Lee but one that cost him his most trusted subordinate and 22 percent of his fighting force. In the battle's aftermath, Horace Greeley, editor of the *New York Tribune*, would write, "My God! It is horrible—horrible; and to think of it, 130,000 magnificent soldiers cut to pieces by less than 60,000 half-starved ragamuffins!"

Lincoln was shaken to his core after the debacle at Chancellorsville: "My God! My God! What will the country say?"

Artillery Lunettes at Fairview

———— >✦< ————

In mid-May 2013, thousands of reenactors and spectators gathered in Spotsylvania County, Virginia, to commemorate the Confederate victory at Chancellorsville. Hundreds of reenactors wearing Confederate gray relived Jackson's march through the Wilderness and rout of their opposite numbers in blue.

Jake Jennette, a four-tour Vietnam veteran, did the impression of Lee, and Greg Randall did the impression of Stonewall Jackson. Randall, a Virginian, does the impression of Jackson at events across the Old Dominion, and the likeness is uncanny in every aspect: his looks, his stature, his beard, his uniform, and the gray, high-topped kepi, angled down, obscuring his eyes. Out of view of the spectators, Jennette had arranged for a small reenactment of the wounding of Jackson, with reenactors from North Carolina doing the impression of their forefathers in the 18th North Carolina Infantry who had fired the fateful shots at Jackson.

At the start of the scenario, Jackson and his staff are riding down a dirt road lined with weeds making their way up a hill when—kaboom!—comes cannon fire from Union reenactors at the top of the hill. Some of the horses rear, and Jackson and company turn and quickly ride back the way they came and into the teeth of the North Carolina reenactors, 100 yards away.

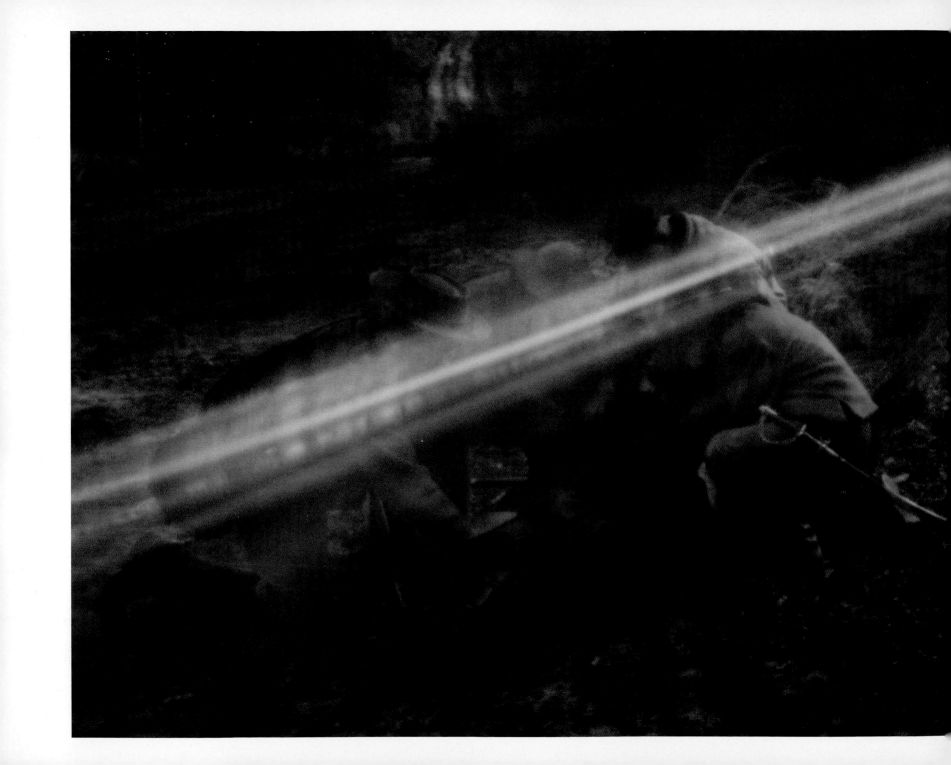

From their ranks, I hear a cry: "Union cavalry on the road, open fire!" followed by a rippling volley of musketry.

"Stop, you are firing into your own men!" a voice from Jackson's party calls out.

"It's a damn Yankee trick, fire!" comes the reply, followed by yet another volley of gunfire. Randall, as Jackson, slumps in the saddle and his fellows ride up alongside to keep him from falling from his horse. They ride through the North Carolina reenactors' line, telling them that they have just shot Stonewall Jackson.

As Stonewall lies wounded on the ground with his cadre of officers surrounding him, there seems to be a charge in the air.

> ❝ Let us cross over the river and rest under the shade of the trees."

At the time, I was able to take just two images of this somber scene. Upon returning home and looking at the photos I had taken, I was stunned. There was a dramatic streak of light running across both images. Homemade pinhole cameras can occasionally leak light, but in all the years I have worked with them, I had never seen anything remotely like this. Under ordinary circumstances, I would have considered the images ruined. But this was a moment of homage for Stonewall Jackson, the transcendent martyr to the Confederate cause, and so a bit of otherworldly interference in this recreation of him at the dying of his light seemed almost fitting.

And beneath the bolt of light, an image of home-going tranquility that recalls Jackson's dying words: "Let us cross over the river and rest under the shade of the trees."

Reenactment of the wounding of Stonewall Jackson

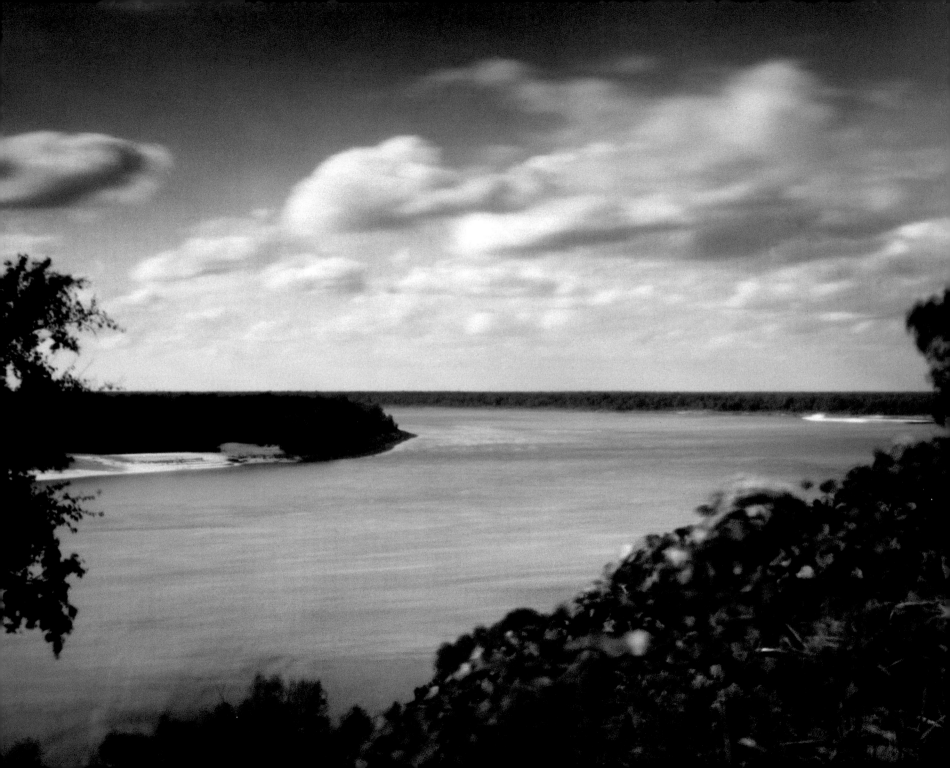

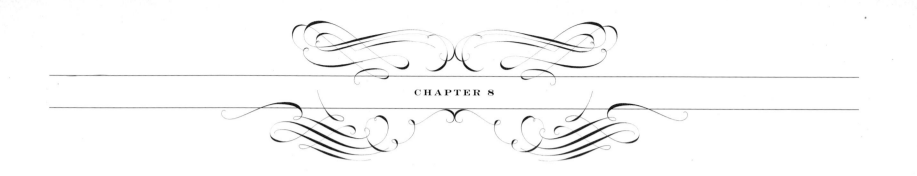

Vicksburg

Over thousands of years, creeks have dug deep ravines into the landscape around Vicksburg as they make their way to the Mississippi River. This seemingly prehistoric landscape was a critical battleground in 1863.

Vicksburg was the last Southern city along the Mississippi still in Confederate hands.

"Vicksburg is the nailhead that holds the South's two halves together," said Jefferson Davis.

"Let us get Vicksburg and all that country is ours," Lincoln told his advisers. "The war can never be brought to a close until that key is in our pocket."

"I am acquainted with that region and know what I am talking about, and valuable as New Orleans will be to us, Vicksburg will be more so," said Lincoln, who as a young man had traveled the Mississippi River to New Orleans as a bow man on a flat boat. "We may take all the northern ports of the Confederacy, and they can still defy us from Vicksburg."

Capturing Vicksburg, the Union would control the entire length of the Mississippi and the Confederacy would be asunder. To accomplish this, in late 1862, Lincoln dispatched General Ulysses S. Grant to the scene.

The Mississippi River makes a hairpin turn at Vicksburg and then runs slowly past the city. Standing on the bluff overlooking the Mississippi, Confederate guns still look down on the waterway, the strategic vantage point from which they could rain fire on Union gunboats attempting to pass the city. The bluff

Mississippi River at Vicksburg

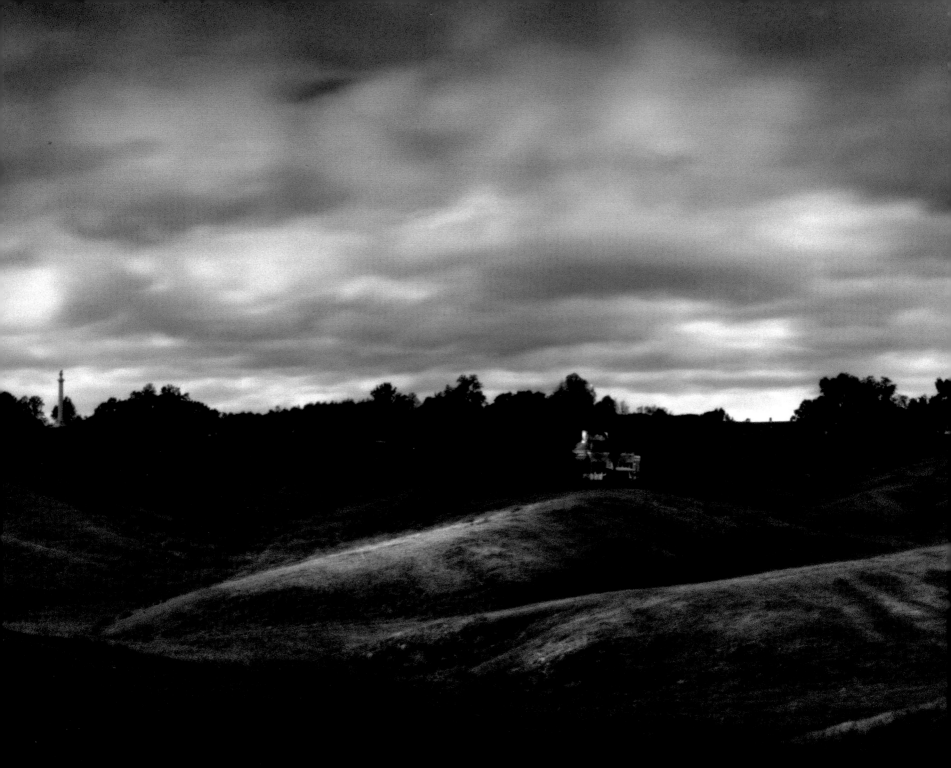

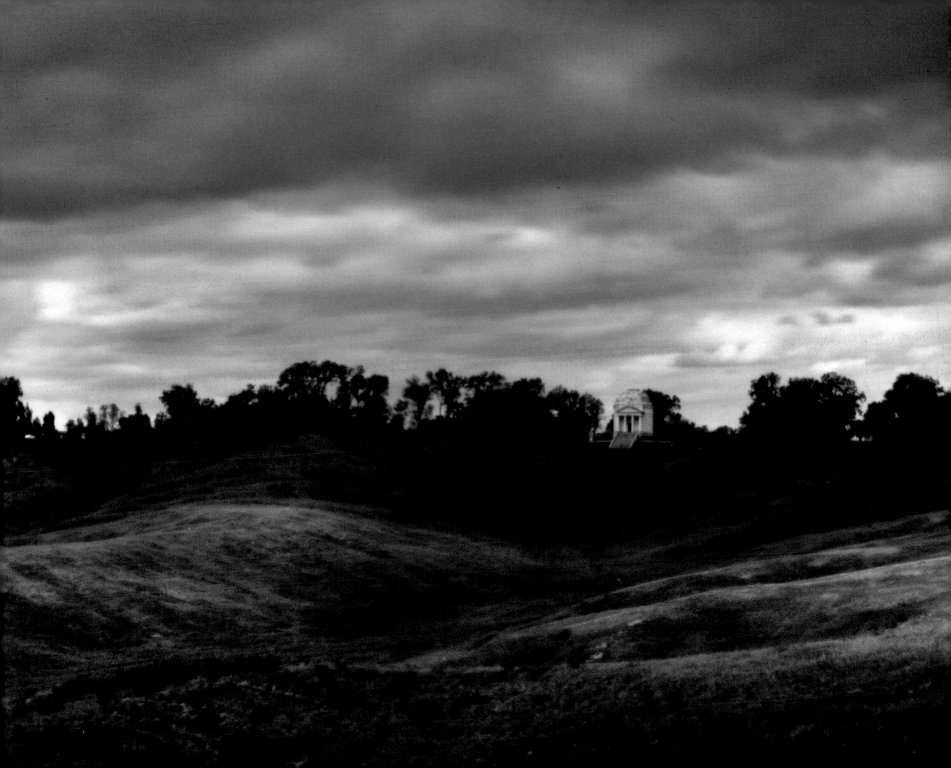

is now overgrown with kudzu. In 1863, the eastern approach to Vicksburg was surrounded by ten miles of earthworks and trenches. It would take Grant eight months to finally capture Vicksburg, and only after a long siege that would starve the city into submission.

The Vicksburg Campaign began in late 1862. Grant's first mission was to get his troops from the west side to the east side of the Mississippi. Early on, Grant attempted to circumvent the river, with soldiers and a thousand slaves (taken from surrounding plantations and promised their freedom) digging what came to be known as "Grant's Canal": actually, a series of canals that would enable them to bypass the city, or even reroute the river. It was an ambitious project, fraught with difficulties, and Grant finally abandoned it after the river rose, flooding the construction site.

It was not until May 1863 that Grant was able to get his troops safely across the Mississippi, moving 24,000 men and 60 guns from the west to the east bank at Bruinsburg, south of Vicksburg, uncontested, in what would be the largest amphibious operation conducted by an American force prior to World War II. Grant had, at long last, brought his Army into enemy territory, and he was exultant.

"When this was effected I felt a degree of relief scarcely ever equaled since. Vicksburg was not yet taken it is true, nor were its defenders demoralized by our previous efforts. I was now in the enemy's country, with a vast river and the stronghold of Vicksburg between me and my base of supplies," he wrote in his memoir. "But I was on dry ground on the same side of the river with the enemy. All the campaign, labors, hardships, and exposures from the month of December previous to this time that had been made and endured, were for the accomplishment of this one object."

Marching up toward Port Gibson, Mississippi, Grant's troops encountered a landscape of dense vegetation crisscrossed by deep ravines.

"The country in this part of Mississippi stands on edge, as it were, the roads running along the ridges except when they occasionally pass from one ridge to another," Grant wrote. "Where there are no clearings, the sides of the hills are covered with a very heavy growth of timber and with undergrowth, and the ravines are filled with vines and canebrakes, almost impenetrable."

Along the old Rodney Road, on the march to Port Gibson, Grant's troops laid claim to the vast Windsor Plantation with its magnificent mansion, the largest antebellum Greek Revival mansion ever built in the state. It was here at Windsor that Grant's troops ate crackers under the shade of trees, a brief respite before pressing on. All that remains today of the mansion are the Windsor Ruins, its tall skeleton of Corinthian columns making a monument to the old order.

After a quick victory in Port Gibson, Grant marched his army not toward Vicksburg, but inland, toward the Mississippi capital of Jackson. Following the Natchez Trace, which snakes through the region, Grant's troops moved north to the town of Raymond, Mississippi. There, on May 12, the Battle of Raymond was fought, a prelude to the Union assault on Jackson, which Grant captured before turning his sights west, chasing the remaining Confederates as they retreated toward the Union's ultimate prize of Vicksburg.

In the fall of 2012, the small city of Raymond hosted a reenactment commemorating the battles fought during the Vicksburg Campaign. The fighting around Raymond in 1863 occurred along the meandering Fourteen Mile Creek, which bisects the town. The first battle scenario depicted the fighting back and

PREVIOUS: *Battlefield at Vicksburg, Mississippi*

LEFT: *Windsor Plantation Ruins, Port Gibson, Mississippi*

forth across Fourteen Mile Creek; I was situated with my pinhole camera at mid-creek, perched on some rocks.

There were times on my travels that I found myself completely immersed in the nineteenth century. This was one of those times. All I could see were the ends of the muskets, blue and gray, on either side, spitting out fire and smoke at each other across the creek, gun smoke billowing into the trees in the afternoon light.

Later that afternoon, Confederate reenactors placed artillery along an elevation that would serve as Champion Hill, where, on May 16, 1863, seven miles west of Jackson, Union and Confederate troops fought a desperate, see-saw battle. This fight culminated in a clash along an old railroad cut on the battlefield; gun smoke once more filled the trees, creating dramatic light on the hallowed ground.

The Confederates were ultimately overwhelmed at Champion Hill and forced to retreat toward Vicksburg. When Grant's troops arrived at Vicksburg in mid-May 1863, they found the city a well-entrenched fortress, completely surrounded by defensive earthworks. These enormous trenches are among the best preserved earthen defenses from the war. At thirty feet in height and stretching for miles, they create a moonlike landscape reminiscent of the battlefields of the First World War.

Grant attempted two assaults on Vicksburg's fortifications—on May 19 and 22—but the defenses were simply too formidable, making the cost in Union lives too great. In the second assault, Union soldiers marched across the no man's land to find themselves up against the Confederates' earthen forts. Carefully

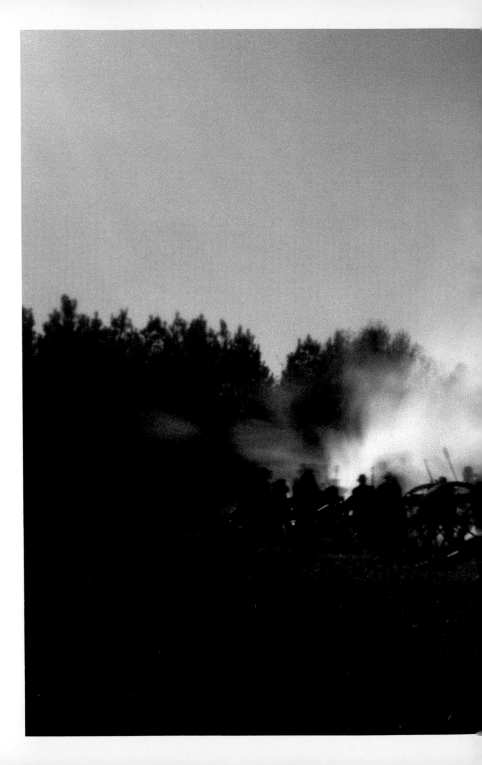

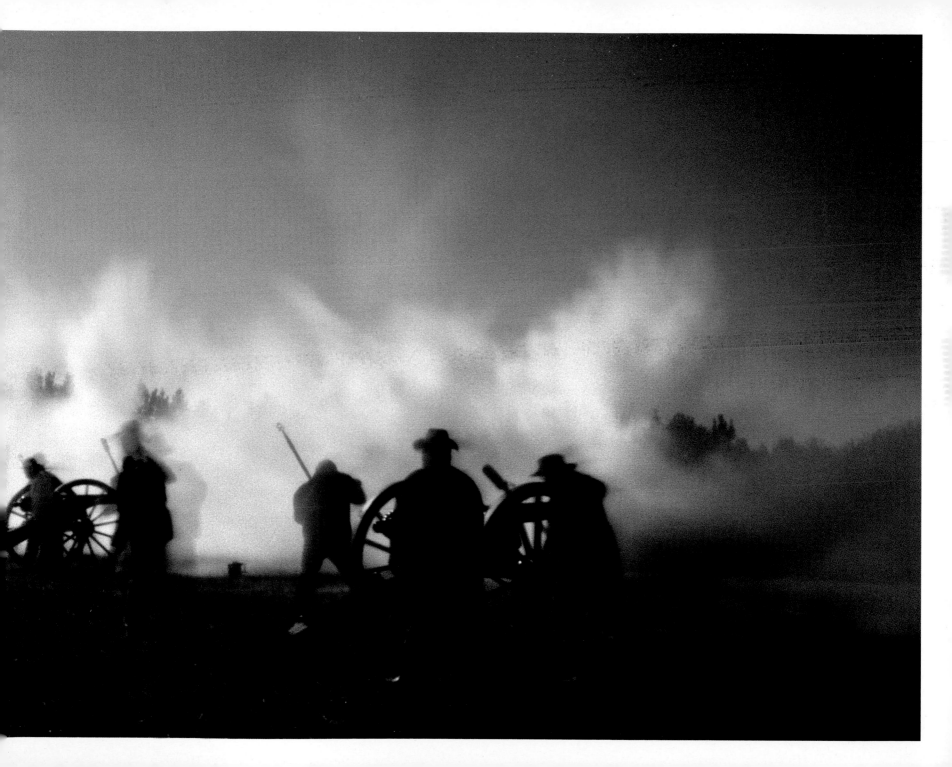

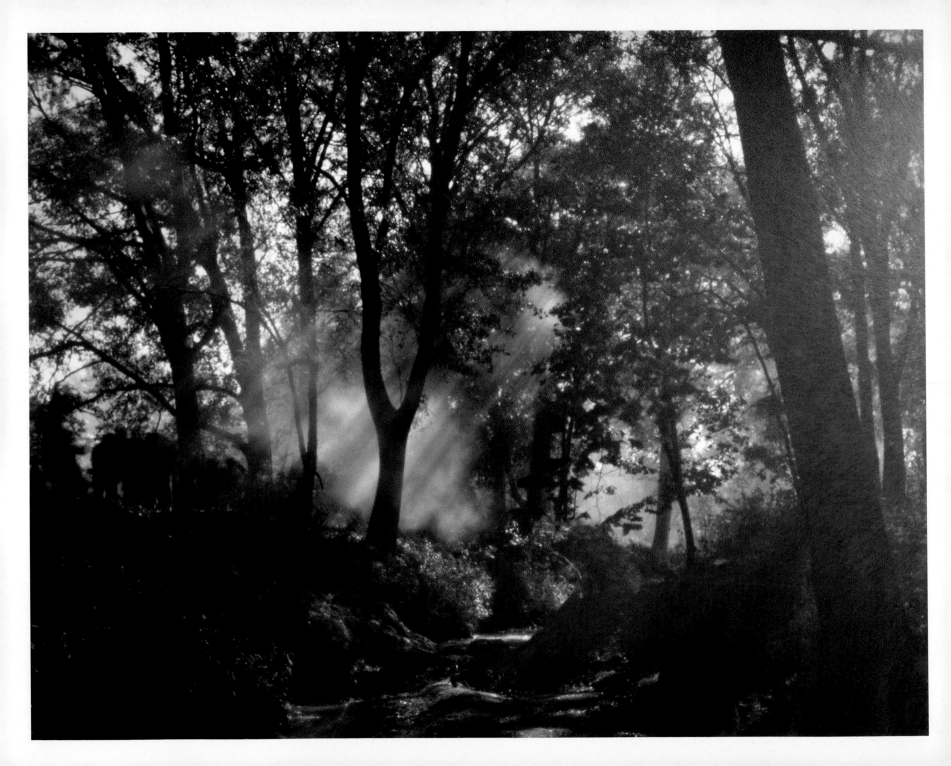

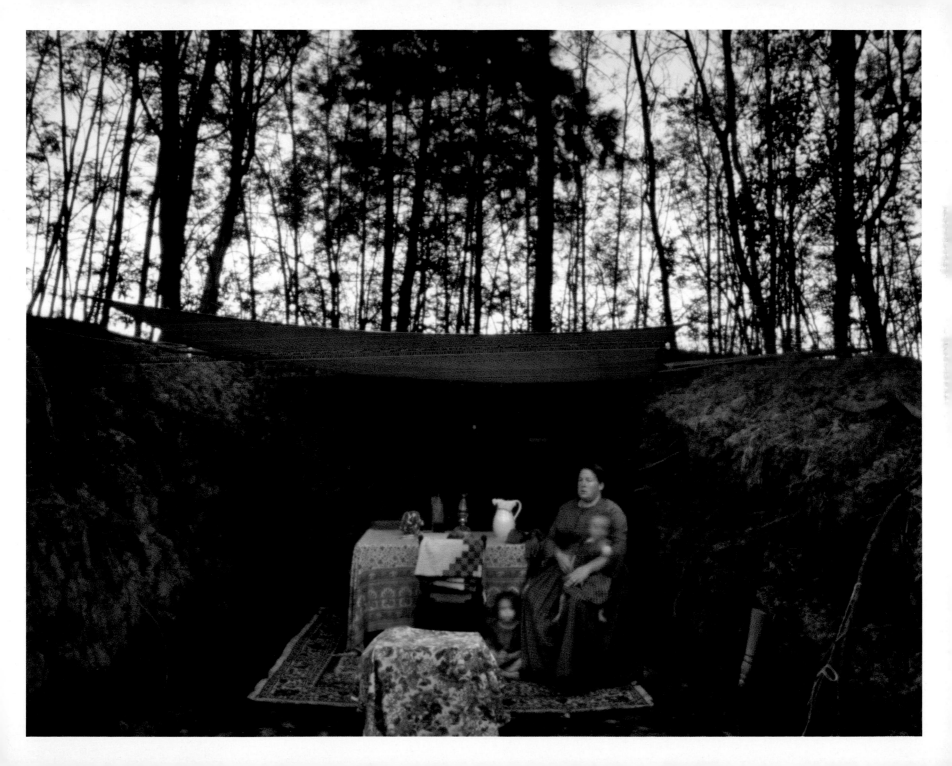

engineered, the forts' walls stood eight to ten feet high with a moat dug along the base.

It was in that moat that Union troops, unable to scale the sheer heights, found themselves trapped, as Confederate defenders rolled fused cannonballs onto them from above. Only under cover of darkness could some of those who survived make their escape from the moat. The rest were captured.

The desperation of that scene was faithfully recreated at the Raymond reenactment. With the help of Park Service rangers, volunteers in Raymond built a replica of one of these earthen forts. The Second Texas Lunette is a crescent-shaped fortification named for the regiment that defended it in 1863. The Lunette in Raymond was built to spec and included a number of artillery embrasures as well as a raised firing platform for the defenders.

Union reenactors built ladders in their camp, designed to scale the fort when they attacked. I joined a group of these ladder-men as they emerged from the woods, running low, heads down, and jumped into the moat and attempted to scale the fort and plant a Union flag at the top. Ultimately, the moat was too deep and the fort's wall too steep to scale. Those of us that weren't "killed" decided to surrender.

Persuaded by the two failed assaults that Vicksburg was impregnable to a direct attack, Grant laid siege to the city, with daily bombardment from his guns in the east and Union Navy gunboats on the river. The residents of Vicksburg resorted to digging tunnels and caves in the hills around the city in hopes of surviving the siege and shelling underground.

In commemoration of those in Vicksburg who burrowed in to withstand the siege, which lasted for six weeks, Amy Clark, a veteran reenactor, stayed in a cave with her two young children on the battlefield at Raymond during the 2012 reenactment. They cooked on an open fire, bundling up in the evenings to keep out the damp and cold. A reenactor for 18 years, Amy said living in the caves was not all that bad.

"As long as we could hold our position, the enemy was limited in supplies of food, men and munitions of war to what they had on hand," Grant wrote. "These could not last always."

By the end of the siege, the people of Vicksburg were eating dogs, cats, horses, mules and even rats.

"Rats are hanging dressed in the market for sale with mule-meat; there is nothing else," Dora Miller wrote in her diary of the siege on July 3.

The next day, on July 4, 1863—one day after the Confederate defeat at Gettysburg—the Confederates at Vicksburg finally capitulated. Vicksburg would not celebrate Independence Day for another 81 years.

Unbeknownst to anyone at Vicksburg, eleven hundred miles to the north, in the town of Gettysburg, another immense battle had just concluded in the Union's favor. The tide of war was turning.

Gettysburg

It was the lushness of the Pennsylvania countryside that drew Lee toward Gettysburg. That, of course, and the daring, tempting, irresistible prospect that, coming off his stunning success at Chancellorsville, he could bring the war north and, with a single great victory, break the spirit of the Union. Lee and his army had defied the odds from the outset of the war, and one more brash triumph could prove decisive.

It was not to be, of course.

Gettysburg would prove to be, in every sense, the high-water mark of the rebel cause. On July 3, culminating in the grand failure of Pickett's Charge, Lee's foray north had been successfully resisted and repelled.

By the next day, July 4, 1863, the tide of the Civil War had irreversibly turned—four score and seven years to the day since, as Lincoln would put it with timeless eloquence in dedicating a portion of the battlefield some four months later, "our fathers brought forth on this continent, a new nation, conceived in liberty, and dedicated to the proposition that all men are created equal."

By 2013, I had been following the progress of the war with the reenactors, one battle to the next—my faithful pinhole camera and I—for two years, and I naturally approached Gettysburg, site of the most famous and fateful battle ever to take place on American soil, with tremendous anticipation.

The view from Little Round Top, Gettysburg

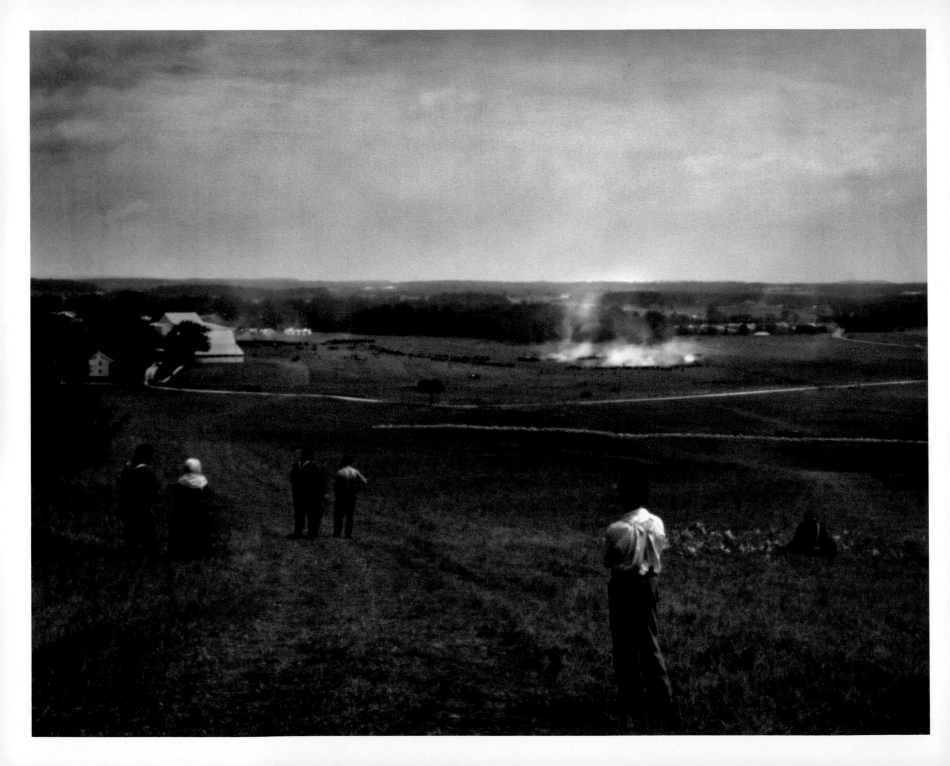

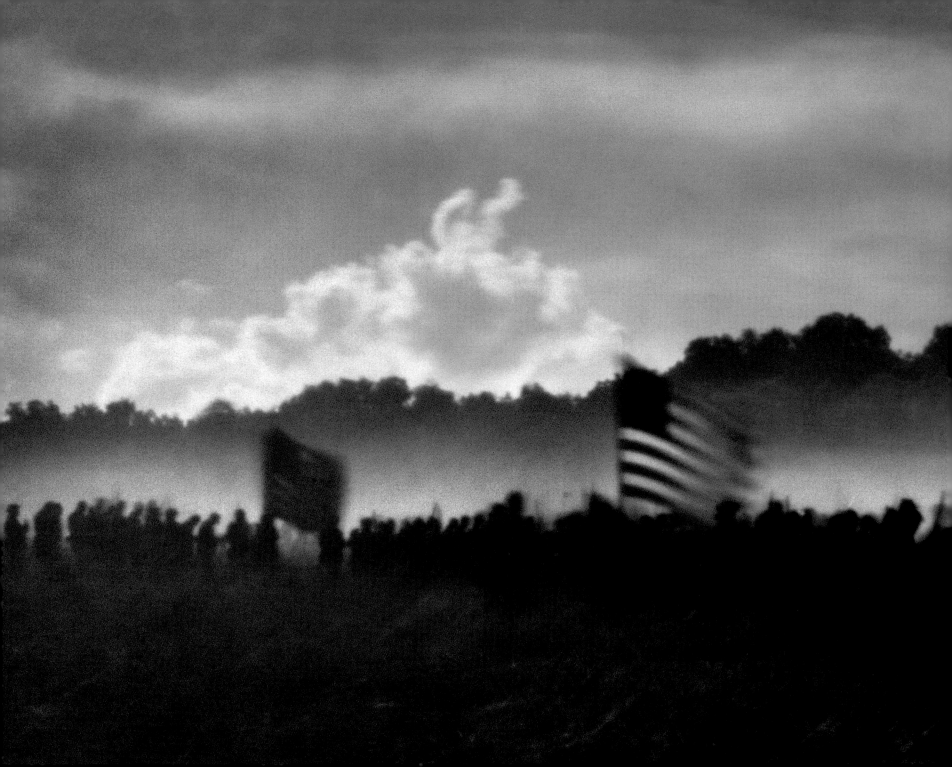

There is great irony in the fact that the scenes of the most brutal havoc in American history, which is precisely what they were, remain pristine preserves of what they were 150 years ago, bucolic spaces in an America that, when war raged across the national landscape, was still mostly rural, a place of farms and fields and hamlets. These places that became battlefields were breathtakingly beautiful then. They remain so today.

No matter the point of the compass from which you come to Gettysburg, you pass through some of the most rich and abundant farms in the country. Fruit-and-vegetable farms. Dairy farms. The elegant simplicity of barns of deep red set against verdant rolling hills, lined, in perfect columns, by groves of ripening cherries. As I drove past them, a passage from an obscure memoir of a Confederate soldier came alive: "The Rebs breaking their line of march toward Gettysburg to lop richly laden branches off the cherry trees for sweet, swift sustenance."

·———>←——·

The first of the two reenactments of this epic battle was held at the Bushey Farm just outside the town of Gettysburg. The Bushey Farm offers an enormous expanse of what appears to be pristine nineteenth-century landscape. From the high ground, near where the reenacting Army of the Potomac had set up camp, not one sign of modern convenience marred the view. It is still a working farm, and much of the land is cultivated but intermingled with wooded hills and tracts of virgin forest. The varied terrain served perfectly to replicate the individual battlegrounds at Gettysburg.

The reenactments of the battles of Culp's Hill and Little Round Top both played out on thickly wooded hills on the farm. It was just as the sun was setting and a full moon was rising that

General Edward "Allegheny" Johnson's division launched its long charge up the hill's steep slopes. And now, 150 years later, as dusk cloaked the wooded landscape and an eerie wail could be heard emanating from the trees below . . . the rebel yell. In the forest night, all you could see were the flashes of thousands of muskets discharging in the darkness.

The next day, I marched with reenactors in the impression of the Twentieth Maine Regiment to the site of their scenario for the battle of Little Round Top. As we marched along a dirt track through the forest, one of the young soldiers struck up "The Battle Cry of Freedom," which was written as a Union anthem fifteen months before Gettysburg. The singing quickly spread, thousands of latter-day soldiers joining in, their marching boots keeping cadence.

·———>←——·

After the rigors and chaos of the reenactments, I returned to Gettysburg to wander the actual battlefield, now mostly empty, and follow the contours of a conflict that, from my reading and the events of the previous few weeks, was branded in my mind.

Following the timeline of the battle, I began my exploration of the battlefield north of town on McPherson Ridge, where the first shots were fired. McPherson's barn, which became a makeshift hospital in the early hours of the conflict, still sits there amid the cultivated fields.

Walking off the beaten path I discovered the quiet, rambling Willoughby Run. The creek saw heavy fighting as Confederate and Union forces grappled on the first day of battle. I sat on the banks of this creek, there in the dense woods, as this little-known, rarely visited location on the battlefield revealed itself in the quiet morning light.

PREVIOUS: *The railroad cut at Gettysburg (right)*
LEFT: *Reenactment at Gettysburg*

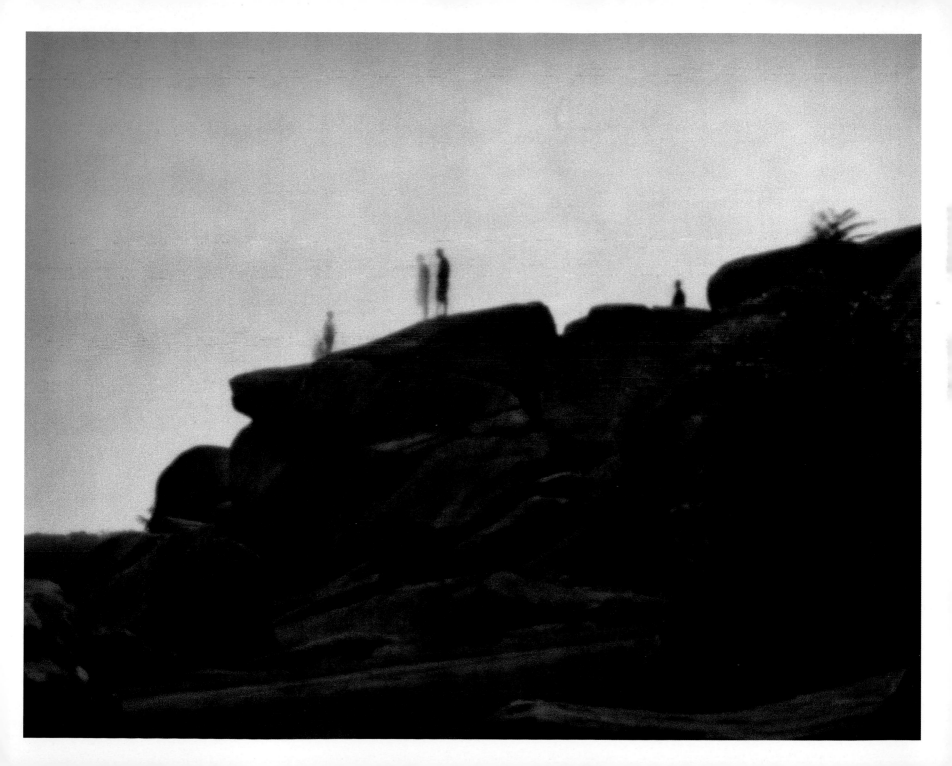

This section of the battlefield is bisected by train tracks. Trains ran through there then, and they run through there now. In July 1863, the path of the tracks provided an avenue of approach for the advancing Confederate army.

The Railroad Cut, as it is known, was dug deep into the indigenous rocks, protecting the attacking Confederates until they were finally overwhelmed by Union forces on July 1, that first day of the battle. As you walk through the cut, surrounded by natural rock wall, an eerie feeling descends upon you. Like many places on the battlefield, the space carries weight and bearing.

On July 2, 1863, the fighting at Gettysburg moved south, to the Peach Orchard, the Wheat Field, the Devil's Den, and Big and Little Round Top. These locales are now infamous for the blood that was shed there. Walking among the glacial boulders that make up the Devil's Den, and knowing well what transpired there on July 2, 1863, I once again was overcome by a powerful, visceral feeling.

The attacking Confederates, after seizing this seemingly impenetrable rock formation, began a long, drawn-out battle with the Union forces arrayed on Little Round Top just a few hundred yards across the valley. Looking down between the giant rocks, you can easily see where Confederate troops would have sought shelter during this intense fight.

Ascending Little Round Top, you come upon the famous statue of General Gouverneur Kemble Warren, the chief engineer of the Army of the Potomac, standing atop a massive boulder and looking out over the battlefield. It was General Warren who discovered that this vital defensive ground was mostly unoccupied and quickly moved Union troops onto the hill just moments before the massive Confederate attack on July 2, 1863.

For the third and final day of fighting at Gettysburg, I explored Cemetery Ridge, the center of the Union line during the battle, and the focal point of Pickett's Charge. On July 3, 1863, fourteen thousand rebel troops emerged from the tree line across from Cemetery Ridge and attacked the Union line, marching steadily across a mile of open ground. The attack was unsuccessful and left eight thousand dead and wounded rebel troops lying between the positions.

The three days of fighting at Gettysburg made it the bloodiest battle in the Civil War. With over fifty thousand casualties, blue and gray, it would be more than a year before all the dead were finally laid to rest. Although seen as a clear victory for the Union, the Battle of Gettysburg was ultimately indecisive.

PREVIOUS: *Devil's Den, Gettysburg*

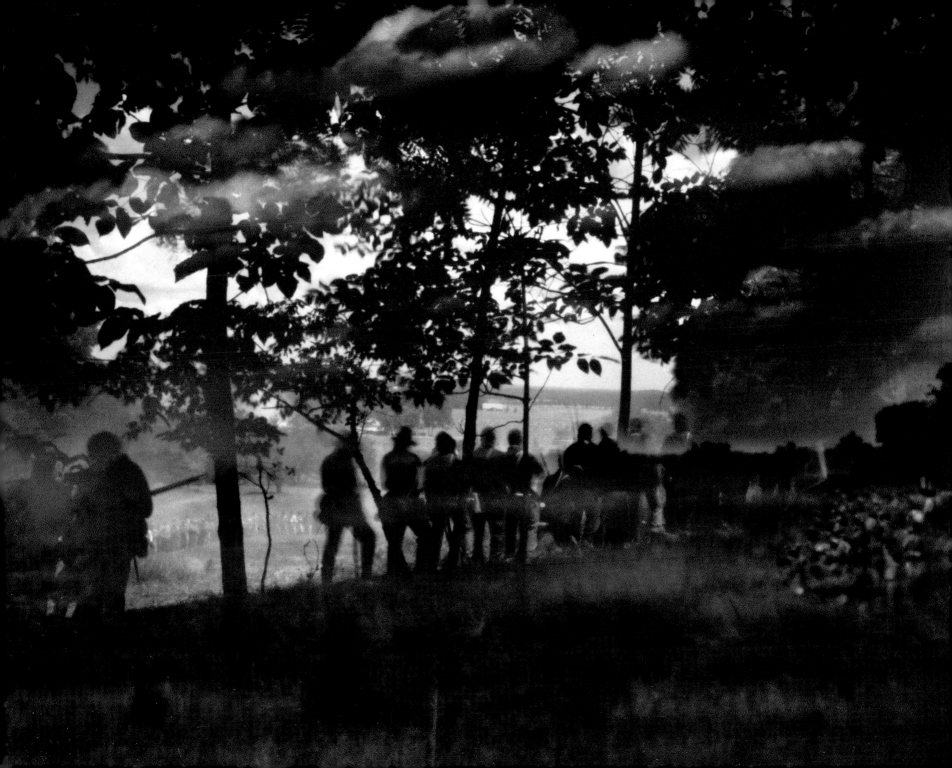

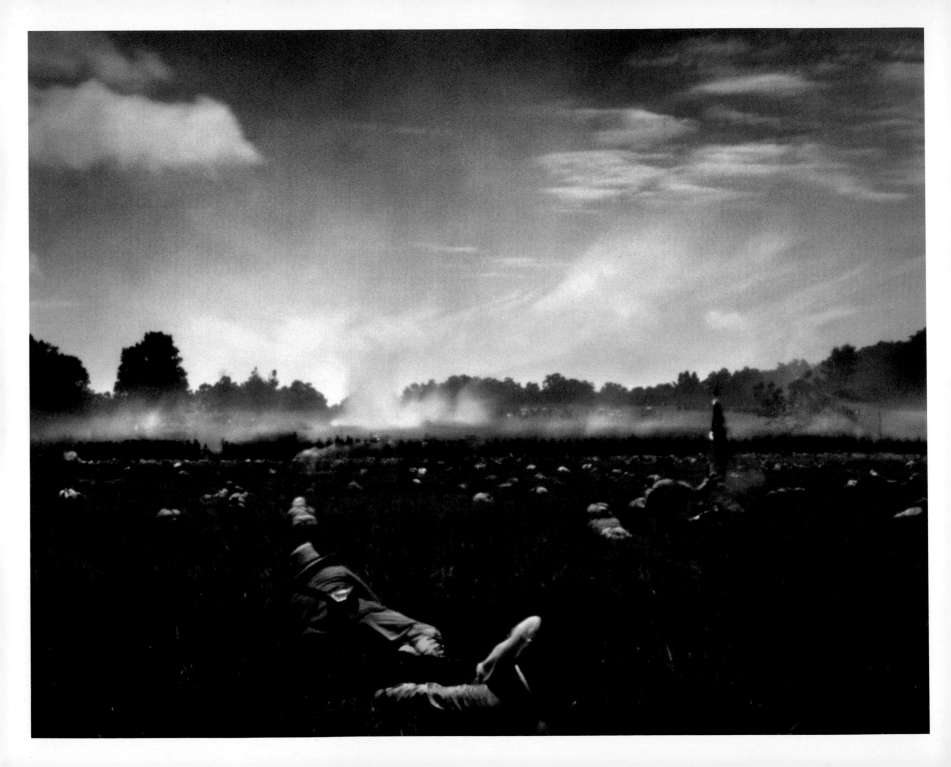

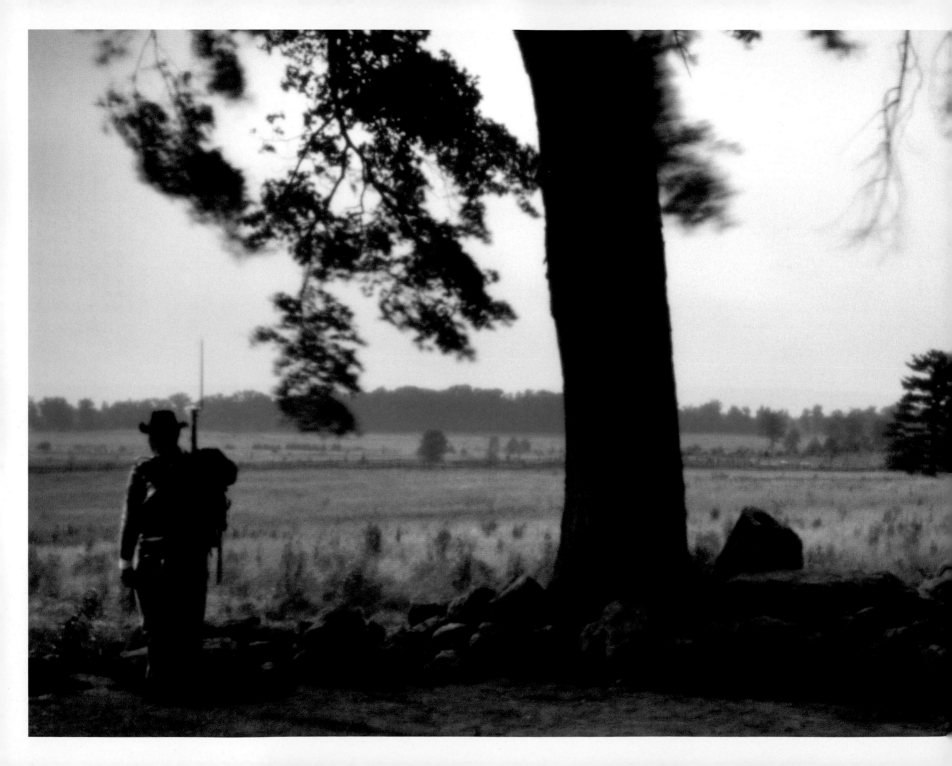

*Yes we'll rally round the flag,
 boys, we'll rally once again,
Shouting the battle cry of freedom,
We will rally from the hillside,
 we'll gather from the plain,
Shouting the battle cry of freedom!
The Union forever! Hurrah, boys, hurrah!
Down with the traitor, up with the star;
While we rally round the flag, boys,
 rally once again,
Shouting the battle cry of freedom!"*

PREVIOUS: *Reenactment of Pickett's Charge (left); fence along the Emmitsburg Road (right)*
LEFT: *Sentry at Cemetery Ridge*

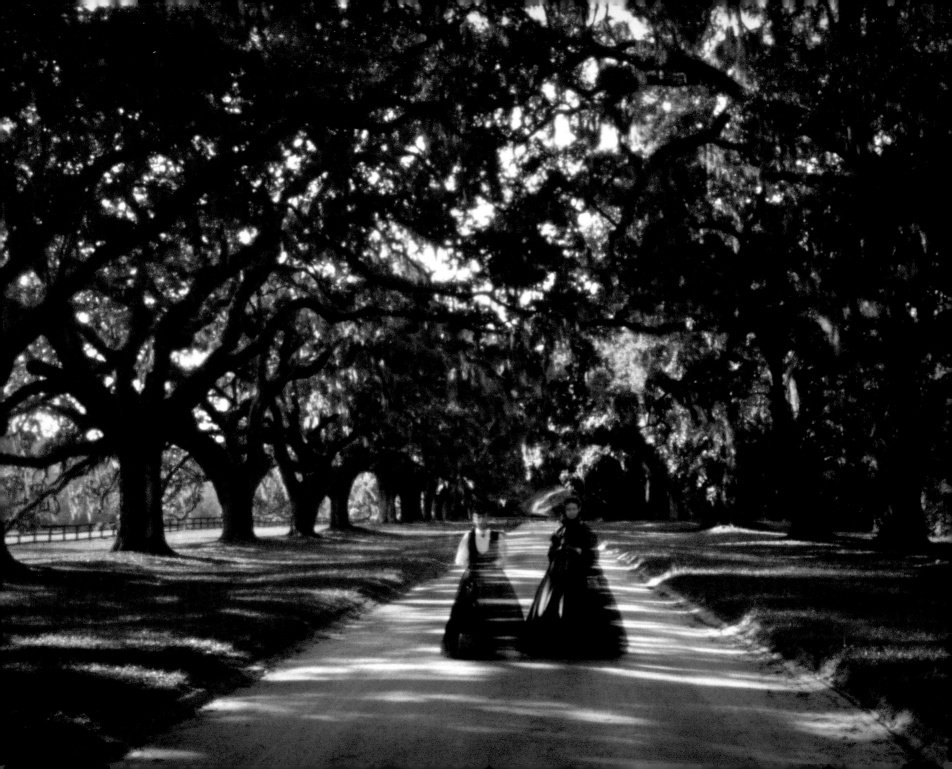

Charleston

The historic Boone Hall Plantation in South Carolina's lowcountry greets you with a mile-long stand of enormous evergreen oak trees draped in Spanish moss. This "Avenue of Oaks" that lines the main drive to the plantation is an iconic, romantic vision of the Antebellum South. The wide grand lane leads to a gate and a large manor house. *Gone With the Wind* begins to play in your head.

But there, bordering the Avenue of Oaks, is a cluster of nine small, neat brick buildings. They are original to the plantation, and to America's original sin. They are the slave cabins, clustered along what a small sign identifies as "Slave Street." They are among the few remaining intact slave quarters in the Southeast, and the only extant brick slave cabins in the United States.

Boone Hall Plantation, South Carolina

They were homes for the slaves who worked as skilled craftsmen and house servants at Boone Hall. Now, they are home to wax figures of slaves.

The Civil War was fought over slavery. But, following the progress of the Civil War from battlefield to battlefield on the sesquicentennial, it is possible to become so absorbed in the landscapes, the military strategy, the victories and defeats, the heroics and blunders, and the sheer enormity of the human toll that one doesn't always stop to reflect on just why all that blood was shed. But in the lowcountry of South Carolina, the legacy of slavery is unavoidable.

Just across the river from Boone Plantation is Charleston, the Queen City of the South, which, by 1860, was already nearly two

centuries old. It was, as much as any place in America, the citadel of slavery in the state that was the wellspring of secession.

On December 20, 1860, the South Carolina Secession Convention, meeting in Charleston, unanimously passed an ordinance severing the ties between the Palmetto State and the United States of America. South Carolina became the first state to secede from the Union.

Less then four months later, on April 12, 1861, General P.G.T. Beauregard, commanding the Confederate forces around Charleston Harbor, opened fire on the Union garrison at Fort Sumter, which surrendered the next day. The Civil War had begun.

But the seeds of the war were planted, even before there was a United States of America, right here, at the mouth of Charleston Harbor, on Sullivan's Island. More than 40 percent of African slaves brought to the British colonies before the American Revolution entered through the port of Charleston. It was there, on Sullivan's Island, that the slaves would be quarantined to be sure they were not carrying disease before being allowed admittance to the mainland and placed on the block in Charleston's slave markets. It was the perverse Ellis Island for those who came to America not by choice but in chains.

I visited Charleston in 2013 to attend a reenactment commemorating the Battle of Fort Wagner at the historic Boone Hall Plantation. The Battle of Fort Wagner, which occurred on neighboring Morris Island, has become famous in the annals of the Civil War for the assault on the fort made by the Massachusetts 54th Regiment; an infantry unit composed

Salt marsh, Mount Pleasant, South Carolina

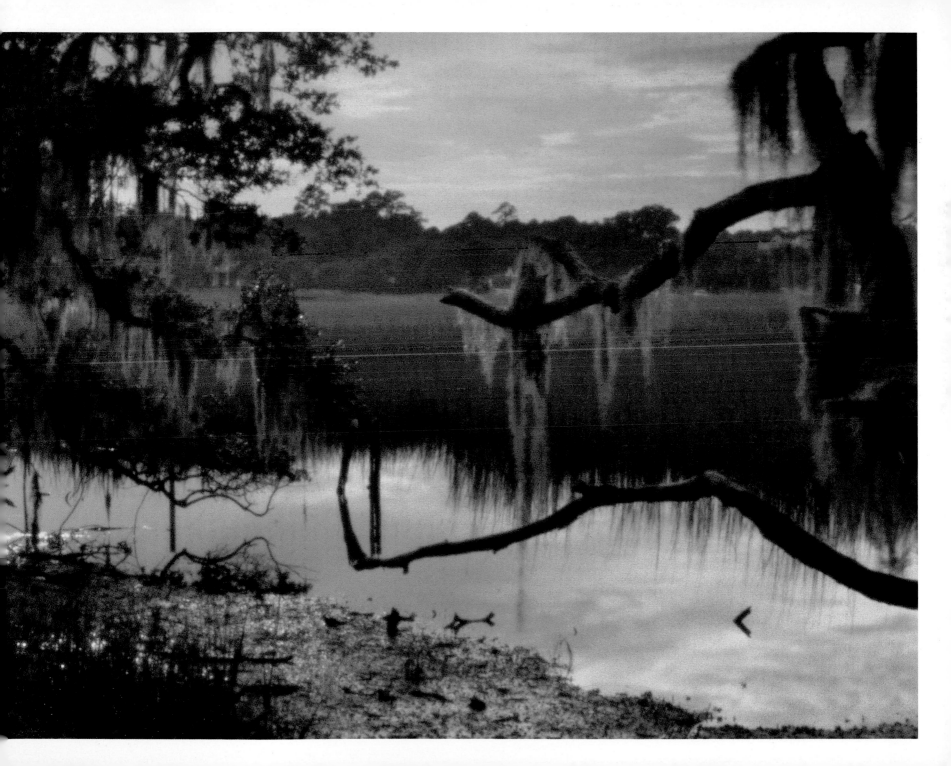

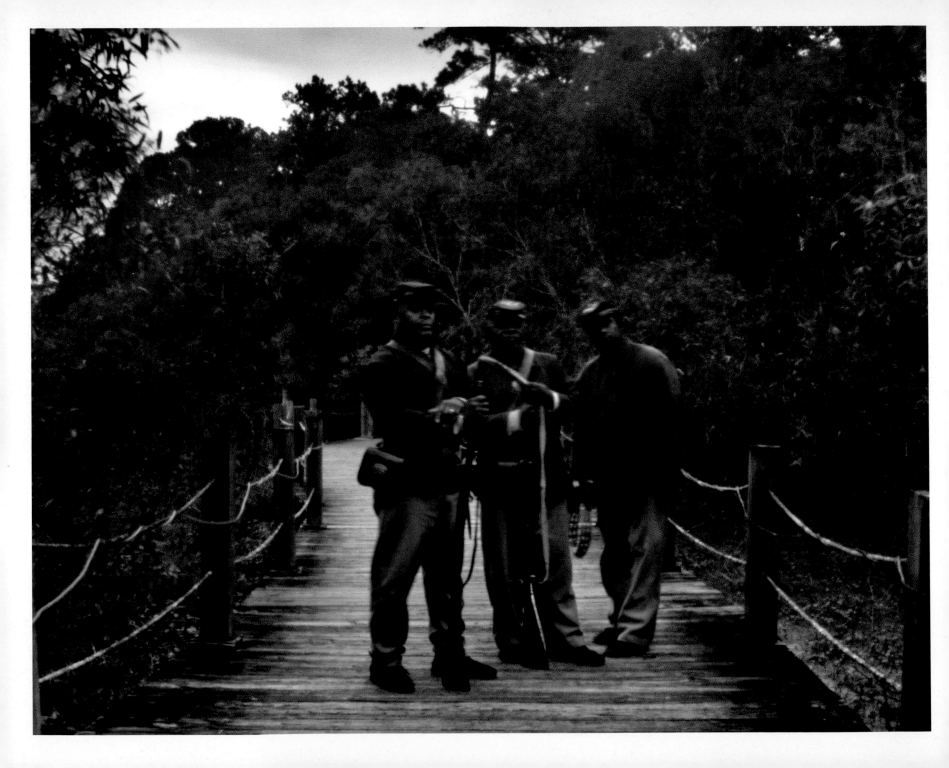

of former slaves and freed black men. Reenactors gathered at Boone Hall weeks before the event to construct an earthen fort that would serve as Fort Wagner for the sesquicentennial event. A small contingent of African American living historians arrived at Boone Hall in the impression of the Massachusetts 54th and planned on assaulting the makeshift fort over the commemorative weekend.

I arrived a week prior to the event and began my explorations of the city and its harbor defenses. The City of Charleston is sheltered among barrier islands and tidal salt marshes, and it is surrounded by forts. The city's naturally protected harbor and navigable rivers made Charleston, or Charles Towne, as it was first called, one of the first areas settled by Europeans in the Americas, for understandable reasons. It continues to carry itself with a European grace and beauty.

The early settlers of Charleston, looking to defend themselves against marauders, pirates, and the various European powers vying for influence in the Carolinas, began erecting defensive forts around the harbor to protect Charleston's commerce and expanding wealth. That wealth largely derived from the slave economy—first through the importation and sale of slaves, then from the large plantations that cultivated everything from indigo and rice to cotton and pecans. These goods were taken downriver by barge from the plantations and shipped through Charleston Harbor out to a global market.

Three islands in the harbor's notoriously forbidding marshes—Sullivan's Island, James Island and Morris Island—each played an enormous role during the Civil War. With Charleston firmly in Confederate control, the South took over Fort Sumter and Fort Moultrie, located on Sullivan's Island, and constructed Fort Lamar and Fort Johnson on James Island. On Morris Island, the Confederates built the formidable Fort Wagner. Together, these forts formed a ring around Charleston Harbor, effectively making the city an impenetrable fortress.

Fort Sumter, built during the War of 1812, is now half of what it once was. The fort was battered during the Civil War, its walls crumbling under a four-year barrage of shelling, a target, like the city itself, of Union artillery, due to its position at the heart of Charleston Harbor. Walking through the bastion today, one might find the cavernous remains damp and claustrophobic.

Morris Island is an uninhabited islet at the entrance to Charleston Harbor, just a quarter mile from Fort Sumter. During the Civil War, the island was the site of the Confederate bastion Fort Wagner. The fort in 1863 spanned the entire width of the island and had the natural protection of the Atlantic Ocean to the east and impassable marshes to the west. The only Union approach to the fort was a full frontal assault along the beach, which directly bore the brunt of Fort Wagner's guns.

In 1863, Lincoln issued the Emancipation Proclamation, declaring slaves in states still in rebellion to be free. And now that this was a war whose declared ambition was to end slavery, the proclamation also allowed freed slaves "into the armed service of the United States to garrison forts, positions, stations, and other places, and to man vessels of all sorts in said service." In response to public outcry over the new black soldiers, the Federal

PREVIOUS: *Fort Sumter*

LEFT: *Reenactors of the 54ᵗʰ Massachusetts*

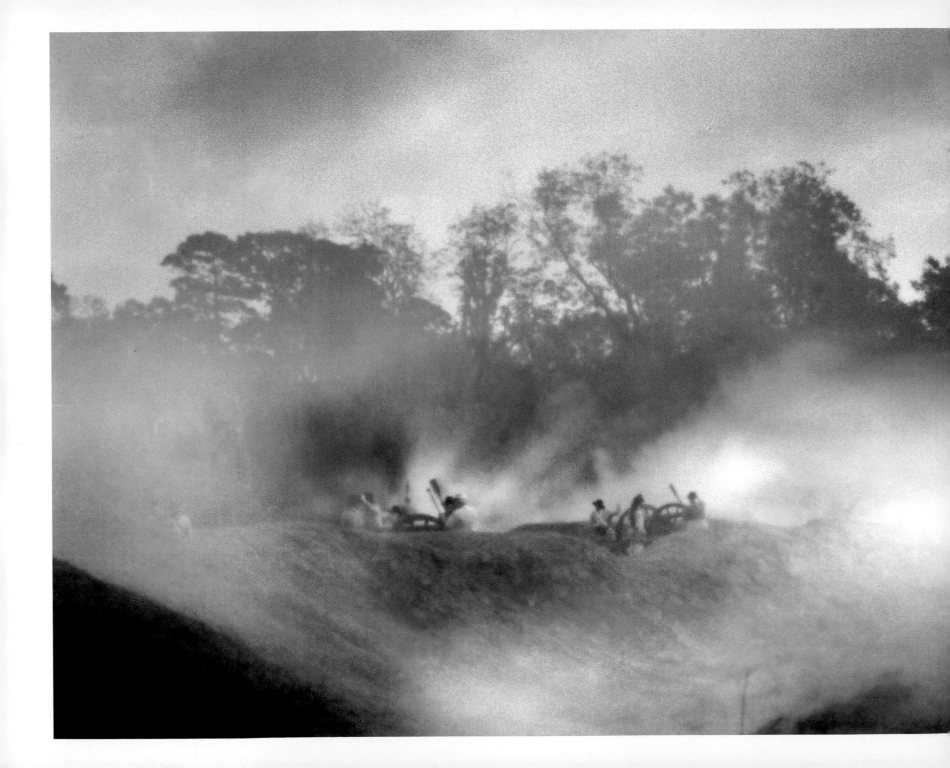

government strictly segregated all "colored" regiments, placing white officers in charge of them.

The 54th Massachusetts Volunteer Infantry would be one of the first official African American units to serve. The 54th's commander, Col. Robert Gould Shaw, son of Boston abolitionists, soon found that his new recruits took to soldiering with zeal. At the second Battle of Fort Wagner on July 18, 1863, they would get their chance at glory.

The Confederate garrison at Fort Wagner consisted of about a thousand men and multiple large-caliber guns. Within the fort's 30-foot earthen walls the Confederate defenders dug numerous bomb-proofs and had the added protection of a water-filled moat at the fort's base. Safe inside their dugouts, the Confederates hunkered down during the bombardment and awaited the inevitable ground attack.

When the shelling stopped, the Confederates, emerging from their bunkers, could plainly see a mass of Union soldiers preparing for an assault on the beach. With evening descending, the 600 members of the 54th readied themselves. Col. Shaw paused and spoke to his men for the last time. He urged them to follow the flag and promised to see them again inside the fort.

Shaw then drew his sword and, with bayonets fixed, the 54th Massachusetts charged at the quickstep across the deep sand dunes and immediately came under severe fire.

Reenactment at Boone Hall Plantation

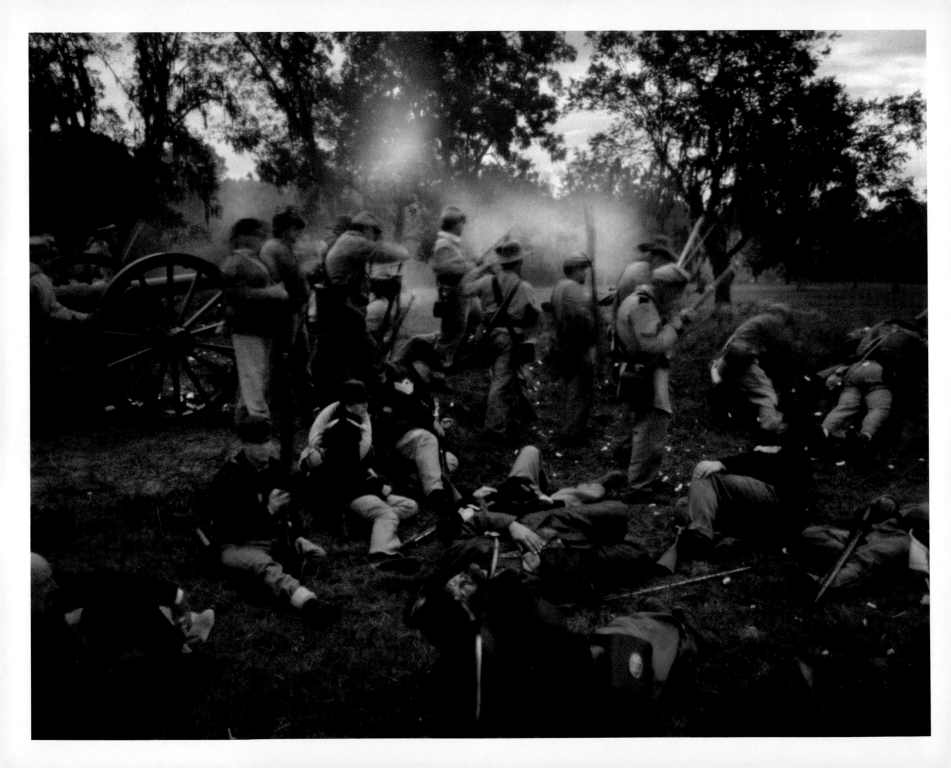

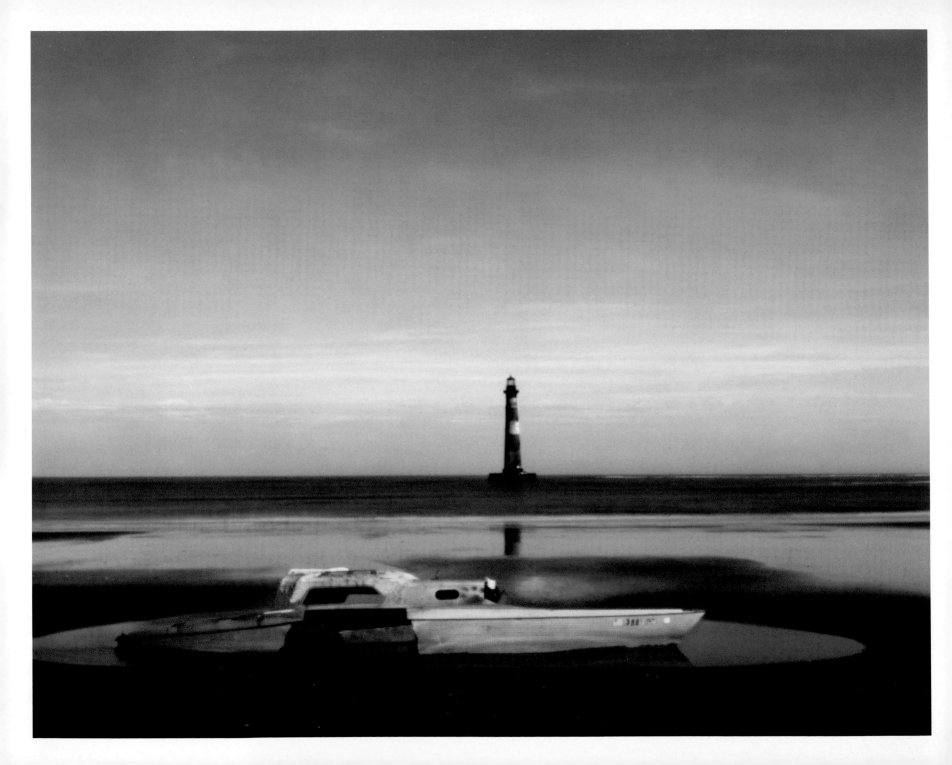

"At that moment," wrote Luis Emilio, an officer with the 54th, "Wagner became a mound of fire, from which poured a stream of shot and shell. Just a brief lull, and the deafening explosions of cannon are renewed, mingled with the crash and rattle of musketry. A sheet of flame, followed by running fire, like electric sparks, swept along the parapet. . . . When this tempest of war came, before which men fell on every side, the only response of the 54th made to the deadly challenge was to change step to the double-quick, that it might sooner close with the foe."

In the assault, soldiers of the 54th eventually scaled the parapet and fought desperately in hand-to-hand combat with the Confederate defenders. The 54th held their ground for a time, but, outnumbered, were eventually repelled, leaving 275 of their number killed, wounded, or captured in the attack. After the battle, the Confederates buried Colonel Shaw, along with his soldiers, in a mass grave outside the fort.

In 2013 at Boone Hall Plantation, Confederate reenactors lined the fort's walls as their counterparts in Union blue emerged out of the tree-line 100 yards away and made their assault, reenacting the famous battle. Joseph McGill, an African American, joined the attack with a handful of colleagues in the impression of the Massachusetts 54th Regiment. Intent on commemorating this battle, McGill and his fellow soldiers charged the makeshift fort and were eventually captured within its walls.

Union troops were never able to crack the defenses of Fort Wagner. But the storms and erosion of the last 150 years did what the Union Army could not. Astonishingly, on Morris Island, there is no surviving evidence of Fort Wagner. The fort, along with the mass graves of the men that fell there, have literally been washed out to sea. The Morris Island Lighthouse, once securely stationed at the southern end of the island, now sits more than a quarter mile offshore, completely surrounded by water.

PREVIOUS: *Morris Island, South Carolina*
LEFT: *Lighthouse, Morris Island*

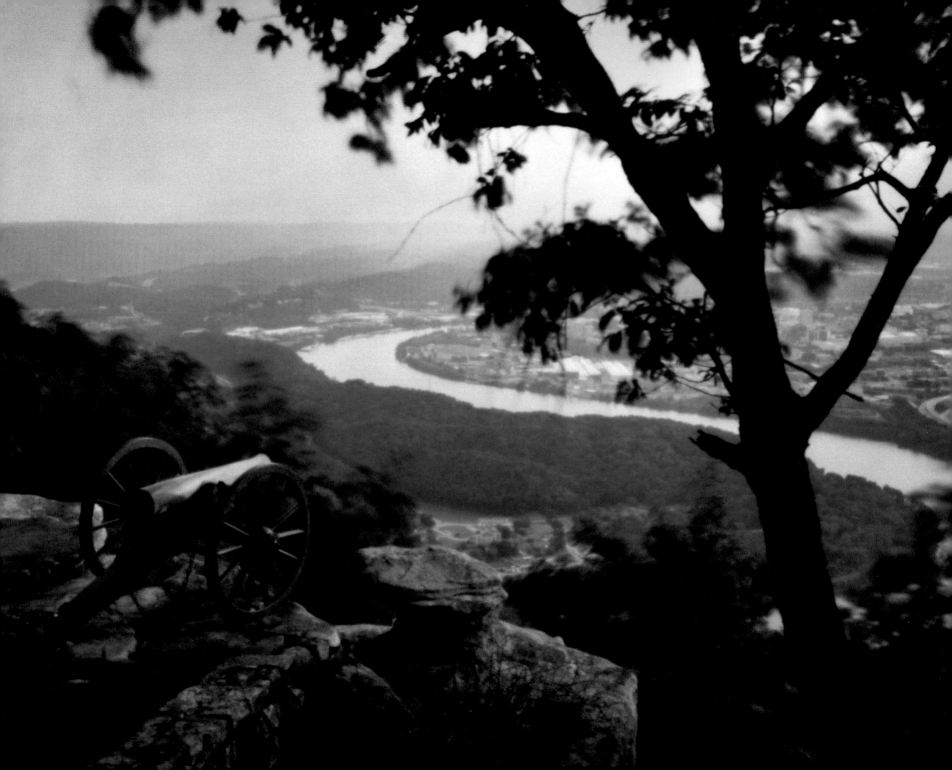

Chickamauga

The Cumberland Plateau, stretching from Kentucky through eastern Tennessee, remains the world's longest hardwood forested plateau. For thousands of years, the Tennessee River has cleaved its way through the Appalachians here, creating thickly forested ridges. On a clear day, you can see the borders of four states—Tennessee, Georgia, Alabama, and North Carolina—from Lookout Mountain. Nineteenth-century cannons line outcroppings on the mountaintop which protects the city of Chattanooga below—a railroad hub today, as it was for the Confederacy during the Civil War.

By the fall of 1863, after the Union victories at Vicksburg and Gettysburg, President Lincoln was determined to keep up the pressure on the Rebels in the West. In September, Union forces, led by General William Rosecrans, left their base at Murfreesboro, Tennessee, and marched east intent on capturing Chattanooga.

The Campaign for Chattanooga would eventually lead the armies into a wilderness south of the city, along a meandering creek called the Chickamauga. What happened around this deep creek—whose name, loosely translated from Cherokee, means "the river of death"—between July and November of 1863 would be one of the great reversals of fortune of the Civil War. The Battle of Chickamauga would be an overwhelming Confederate victory, their last in the West. Two months later, the Union forces would turn the tide at the Battle of Missionary Ridge and chase the Confederates from Tennessee into Georgia.

Lookout Mountain, Chattanooga, Tennessee

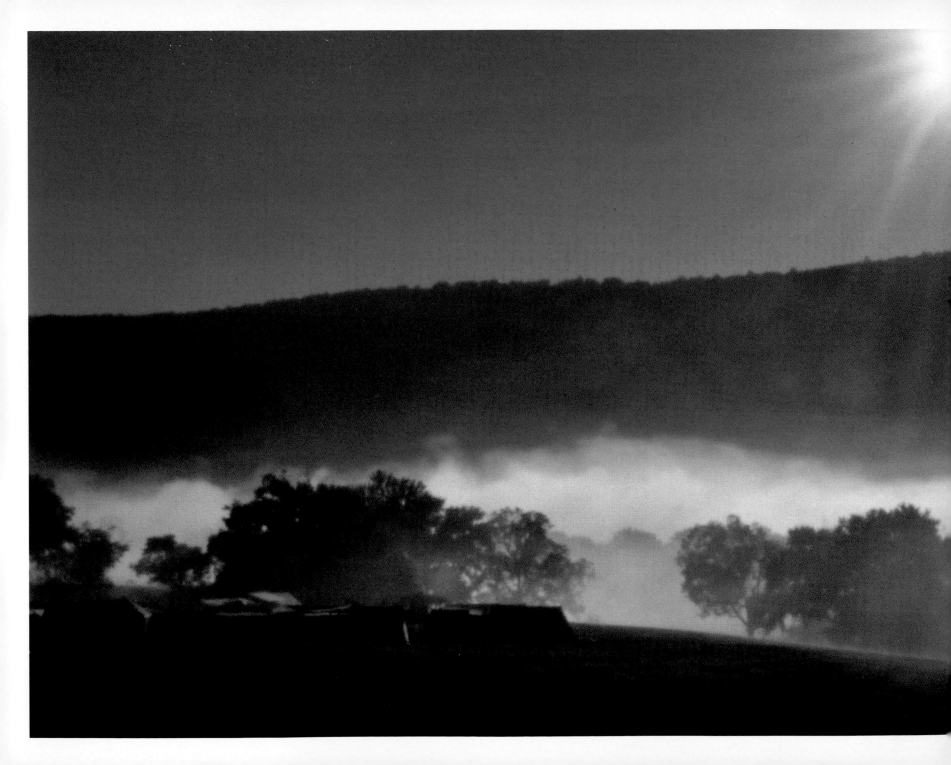

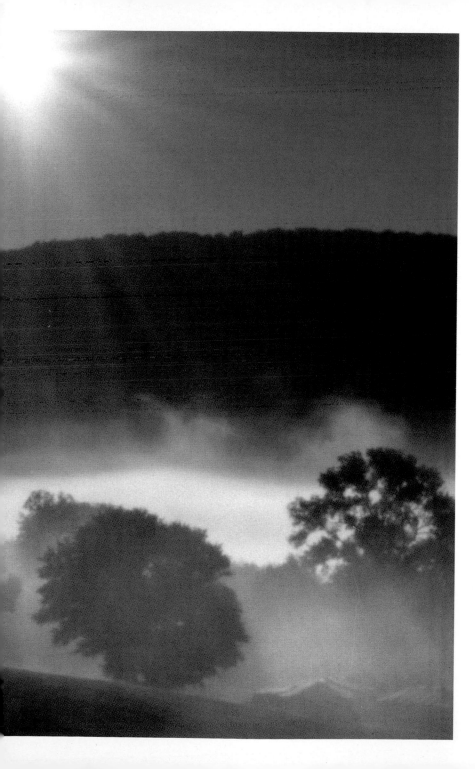

On September 9, 1963, General Rosecrans, after a stealthy campaign of feint and maneuver, captured the city of Chattanooga without a shot fired. After he dispatched Union troops to cut the city's supply lines, the Confederates were forced to abandon the city and retreat south. Elated, Rosecrans wired Washington, taking credit for the city's capture and promising to follow the retreating Rebels to their death.

But the Confederates were not retreating. Confederate General Braxton Bragg had reorganized his army, and the Union detachment who thought they were chasing the Confederates were instead rushing straight into a trap. On September 11, the Confederates confronted a portion of Rosecrans' Federals in the hills south of Chickamauga—in a place called McLemore's Cove. The Federals, realizing they were outnumbered, managed to retreat north toward Chattanooga and safety, but the armies would meet again. One week later, 25 miles to the north, the two evenly matched armies would fight a vicious, two-day battle along Chickamauga Creek.

Arriving on the scene in 1863, Confederate Sam Watkins described what he saw:

"The battlefield was in a rough and broken country, with trees and undergrowth that ever since the creation had never been disturbed by the ax of civilized man. It looked wild, weird, and uncivilized."

In 2013, thousands of reenactors and living historians from around the country set up camp in McLemore's Cove to commemorate the second bloodiest battle of the American Civil War. The rising sun burned through low hanging fog, revealing

McLemore's Cove, Chickamauga Georgia

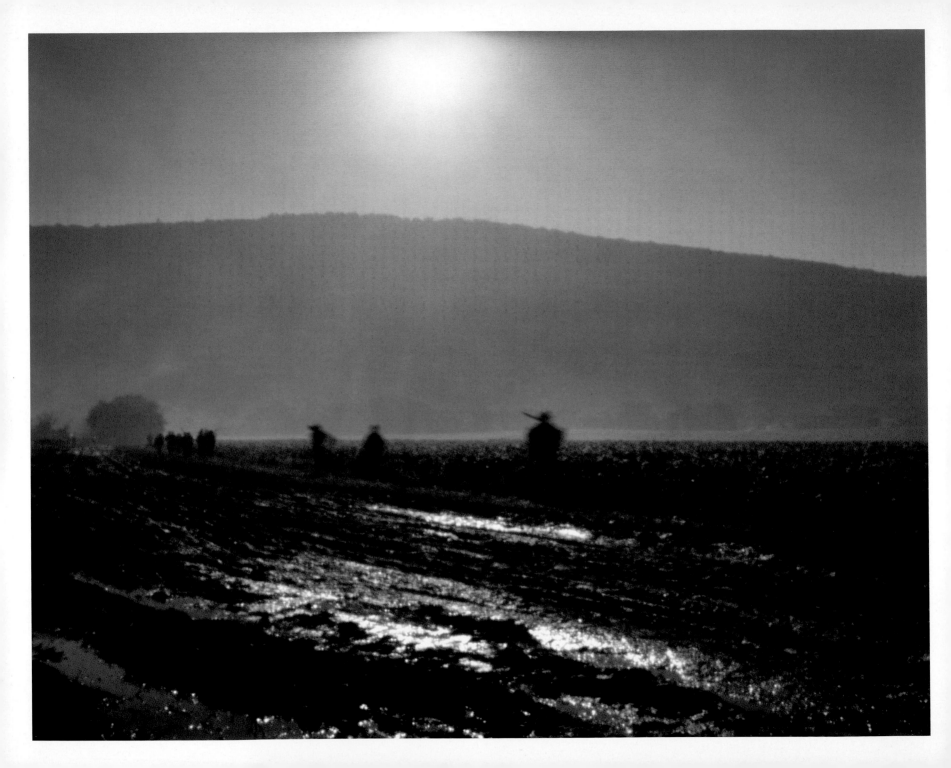

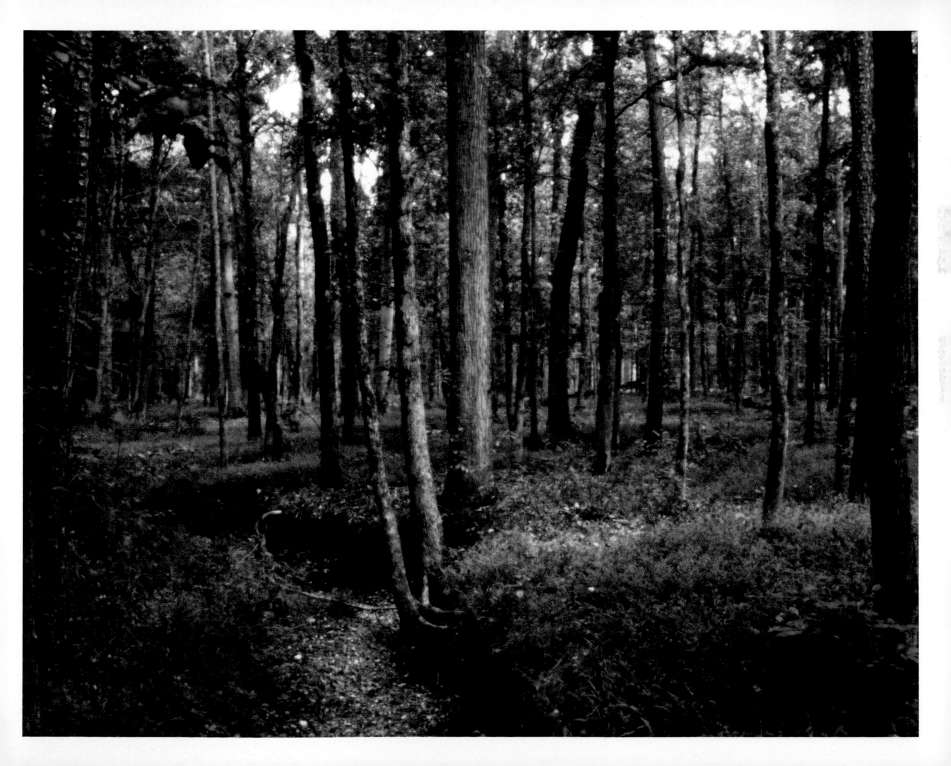

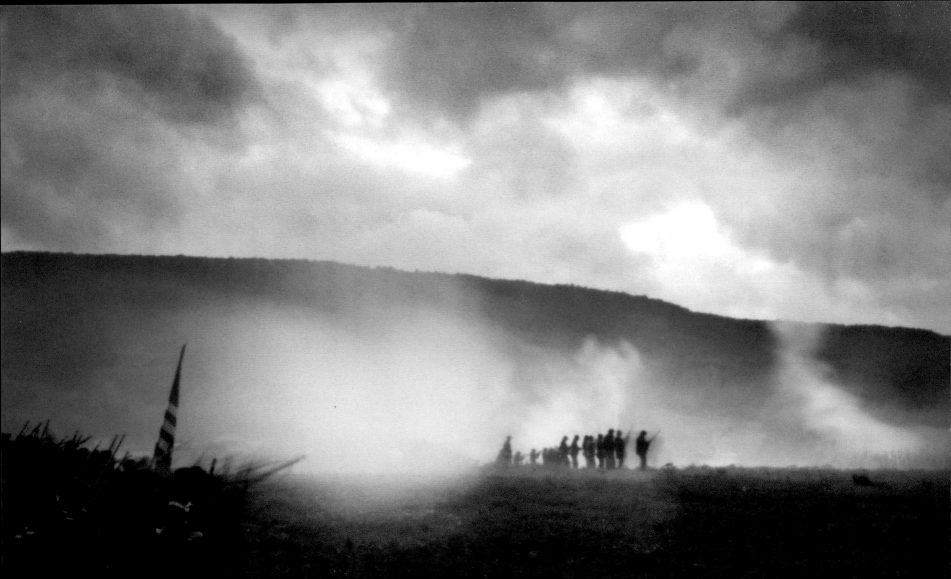

thousands of canvas tents pitched in the valley. The smoke from hundreds of wood fires, cooking breakfast for the weekend warriors, mingled with the morning mist. Before the end of the day, the fog would give way to gun smoke, filling the valley as it had 150 years ago. But not before a torrential downpour turned the valley into a sea of mud.

The terrain around Chickamauga Creek is still heavily wooded, the landscape broken only by a few, now-historic clearings, small frontier farms that became killing grounds starting on September 19, 1863. The dark and dense forests made for unexpected, deadly encounters. Formations of soldiers would march through the woodlands and suddenly come upon the enemy. Vicious stand-up fights ensued.

As historian Bruce Catton wrote, "The battle . . . went by nobody's plan, once the first shots were fired. A Federal brigadier summed it up perfectly when he wrote that it was a mad irregular battle, very much resembling guerrilla warfare on a vast scale, in which one army was bushwhacking the other, and wherein all the science and art of war went for nothing."

More than 120,000 soldiers would clash in the wilderness here. The two-day fight was the second bloodiest battle of the Civil War after Gettysburg. At dawn on September 19, 1863, the two armies clashed at two bridge crossings on the Chickamauga. The fighting continued into the surrounding forest, evolving into a series of assaults and counterattacks. Confusion reigned and neither side gained an advantage, which forced the two armies to push more soldiers into the fight. The day's fighting ended in

stalemate, with both sides bloodied but still evenly matched. But the balance of power would shift overnight.

Confederate General James Longstreet arrived on the scene that evening with reinforcements. At dawn on September 20, the Confederates attacked again. They were held back for a time but eventually overwhelmed the Federals. In the late afternoon, Longstreet's Confederates broke through the Union line, forcing a pell-mell Union retreat.

In September 2013, low-lying morning fog filled Dyer Field, the site of Longstreet's attack. A reconstruction of the rough-hewn Brotherton cabin along the old Lafayette Road sits on the site, its open fields surrounded by cross-rail fences and dense woodlands. It is here that Longstreet's troops broke through on September 20 and sent the Union Army reeling.

"The Lafayette road along or near which the broken lines of each army were rallied and reformed, and across which the surging currents of fire had repeatedly rolled, became the 'bloody lane' of Chickamauga," said Confederate General John Gordon.

The Union retreat from Chickamauga was not a total rout. Union General George Thomas managed to rally some troops and fight an intense rearguard battle at Horseshoe Ridge, which succeeded in holding back the Confederates until what was left of the Union Army could escape Chickamauga to the defenses around Chattanooga.

The intense fighting that occurred through the evening of September 20 around Horseshoe Ridge was a tactical nightmare

Chickamauga, Georgia

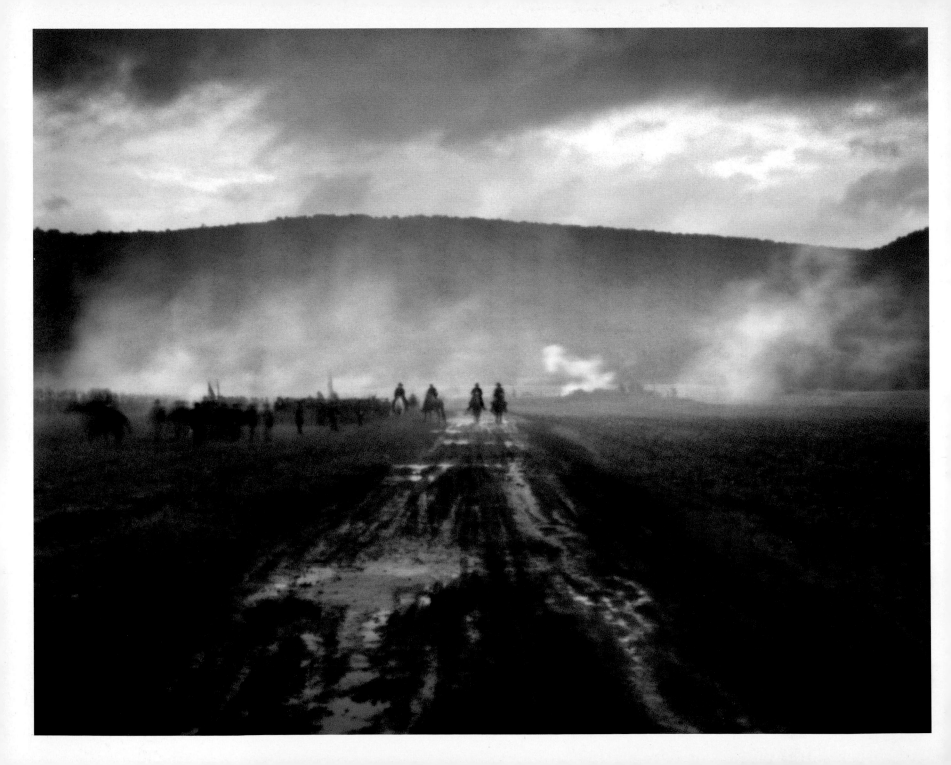

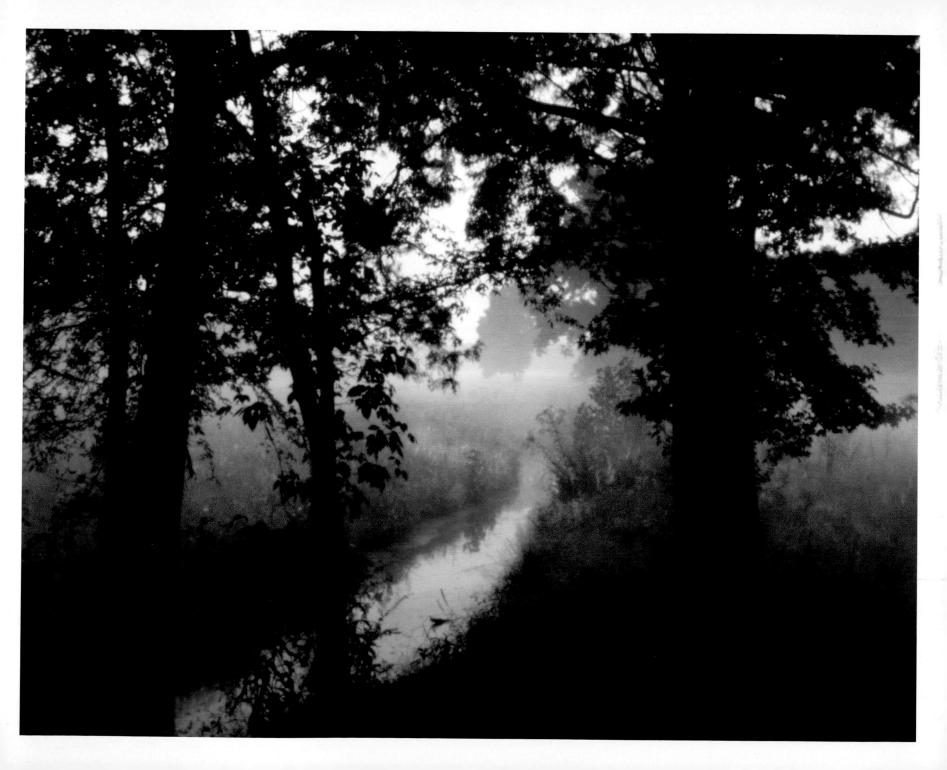

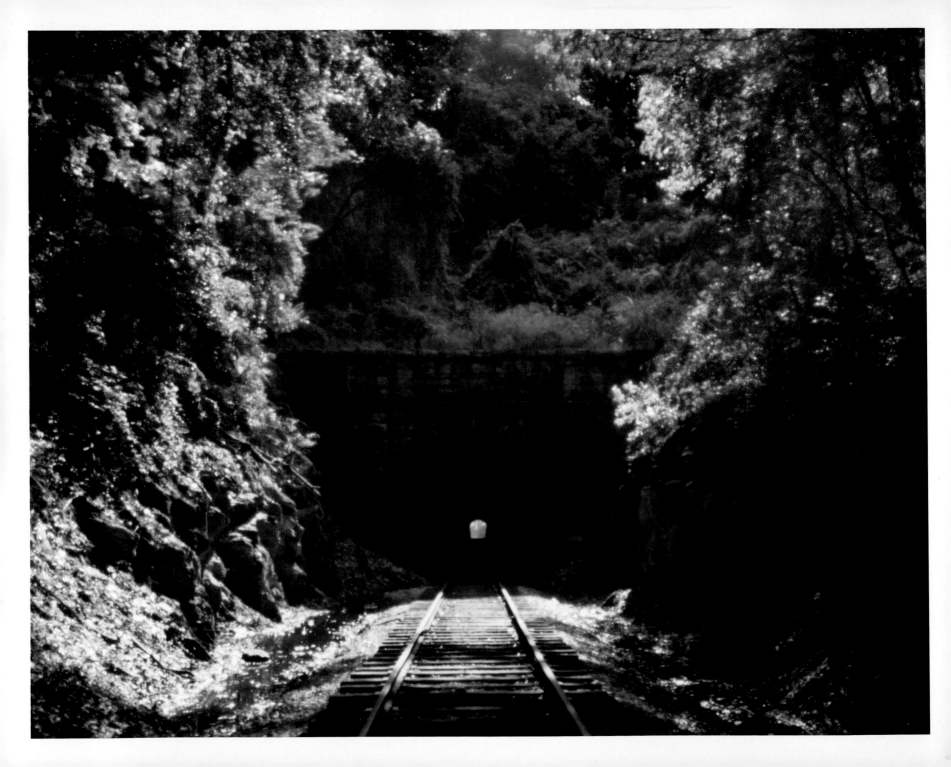

for the Confederates and was remembered by the veterans as one of the most frightening battles of the war.

As darkness descended, the lack of visibility in the wooded hills worked to General Thomas' advantage as his troops fought off numerous Confederate assaults. Thomas managed to hold back the Rebel onslaught and end the battle on Snodgrass Hill, earning him an immortal sobriquet: the Rock of Chickamauga.

Nearly 35,000 men had been killed or wounded in the two-day fight. Walking through the forests of the battlefield at dusk in 2013, it seemed the specter of the slaughter lingered yet in the trees and thick undergrowth. Reading veteran Ambrose Bierce's remembrance of the "haunted landscape" in "Chickamauga," or the reflections of Confederate private Sam Watkins, should be enough to spook anyone exploring the wilderness here.

The Battle of Chickamauga was a clear Confederate victory. The following day, the Confederate forces occupied the hills surrounding Chattanooga and launched a two-month siege of the Union troops now penned up in the city, bringing them near starvation before the garrison was relieved with supplies and reinforcements, led by Ulysses S. Grant.

Arriving with Grant was one of his most trusted subordinates, William Tecumseh Sherman. Together, they would execute a breakout from Chattanooga that would stun the nation.

On November 25, 1863, Grant gathered his forces and attacked the Confederates on Missionary Ridge and Lookout Mountain. Despite the strong defensive positions held by the Confederates, the battles were unequivocal Union victories. The Confederates in their mountain redoubts were sent retreating into Georgia.

Long after the war had ended, Confederate Lieutenant General Daniel Harvey Hill wrote that the victory at Chickamauga had exacted an awful toll on the Rebel spirit. There was "no more splendid fighting" in the war, he wrote, "but it seems to me that the élan of the Southern soldier was never seen after Chickamauga—that brilliant dash which had distinguished him was gone forever. . . . He fought stoutly to the last, but after Chickamauga, with the sullenness of despair and without the enthusiasm of hope. That barren victory sealed the fate of the Southern Confederacy."

Shelby Foote recalled one telling scene in his magisterial Civil War history:

"Captain, this is the death knell of the Confederacy," a junior officer remarked to his company commander as they were withdrawing from Missionary Ridge. "If we cannot cope with those fellows with the advantages we had on this line, there is not a line between here and the Atlantic Ocean where we can stop them."

"Hush, Lieutenant," the captain told him, slogging rearward through the darkness. "That is treason you are talking."

Whiteside Tunnel, Missionary Ridge

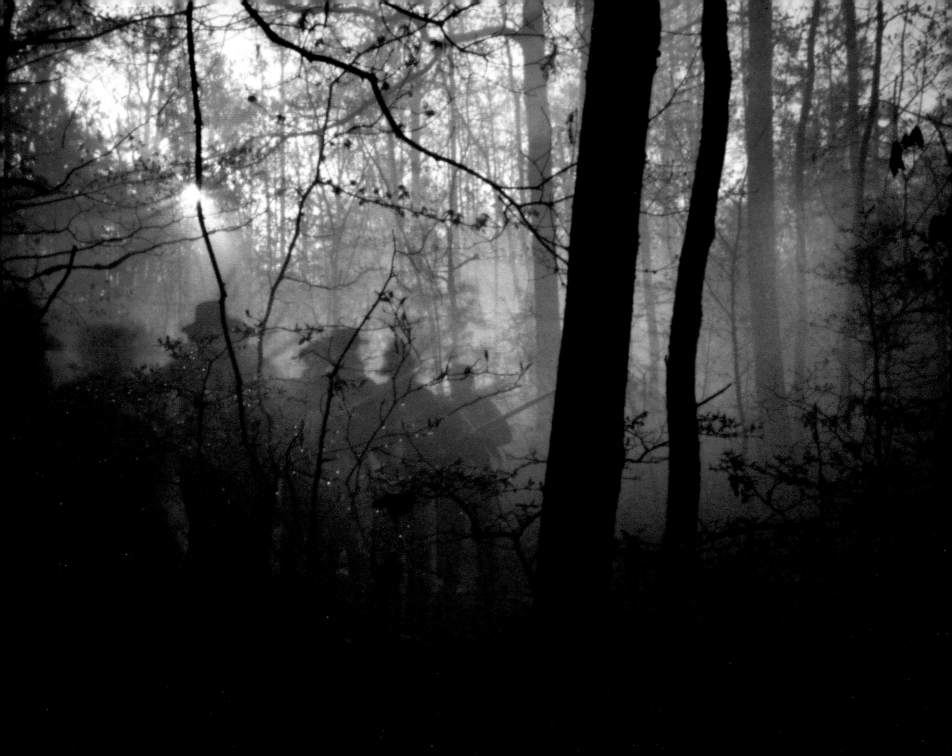

The Overland Campaign

In the spring of 2014, the dogwoods were in bloom in the leafy wilderness of Virginia. One hundred fifty years earlier, the Union and Confederate armies fought a vicious battle in the shade of these same blossoms.

Known collectively as the Overland Campaign, the fighting that began in the Virginia wilderness in the spring of 1864 would not climax until one year later at Appomattox, Virginia. In May 1864, newly promoted Commander of the Union Army Ulysses S. Grant inaugurated a campaign across the country, intended to bring an end to the rebellion. Engaging all the Confederate armies at once would prevent one Rebel army from aiding the other. In the end, Grant believed, the Union's sheer superiority in numbers would ultimately overwhelm the South.

In Virginia, Grant sent Union troops into the Shenandoah Valley and an additional 30,000-man force up the Virginia Peninsula. Grant himself would face Confederate General Robert E. Lee and his legendary Army of Northern Virginia encamped near Fredericksburg. In early May, Grant led a 120,000-man army across the Rappahannock and Radian rivers into Virginia, intent on finally destroying Lee and his band of Rebels.

Four major battles occurred in the campaign between May and June of 1864, causing mass casualties for both armies. All would end in stalemate. The attrition of a month of non-stop combat affected the morale of both armies. Although Confederate casualty numbers are hard to come by even today, at the height of the campaign, Union losses averaged two thousand men a day.

Wilderness in Moseley, Virginia

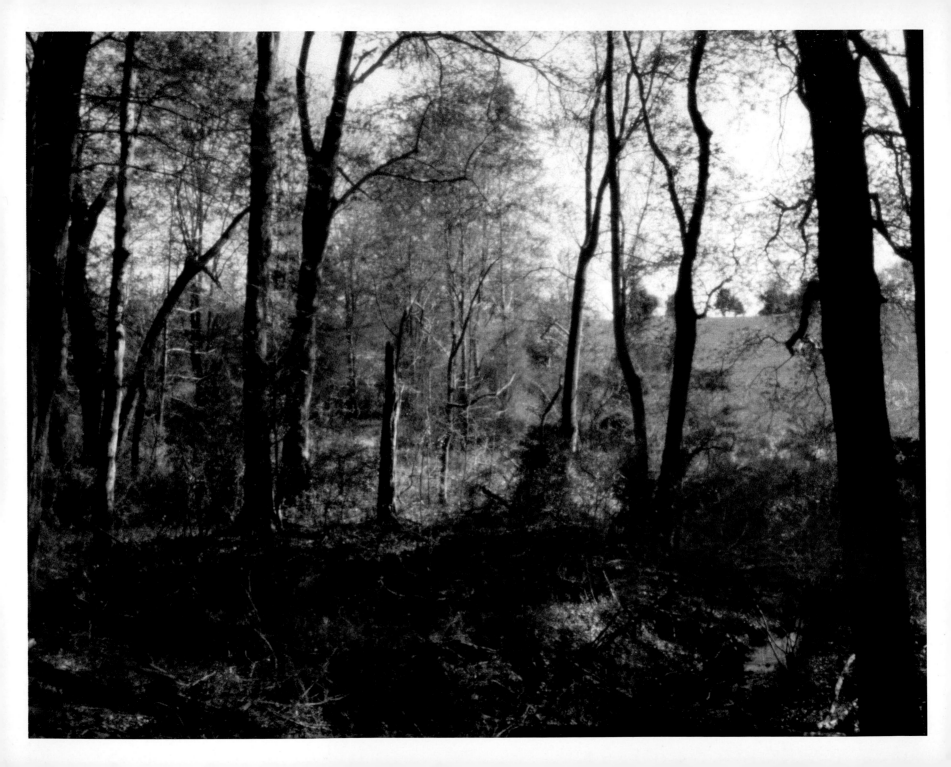

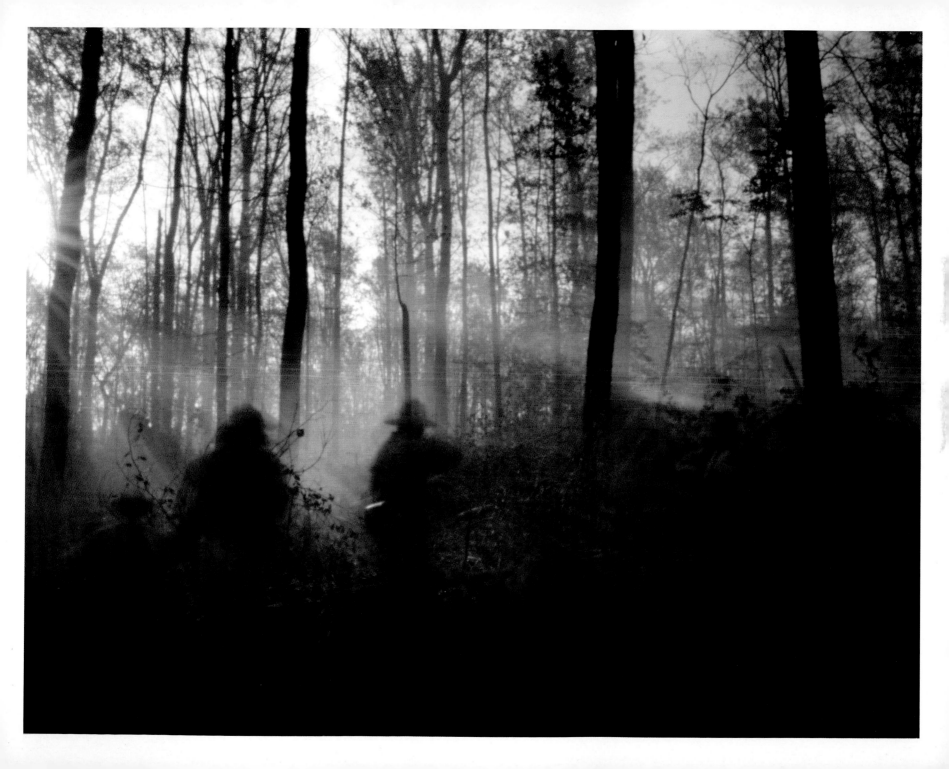

The Wilderness—May 1864

The Union Army was quite familiar with the ground they were traveling. Just a year before, the two armies had met hereabouts, fighting the Battle of Chancellorsville. Marching the same terrain in 1864, Federal soldiers commented in their journals on the landscape's war-torn look. The hills and fields along the rivers were littered with the refuse of the two armies and the evidence of battle. In the woods, Union troops came upon the skeletal remains of soldiers hastily buried the year before. There was, one solider wrote, "a sense of ominous dread, which many of us found impossible to shake off."

"It was a very easy matter to discover just where pools of blood had been," wrote another, "for those particular spots were marked by the greenest tufts of grass and brightest flowers to be found upon the field."

For Grant's soldiers, back in Virginia's Wilderness, memories of the 1863 debacle at Chancellorsville were still very fresh in their minds. In the Confederate camp, the mood was entirely different. Out-numbered as usual, the Confederate soldiers understood that the region's cramped wooded terrain would work to their advantage. They would again wrestle with the Union Army in the tangles of the Wilderness, determined to stop them there.

The chaos of fighting in the Wilderness in 1864 would be much like the battle the year before. It was, a participant wrote, "a battle of invisibles with invisibles" amid the dense woodlands.

In May 2014, I got to experience what this confused forest fighting might have looked like. Morning fog filled the tangled woodland in Moseley, Virginia, where reenactors prepared to skirmish in the predawn light. Once the skirmishing started, a veil of gun smoke descended on the forest. Reenactors turned into silhouettes and within the first five minutes you couldn't tell who was who. The ability to distinguish gray from blue, friend from foe, was lost.

As at Chancellorsville, the forest caught fire during the battle in 1864, creating horrific conditions for the wounded. That evening, as the fighting subsided, the fires raged and the screams of those incapacitated in the fighting resounded among the troops hunkered down in their forest trenches. The nightmarish scene would haunt the soldiers of both armies and, as far as I am concerned, still haunts these woodlands today.

Outside the confines of the National Battlefield, I explored an old railroad grade used by the Confederates in a devastating counterattack on May 6, 1864. The elevated grade still runs through a forest today, first north and gradually curving east to where General Longstreet's Confederates launched the counterattack that would eventually end the fighting. Looking east along the grade, through the trees, are spacious backyards with swing sets. To the west, a preserved portion of the Wilderness battlefield, dense forest is all the eye can see.

The Battle of the Wilderness had ended in stalemate. General Grant disengaged his army and headed for the nearest strategic crossroads on the map.

PREVIOUS: *The Wilderness Battlefield*

RIGHT: *Reenactment at Spotsylvania Court House*

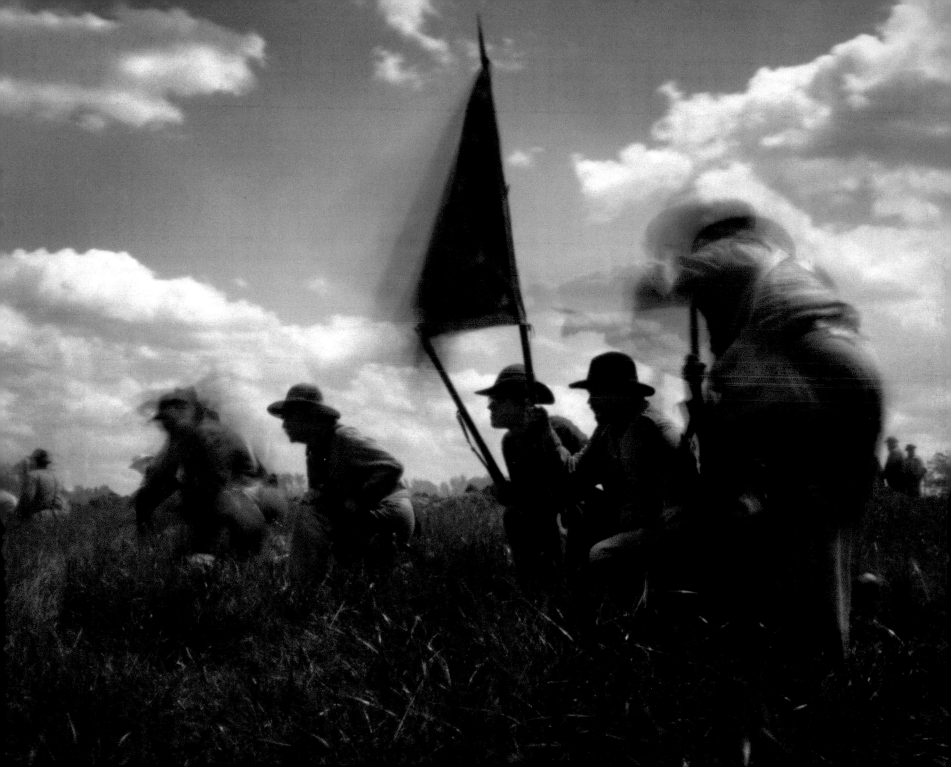

Spotsylvania Court House

Along the Brock Road today, outside the small town of Spotsylvania, Virginia, wildflowers grow on Laurel Hill. On May 8, 1864, this same road led the Union Army to their first combat in what would be called the Battle of Spotsylvania Court House—or by its veterans, simply Bloody Spotsylvania.

When the Union forces arrived, they found the Confederates entrenched and waiting for them. Overnight, Lee's soldiers had engineered an extensive line of formidable earthworks across the Union Army's line of march. At this late stage in the war, whenever an army stopped marching, they would immediately dig defensive trenches for protection. Battlefields, like the National Battlefield at Spotsylvania, were often transformed into treeless landscapes bordered by trench works.

The Battle at Spotsylvania Court House lasted two weeks. But it is best remembered for the assault made by Grant's troops on May 12 at a salient along the Confederate works known as the Mule Shoe. Seen as a weak spot in the Rebel defenses, the Mule Shoe protruded out from the main Confederate trench line, ripe for envelopment. It would come to be called the Bloody Angle.

In the predawn hours of May 12, 1864, 20,000 Union troops were hidden in the mist-shrouded tree line opposite the Confederate trenches at Spotsylvania. What transpired over the next 24 hours would be the longest and most savage battle of the Civil

Battlefield at Spotsylvania, Virginia

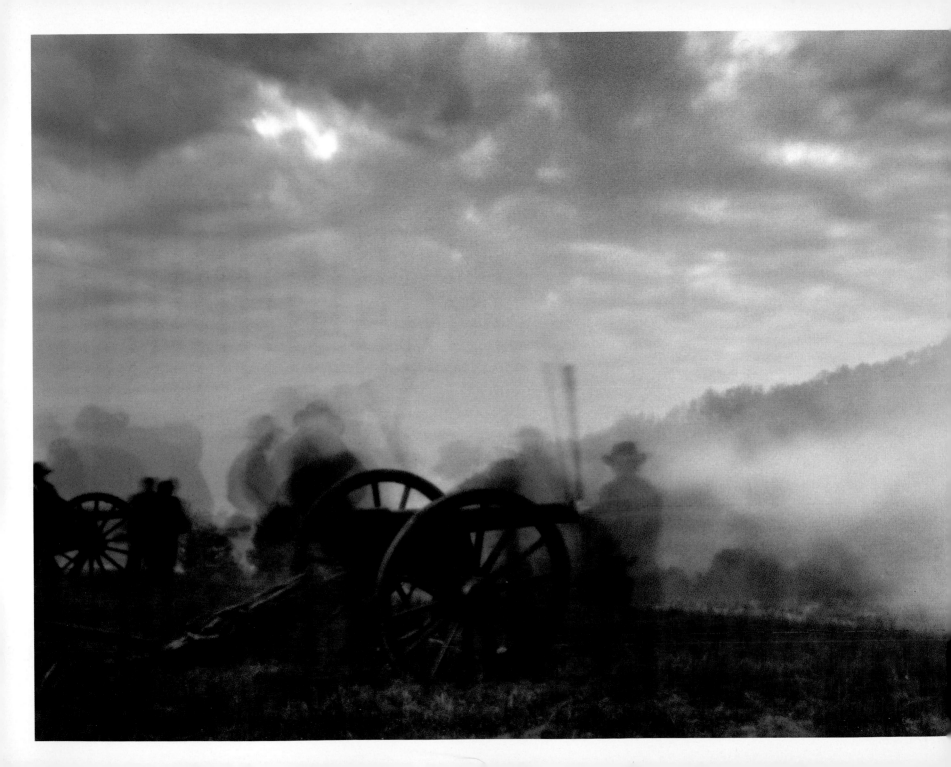

> 66 *The lines and colors of both armies stood waving within twenty feet of each other and there was a continuous roar and crash of musketry."*
>
> —Rufus Dawes

Reenactment at Spotsylvania Court House

War. The Union attackers engaged with the Confederates in a desperate hand-to-hand battle that left an appalling scene of carnage. Bodies of the dead and wounded were piled on top of each other; as a witness wrote, they were "exhibiting every ghastly phase of mutilation."

"Trees over a foot and a half in diameter were cut completely in two by the incessant musketry fire," wrote Confederate General John Gordon. "We had not only shot down an army, but also a forest."

In 2014, flowering dogwood trees dot the open space between the Confederate trench line and the forest where the Union attackers emerged. The battlefield is now a popular jogging and dog-walking area. The Mule Shoe and Confederate trenches at Spotsylvania are still plainly visible. The tree line that hid the attacking Union remains only a couple hundred yards from the trench remains.

In May 2014, reenactors gathered in Spotsylvania County to commemorate the bloody battle. Organizers had dug trenches across an empty field near the old courthouse. Jumping into the trenches with the Confederate reenactors, I had an unimpeded view of the attackers in Union blue as they coolly marched in battle lines toward us. Near a bulge in the trench line, reenactors engaged in hand-to-hand combat at their own Bloody Angle.

After initial Union success, the Battle at Spotsylvania devolved into another stalemate. Lee's defensive lines were too formidable and Grant again sought to find a way around the Confederates, disengaging his army from Spotsylvania and leading it to the next vital crossroads on the map, the North Anna River.

Fog shrouded tree line at Spotsylvaina

North Anna River

At this point, Lee was well aware of what Grant was up to. The North Anna River flows past the railroad crossing at Hanover Junction, Lee's main supply depot, and thus, a most crucial defensive line for the Confederates. Lee's troops dug extensive trenches and earthworks along the river bluff, and they hoped Grant would take the bait.

The Confederate position along the North Anna River took the shape of an inverted "U". Lee knew that Grant would have to split his forces to mount an attack, and prepared to seize the opportunity to destroy the two contingents piecemeal. Grant did what Lee thought he would do, but, realizing his predicament in time, Grant pulled his army back across the river in search of more productive ground to fight on.

Walking the North Anna Battlefield today, the reasons that events played out as they did are apparent. On the south side of the river, Confederate trenches still overlook the North Anna River. Rifle pits dug in along the steep bluff made crossing the river at Ox Ford a deadly endeavor. Union troops who crossed here were quickly caught in a trap. The bluff is entirely too steep to climb, and the assaulting Union troops had to re-cross the river under fire to escape.

I descended the bluff to the river's edge and marveled at how close and difficult the fighting must have been. Lee's brilliant defensive position would force Grant to again seek another route around the Confederates, leading to a place called Cold Harbor.

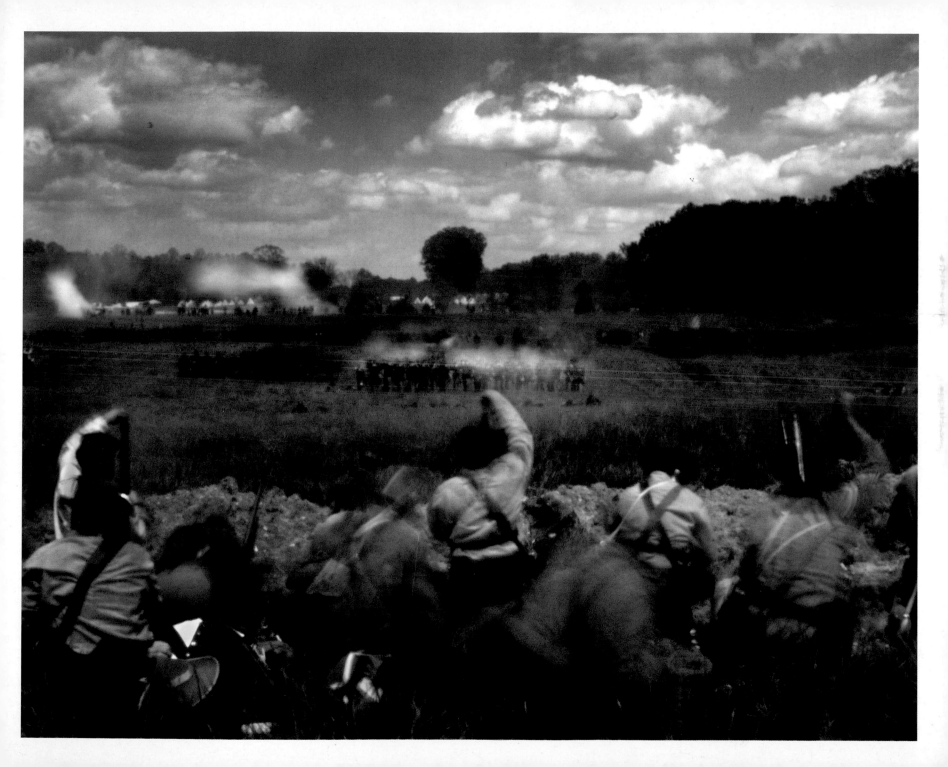

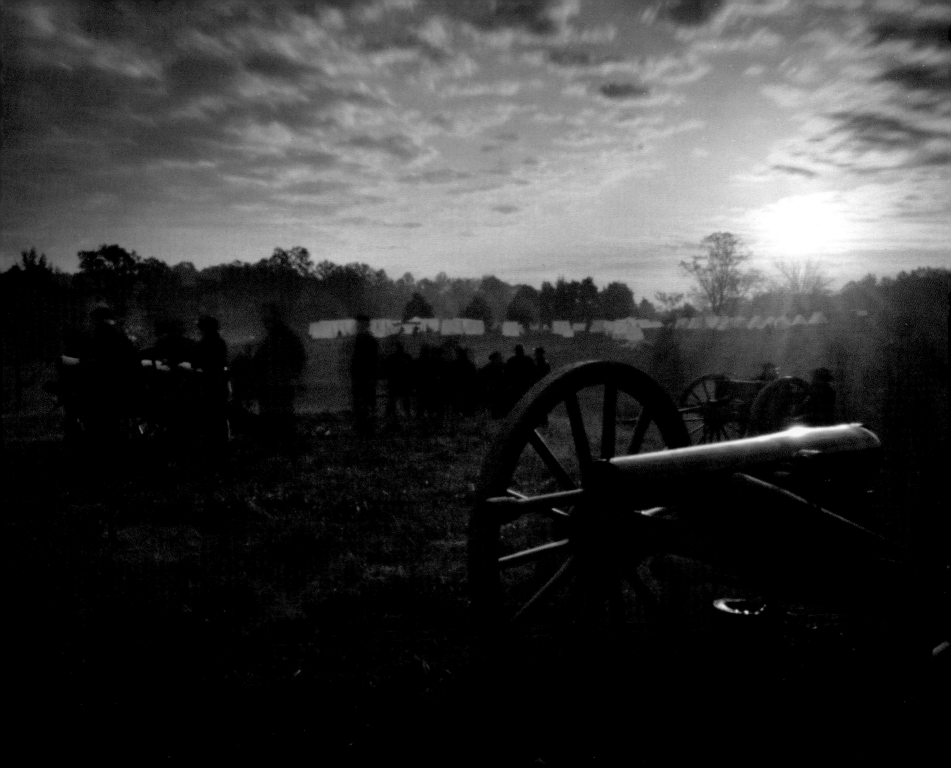

Cold Harbor

Cold Harbor has to be one of the spookiest Civil War battlefields in America. Entering the military park, you soon come upon ghostly mounds in the forest. They are the remains of Confederate trenches hastily built in late June 1864 to defend against Grant's maneuver south from the North Anna River.

Grant, believing the Confederates to be on their last legs, sent an overwhelming 50,000 troops to attack the Rebel lines here on June 3, 1864. Yet, in one of the most lopsided assaults in the war, the attacking Union force was stopped cold. Within the first hour of the engagement, the Union attackers found themselves hopelessly pinned down in front of the Rebel works. Twelve thousand Union soldiers were killed or wounded in the first hours of the battle, which Grant called off later that afternoon.

The attack would haunt Grant for the rest of his life. He was called a "butcher" when news of the Battle at Cold Harbor reached the North. Grant felt the criticism keenly.

"I have always regretted that the last assault at Cold Harbor was ever made," Grant wrote in his memoirs.

Strolling through the forest at Cold Harbor toward the Confederate trenches today, I was filled with foreboding. The Union soldiers that charged across this landscape knew they were most likely on a suicide mission. The evening before the attack, soldiers were seen sewing their names to the insides of their tunics so they could be identified on the field in case they were killed or mortally wounded: a grimly practical precursor of dog tags.

A full month of continuous combat in Virginia was taking a toll on both armies. After the disastrous assault on June 3rd, many Union soldiers simply refused to renew the attack at Cold Harbor. Stymied once again, Grant would keep a portion of his army in place at Cold Harbor, but he would also move the rest of his battered force south toward the James River in hopes of outflanking his enemy.

Reaching the river, Grant ordered his troops to cross the James and march 35 miles at a swift pace in hopes of capturing the city of Petersburg, Virginia. Thus would end the Overland Campaign and begin the Siege of Petersburg.

PREVIOUS: *Totopotomy Creek Battlefield (left);*
Reenactment at Spotsylvania Court House (right)

NEXT: *Hanover Junction and North Anna River (154-155)*

Atlanta

Looking east from Lookout Mountain in Chattanooga, Tennessee, you will see the mountain ranges seem to go on and on. General William Tecumseh Sherman took in this view in the spring of 1864 and began to prepare his army for its next campaign.

Sherman had his sights set on the last industrial hub left of the Confederacy: the city of Atlanta. But before laying siege to the city, Sherman and his troops would have to march 100 miles through the vast wilderness of northwest Georgia. It was called Cherokee Country back then because, only 30 years earlier, that's exactly what it was.

The mountainous region today looks much like it did 150 years ago. When one of Sherman's soldiers from Illinois—the second flattest state in the Union—first beheld the mountains, he said:

"I think God Almighty might have made the world in four days if he had not ruffed it up so."

Sherman would confront General Joseph E. Johnston and the Army of Tennessee in a war of mobility. Unlike the stagnant trench warfare awaiting Grant's troops around Petersburg, Virginia, Sherman's campaign through Georgia would be a series of flanking maneuvers using his superior numbers to hold the Confederates in their mountain strongholds while moving a portion of his army around the enemy's flanks. He would eventually force the enemy to retreat all 100 miles back to the gates of Atlanta.

The Atlanta Campaign was the testing ground for a new tactic that Generals Sherman and Grant had devised. Sherman would lead his men deep into enemy territory, cut off from Union supplies and communications. They would live off the land.

Battlefield at Resaca, Georgia

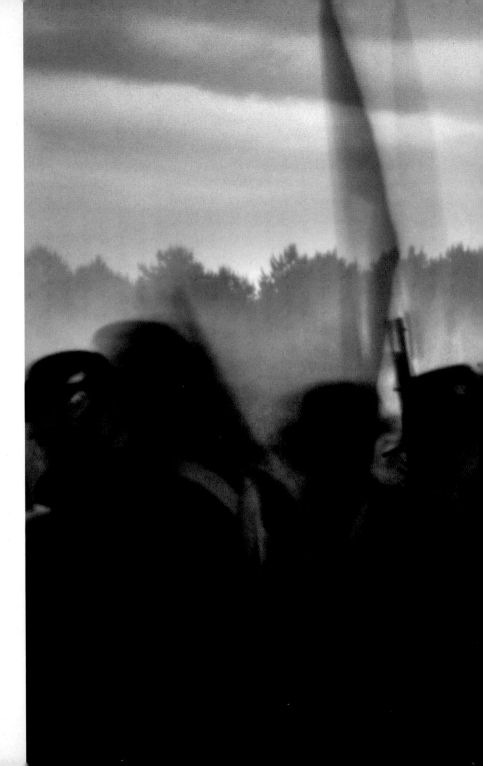

"Georgia has a million of inhabitants. If they can live, we should not starve. If the enemy interrupt our communications, I will be absolved from all obligations to subsist on our own resources, and will feel perfectly justified in taking whatever and wherever we can find."

Sherman would strip his lean army bare for the campaign. Ammunition and supplies were loaded on wagons. Soldiers were ordered to leave their tents behind, and sleep on the ground under minimal tent flies.

It was what would come to be called Sherman's "total war strategy," bringing the war to the South's homesteads and the womenfolk who had tended them in the absence of their husbands, sons, and fathers. He would teach them that war was hell and break the spirit that had sustained the armies in the field.

The campaign followed the course of the Western/Atlanta Railroad that runs from Chattanooga to Atlanta. That railroad bed is still in use today. If you follow its course across Northwest Georgia, you'll see that nearly all the battle sites associated with the campaign can be found in a band along the tracks that continue to move freight between the two cities today.

Climbing Rocky Face Ridge near Dalton, Georgia, I explored Dug Gap, one of the many mountain passes defended by the Confederates in the campaign. A makeshift wall of boulders still lines the crest of the mountain, erected here by the Confederates who successfully defended the gap in May 1864. The mountain is covered in dense forests and giant rock formations, typical of the difficult terrain Sherman's troops would have had to contend with.

The two opposing armies met first at Rocky Face Mountain outside of Dalton. The steep, sheer rock at its summit, laced with defensive trenches, earthworks, boulder traps, and Rebel artillery, made a direct assault impossible. Sherman would instead seek to outflank the stronghold.

Engaging the Confederates at its base, Sherman ordered a portion of his army to surround the mountain, causing the Confederates to retreat eastward.

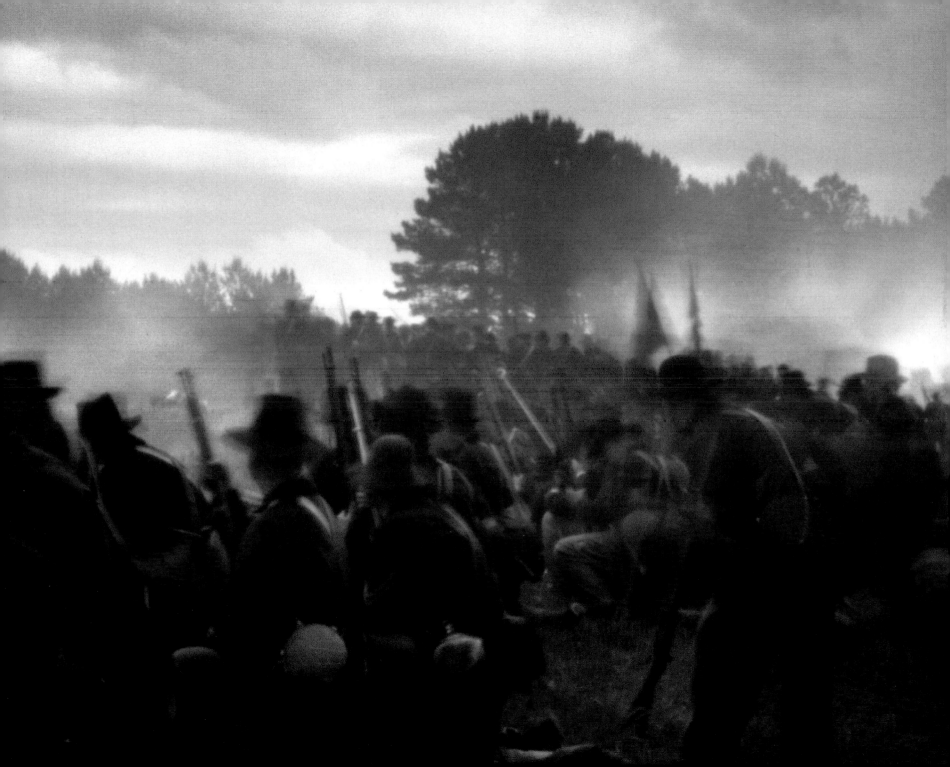

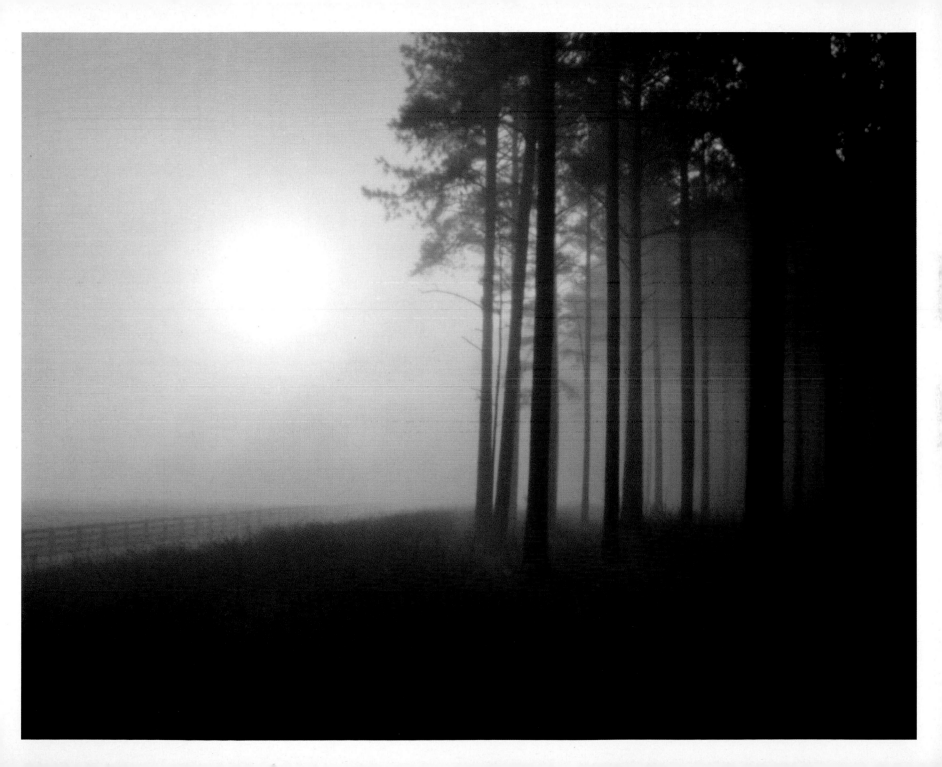

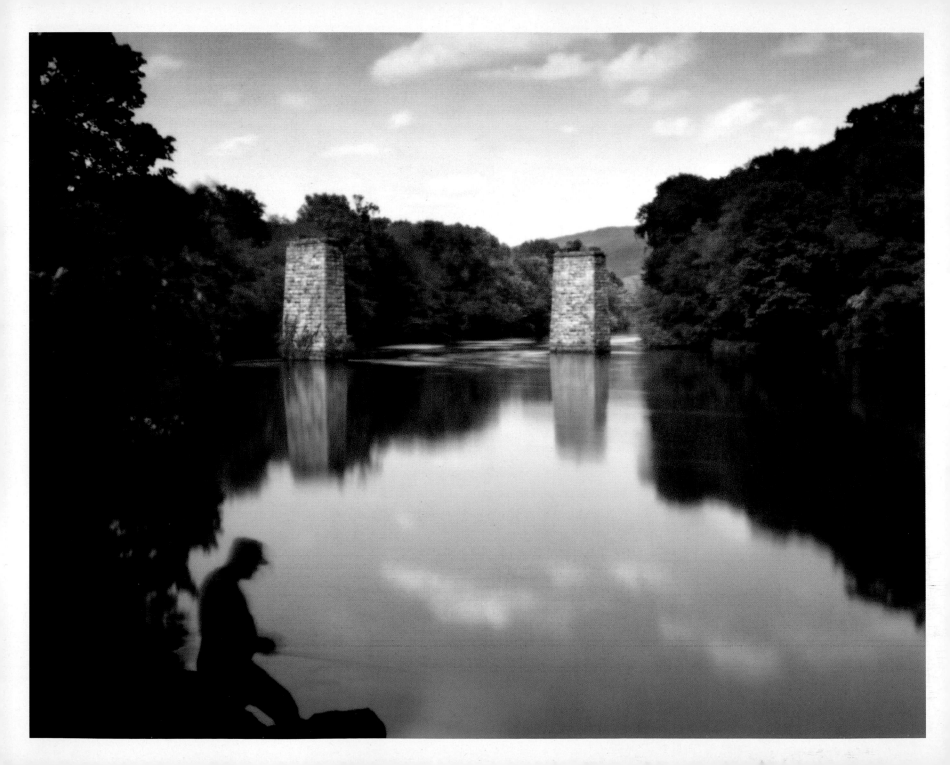

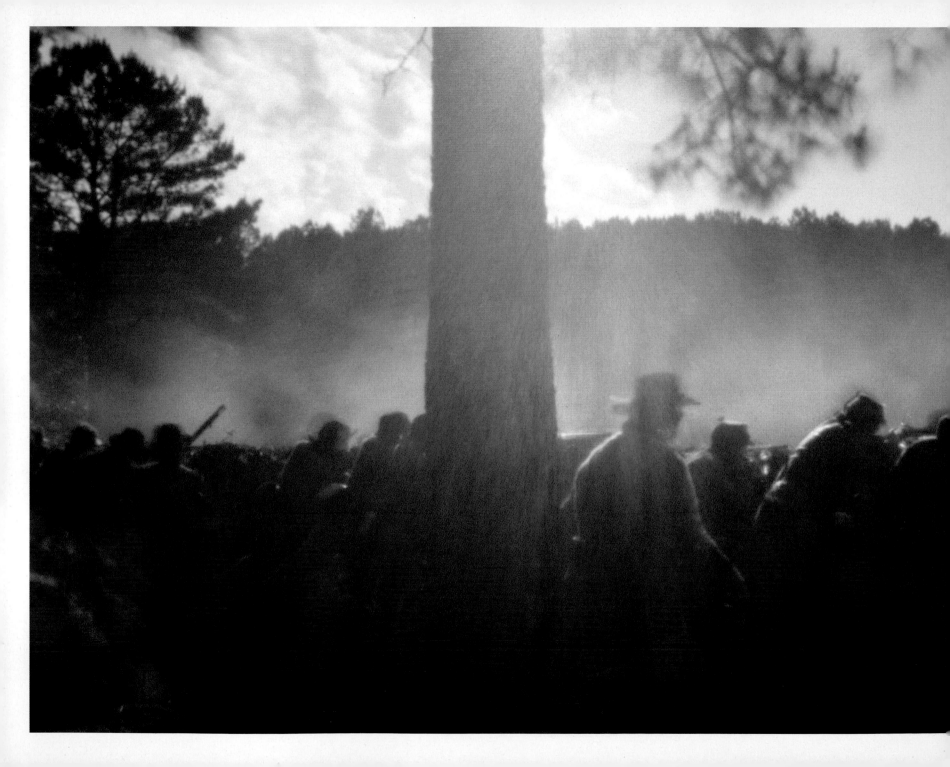

Following the railroad, the armies next engaged at Tunnel Hill. The railroad tunnel here, constructed in the mid-1800s, is still the longest rail tunnel in the South and was captured intact by Sherman's troops. The cold, leaky tunnel is now a tourist attraction.

The two armies had their first stand-up engagement near the town of Resaca, Georgia. Today the Battlefield at Resaca is preserved in its original state and is one of a number of Civil War battlefields in the country held in private hands. As such, the 150th anniversary reenactment played out on the very ground the soldiers fought on in 1864.

The battlefield is a series of wild-grass lined hills broken by stands of pine forests, with a still-active railroad track at its eastern edge. Recalling their ancestors' fierce defense, Confederate reenactors were permitted to construct earthworks on the old battlefield. Those thousands of reenactors, engaged in a number of battle scenarios, slept in the nearby woods.

I joined Union reenactors in the impression of the 70th Indiana Volunteer Regiment in their forest bivouac, where they were sleeping, per Sherman's original orders, under tent flies. It rained that weekend, and a muddy trail leading from the camp to the fields bore hundreds of boot prints.

In 1864, the 70th Indiana was under the command of Col. Benjamin Harrison, who would serve as the 23rd president of the United States. I followed this unit as a reenactor. Jim Butler, in the impression of Harrison, led a famous charge to capture a four-gun battery held by the Confederates at Resaca.

Crossing the field in 2014, the soldiers methodically marched "under fire," capturing an earthwork 100 feet from the battery.

Butler called out as he mounted the earthwork, "Men of Indiana, are you ready?"

He was answered with an enormous "hurrah," as the Indianans scrambled over the gun emplacement and claimed the battery.

PREVIOUS: *Etowah River (left); Allatoona Deep Cut (right)*

LEFT: *Reenactment at Resaca, Georgia*

The battle ended on May 15, 1864. As Sherman's troops continued to press east, the Confederates slowed them by burning a bridge over the Etowah River. The buttresses of that bridge still sit in the slow-moving waters of the Etowah, which is now a popular fishing hole.

The last big obstacle Sherman and his troops would have to confront before reaching Atlanta was Kennesaw Mountain. Johnston had turned the mountain into a vast stronghold. Viewed from the west on modern Route 41, Kennesaw still looms over the landscape. Today Kennesaw Mountain Battlefield Park is a popular area for joggers and hikers willing to brave the steep mountain trails, passing the remains of rifle pits and trenches dug by the Confederate defenders in 1864.

Sherman ordered a number of frontal assaults on the Confederate entrenchments at Kennesaw Mountain, all of which were repelled, with heavy losses on the Union side.

"They seemed to walk up and take death as coolly as if they were automatic or wooden men, and our boys did not shoot for the fun of the thing," wrote Sam Watkins, a Confederate memoirist, who was in the trenches at Kennesaw Mountain.

Between June 18 and July 2, 1864, the Confederates lost 800 soldiers; the Union, 3,000. Nonetheless, in the face of Sherman's flanking movements, the Confederates were forced to retreat from Kennesaw toward their defenses surrounding Atlanta. The view from Kennesaw's summit today, as in 1864, is unimpeded when one is looking west out over the Etowah Valley. Looking east from here, Sherman got his first glimpse of his ultimate objective: the city of Atlanta, twenty miles away.

But Sherman's troops still needed to cross the Chattahoochee River. Heavily defended by the Confederates, Sherman once again succeeded in outflanking his foe. Finally reaching the outskirts of the city, Sherman and his troops were confronted with the city's massive earthwork defenses. Sherman ordered his troops to dig in and began siege operations with daily bombardment of the city.

"The pick and spade followed the musket so closely," recalled Union Sgt. Lyman Widney, "that within an hour we saw long lines of fresh clay marking the new position and already challenging the enemy to come forth and try their efficiency."

Confederate General Johnston was relieved from duty after his failure to stop Sherman at the Chattahoochie; his replacement was General John B Hood. Missing an arm from Gettysburg and a leg from Chickamauga, Hood was an aggressive commander and promised the Confederate authorities that he would crush Sherman.

Hood did engage Sherman in a number of costly battles around Atlanta, but all ended in defeat. Nevertheless, the fury of those Confederate attacks convinced Sherman that another flanking movement was in order. Dispatching a large portion of his army south, Sherman led his troops in the Battle of Jonesboro east of the city, routing the last Confederate forces there.

On September 2, 1864, after five months of campaigning, the city was surrendered.

"So Atlanta is ours, and fairly won," Sherman reported to Washington.

Sherman's troops entered the city, securing it as a base of operations. They would occupy the city for two months, refitting and preparing for their next campaign, Sherman's March to the Sea, the campaign that would make him famous. He left behind a city in ruins and in flames.

As Sherman would write in a congratulatory order to his troops after they arrived in Savannah, "We quietly and deliberately destroyed Atlanta."

Kennesaw Mountain, Georgia, 20 miles northwest of Atlanta

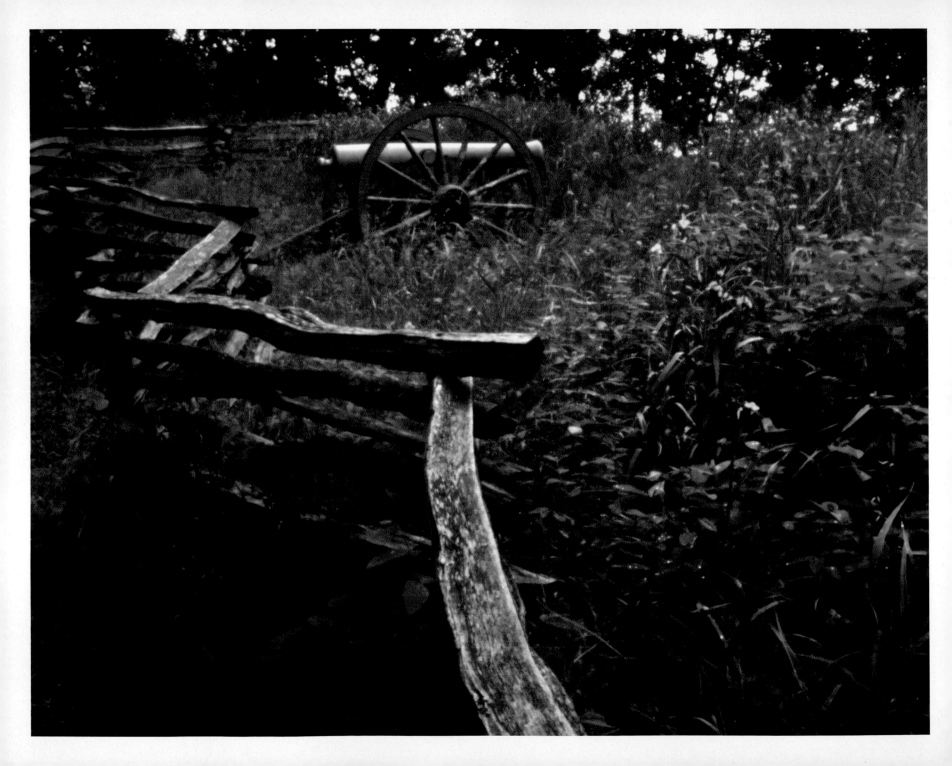

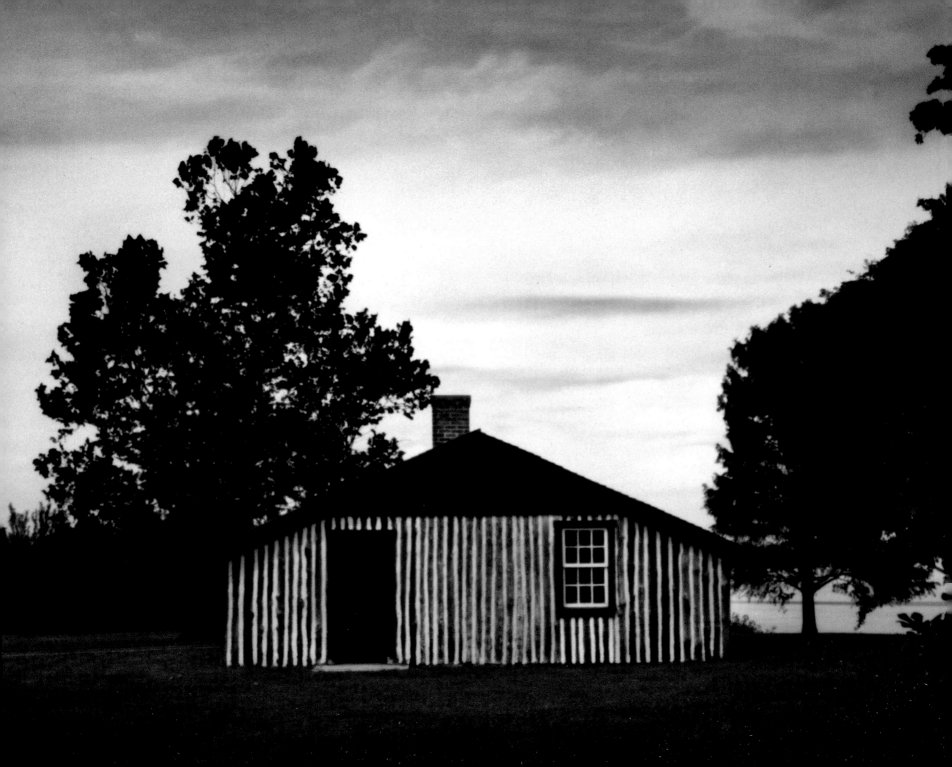

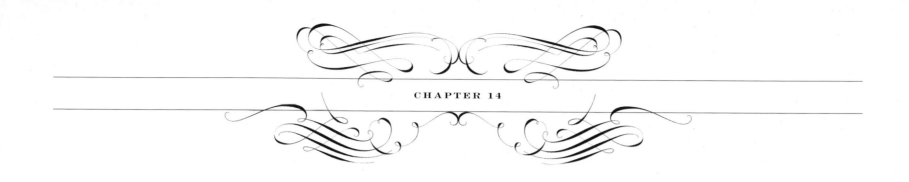

The Siege of Petersburg

Walking through the woods on the National Battlefield at Petersburg in September 2014, I was stopped in my tracks by a curious sound. Standing amid the old earthworks from the battle in 1864, I heard the mournful melody of a soldier's bugle emanating from the forest. It was coming from Fort Lee, an active Army base near the battlefield. But, to my ear, it was a sesquicentennial echo.

In June 1864, Ulysses S. Grant and the Union Army rushed to the outskirts of the lightly defended city of Petersburg, hoping to capture the vital railroad hub. After a month-long slog through Virginia in the Overland Campaign, Grant's soldiers had little stomach for assaulting the defenses around the city. Their initial attempt was unsuccessful and would lead to the longest siege in American history.

That same month, Robert E. Lee had warned his subordinate commanders that Grant's army would need to be destroyed before it reached the James River. If Grant's soldiers crossed the river, Lee surmised they would lay siege to Petersburg and it would be only a matter of time before the Confederates ran out of resources.

Since May, Lee and the Army of Northern Virginia had managed to stymie Grant's superior force in the Overland Campaign, but the attrition of a solid month of fighting had physically worn the Rebel force down, eroding their morale.

Despite Lee's brilliant defense in the four major battles of the campaign, his army was still outnumbered and the Federals were at the doorstep of the Confederate capital of Richmond. Lee had stopped Grant six miles outside the city, at Cold Harbor, but his

Grant's headquarters at City Point, Virginia

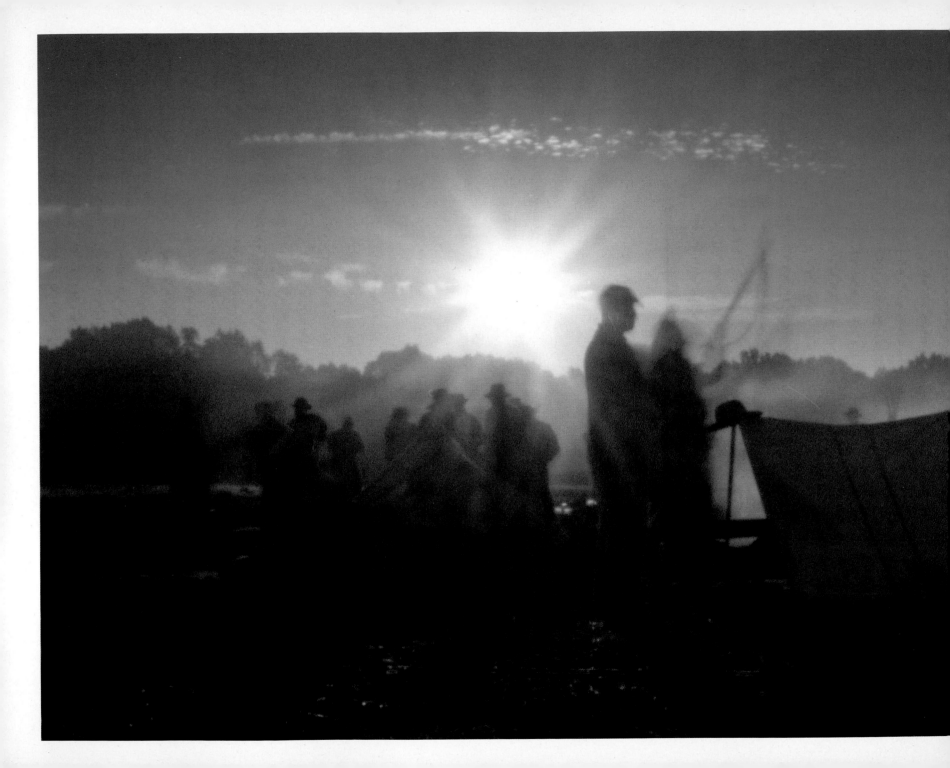

soldiers were low on supplies and lacking reinforcements. The Confederate commander's apprehension about Grant's intentions would prove correct.

On the evening of June 14, thirty miles east of Cold Harbor, Union engineers began construction of what would be the longest pontoon bridge in military history. Erected in just eight hours, using ships anchored in the James River as supports, the 2,200-foot span was a military marvel. By June 17, still unbeknownst to the Confederates, the Federals stealthily crossed the river with 100,000 troops, 5,000 wagons and 2,800 head of cattle. Union troops were marching toward Petersburg.

For the first time since the fighting began in May, Grant had truly stolen a march on Lee. Seeking to capitalize on his advantage, Grant rushed his troops toward Petersburg, hoping to seize the city before Lee could send reinforcements. But it was not to be. Wearied by a solid month of combat, the Union soldiers would surround and seek to starve out the city rather than engage in a bloody head-on assault.

Today parts of Petersburg still resemble what the city looked like during the Civil War. Eighteenth-century warehouses and row houses dominate a historic district in the old downtown. Old mills dot the Appomattox River, which flows past Pocahontas Island, considered the oldest free-black community in America. Steven Spielberg used Petersburg as a backdrop for his film *Lincoln*. Simply covering the streets with sawdust was enough to convincingly make the city appear as it would have looked 150 years ago.

Unlike the city of Petersburg, the National Battlefield outside the city looks nothing like it did in 1864. During the ten-month siege, the city was surrounded by an incredible thirty-five miles of trench works.

NEXT: *Confederate trench at Petersburg*

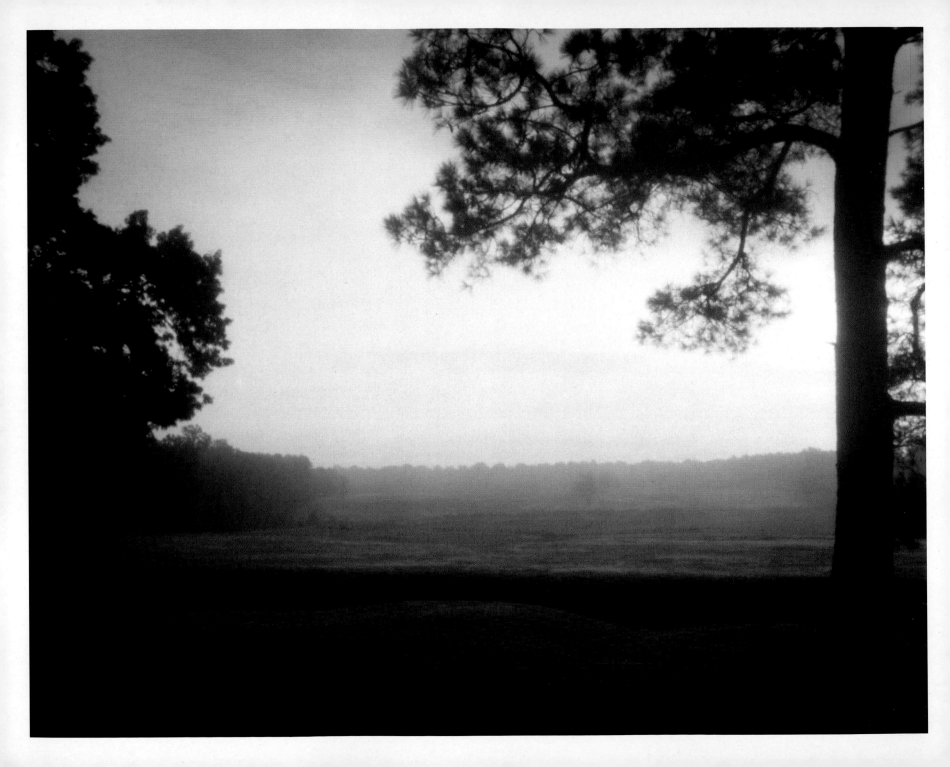

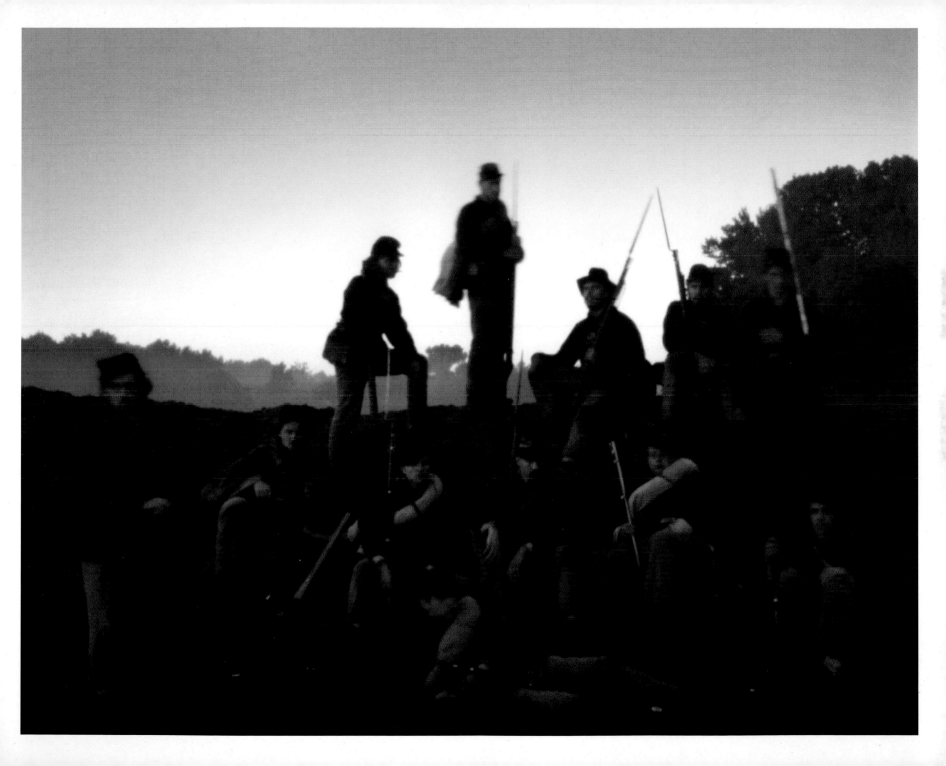

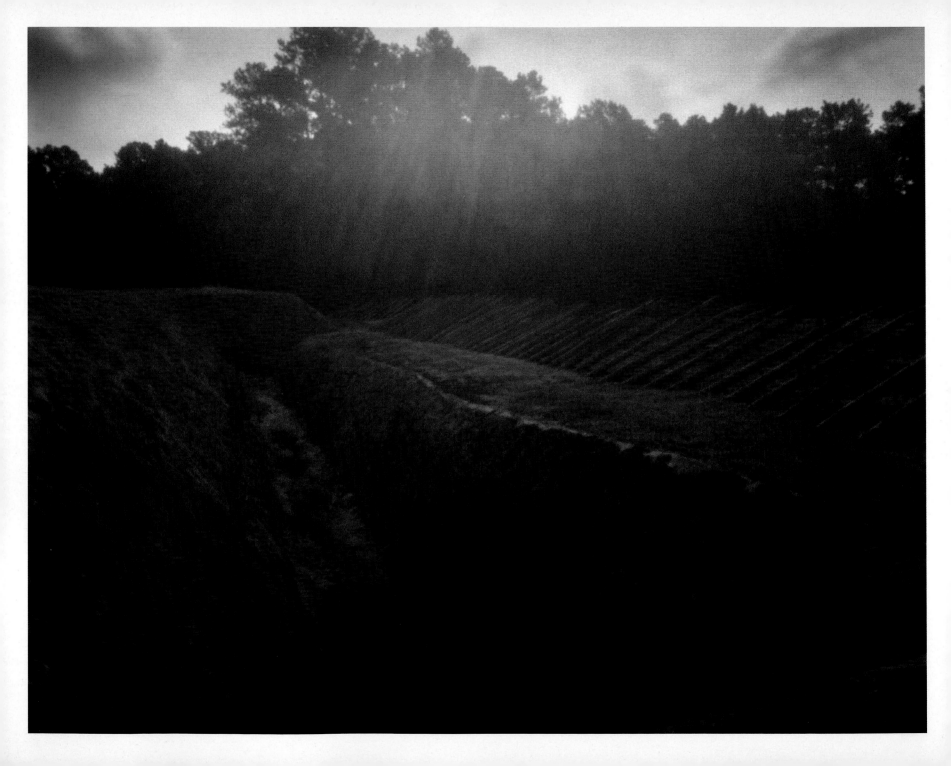

" *Oh, Lord, we are having a mighty big fight down here, and a sight of trouble; and we do hope, Lord, that you will take a proper view of this subject, and give us the victory.*"

—Confederate soldier

PREVIOUS: *Reconstructed trench at Pamplin Historical Park, Petersburg (left); Downtown Petersburg (right)*

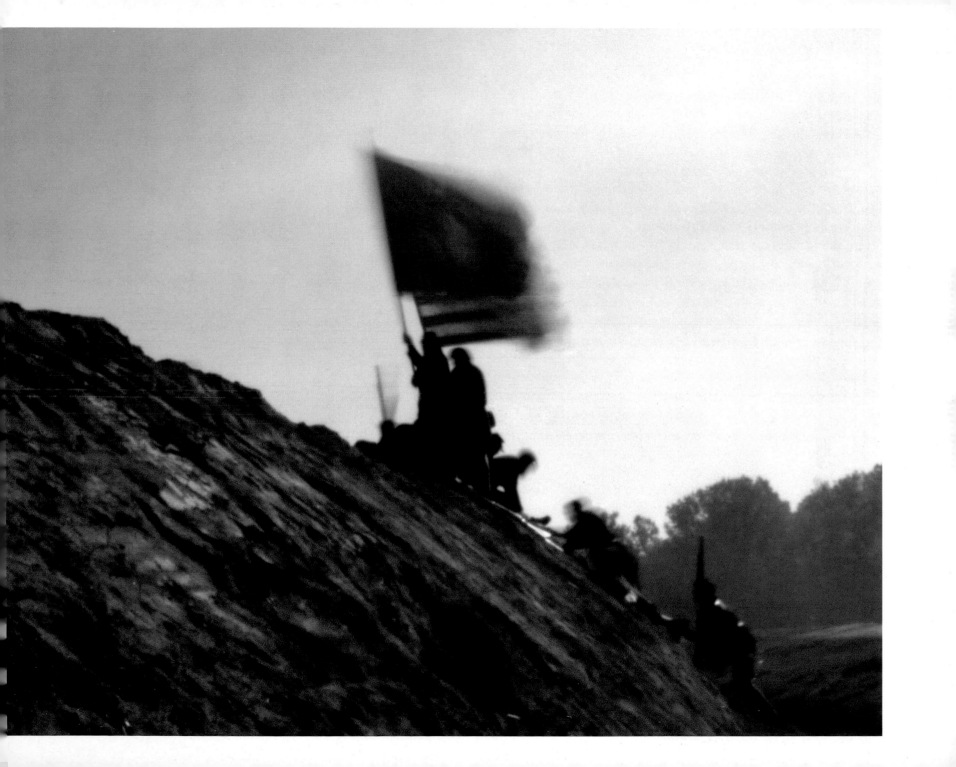

Those Union troops would find themselves trapped in the crater they had created, engaged in vicious hand-to-hand combat with the remaining Confederate defenders. After the initial shock of the blast, Confederate troops swarmed toward the crater, pinning the Federals down. The next few hours would see some of the most brutal fighting of the Civil War.

A witness to the debacle, Colonel Stephen M. Weld of the 56th Massachusetts Regiment, wrote,

"Here, in the crater, was a confused mob of men continually increasing by fresh arrivals. Of course, nothing could be seen from this crater of the situation of affairs around us. Any attempt to move forward from this crater was absolutely hopeless."

Major William H. Etheredge, commanding the 41st Virginia Regiment wrote,

"We pushed to the front, and reaching the ditch, in we went with empty muskets, depending on the bayonet and breach of the gun, and a regular hand to hand encounter took place. The scene that follows beggars description: our men would drive the bayonet into one man, pull it out, turn and butt and knock the brains out of another, and so on until the ditch ran with blood of the dead and dying."

The Union forces, thousands of casualties later, were eventually repelled in the attack.

"It was the saddest affair I have witnessed in the war," Grant wrote in his report to the chief of staff, Major General Henry Halleck.

The Crater, a tourist attraction in the days after the Civil War, today bears no trace of the carnage. It is merely a depression along the Confederate trench works, its walls now lined with grass, its perimeter trimmed with trees. Just a hundred yards away, the National Park Service has reconstructed the entrance to the mine shaft to give visitors a vivid sense of how close the fighting was at Petersburg.

The failure to break through at the Battle of the Crater forced Grant to return to his siege strategy. Union troops would continue to envelop Petersburg. With winter's approach, the two stalemated armies settled in for a long, cold winter in the trenches. Amid the winter quiet on the Petersburg front, on January 29, 1865, hard by the remains of the Crater, a white flag appeared on the Rebel parapet. A Confederate messenger crossed no-man's-land to deliver a letter to Grant. A group of Confederate Peace Commissioners was there to talk with Lincoln about a possible negotiated peace and end to the war.

The troops of both armies at Petersburg stood at the top of their trenches and cheered as the carriage of Confederate negotiators made its way across the pockmarked battleground toward Grant's headquarters at City Point, Virginia. But Lincoln was not as hopeful as the tired soldiers entrenched at Petersburg.

"Let nothing which is transpiring change, hinder, or delay your military movements or plans," Lincoln wrote Grant.

The peace conference proved a failure, and the commanders of both armies at Petersburg began to plan their spring offensives.

Fort Gregg, Petersburg, Virginia

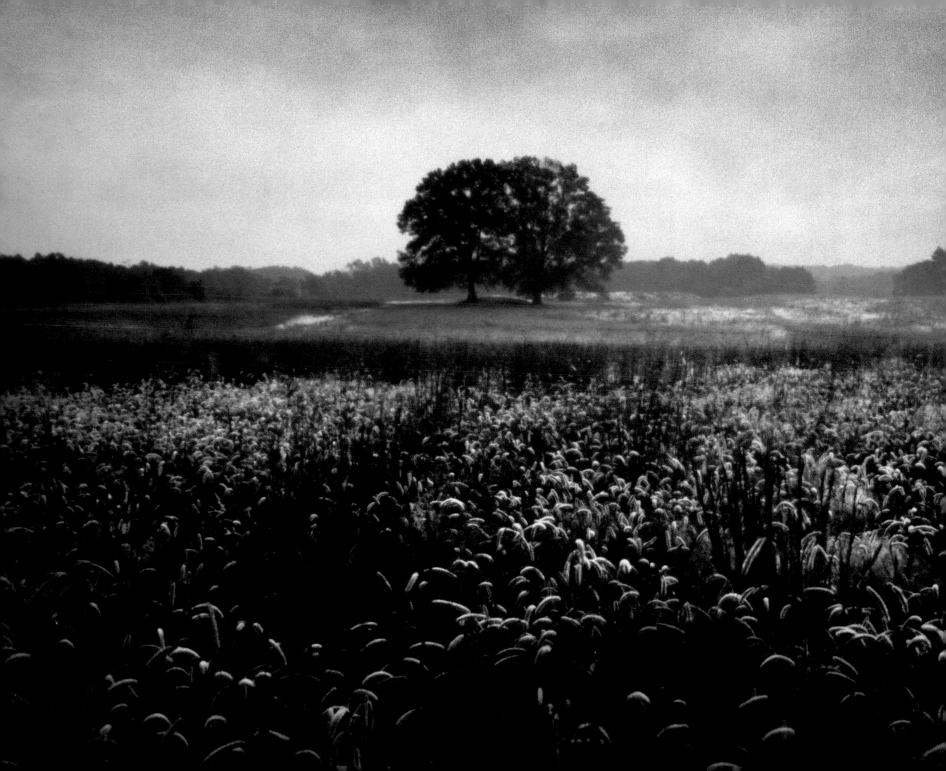

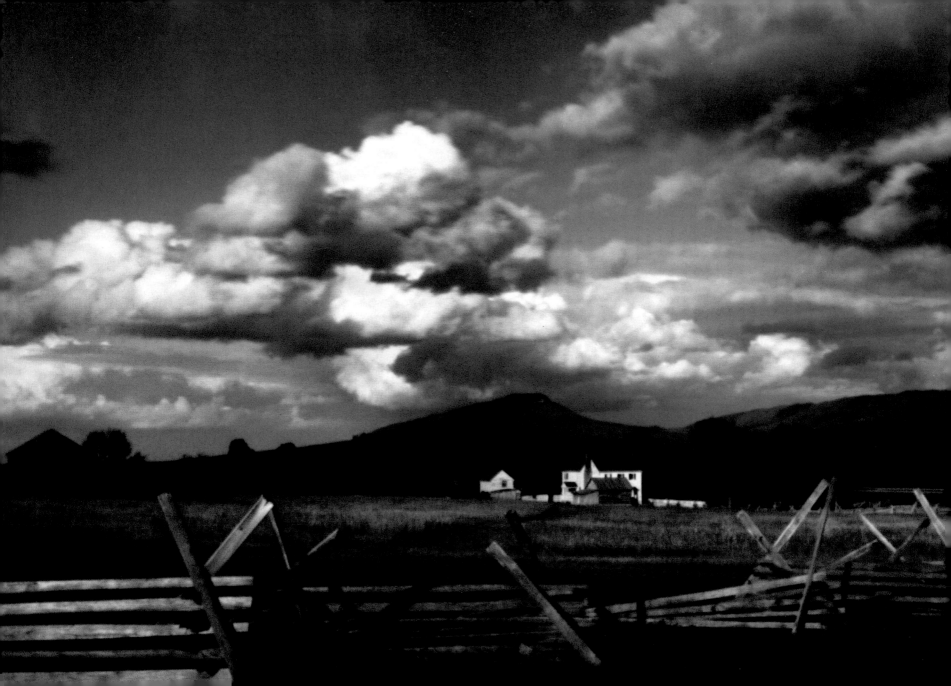

Shenandoah Valley 1864

Standing on the heights at Signal Knob in Shenandoah National Park, you can clearly see the rolling fields of the Belle Grove Plantation twenty miles to the west. In the fall of 1864, Confederate General John Gordon, reconnoitering from Signal Knob, took in this same view and glimpsed an opportunity for his beleaguered soldiers.

The fields of Belle Grove were dotted with the tents of 30,000 unsuspecting Union soldiers. Gordon and the Confederates, by sheer will and with few supplies, had regrouped from their recent defeats in the valley and were poised to deliver a knockout blow to the enemy. Through the night of October 18, Gordon secretly led his men through the mountains and then surprised the Union encampment at Belle Grove in a predawn attack, rousing

the Union soldiers in the fog-shrouded morning with a blood-curdling Rebel Yell.

"They sprang from their beds to find Confederate bayonets at their breasts," Gordon wrote.

By 9:00 am, the Battle of Cedar Creek seemed to be all but over, with the Confederates enjoying the hot breakfasts left behind by the retreating Federals. But by mid-afternoon, victory had turned to devastating defeat, as Union General Phil Sheridan, in his famous ride from Winchester, reorganized and rallied the routed Federals and turned the tide for the Union.

"Other days during our war witnessed a brilliant triumph or a crushing defeat for the one army or the other; but no other single day saw each of the contending armies victorious and vanquished

Battlefield at New Market, Virginia

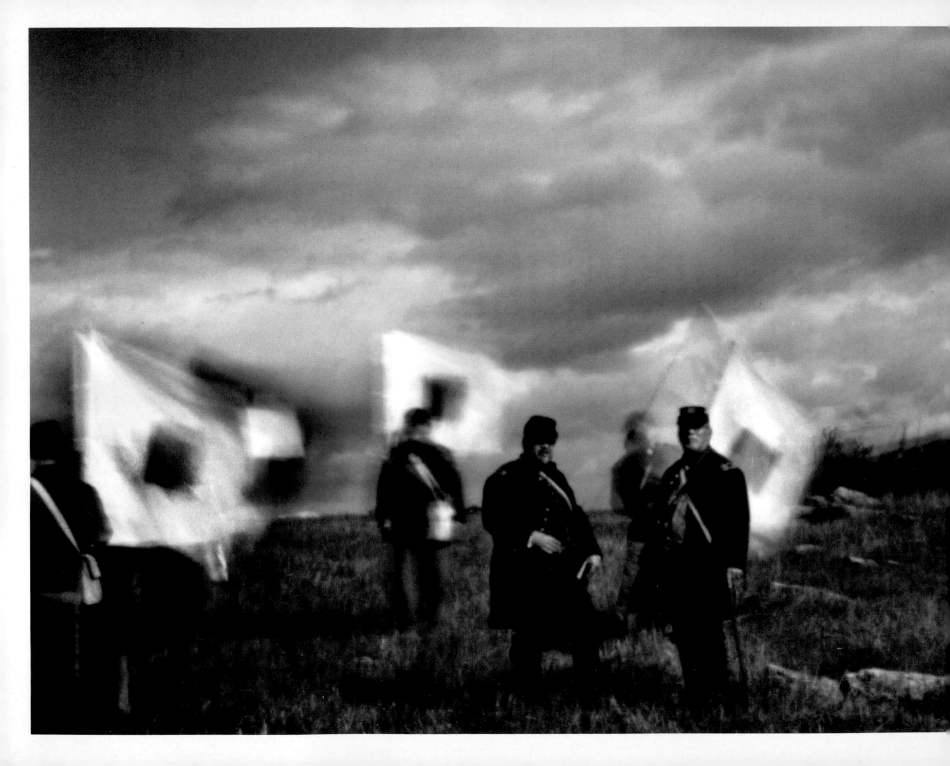

on the same field and between the rising and setting of the same sun," Gordon wrote.

The Battle of Cedar Creek on October 19 was one of three major battles won by the Union in the valley in 1864. The battles of Third Winchester, Fisher's Hill and Cedar Creek were all devastating defeats for the Confederacy that finally shut down Rebel operations in the Shenandoah Valley.

I returned to this region of Virginia in October 2014 to attend a reenactment at Belle Grove Plantation. Over the commemorative weekend, thousands of reenactors set up their regimental camps at Belle Grove and lined the banks of Cedar Creek. Having traveled to this part of Virginia in 2012, I was glad to return to its lush beauty. Trees along the mountain elevations were beginning to turn color, the hayfields were cut, and late-season corn could be seen growing along the old Valley Pike. Fog hung thick in the windy mountain gaps along the Skyline Drive in Shenandoah National Park, the views of the valley below coming and going with the passing of clouds.

The valley's topography lent itself to a different kind of warfare than the claustrophobic clinches of earthworks and trenches around Petersburg. The battles in the wide-open spaces of the valley in 1864 would be "stand-up" fights attended by thundering cavalry charges.

The sheer abundance of the Shenandoah Valley made it a prize both armies coveted. In 1864, Sheridan arrived in the valley with 35,000 Union troops under orders from Grant to follow the Confederates to their death and destroy anything of value in the valley. Unlike prior campaigns, the Union commander would select a strong force of veteran soldiers to accompany Sheridan

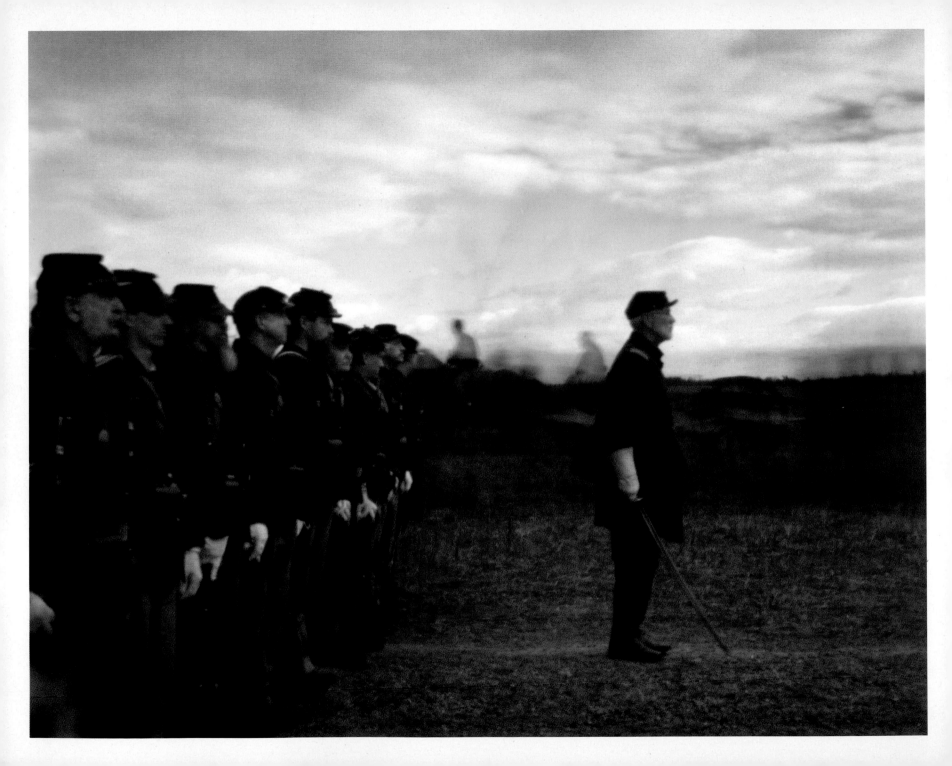

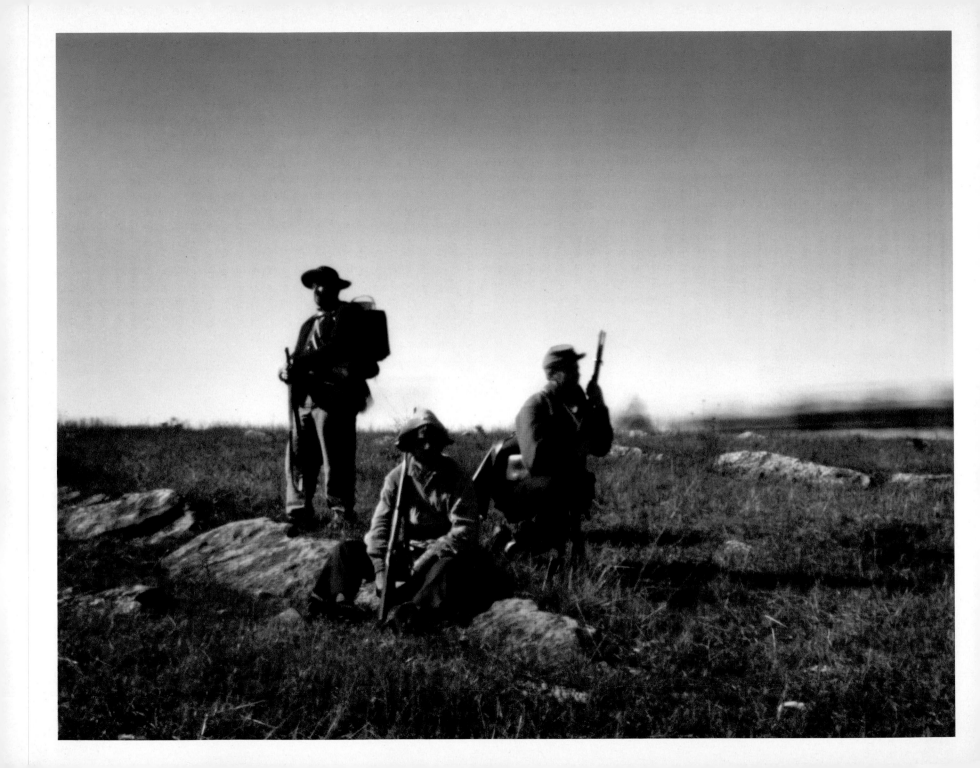

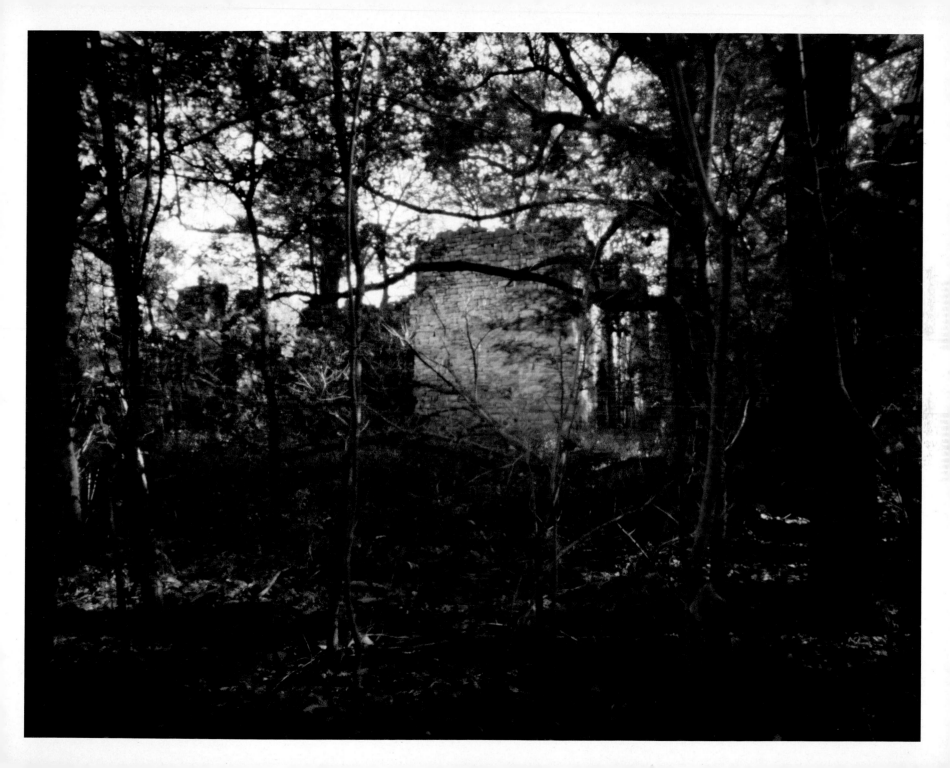

Today, working farms and dramatic mountain views surround Fisher's Hill as they did 150 years ago. I watched as warm morning light crawled across this historic landscape with a faint hum of traffic coming from the nearby Valley Pike.

The Confederates were pressed in their retreat from Fisher's Hill south along the Valley Pike. Harassed by Union cavalry during the entire sixty-mile march to Harrisonburg, the Confederates were forced into desperate rearguard actions along the way as Early sought to save his soldiers from complete destruction.

Near Harrisonburg, the two armies would skirmish around the old battlefields of Cross Keys and Port Republic. Dispersing the remaining Confederate forces, Sheridan led his victorious troops north to complete the second half of his mission in the valley: the wholesale destruction of anything and everything of value.

Marching back toward Winchester, Sheridan would put the Shenandoah Valley to the torch, knowing that, in so doing, he would not have to utterly defeat the Shenandoah Confederates in combat. By destroying everything of worth in the valley, he would deny its value to the Confederacy. Without crops and livestock, the valley would be useless to them.

In their march, Sheridan's troops burned 2,000 barns and 70 mills. They took with them 4,000 cattle and 3,000 sheep, appropriated from the valley's farms. Columns of dark smoke filled the horizon as Sheridan's troops laid waste to the region. It was, as citizens of the valley came to call it, "The Burning."

The skeletal remains of some of the charred mills Sheridan's army left behind can still be found in the valley today. Along Cedar Creek, there is what's left of Stickley Mill, overgrown with a tangle of trees and brambles, looking like a medieval ruin in the forest.

By the fall of 1864, believing the campaign all but over, Sheridan put his soldiers in camp around Cedar Creek and took up residence in Winchester. Sheridan was planning on joining Grant in the fighting around Petersburg when, on the morning of October 19, he was roused from his bed by the sounds of cannon fire. Sheridan swiftly mounted his horse and rode pell-mell toward Cedar Creek, where he was greeted by retreating throngs of his soldiers. By mid-afternoon, Sheridan had his army in hand and led a devastating counterattack on the Confederates, utterly routing them and making their defeat complete, leaving the Shenandoah Valley in Union hands for the rest of the war.

In the early morning hours of October 19, 2014, Union reenactors formed a Grand Review. Arrayed along the hilly fields, more than a thousand infantrymen, artillerists, and cavalry troops wearing white gloves stood at attention as their commander reviewed them before the battle reenactment.

Later, in the smoky aftermath of the battle, I came upon a young Confederate reenactor with his hands up, surrendering to a fellow reenactor in Union blue. The Confederate, Doug Camper, had tears in his eyes as the Union soldier grabbed him

PREVIOUS: *Ruins of the Stickley Mill, Middleton, Virginia*

RIGHT: *Reenactment at Cedar Creek Battlefield*

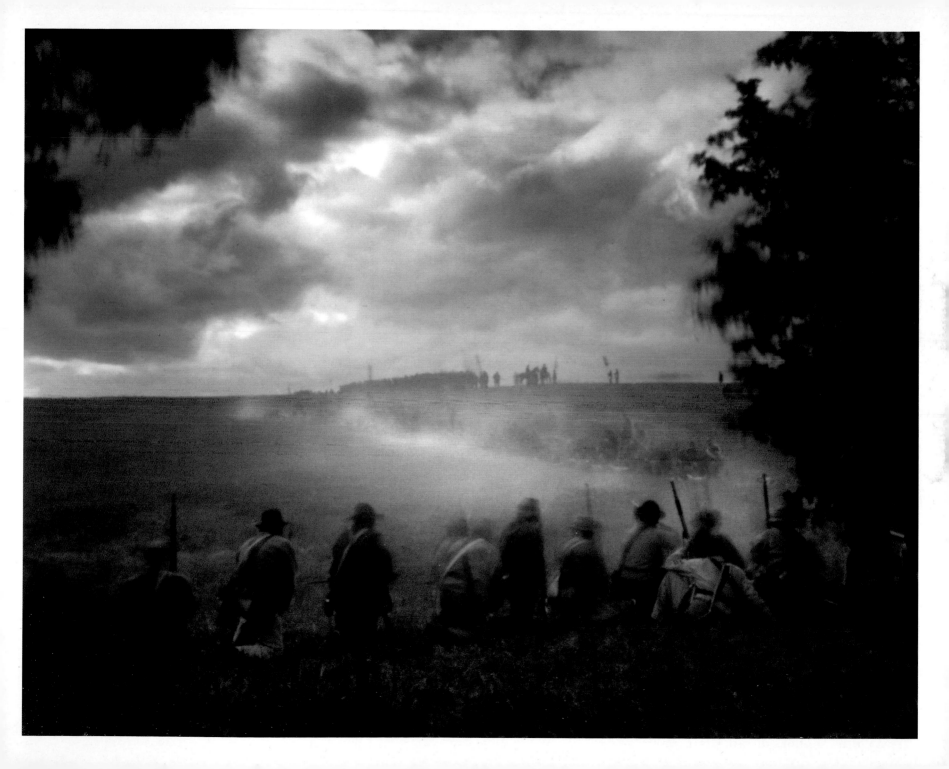

by the scruff of his collar and took his rifle. Camper explained to me that his great-great grandfather, serving with the Confederate Army in the Shenandoah, had surrendered at the Battle of Cedar Creek, and, 150 years later, he felt compelled to do so as well.

The sun sets golden over the Belle Grove plantation 150 years after this seminal event. The spectators go home, the reenactors go back to the camps, and the wind blows across the now-empty battlefield of Cedar Creek.

General Gordon was right when he wrote, after the war:

> 66 *The sun in his circuit shines on few lovelier landscapes than that of Cedar Creek in the Valley of Virginia."*
>
> —General John B. Gordan

Heater House, Cedar Creek Battlefield

March to the Sea

On November 15, 1864, William Tecumseh Sherman left Atlanta with 62,000 soldiers and began to march toward the sea. The City of Atlanta, Sherman's base of operations for the preceding two months, was still burning and lay in ruins. The Burning of Atlanta would make Sherman the most hated man in the South during the Civil War.

Sherman set out to deny the Southern citizenry the resources they would need to survive. After all, according to the Union commander, they kept the Confederate armies supplied and fighting. In his campaign through Georgia, Sherman would bring the war home and "make old and young, rich and poor, feel the hard hand of war."

"Until we can repopulate Georgia it is useless to occupy it, but utter destruction of its roads, houses, and people will cripple their military resources," Sherman wrote Grant in a telegram from just outside Atlanta on October 9. "I can make this march, and I will make Georgia howl."

Sherman had his sights set on the coastal City of Savannah. Cutting his communications and supply lines, Sherman would march his army deep into enemy territory. Sherman's capture of Savannah, which could open up a supply line to the sea, would be a devastating blow to the Confederacy. His march would demonstrate that, at this late stage in the war, the Confederates were simply unable to resist the Union advance.

Sherman encountered remarkably little resistance in his campaign to Savannah. The Confederate forces that should have been protecting eastern Georgia were in Tennessee. All Sherman's veteran soldiers faced was a small contingent of

Ogeechee River, Richmond Hill, Georgia

Southern cavalry and a mere 5,000 inexperienced militiamen. For Sherman's soldiers, hardened by the brutal campaign to capture Atlanta, the March to the Sea would be more akin to a raucous Boy Scout outing, except, perhaps, in some matters, with less discipline.

Arriving in Atlanta in December 2014, I began a journey to retrace Sherman's March to the Sea. I wondered what evidence would remain of a campaign that carved a path of destruction across the Georgia heartland, but without any pitched battles.

The route the armies followed in 1864 takes you along the old country roads, now mostly paved, that still meander across this region of Georgia. Occasionally, one catches a glimpse of the skeletal remains of a nineteenth-century home, a lone chimney and hearth the only evidence of Sherman's passing.

Driving east from Atlanta, the landscape appears much as Sherman described it in 1864. Using census maps of the day, he marched his army through a fertile stretch of southeastern Georgia that remains rich farm country.

Sherman's troops would live off the land, with each command forming teams of foragers to comb the countryside for sustenance. These roving bands of foragers, who became known as "bummers," were responsible for some of the more heinous acts of thievery and wanton destruction during the march. With food plentiful, foraging became more about finding hidden treasure troves of plantation tableware and silver, a further assault on the women of the South.

Anticipating the liberation of thousands of slaves along their route of march, Sherman put his commanders on details to take advantage of the manpower and put the newly freed men to work in felling trees to corduroy roads and build bridges. Ultimately, an army of freed slaves joined Sherman's march.

It took five weeks for Sherman's men to make the three-hundred-mile journey. Averaging 12 to 15 miles a day, Sherman's army marched across a huge swath of southeastern Georgia, burning and destroying plantations and railroads as they went. Broken up into two independent wings, Sherman's columns drifted toward the cities of Macon and Augusta before turning toward the sea.

On Nov. 20, 1864, 100 miles due east from Atlanta, Sherman's troops entered the town of Milledgeville, then the capital of Georgia. The governor and the state legislature had fled Milledgeville in haste, leaving the remaining citizens to gape as Sherman's army occupied the town. Sherman's troops entered the grand State Capitol building and proceeded to hold a mock session of the Georgia legislature. Choosing a speaker and debating the idea of Georgia secession, the Federal soldiers

Ruins along Sherman's March, Bostwick, Georgia

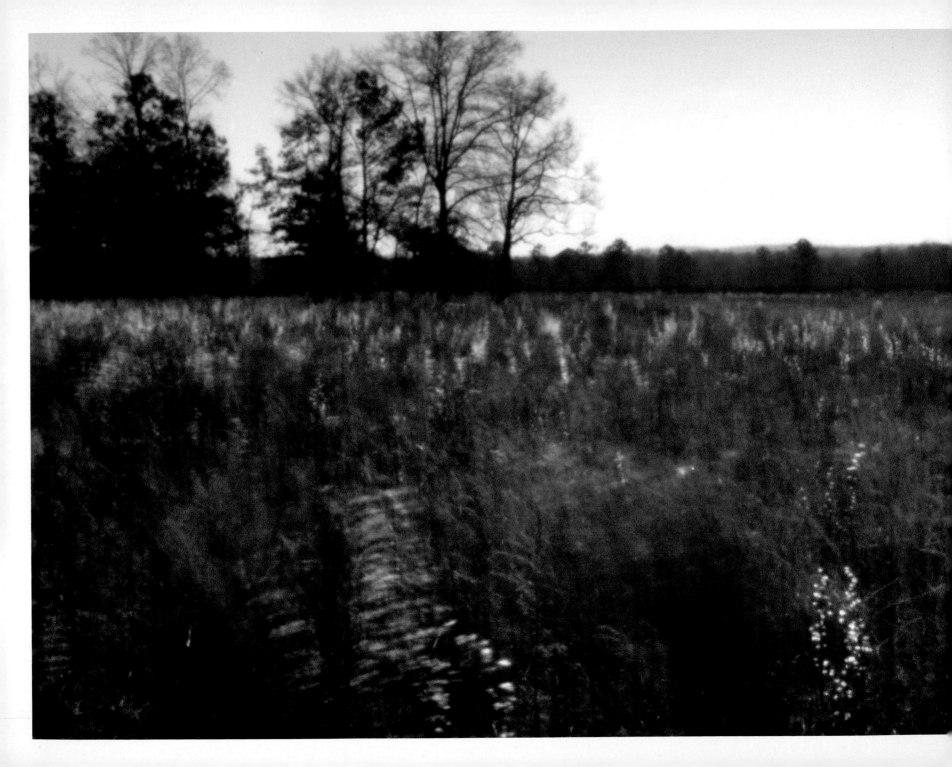

ended the gathering by voting the state back into the Union. The old Capitol building in Milledgeville remains the oldest public building in the country and is now home to the Georgia Military Institute.

As Sherman's troops settled in at Milledgeville, 25 miles to the south, near the town of Griswoldville, a brigade of Union soldiers detailed to protect the army's wagon train were setting up their camp for the night when they saw a long line of Confederates emerging from the forest about a mile away.

Setting up a hasty defense of felled trees, the meager Union force of 1,500 men prepared to meet 4,000 attacking Rebels. But this Rebel army was made up of old men and young boys whom General Joseph Wheeler, the Confederate cavalry commander, had forcibly conscripted as he combed the countryside for reinforcements.

Attacking across a broad front, the unpracticed soldiers marched into the withering fire of the Union soldiers with their Spencer carbines and were mowed down. In no time, 500 Confederate soldiers lay wounded and dying.

" *I will make Georgia howl."*

—William Tecumseh Sherman

LEFT: *Battlefield at Griswoldville, Georgia*

NEXT: *Track repairs in Griswoldville, Georgia (left); Reenactors in Richmond Hill, Georgia (right)*

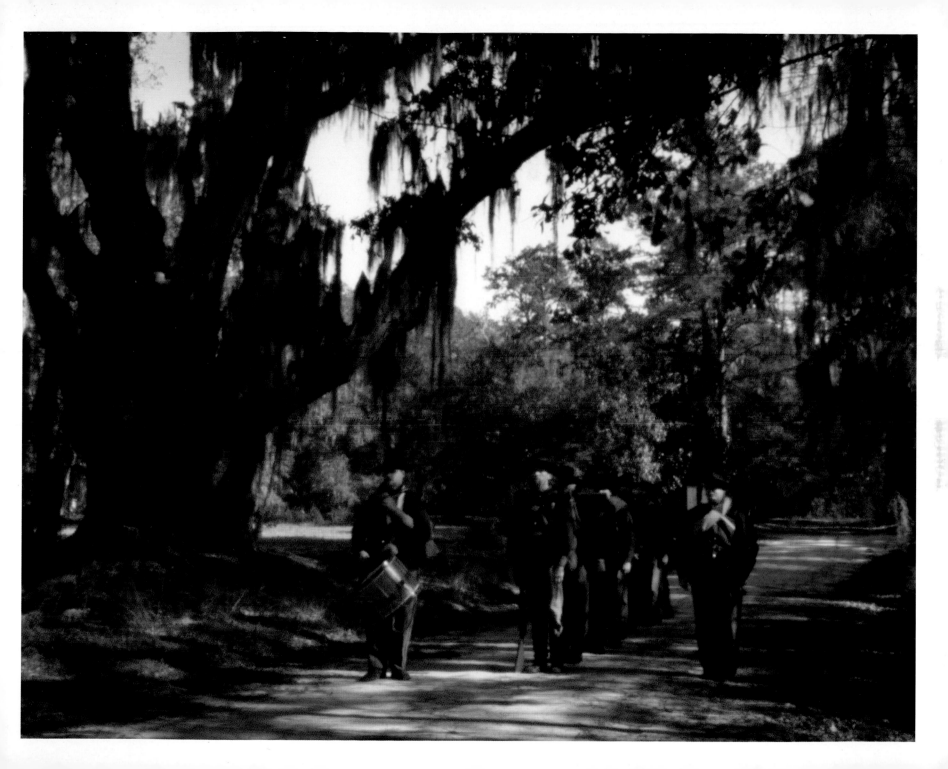

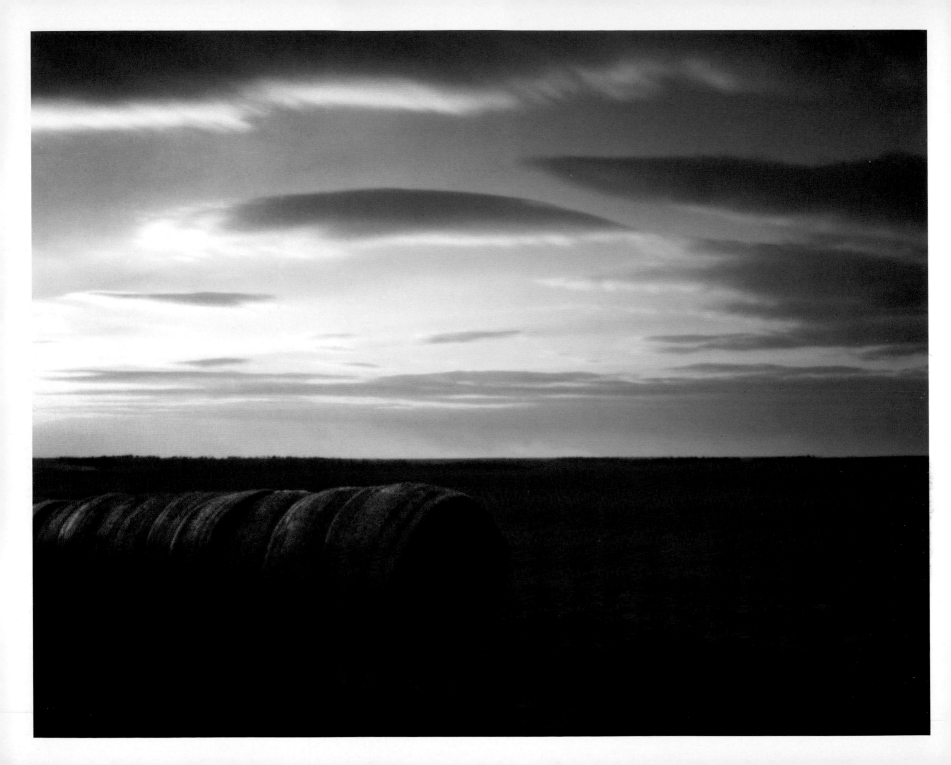

"I was never so affected at the sight of wounded and dead before. Old grey-haired and weakly looking men and little boys, not over 15 years old, lay dead or writhing in pain. I did pity those boys, they almost all who could talk, said the Rebel cavalry gathered them up and forced them in."

In Griswoldville, a small plaque and flagpole marks the spot of the only fierce battle of Sherman's march. Wind blows tall grasses in an open field. The tree line where the attack began is still plainly visible a mile away.

Marching east toward the coast, the Union army encountered vast pine forests; the sandy soil and climate in eastern Georgia provides a perfect habitat for the fragrant trees. Today, wild pine forests abut perfectly manicured stands of trees, destined for the mill. Many a period memoir recounts the sensation of walking through these pine barrens, over the forest floor, devoid of underbrush, carpeted in pine needles.

Following the route of the left wing of Sherman's army, I visited Buckhead Church near Millen, Georgia, the site of a small skirmish on November 27. On that day, Wheeler, the Confederate cavalry commander, deployed church pews as a pontoon bridge to cross Buckhead Creek in pursuit of the Union Army.

Entering the nineteenth-century church, I was amazed to find telltale reminders of the pew's wartime service: hoof prints still mar their surface.

As Sherman's armies neared Savannah, the abundance of Georgia's interior was no more. Union soldiers subsisted for the first time on rice in the coastal lowlands, which is a landscape of rice fields, amid thick, dreamy swamps dominated by palmetto, cypress, cedar, and live oak trees, all hauntingly draped with Spanish moss.

The City of Savannah is surrounded by large navigable rivers, all of which reach inland and are fed by thousands of smaller rivers and creeks that stretch through the region. Anticipating the watery terrain, each of Sherman's armies brought along pontoon bridges engineered to ford the rivers and creeks they would encounter on their march.

On December 8, 1864, at Ebenezer Creek, one of Sherman's columns, led by the unfortunately named General Jefferson Davis, was having a particularly difficult time in the swampy terrain. Harassed by Confederate cavalry, Davis ordered his men to bridge the creek and planned to remove the pontoons when they were safely on the far bank. At this late stage of the march, thou-

PREVIOUS: *Cotton fields in Riddleville, Georgia (left);*
Marred pews at Buckhead Church, Millen, Georgia (right)

RIGHT: *Ebenezer Creek, Springfield, Georgia*

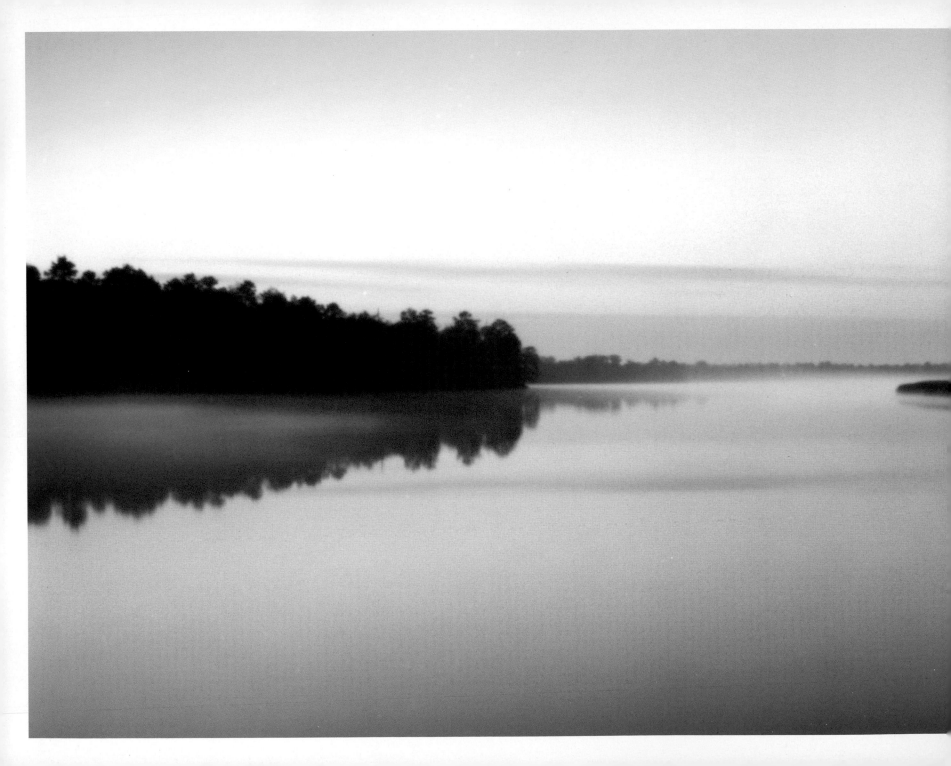

sands of freed slaves and their families were following Davis's army for sustenance and security. But to Davis, the thousands of freed slaves were a nuisance and an albatross, slowing his march to the sea. In one of the most notorious acts of cruelty of the war, Davis had the freedmen wait until the army had crossed, and then, before they could follow, had the pontoon bridges dismantled. Some of those left behind desperately attempted to cross the icy waters and drowned. The rest were delivered into Confederate hands.

Twenty miles outside of Savannah, the Union troops reached Highbridge on the Ogeechee River, which flows ten miles out to the Atlantic Ocean. That evening, Federal officers asked for volunteers to take a boat down the Ogeechee and attempt to make contact with the Union Navy, anchored in Ossabaw Sound. Several young officers stepped forward for the clandestine journey, in which, under cover of darkness, they quietly rowed past the Confederate forts along the river and made contact with the Navy.

The news was telegraphed north. Sherman had reached the sea.

Ogeechee River at King's Bridge, Richmond Hill, Georgia

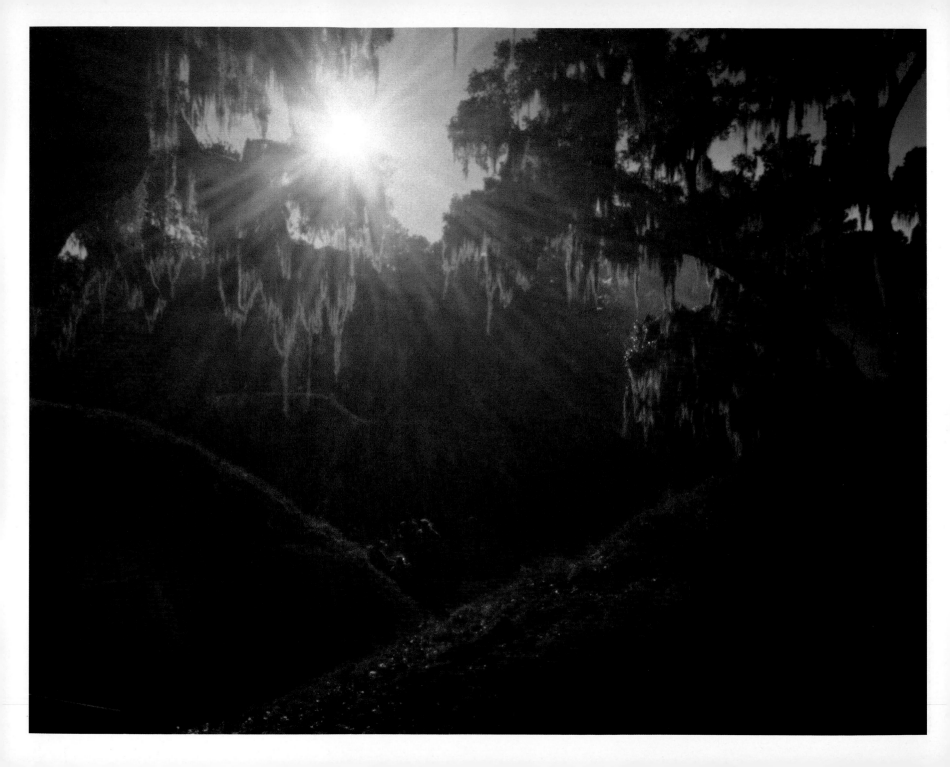

Near the mouth of the Ogeechee River lies Fort McAllister, which prevented Union Navy ships from entering the waterway and protected the large plantations upriver. Sherman quickly surmised that with the capture of Fort McAllister, he would have control of the river, access to the sea, and a reliable supply line for his eventual siege of Savannah. On December 13, Sherman's troops captured the fort in a dramatic fifteen- minute battle.

My arrival near Savannah coincided with a reenactment at Fort McAllister, one of the best-preserved earthen Civil War–era forts. Saved from ruin by Henry Ford, who built his winter home nearby, the earthen walls of Fort McAllister tower thirty feet in height and still stand guard over the slow-moving Ogeechee River. Giant moss-laden oak trees grow from the fort's walls today, shading an interior that contains numerous bomb proofs, ordinance bunkers and underground living quarters.

In December 2014, Confederate reenactors reoccupied the fort and prepared for the sesquicentennial assault from their Union counterparts, bivouacked in the surrounding forest. Wood smoke could be seen rising from the fort interior, where reenactors slept in the fort's underground bunkers.

Union reenactors went into formation in the surrounding woods exactly 150 years to the minute from the date of the famous battle. As dusk descended, the attack began, as reenactors in Union blue marched through the woods. Approaching the fort, they fired a volley and rushed to scale the fortress walls. Gun smoke hung in the subtropical air as they overwhelmed the fort's defenders. Faithful to the historical script, within 15 minutes, the 150-man garrison surrendered.

The capture of Fort McAllister in 1864 sealed the fate of Savannah. The 14,000-man Confederate garrison in the city, seeing the hopelessness of resisting Sherman's advance, quietly abandoned the city. Constructing a pontoon bridge across the Savannah River, the Confederates marched into South Carolina to fight another day. Sherman's troops were grateful. Assaulting Savannah along the narrow elevated causeways into the city would have been a bloody affair.

I had an opportunity to visit one of the causeways, which is now a nature trail on the grounds of the Savannah Christian

PREVIOUS: *Fort McAllister, Richmond Hill, Georgia (left);*
Downtown Savannah (right)

RIGHT: *Confederate sentry at Fort McAllister*

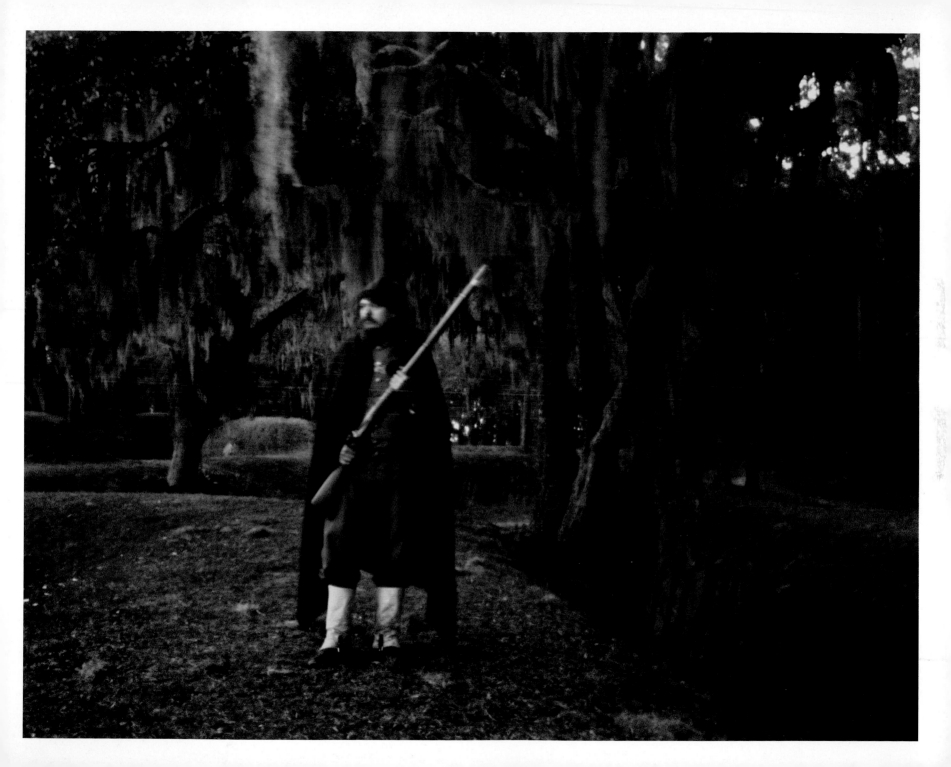

Preparatory School. The "Union Causeway," as it's now called, was an elevated road between rice paddies and was used by Federal troops in the brief Battle of Shaw's Dam.

On Christmas Eve 1864, Sherman sent a telegram to Abraham Lincoln: "I beg to present you, as a Christmas gift, the city of Savannah, with 150 heavy guns and plenty of ammunition, and also about 25,000 bales of cotton."

Sherman and his army longed to take their fight into South Carolina, the state where the war started, the great agitator for secession.

"The truth is, the whole army is burning with an insatiable desire to wreak vengeance upon South Carolina," wrote Sherman. "I almost tremble at her fate, but feel that she deserves all that seems in store for her."

The Union Causeway, Savannah, Georgia

The Last Campaign

As General Ulysses S. Grant predicted, the lateral movement of his armies over the last months of 1864, as well as the envelopment of the City of Petersburg, had stretched the Confederate ranks to the breaking point. Nine months of siege warfare at Petersburg left the Southern forces entrenched around the city worn thin, with precious few resources. Lee knew a Union breakthrough was inevitable. He recommended abandoning Richmond, the Confederate capital.

Foreseeing a spring offensive from Grant, Lee decided to strike first. He ordered General John B. Gordon to plan an assault on the Union lines that would keep the Federals off balance long enough for Lee to extricate his army from Petersburg and live to fight another day.

Lee's plan was to take his army south and join forces with General Joseph E. Johnston's troops fighting Sherman in the Carolinas. Together, they would smash Sherman's army and then move north to confront Grant. Lee entreated Gordon to plan the assault carefully. The Rebels, with their dwindling supplies and manpower, would have only one chance to escape Petersburg.

Gordon chose Colquitt's Salient—a mire 100 yards from the earthen walls of the Union's Fort Stedman—as their jumping-off

Trestle Ruins on the James River, Richmond, Virginia

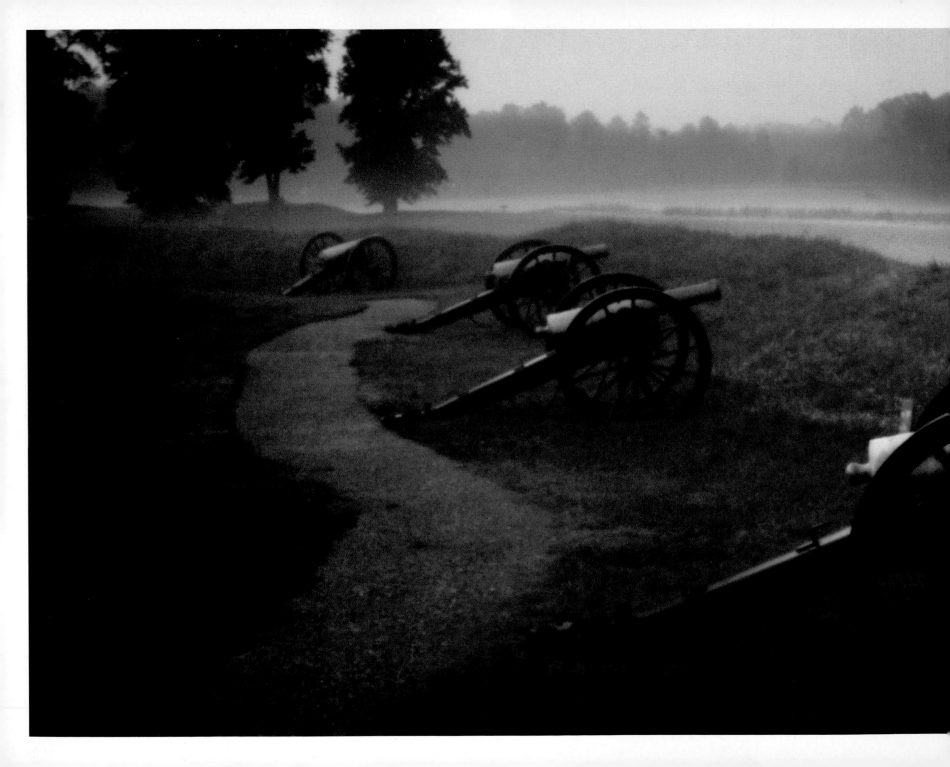

Fort Stedman, Petersburg, Virginia

point for the surprise attack. Walking this ground today is an education. Young Army cadets from nearby Fort Lee can be seen touring the battleground in groups with their instructors on a daily basis. The earthen walls of Fort Stedman, worn down over the years, nevertheless remain intact. Union guns now look out from embrasures lined with wild grass across the small valley to the remains of the Confederate trenches at Colquitt's Salient.

The short walk from the fort to the Confederate trench line takes just a few minutes. In 1865, this area was a small no-man's-land. The pickets of each army were within easy sniping distance of one another. But, at this late date in the conflict, war-weary pickets were as likely to talk to one another as shoot at one another.

"The pickets of the two armies were so close together at this point," Gordon wrote, "that there was an understanding between them, either expressed or implied, that they would not shoot each other down except when necessary." Confederate and Union pickets would meet between the lines to exchange newspapers and trade coffee and tobacco. Fraternization had become so commonplace that officers were assigned to oversee these impromptu interactions.

This led to a curious incident in the minutes before the Battle of Fort Stedman. In the predawn hours of March 25, ten thousand Confederates hid in the trenches opposite the fort and waited in the dark for the signal to attack. That honor was given by Gen-

eral Gordon to a young Confederate private who, when the signal was given, was to fire his rifle to start the assault.

The private had been serving as a picket at the salient and had become friendly with his opposite number manning the Union picket line. The young soldier was reluctant to break their unwritten rule, so when Gordon turned and signaled to him to start the attack he defiantly held his fire. Gordon related in his memoirs what happened next:

"He at once called to his kindhearted foe and said: 'Hello, Yank! Wake up; we are going to shell the woods. Look out; we are coming.'"

The stillness of the night was finally broken by a rifle shot and 10,000 Confederates surged forward. In minutes, the attacking Rebels quickly overran the Union soldiers defending the fort. Gordon's men captured or killed Stedman's defenders and turned the fort's guns on the adjacent forts along the Union line.

As the sun rose, an intense battle ensued. The Confederate attack at Fort Stedman was a complete success, but the Federal's superiority in numbers soon began to turn the tide. Union soldiers were rushed into the breech, eventually recapturing the fort and sending the surviving Confederates retreating back to their own lines. The Federal troops that rushed in and sealed the breech in the attack were unaware of what they had just achieved. With their counterattack, the Union army had just beaten back the last Confederate offensive of the Civil War.

Five days later, Grant inaugurated the Five Forks Campaign. Union success at Five Forks prompted Grant to order an all-out assault the next day along the entire Petersburg front. On April 2, more than 100,000 Union soldiers assaulted the 35 miles of trenches at Petersburg. After 18 hours of desperate combat, the Union soldiers finally achieved their breakthrough.

"Then and there," wrote an exultant Connecticut soldier, "then and there the long-tried and ever faithful soldiers of the Republic saw daylight!"

Lee and what remained of the Confederate Army marched through Petersburg, crossing the Appomattox River and burning the bridges behind them as they retreated west.

Just as the Union Army achieved its breakthrough at Petersburg, word came that 20 miles to the north, Richmond was burning. The Confederate capital was being abandoned.

Thus would begin the last campaign of the Civil War in Virginia. Jefferson Davis and the Confederate Government in Richmond had boarded trains and fled south, literally a government on wheels. The once invincible Army of Northern Virginia and their feared commander, Robert E. Lee, were in desperate retreat and near destruction.

The Appomattox Campaign

Traveling the Confederate retreat route in 2015, it seems to have changed little over the years. Sparsely populated today as it was

Assault on Fort Harrison, Henrico, Virginia

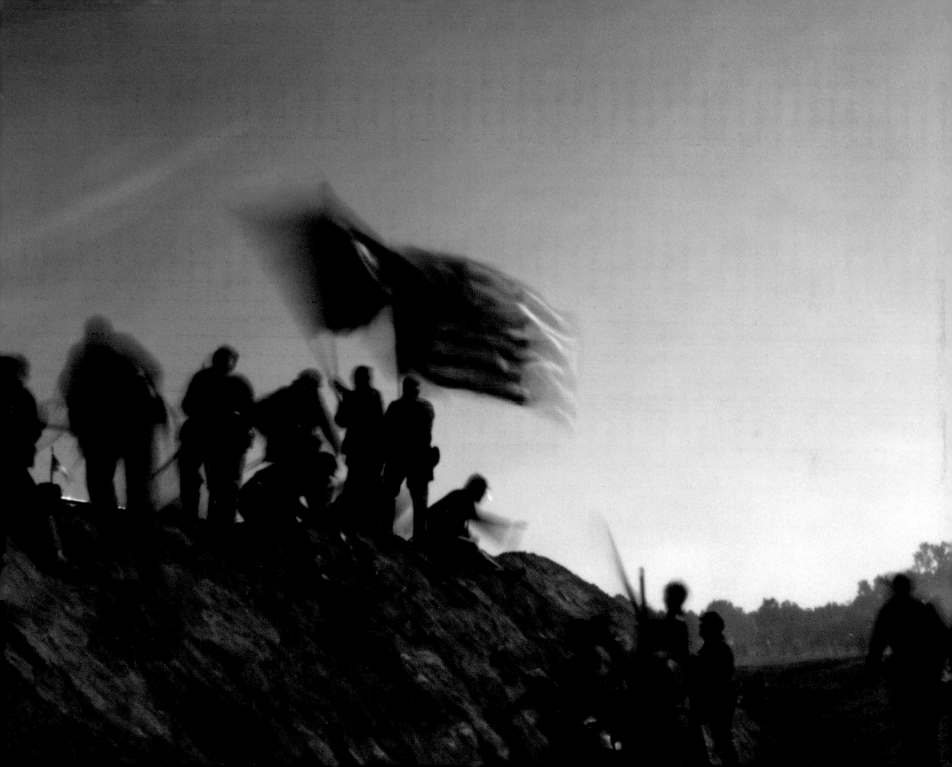

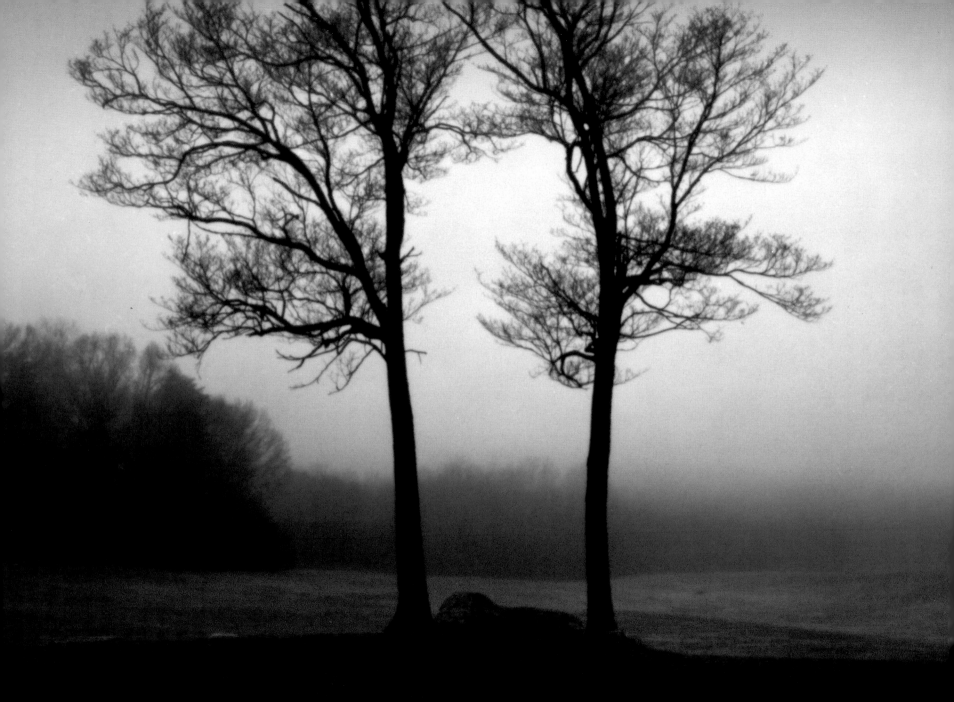

150 years ago, the rolling terrain of Prince Edward County, Virginia is interspersed with tracks of forest broken by cultivated fields and rough-hewn farms.

Both armies initially felt exhilarated on leaving behind the trenches around Petersburg and Richmond for the open air. Union troops sensed that this would be their last, ultimately triumphal campaign. And Confederates believed, against all reason, that Lee would be able to turn the tables on the pursuing Federals. The Last Campaign in Virginia devolved into one continuous battle broken only by forced all-night marches. After nine months of trench warfare, the exertions needed in this tumbling terrain west of Petersburg soon took its toll on the soldiers of both armies, but was particularly difficult for the Confederates.

"Soon began the continuous and final battle," Confederate General John B. Gordon wrote. "Fighting all day, marching all night, with exhaustion and hunger claiming their victims at every mile of the march, with charges of infantry in the rear and of cavalry on the flanks, it seemed the war god had turned loose all his furies to revel in havoc. On and on, hour after hour, from hilltop to hilltop, the lines were alternately forming, fighting, and retreating, making one almost continuous shifting battle."

The Confederate route of retreat in 1865 was littered with broken-down wagons and ambulances, guns with cracked and damaged wheels, discarded blankets and rifles, stragglers and soldiers, so long deprived of rations, that they "dropped in the middle of the road from utter exhaustion."

Sailor's Creek Battlefield, Virginia

The evidence of Confederate collapse made Grant push all the harder, and, this time, his troops didn't complain about the forced marches. They sensed the end was near.

Sailor's Creek

The Union Army, looking for a way to split up the retreating Confederates, found an opening near a tributary to the Appomattox River at Sailor's Creek. The relentless march had caused the Confederate columns to become separated from one another, and the Union Cavalry units, led by General George Armstrong Custer, were able to get between them.

On April 6, the Federal armies surrounded a large contingent of the Confederates at the creek and nearly destroyed them.

Only the arrival of Lee and his reinforcements enabled the Confederates to make their escape, but they had suffered a catastrophic loss, with Union troops capturing six generals—including Lee's son, Custis—and 6,000 exhausted Confederate troops.

"A few more Sailor's Creeks and it will be all over," Lee wrote Jefferson Davis.

In March 2015, reenactors returned to the hills around Sailor's Creek. Bivouacked in the surrounding forests, living historians woke to a cold spring morning. Snowflakes blew in the air as the reenactors huddled around campfires. Union reenactors attacked through a marsh, splashed across Sailor's Creek and scaled a hill where the Confederates, rifles ready, awaited.

I stood with the Confederates in the mock battle and watched as the Federals surged toward them, engaging in a last hand-

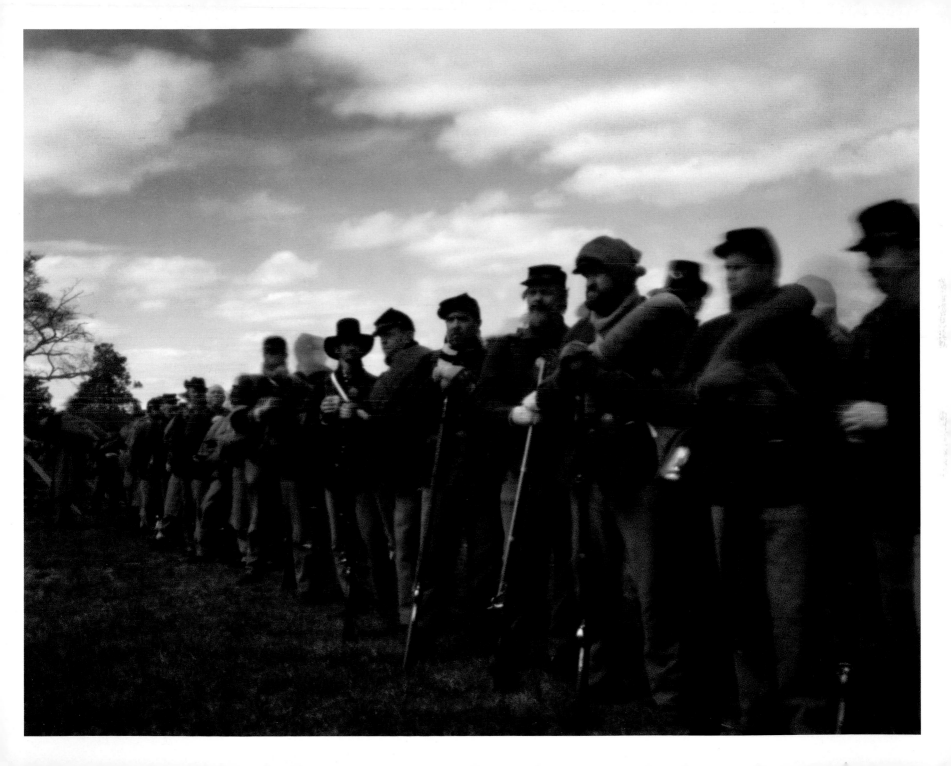

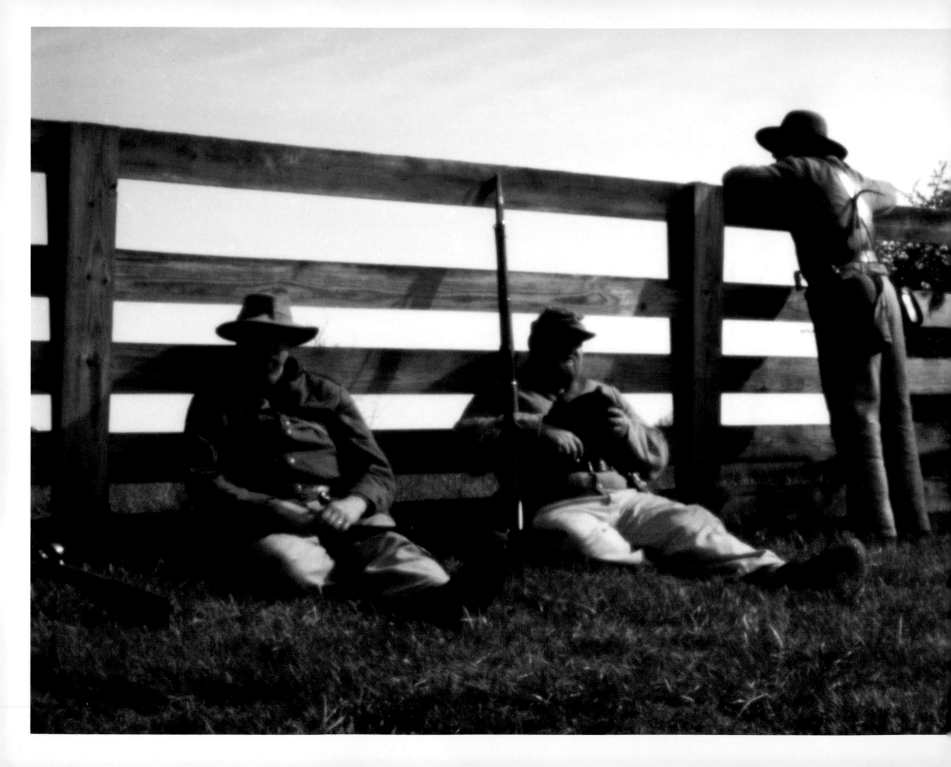

to-hand struggle to subdue the remaining Rebels. On cue and seemingly out of nowhere, Union reenactors on horseback came crashing into the exposed flank of the Confederates, screaming and waving their sabers. The Confederate reenactors stood and held their rifles upside down in a sign of capitulation. As the gun smoke drifted away, a tangled mass of "dead and wounded" were revealed upon the hill. Within an hour, the battlefield park was again empty, aside from the reenactors encamped along the fringes of the forest, the wind blowing the wood smoke of their campfires across a silent landscape.

High Bridge

After the Battle of Sailor's Creek, what remained of Lee's army continued the retreat west, hurrying to cross the Appomattox River at High Bridge near Farmville, Virginia.

High Bridge was a tall railroad trestle spanning the river, and the Confederates set it alight to stop their pursuers. They also set a smaller wagon bridge below the railroad bridge on fire, but the Union troops arrived in time to secure it, save it from destruction, and make the crossing.

The Rebels counterattacked but failed to dislodge the Union soldiers from their bridgehead.

The failure of Lee's troops to destroy both bridges had sealed the Confederates' fate.

High Bridge still crosses the Appomattox River; the towering rail bed is now a nature trail. Supports for the old Civil War

PREVIOUS: *Appomattox River, Farmville, Virginia (left); reenactors at Sailor's Creek (right)*
LEFT: *Reenactors lounge at Appomattox Court House*

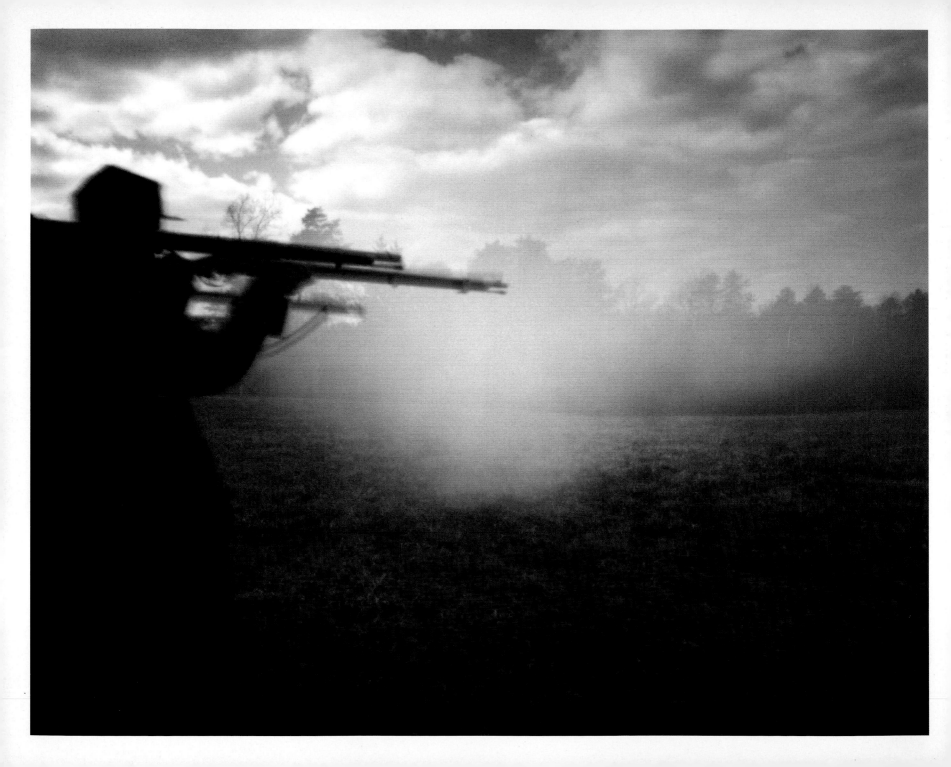

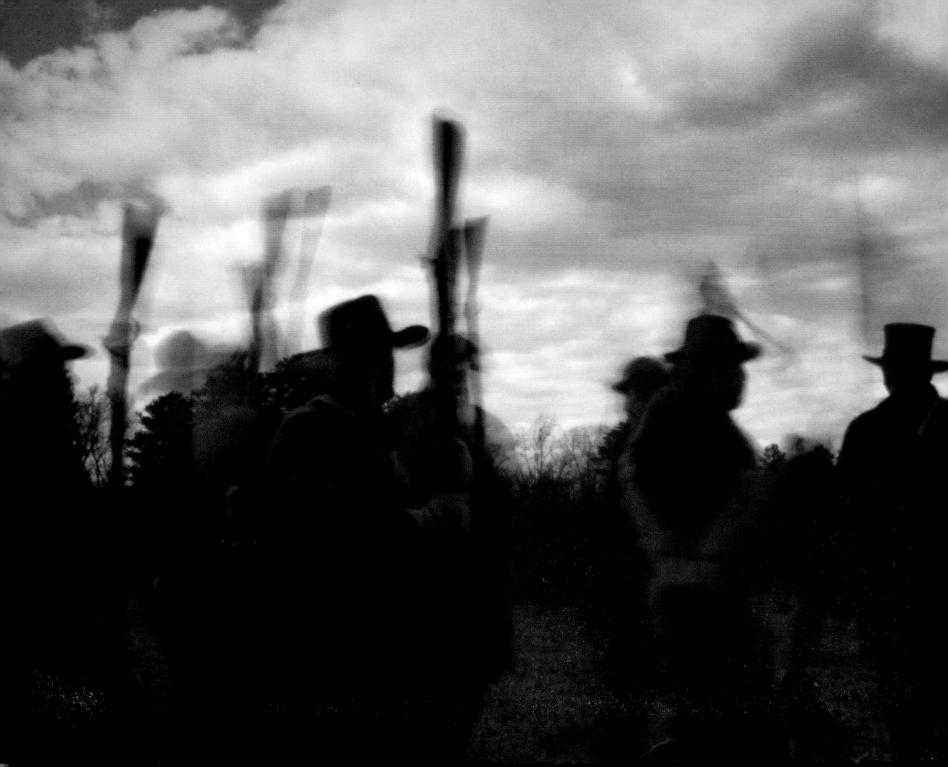

bridge can be seen alongside the newer span. Below the bridge, at the river's edge, the remains of the old wagon road lead to the original location of the lower span.

"While news of the failure at High Bridge made surrender seem inevitable, it would be the arrival of Sheridan at Appomattox Station that forced Lee to accept it."

Appomattox Station

As the Union Army harried the Confederates west, Grant began a correspondence through the lines in attempt to stop further bloodshed.

Grant wrote to Lee, "The result of the last week must convince you of the hopelessness of further resistance on the part of the Army of Northern Virginia in this struggle. I feel that it is so, and regard it as my duty to shift from myself the responsibility of any further effusion of blood, by asking of you the surrender of that portion of the Confederate States army known as the Army of Northern Virginia."

> " *We had no other objective than the Confederate Armies, and I was anxious to close the thing up at once.*"
>
> —Ulysses S. Grant

Lee and his lieutenants believed there was still a chance to escape the Federal cordon. Thirty miles west of Farmville, at Appomattox Station, trains with supplies were waiting for the Confederates. But Union cavalry led by Custer beat them there. Fierce fighting ensued, which lasted through the night. Without those supplies, the Confederates could go no further.

That evening, Lee held his last council of war. Lee and his lieutenants agreed that they would try one more time to break out of the Union encirclement. At dawn the next morning, all the available Confederate troops would push forward in an attempt to break the Federal cordon and escape south. Leaving the meeting, General Gordon sent an aide back to ask Lee where his troops should bivouac for the night. Lee, realizing the hopelessness of their situation, responded in jest, "Yes. Tell General Gordon that I should be glad for him to halt just beyond the Tennessee line."

At dawn the following day, the final battle of the Civil War in Virginia would be fought at Appomattox Court House.

PREVIOUS: *High Bridge, Farmville, Virginia (right)*
LEFT: *Capitulation at Sailor's Creek*

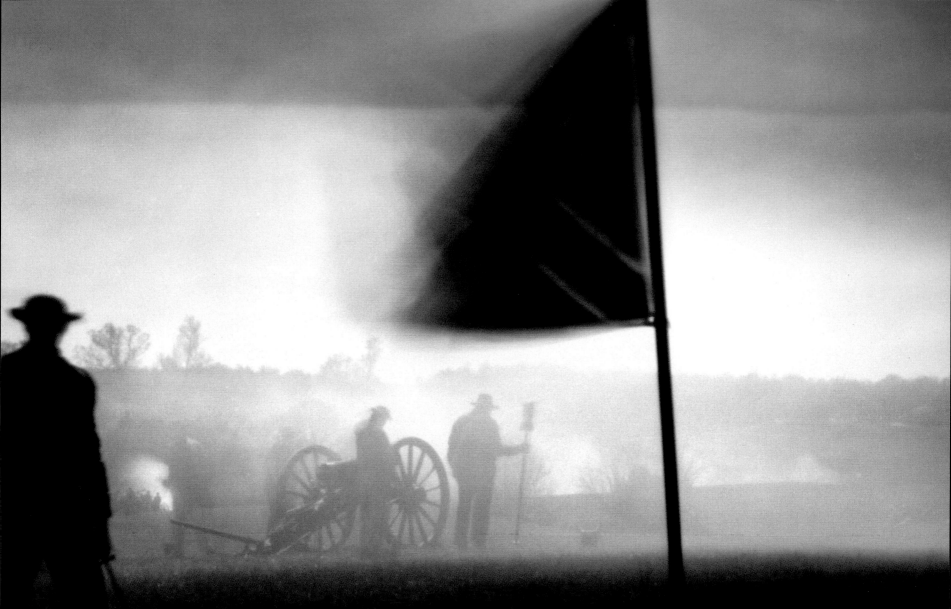

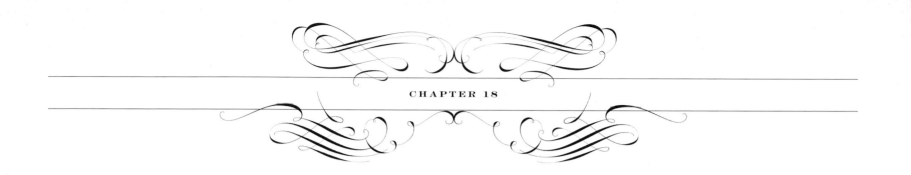

Appomattox Court House

On the morning of April 9, 1865, the last vestiges of Robert E. Lee's Confederate Army gathered their forces outside of the Village of Appomattox for their final battle of the American Civil War in Virginia. The Union Army finally had the Rebels surrounded.

The preceding seven days had been an exhausting series of stubborn rearguard battles followed by all-night marches. Lee's starving and bone-tired troops arrived at Appomattox intent on distributing the rations waiting for them in boxcars at the local train station only to find that the Federals had beaten them there.

As the first light began to appear on the horizon the next morning, Lee issued his last order of battle, sending General John B. Gordon and what remained of the Army of Northern Virginia down the Lynchburg Stage Road in a final attempt to break out of the Federal encirclement. Federal troops had erected breastworks across the Confederate's intended line of march and were waiting for the Rebels. Despite their exhausted condition, the Confederates attacked and overran the Union position, but Federal reinforcements were near at hand.

The sight of tens of thousands of fresh Union troops was the last nail in the coffin for the remaining Confederates. Gordon sent a dispatch to Lee explaining their predicament, which was that the Yankees had blocked their way: "General Lee, I have fought my corps to a frazzle, and I fear I can do nothing unless I am heavily supported by Longstreet's corps."

Battle at Appomattox Court House

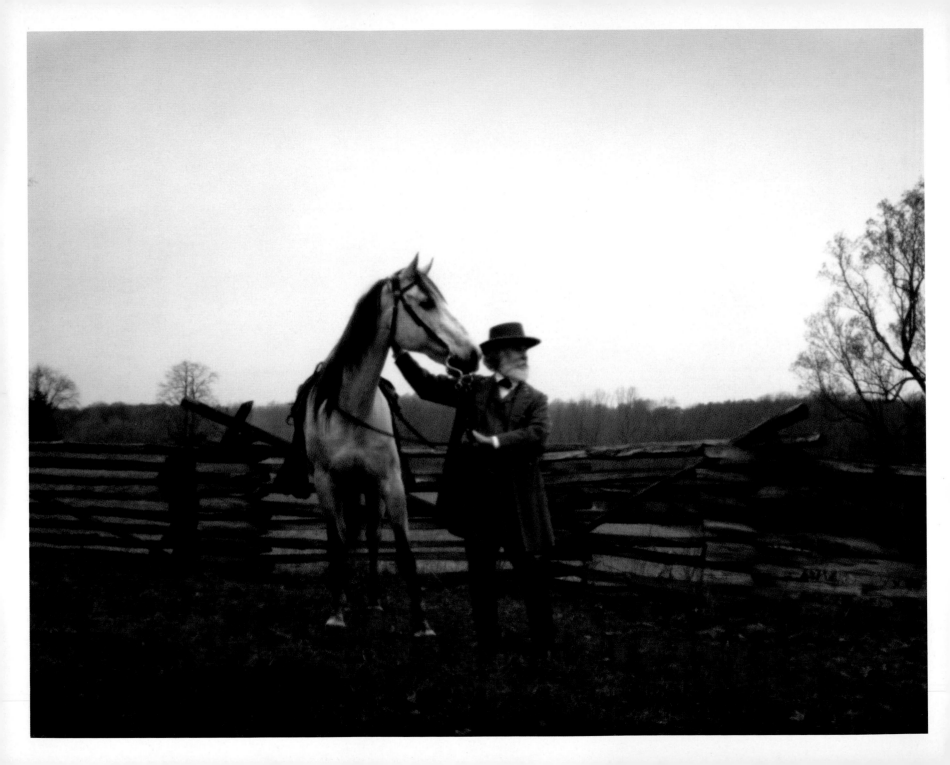

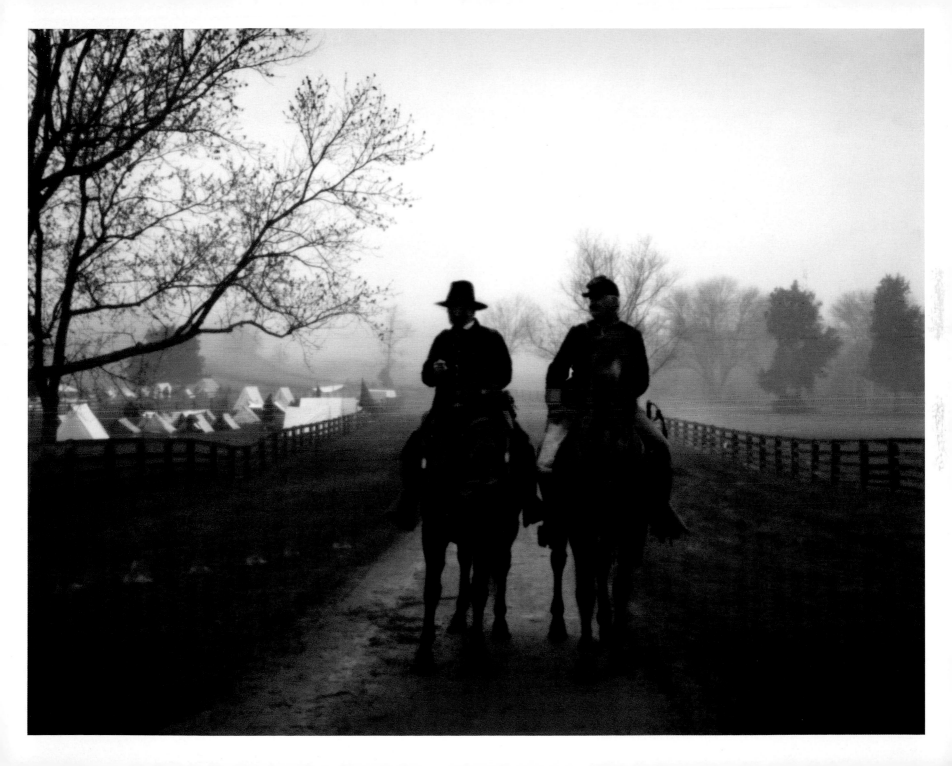

What remained of General Longstreet's troops were now hopelessly separated and cut off from Gordon. The Army of Northern Virginia had fought its last battle.

Upon receiving Gordon's dispatch, Lee made the fateful decision: "There is nothing left me but to go and see General Grant, and I had rather die a thousand deaths."

Lee sent correspondence through the lines to General Grant: "General: I received your note of this morning on the picket line whither I had come to meet you and ascertain definitely what terms were embraced in your proposal of yesterday with reference to the surrender of this army. I now request an interview in accordance with the offer contained in your letter of yesterday for that purpose."

The Surrender

Lee had emerged from his tent later that morning immaculately dressed in a new uniform. Wearing a ceremonial sword at his side, Lee told his aide-de-camp Col. Charles Venable that he had better look his best as he would likely be General Grant's prisoner this day. Lee, after all, was surrendering himself and his army to an enemy commander who had earned the moniker, "Unconditional Surrender Grant."

Approaching Appomattox Court House, Grant was met by Sheridan and directed to the home of local resident Wilber McLean where Lee was waiting for him. It seemed a strange coincidence that McLean's home had been chosen for the war's closing ceremony. In 1861, Wilber McLean was living in Manassas, Virginia, when some of the first shots of the Civil War caused him to move his family to Appomattox. McLean had hoped to escape the war, only now to have the final battle in his front yard and the war's most profound moment unfolding in his living room.

On the afternoon of April 9, Lee surrendered himself and the Army of Northern Virginia to Grant in a meeting that would set the tone for a new United States of America. The terms offered by the Union commander set free the conquered soldiers on the simple condition that they would promise never again to take up arms against the United States.

The fighting was over in Virginia.

Appomattox 2015

In April 2015 the National Park Service hosted a weeklong event commemorating the 150th anniversary of the surrender of the Confederate forces at Appomattox Court House. Thousands of

PREVIOUS: *Reenactors as Lee and Grant at Appomattox*

RIGHT: *The McLean House, Appomattox, Virginia*

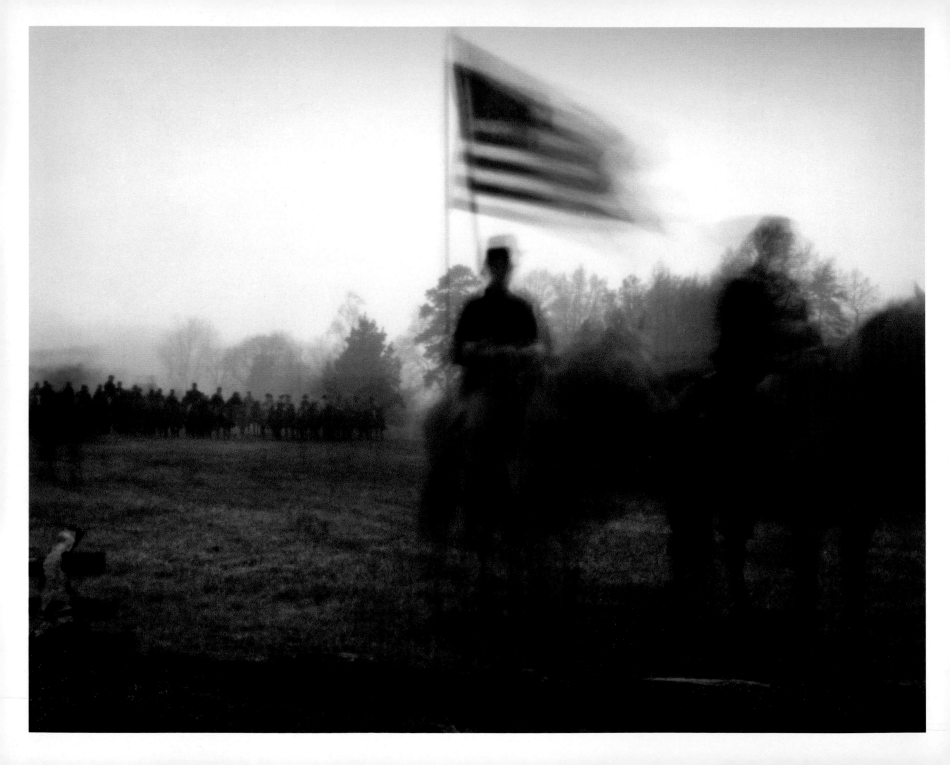

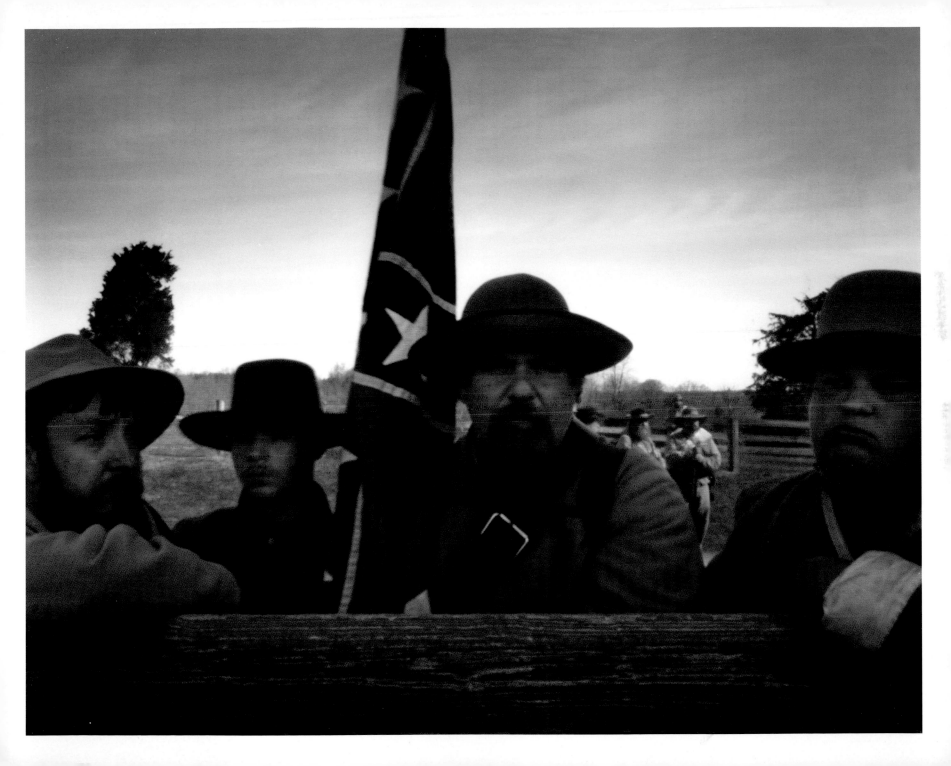

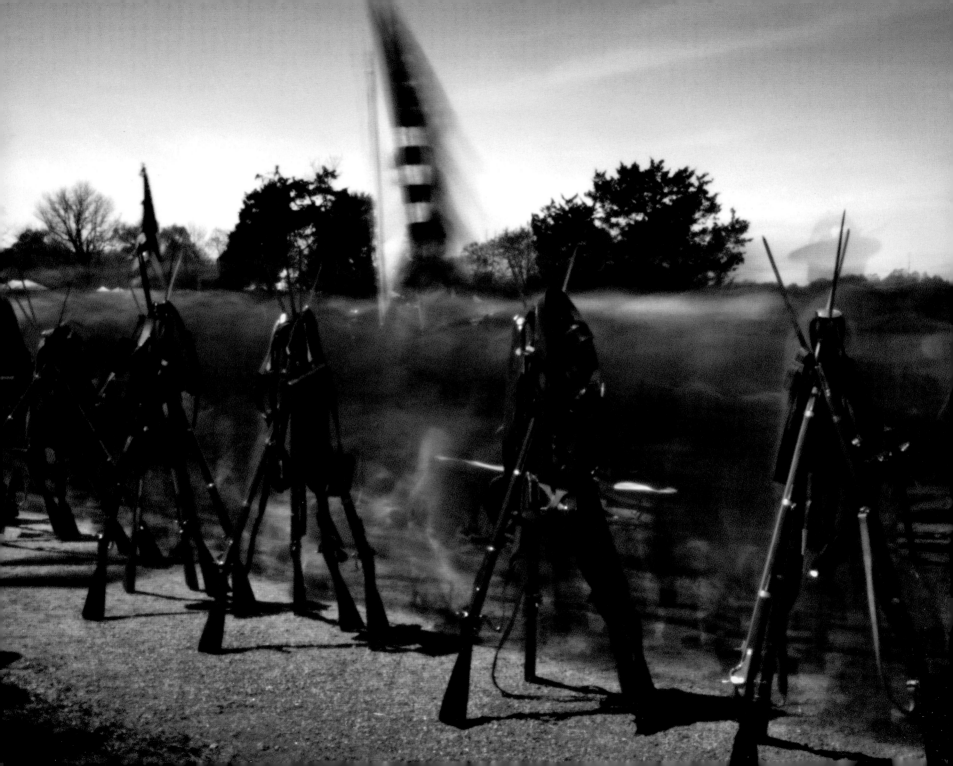

Americans attended the ceremonies, where reenactors in Confederate gray stacked their arms and carefully folded their battle flags once again under the respectful eyes of their counterparts in Union blue.

The Park Service made a special effort to invite descendants of Union and Confederate veterans to the sesquicentennial ceremony. Hundreds were in attendance and invited to march in their own commemorative parade.

Among those attending was Toni Cross of Ohio who had timed her annual family reunion to coincide with the festivities at Appomattox. Cross and her family had much to celebrate at Appomattox. Cross's great-great-grandmother was a resident slave at the Bocock-Isbell House, a historic home on the grounds at the National Park. The Confederate surrender at Appomattox Court House was a birth of freedom.

The National Historic Park at Appomattox Court House is a beautifully preserved nineteenth-century landscape. The old Lynchburg Stage Road, the main road through Appomattox in the 1860s, still leads to the old Court House today. Preserved in its original state, the dirt road is lined with cross-rail fences and curves its way through the bucolic village. It was along this very road that the Confederates stacked their rifles and folded their battle flags.

Along the road sits the Wilber McLean House. The modest red-brick home would become famous for the hour-and-a-half-

long conference that occurred there on April 9, 1865—so famous, in fact, that not more than a few minutes after the signing, articles from the house were being appropriated as souvenirs. With tens of thousands of soldiers in the vicinity, each one looking to take home a memento, it's a wonder the house survived the surrender.

Reenactors came from around the country to volunteer for the Park Service commemoration at Appomattox. Encamped on the grounds, Union and Confederate living historians repeated the surrender ceremony nearly a dozen times for visiting spectators.

Reenactor Andrew Dixon of North Carolina participated in the ceremonies to honor an ancestor who fought with the 28th North Carolina Regiment and was killed at Malvern Hill in 1862. Dixon and his comrades were in full "1865" mode and found it difficult to suppress their emotions.

"We were our ancestors that day," he said.

Noah Cline, Stephen Harris's great-great grandfather, was a private in the 28th who was wounded in action and died in 1864, leaving behind a wife and six children. At the surrender ceremonies in 2015, Harris bore the battle flag of the 28th, heavy with emotion.

"I did in the back of my mind smile," he said. Noah Cline didn't live to see the war end, but "his blood is coursing through my veins and I made it to Appomattox."

Union reenactors lined the old Lynchburg Stage Road and stood at attention as Confederates marched in and formally stacked their rifles and set down their cartridge boxes as part of

PREVIOUS: *Union cavalry at Appomattox (left); reenactors of the 28th North Carolina Regiment (right)*

LEFT: *Surrender ceremony at Appomattox*

the ceremony. Rebel reenactors then rolled their battle flags and set them across the stacked rifles and marched away, leaving their weapons to be gathered up by their Union hosts.

Mirroring the events of 1865, Union reenactors stood at attention during the proceedings in respect to their surrendering foe. In 1865 Major General Joshua Lawrence Chamberlain, of Gettysburg fame, received the surrender of the Confederate troops and later penned a short memoir describing the events at Appomattox that eventful day. His account of the ceremony has come down through the ages as a sign of the respect the two armies had gained for one another after four long years of war:

"Before us in proud humiliation stood the embodiment of manhood: men whom neither toils and sufferings, nor the fact of death, nor disaster, nor hopelessness could bend from their resolve; standing before us now, thin, worn, and famished, but erect, and with eyes looking level into ours, waking memories that bound us together as no other bond—was not such manhood to be welcomed back into a Union so tested and assured?

" *Before us in proud humiliation stood the embodiment of manhood: men whom neither toils nor sufferings, nor the fact of death, nor disaster, nor helplessness could bend from their resolve."*

—Joshua Lawrence Chamberlain

"Gordon, at the head of the column, riding with heavy spirit and downcast face, catches the sound of shifting arms, looks up, and, taking the meaning, wheels superbly, making with himself and his horse one uplifted figure, with profound salutation as he drops the point of his sword to the boot toe; then facing to his own command, gives word for his successive brigades to pass us with the same position of the manual—honor answering honor.

"On our part not a sound of trumpet more, nor roll of drum; not a cheer, nor word nor whisper of vain-glorying, nor motion of man standing again at the order, but an awed stillness rather, and breath holding, as if it were the passing of the dead!"

The surrender of the Confederates at Appomattox Court House was not the end of the Civil War. Rebel armies were still fighting in the South, but Grant's magnanimity and lenient terms and Lee's stoicism in defeat sent a powerful signal to the remaining Confederate armies in the field who, in the couple of months that followed, would, one after the other, surrender under equally generous terms.

The long and terrible Civil War was drawing to a close.

The Long Road Home, Appomattox, Virginia

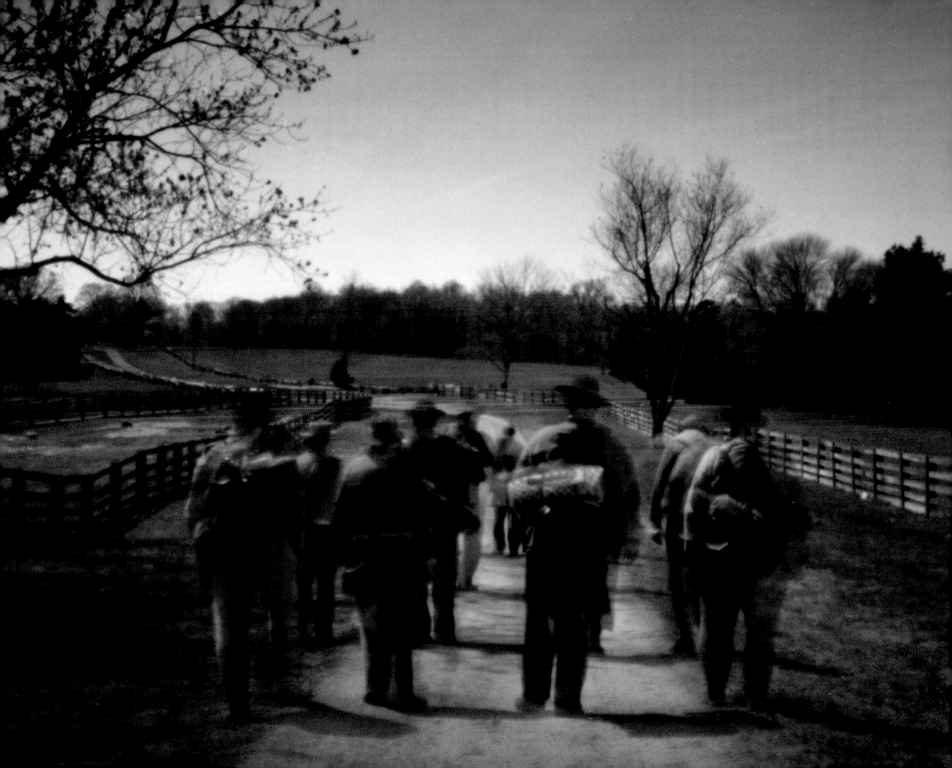

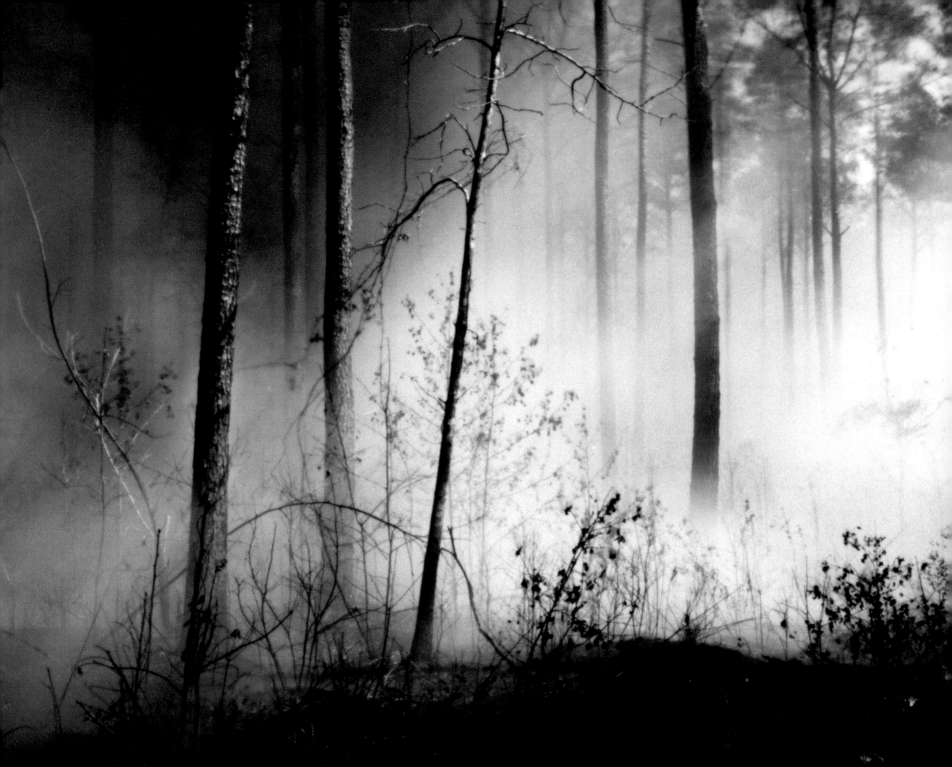

The Carolinas Campaign

our months before the signing of the surrender at Appomattox, in January 1865, General Sherman led 60,000 of his veteran soldiers from the conquered city of Savannah into South Carolina with one goal in mind: wreaking vengeance.

"My aim then was to whip the rebels, to humble their pride, to follow them to their inmost recesses, and make them fear and dread us. 'Fear of the Lord is the beginning of wisdom.'" Sherman wrote. Sherman and his troops were adamant that South Carolina would reap what it had sown four years earlier when it was the first state to secede from the Union. The destruction of the March to the Sea would, Union soldiers promised, pale in comparison to what they had in store for what we now call the Palmetto State.

Brush fire outside Charleston, South Carolina

Sherman's Smoky March through the Carolinas would be the final campaign of the American Civil War.

As with the March to the Sea in January 1865, Sherman's troops would face little opposition in their campaign across the Carolinas, with Confederate forces dispersed and unsure of Sherman's intended destination. Instead, Sherman's troops, broken up into two wings, would mostly do battle with South Carolina's swamps.

During the march, the Union infantryman's usual weapon, the rifle, was replaced by the ax and the friction match. Sherman had gathered a cadre of 6,600 "pioneers," the corps responsible for building and repairing roads and bridges along the army's path. Lumbermen from Michigan and rail-splitters from Indiana

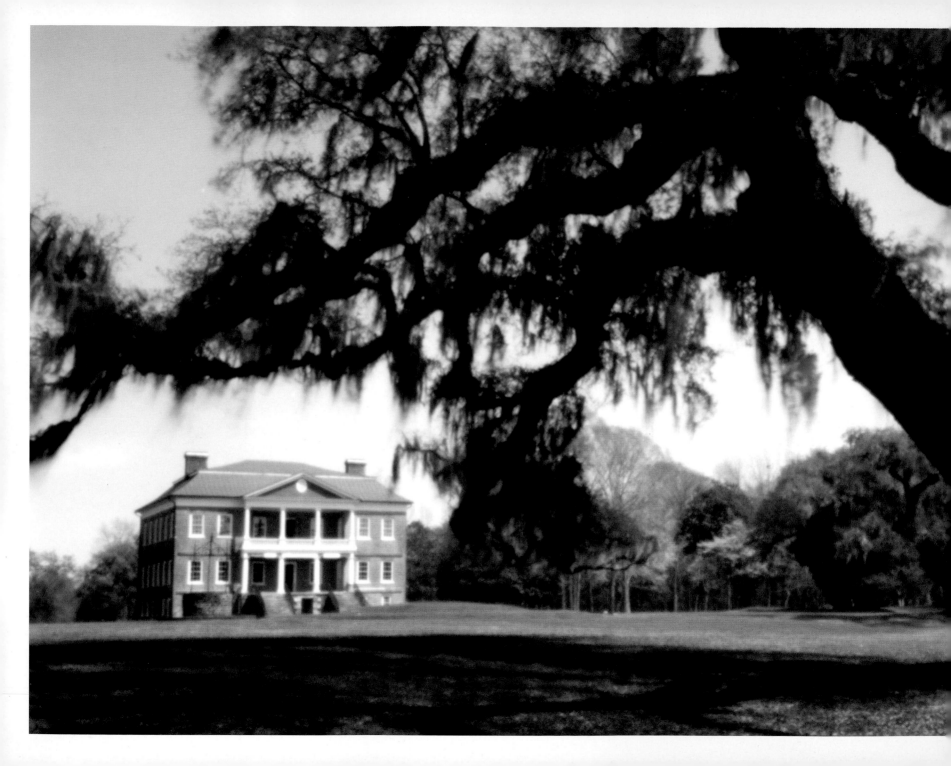

and Illinois were organized and armed with axes to cut their way through the swamps, corduroying roads for the troops and their attending column of 2,500 wagons and ambulances. Marching an army twelve to fifteen miles a day through such terrain was an achievement almost unequaled in the history of warfare.

"Not since the days of Julius Caesar has the world seen such an army," marveled General Joseph E. Johnston, commanding the Confederate forces in the Carolinas.

Long columns of smoke would mark Sherman's march through the Carolinas. So it was with some surprise, while driving south from Charleston in March 2015, that I watched columns of smoke rising on the horizon. Wild fires could be seen burning in the distance. I stopped along a country road and watched local authorities manage a controlled burn. Dead leaves crackled as dense clouds of smoke filled the skies. It seemed an appropriately auspicious start to my Carolina journey.

Before leaving the Charleston area, I had a chance to visit some of the region's famous plantations. Just fifteen minutes from the city center along the Ashley River, a day's march in 1865, were the wealthiest plantations in nineteenth-century America. To the conquering Union troops, they represented the Southern aristocracy and the institution of slavery, and many were burned to the ground.

One plantation manor along the Ashley River that survived was Drayton Hall, now open to the public, with its original surviving manor house. Neighboring Magnolia Plantation, known for its luxurious gardens, opened to the paying public in the years after the Civil War; the admission fees were used to pay for Magnolia

Dayton Hall, Charleston, South Carolina

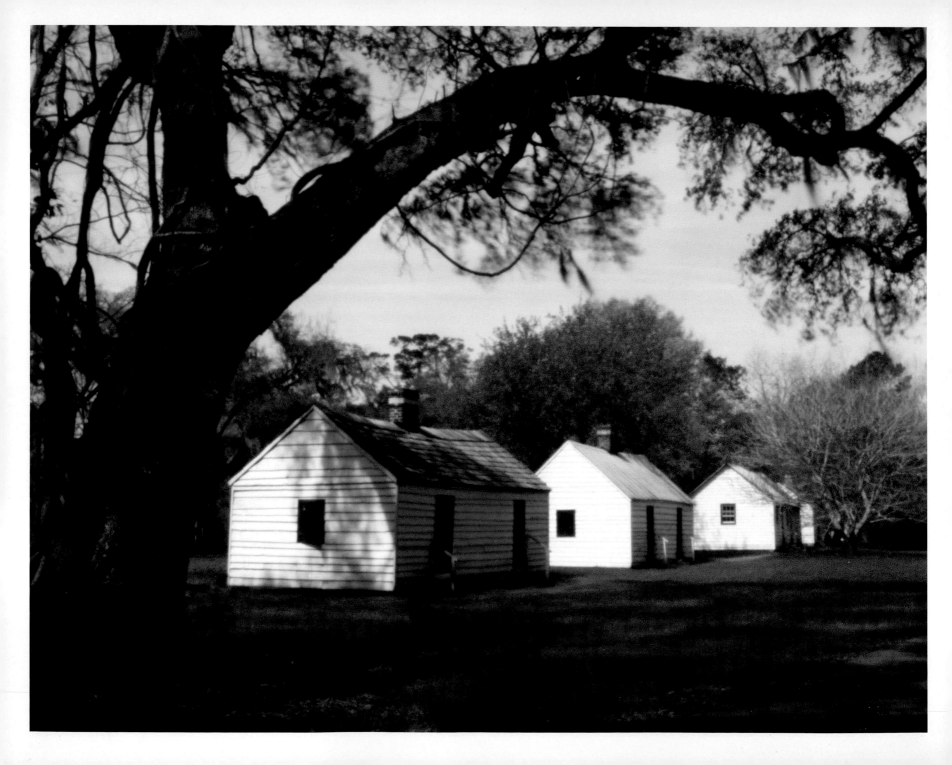

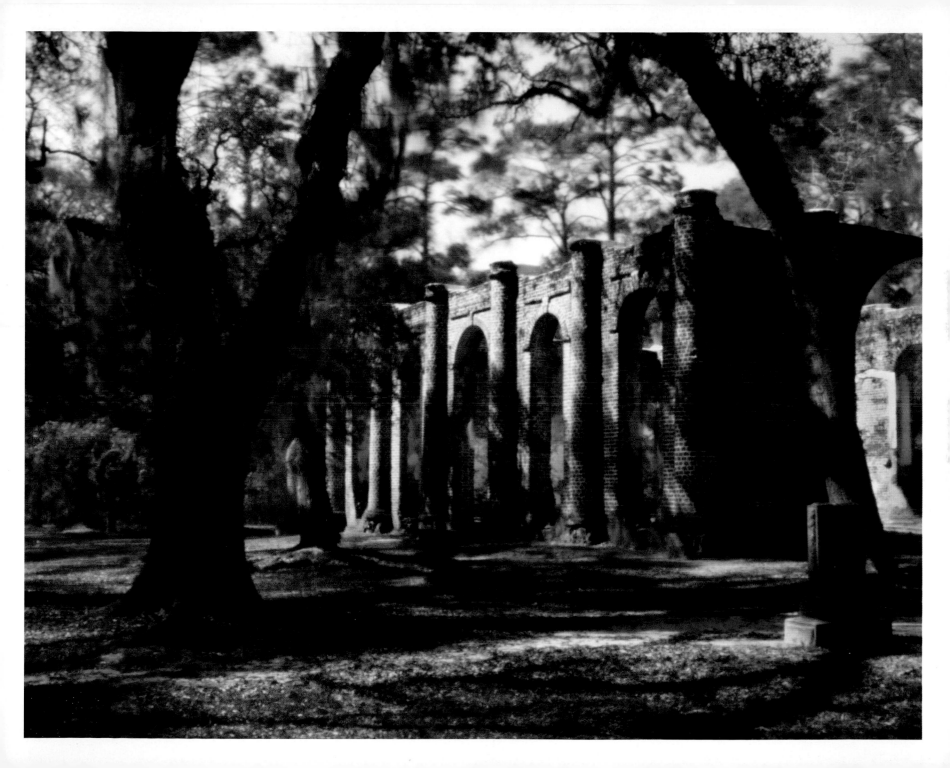

plantation's reconstruction. Amid the gardens, surrounded by swamps, are the plantation's whitewashed slave cabins.

After crossing the Savannah River in 1865, Sherman's men began their march through the coastal lowlands of South Carolina. Sparsely populated in the mid-nineteenth century, the region was known for its enormous rice plantations and impenetrable swamps.

Much of South Carolina's wealth in the nineteenth century was based on cultivating rice and slavery. Sherman's troops encountered incomparable wealth, virtually untouched by war, alongside the miserable conditions of the slaves who made it possible, and were enraged. They burned everything in their path. Even churches were not spared. The Shelton Church in Yemassee, South Carolina, has the unique distinction of being torched in two American wars. The church was burned by British troops marching through the Carolinas in 1779, rebuilt, then destroyed again by Sherman's troops in 1865. The ruins of the church stand today as a testament to the violence this region has endured over the centuries.

On February 2, 1865, Confederate troops attempted to stop one of Sherman's wings at the Salkehatchie River, near Ehrhardt, South Carolina, at what was known as the Battle of River's Bridge. For two days, Sherman's troops waded through swamps to attack a small band of entrenched Confederates. After burning the bridge that crossed the river, the Confederate force manned the extensive earthworks constructed to defend the river's north side. On the second day of the battle,

PREVIOUS: *Slave cabins at Magnolia Plantation (left); Shelton Church ruins,*
Yemasse, South Carolina (right)
LEFT: *Trenches at Rivers Bridge Battlefield*

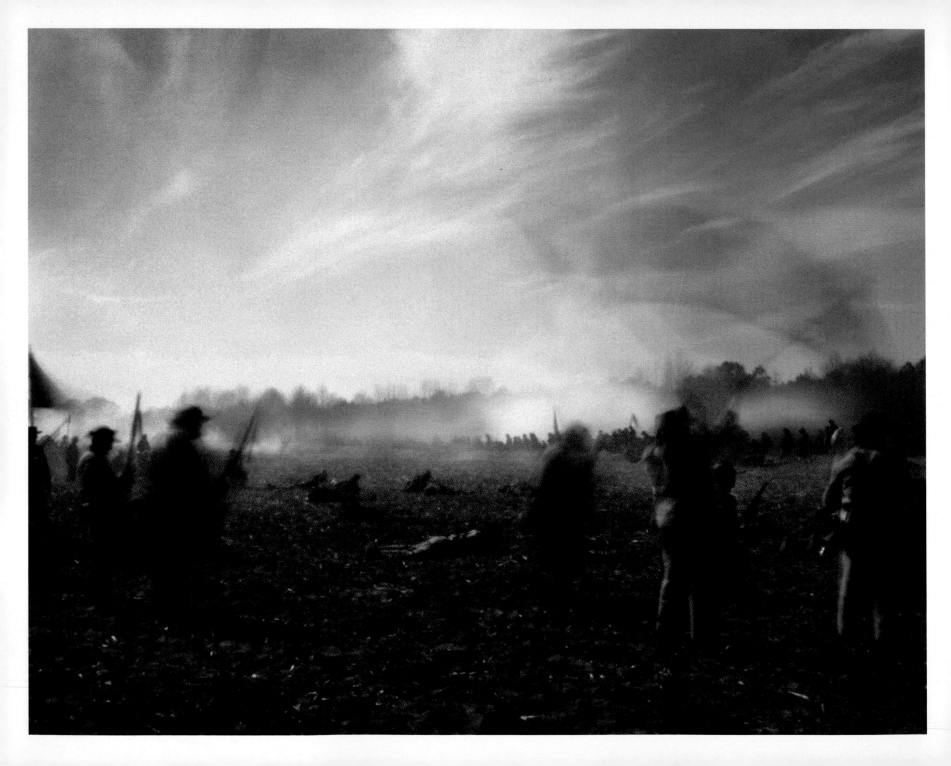

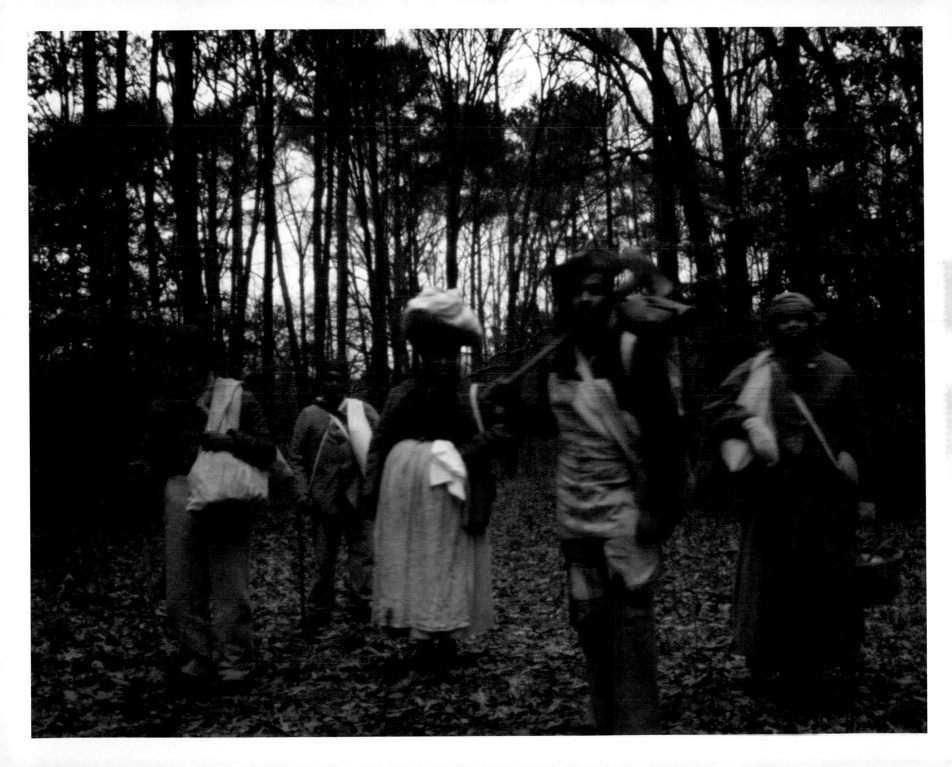

a portion of the Union force crossed upriver and outflanked this strong defensive position, forcing the Confederates to withdraw. Extensive trench works still line the north side of the river today.

Fifteen South Carolina towns were put to the torch in Sherman's march through the Palmetto State. Emboldened by the meager resistance offered by the Confederates, Union foragers soon became reckless in their jaunts through the countryside. Confederate retribution followed. Roving bands of Confederate cavalry began to hunt down the foragers; they hung the ones they caught from trees bearing placards: "Death to all Foragers."

Sherman was disturbed to hear the reports of abuses by his foragers, but he would later confess, "I would have pardoned them for anything short of treason."

In February 1865, Sherman's two wings began their approach to the South Carolina capital. On February 17, after lobbing a few shells into the city, Sherman's troops occupied Columbia. The retreating Confederates had set bales of cotton along the city's main street alight, but they were soon extinguished. These bales would later be reignited by inebriated Federal troops bent on destroying Columbia. A particularly windy night helped to fan the flames that eventually spread through the entire town. Two-thirds of the city would burn to the ground that evening, even though Sherman called forth hundreds of troops to help douse the flames. By 4 a.m. the wind relented, and the fires were finally extinguished.

"Though I never ordered it, and never wished it," Sherman was to say of the burning, "I have never shed any tears over it, because I believe that it hastened what we all fought for—the end of the war."

The State Capitol in Columbia survived the burning, and it still shows signs of Sherman's passing today. Bronze stars on the south and east facade of the building mark places where the Capitol was hit during the brief shelling of the city preceding Sherman's occupation. During my visit to Columbia, the Confederate flag was still flying over a Civil War memorial directly in front of the Capitol Building.

Leaving Columbia in ruins, Sherman and his force crossed the border and continued their march into North Carolina. Union troops noted in their diaries and journals that North Carolina was a breath of fresh air compared to her sister state. The terrain was greener, a series of hills and cultivated valleys broken by tall stands of trees and tracks of woods.

You get the same feeling today as you drive from South Carolina into North Carolina. The vine and moss-choked landscape gives way to a taller and lusher terrain. But it was not just the physical landscape that changed. When Sherman's troops occupied the town with little opposition after crossing the Cape Fear River at Fayetteville, Union troops noticed that the North Carolinians were less hostile than the South Carolinians.

North Carolina was reluctant to secede, and was the last Southern state to join the Confederacy in 1861. Sherman took this into consideration and modified his marching orders, limiting the foraging and putting his soldiers on a tighter leash.

Ironically, though, it was in North Carolina that Sherman's troops experienced the first real opposition to their march across the Carolinas.

Moving north from Fayetteville, Sherman's force continued to march in two separate wings, presenting a target for the Confederate troops gathering near Smithfield. Too weak to confront

PREVIOUS: *Reenactment at Bentonville, North Carolina*

LEFT: *Confederate flag at the State House in Columbia, South Carolina*

Sherman's entire force, the Confederates planned on focusing their attack on one wing and then the other in a last-ditch effort to destroy the Union Army.

The first real concerted effort to stop Sherman's advance occurred north of Fayetteville, in what became known as the Battle of Averasborough. On March 15 and 16, although they were outnumbered three-to-one, Confederates commanded by General William Hardee fought a fierce back-and-forth engagement with one of Sherman's columns and held it at bay for two days before retreating north. Three days after the Battle of Averasborough, and thirty miles to the east, the Confederates would make their last stand outside the small town of Bentonville, North Carolina.

In March 2015, reenactors from around the country arrived in Bentonville to commemorate this closing battle of the Civil War. Union campaigners, in the impression of Sherman's troops, marched into camp with live chickens strapped to their haversacks, spread their rubber blankets in the surrounding forest, and settled in for the commemorative weekend. The living historians would be sleeping and campaigning on the same hallowed ground fought over 150 years ago.

Joining these reenactors was a group of African Americans in the impression of what were called "contraband"—the thousands of former slaves who had joined Sherman's march through the Carolinas in 1865. Sherman was seen as a liberator to the former slaves, and these reenactors embraced that history. With axes in hand, the men served as pioneers, the women as seamstresses and cooks.

My travels through the Carolinas would eventually lead me to Bennett Place in Durham, North Carolina. It was here, in a small frontier cabin, that Sherman and Johnston met and signed the surrender on April 28, 1865. The cabin and its modest out buildings have been preserved as well as the old dirt road where the two commanders tied up their horses for the conference. The terms of Johnston's surrender of the last large Confederate army in the field were identical to the generous terms Grant had offered Lee on April 9 at Appomattox.

It would take another two months for the last Confederate general to finally capitulate. Brigadier General Stand Watie, a Cherokee chief and his assorted band of Confederate Cherokees, Creeks, Seminoles, and Osages, finally laid down their arms at Fort Towson, Oklahoma, on June 23rd, 1865.

In April 2015, reenactors gathered at Bennett Place for the sesquicentennial commemoration of the surrender. Three months later, in response to the horrific shooting at Emanuel Church in Charleston, the Confederate flag on the State Capitol grounds in Columbia, South Carolina, was finally lowered and placed in the Confederate Relic Room and Military Museum at the South Carolina State Museum, one hundred and fifty years after the end of the Civil War.

Tomotley Plantation in Beaufort County, South Carolina

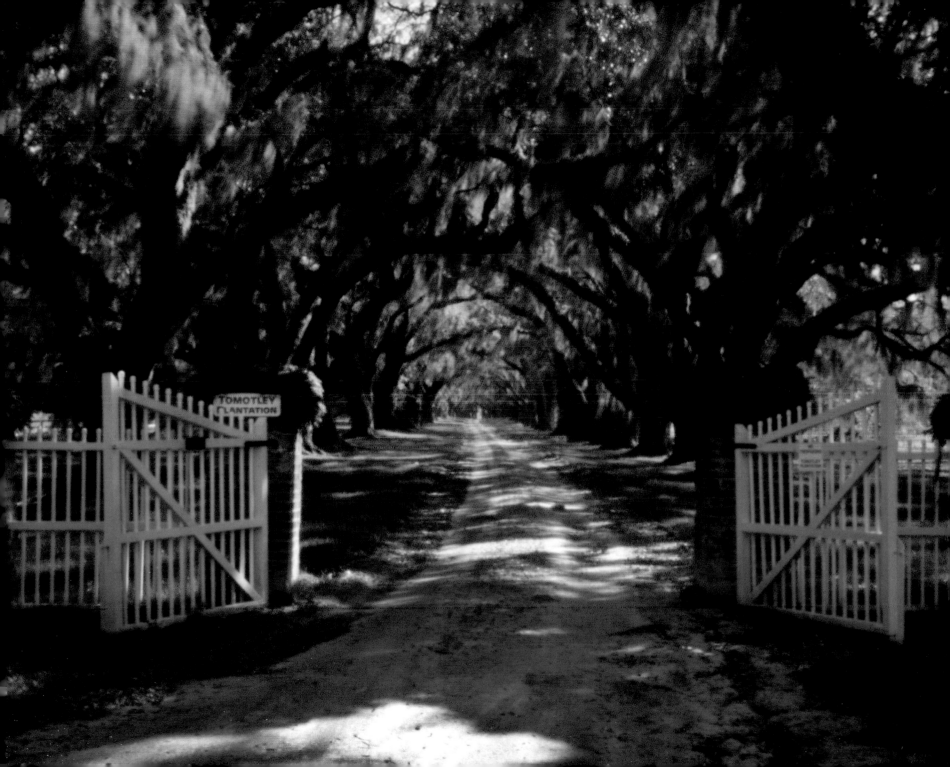

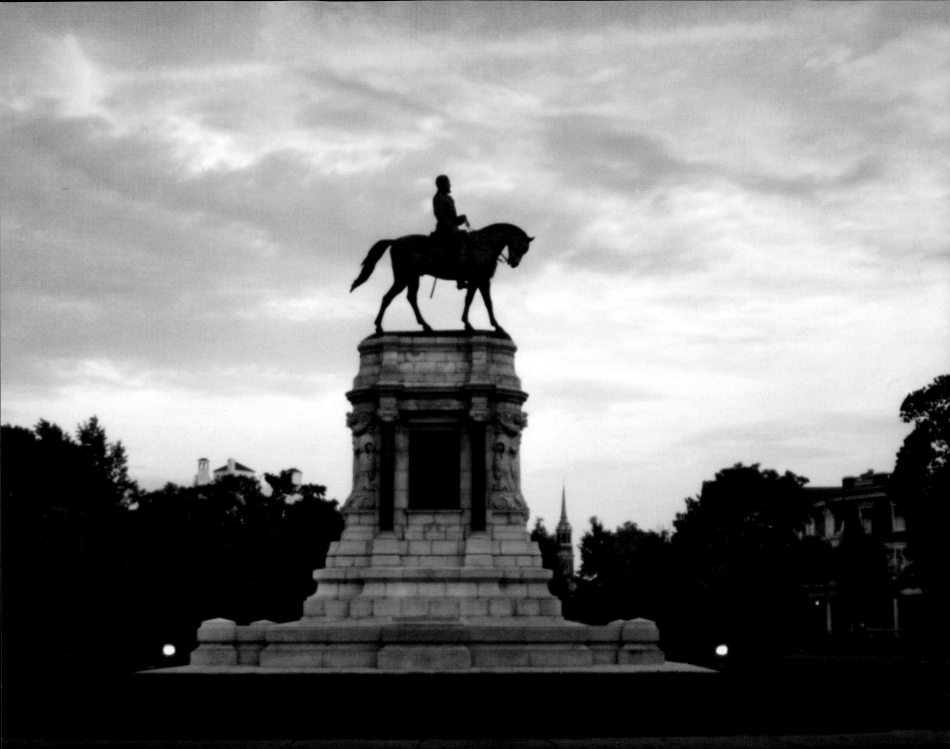

Afterword

In May 2015 reenactors and living historians from around the country converged on Washington, D.C., to participate in a commemoration of the Grand Review. One hundred fifty years earlier, the Union Armies—some 150,000 soldiers—marched through Washington for two days in an awe-inspiring military procession celebrating the end of the Civil War. Just as in 1865, the reenactors paraded past the Capitol building and up Pennsylvania Avenue, waving the Stars and Stripes in their last march of the sesquicentennial.

One month later, in a twist of fate, the Stars and Bars, the Confederate battle flag, was solemnly lowered and removed, once and for all, from a memorial on the grounds of the South Carolina Statehouse at a ceremony attended by some 10,000 people, mostly cheering, but some, clutching little Rebel flags, quietly mourning.

That the flag of secession would inspire such passions 150 years after the war's end was a testament to the lasting and continuing legacy of the Civil War—along with the Revolution, the defining event of American history and, singularly, the nation's greatest cataclysm and deepest wound.

The United States has existed as a nation far longer after the Civil War than it had been a nation before it. If, when Lincoln delivered the Gettysburg Address, it was four score and seven years since "our fathers brought forth on this continent, a new nation, conceived in liberty, and dedicated to the proposition that all men are created equal," it had been, by 2015, seven score

Robert E. Lee Memorial, Richmond, Virginia

"For too long we've been blind to the way past injustices continue to shape the present," Obama said. "Removing the flag from this state's Capitol would not be an act of political correctness. It would not be an insult to the valor of Confederate soldiers. It would simply be an acknowledgment that the cause for which they fought—the cause of slavery—was wrong. The imposition of Jim Crow after the Civil War, the resistance to civil rights for all people, was wrong."

Obama was speaking 150 years after Abraham Lincoln's Second Inaugural Address on March 4, 1865. The anniversary of the end of the war that had consumed his presidency and nearly destroyed, but ultimately saved the nation, was little more than a month away.

·———�> ✦ <———·

I consider my sesquicentennial trek to have been a sacred honor, an extended period of contemplation and study of the American Civil War, during which I read countless vivid histories and memoirs but was also guided by and grounded in the very landscapes that were soaked so long ago in the blood of blue and gray.

This book is a commemoration of that collective sacrifice and suffering without which America would not be America. I hope, amid the temporal passions of the day, these slow-motion photographs will offer the reader an opportunity for reflection.

Thanks to a century and a half of preservation efforts, the battlefields remain remarkably untouched by time. I walked and photographed these battlegrounds with the strange knowledge that the soldiers who fought there 150 years ago would still recognize these landscapes.

More surprising to me was that much of the countryside where the war was waged remains just that: countryside. Apart from the paved roads and power lines, a broad swath of the nation where these battles were fought retains a nineteenth-century agrarian feel.

As I traveled to the Shiloh National Battlefield in Tennessee, the country roads wended their way through what still seemed a wilderness. Corinth, Mississippi, the nearest city of any size, is still just a sleepy old Southern town.

The wilds of Virginia seemed haunted by Confederate ghosts, Georgia by Native American spirits.

My journey tracked many of the country's mighty rivers: the Mississippi, the Shenandoah, the James, and the Rappahannock, to name a few. These were the highways of the nineteenth century.

The building of America's railroads coincided with the Civil War. I walked along many old rail beds that were brand new then and are still bearing train traffic today.

The Butcher's Bill for the war was, it is estimated, between 620,000 and 850,000. In the North, of the surviving soldiers, one in 13 was missing an arm or leg. Outnumbered in the war, the South faired even worse. In 1866, the State of Mississippi allotted one-fifth of its revenues for the purchase of artificial limbs.

After spending four years recapitulating the war, meeting reenactors, many blood of the blood of those who died, it is still

Lincoln's Memorial

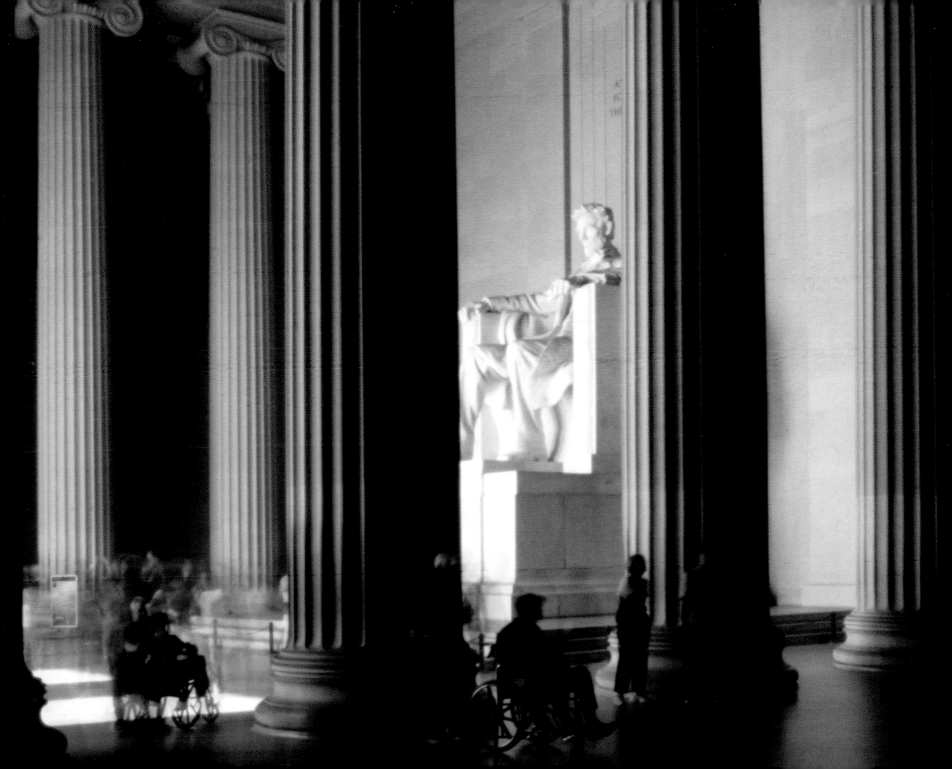

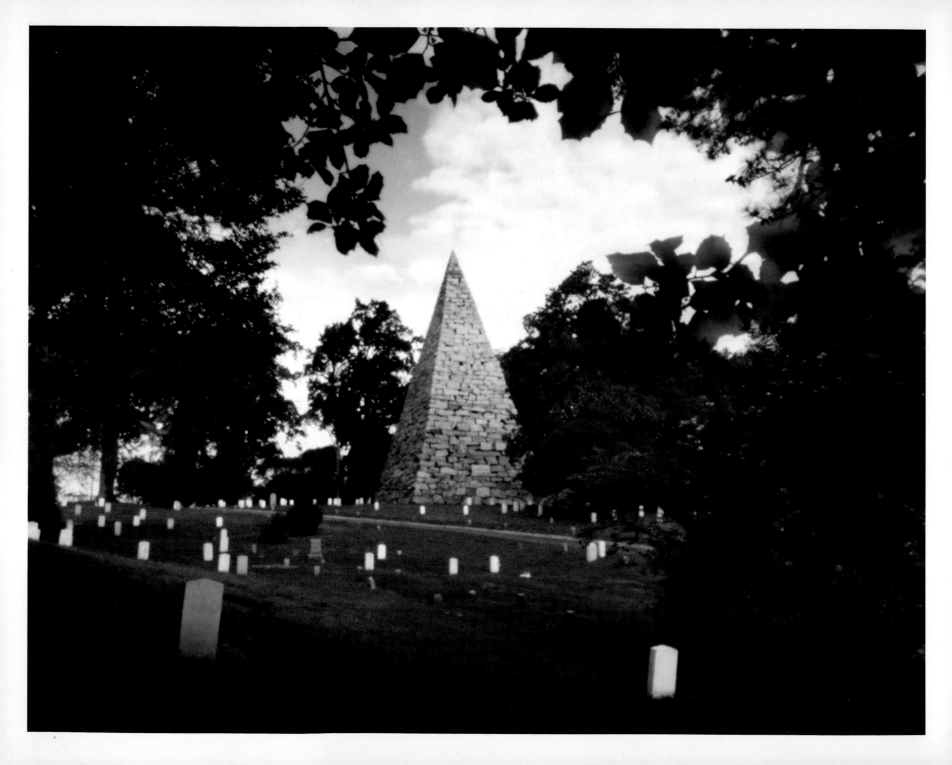

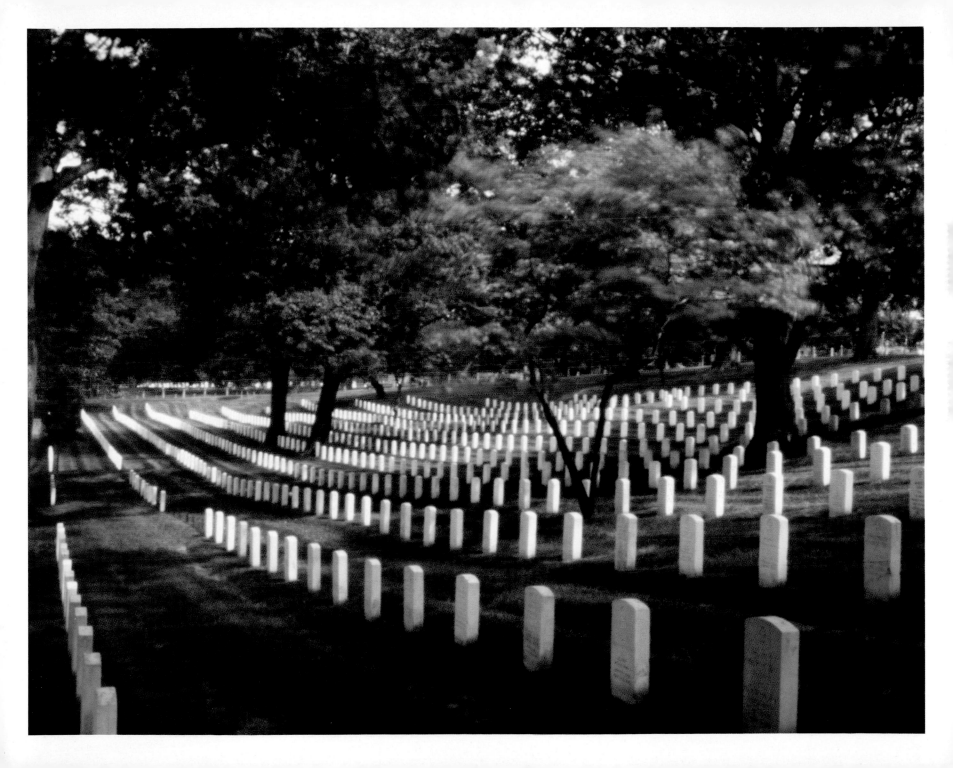

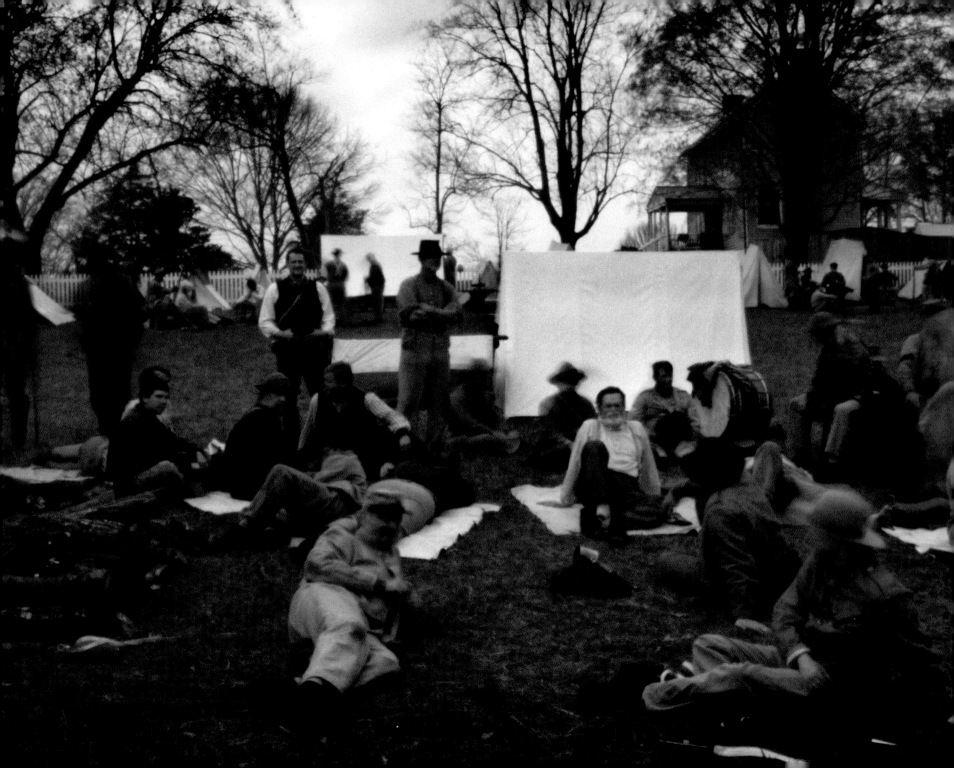

hard to fathom the human toll, the bravery, the terror, and, all through it, the uncertainty of the ultimate outcome.

The soldiers who survived the war, both from the North and South, realized that they had had a hand in writing history. Even before the war ended, the soldiers themselves were already reenacting sham battles they fought for awed spectators. Their descendants have carried on that tradition ever since.

I approached this project with a vague sense of reenactors as kitschy hobbyists. But I would soon learn how serious and personal their attachments were to remembering and respecting the roles played by what for many of them were kin. My unexpected immersion into reenacting—a necessity if this project was going to work—was a baptism by fire. Gaining permission to be on the field during reenactment was challenging from the start. I was forever at the mercy of circumstance: where the events were taking place and who was in charge. Showing up in the garb of a nineteenth-century photographer with a pinhole camera was hardly sufficient. After registering as a reenactor months ahead of time, I would arrive and have to negotiate my access at each event. Arriving with a rifle and black powder would have been a lot easier.

Gaining access to the reenactments was humbling, and I felt bound to render images that would illustrate the scenes I had read about in period memoirs and enrich the battlefield landscapes. The project took me through twelve different states and a myriad of long-forgotten fields. There were over 10,000 battles and skirmishes during the Civil War, and from the very beginning, I knew I would have to be very selective about where I went, ultimately exploring 18 major battle sites. More than a thousand miles separated the rolling fields of Gettysburg, Pennsylvania, and the deep ravines of Vicksburg, Mississippi.

I met many great people along the way, dedicated to history. I'd be remiss if I didn't thank all the reenactors out there who came to my assistance, some going as far as to hide my camera and tripod in their gear to help sneak me in on those occasions when I was denied access. Once the gun smoke clouded the field of battle, I knew I was safe from being discovered and bounced. Call it the fog of reenactment.

I don't relish the memory of running through a tangle of woods dodging North Carolina State Troopers as I tried to gain access to the 150th anniversary Battle of Bentonville. I felt like I was some kind of nineteenth-century paparazzo, hiding behind trees, trying to make an image of the battle.

There were also times when I was right in the thick of it, ankle deep in mud and choking on gun smoke. Jumping into a trench with the Confederates during the 150th anniversary of the Battle of Spotsylvania, I struggled in the mud to set up the camera alongside hundreds of screaming Southerners delivering curse-laden volleys of musketry to thousands of approaching Union troops.

PREVIOUS: *Confederate Memorial Hollywood Cemetery (left);*

Arlington National Cemetery (right)

LEFT: *Confederate parolees at Appomattox*

In Moseley, Virginia, during a lull in a predawn skirmish, I was mistaken for a Union soldier in the smoke-choked wilderness and fired on by Confederate Cavalry, giving me a vivid understanding of the many tragic incidences of friendly fire during the war. The black powder weapons used during the Civil War could quickly fill the battlefield, obscuring the ability to tell friend from foe.

Between the screaming and gun smoke, I found myself reduced to a kind of stupor after many of these mock battles. The most moving moments of my journey were among the quietest: the simple explorations of the battle landscapes, walking these hallowed fields.

To this day, more books are written about the American Civil War than about any other subject, offering endless opportunities to delve as deeply as you could want into every aspect of the war. The National Park Service continues to maintain most of the Civil War battlefields in the country and to hold programs throughout the year for history buffs and visitors.

But, beyond Gettysburg, America's most visited Civil War battlefield, I found the country's battlegrounds to be mostly deserted, which made for more profound and intimate explorations.

In my last trip for the project, I visited Arlington National Cemetery. The land now occupied by the national burial ground was the former plantation home of Robert E. Lee, seized by Union troops in 1861. The plantation's large manor, Arlington House, still sits on the hill overlooking Washington, D.C., the Potomac River, and hundreds of thousands of grave-sites of Americans who served their country. The graves of both Union and Confederate soldiers can be found here.

Walking through Arlington after four years of traveling around the country, I found myself oddly puzzled that my sesquicentennial journey was over, that the war whose anniversary I had tracked had ever ended. I had just witnessed years of Americans shooting at each other in these mock battles, and after a time, I began to feel it would just go on and on.

What brought the country from the brink of disunion and destruction was Lincoln's "with malice toward none, with charity for all" stance, and the complementary spirit of respect and conciliation exemplified by Grant and Lee. It's important for Americans to know this.

At the end of *Battle-Pieces and Aspects of the War*, Herman Melville's book of Civil War poems, the author includes a prose supplement in which he worries that a "Northern writer, however patriotic . . . must revolt from acting on paper a part any way akin to that of the live dog to the dead lion; and yet it is right to rejoice for our triumph, so far as it may justly imply an advance for our whole country and for humanity."

As Melville wrote in his concluding words, "Let us pray that the terrible historic tragedy of our time may not have been enacted without instructing our whole beloved country through terror and pity; and may fulfillment verify in the end those expectations which kindle the bards of Progress and Humanity."

Flags at rest, Washington DC

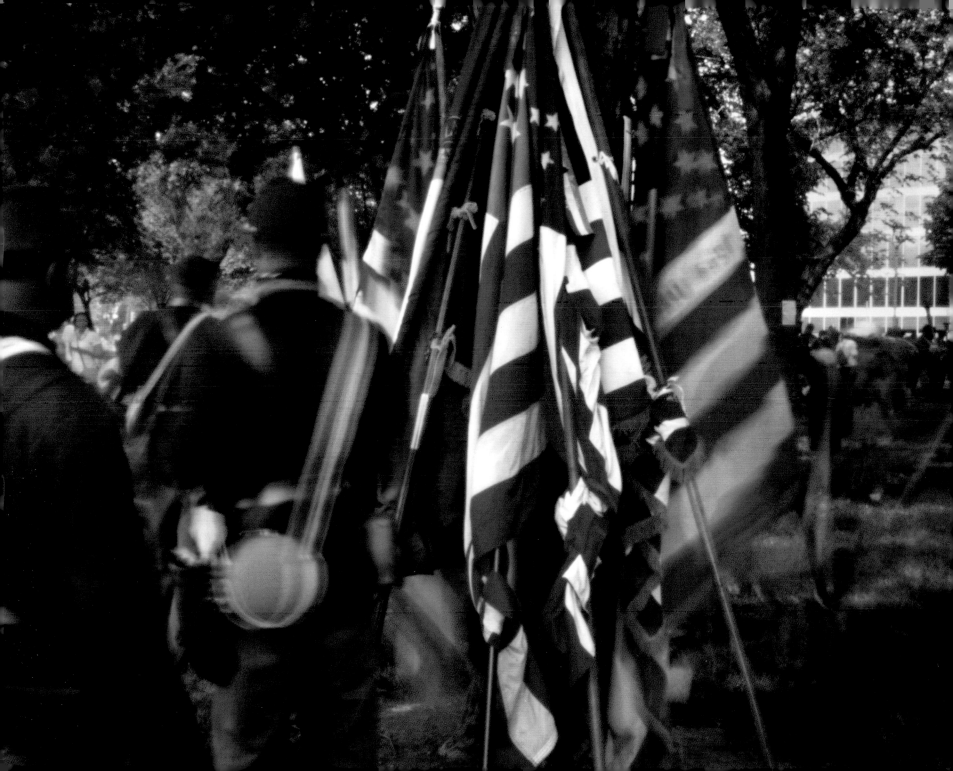

> " How often in the years that close,
> When truce had stilled the sieging gun,
> The soldiers, mounting on their works,
> With mutual curious glance have run
> From face to face along the fronting show,
> And kinsman spied, or friend—even in a foe.

It ends:

> " O, now that brave men yield the sword,
> Mine be the manful soldier-view;
> By how much more they boldly warred,
> By so much more is mercy due:
> When Vicksburg fell, and the
> moody files marched out,
> Silent the victors stood,
> scorning to raise a shout."

Cedar Creek Battlefield, Middleton, Virginia

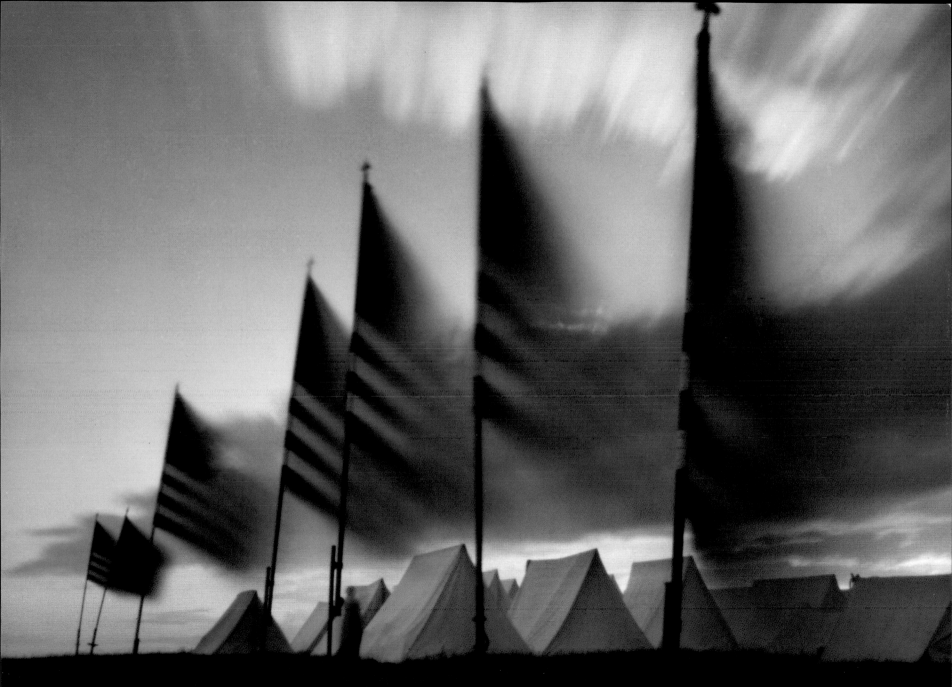

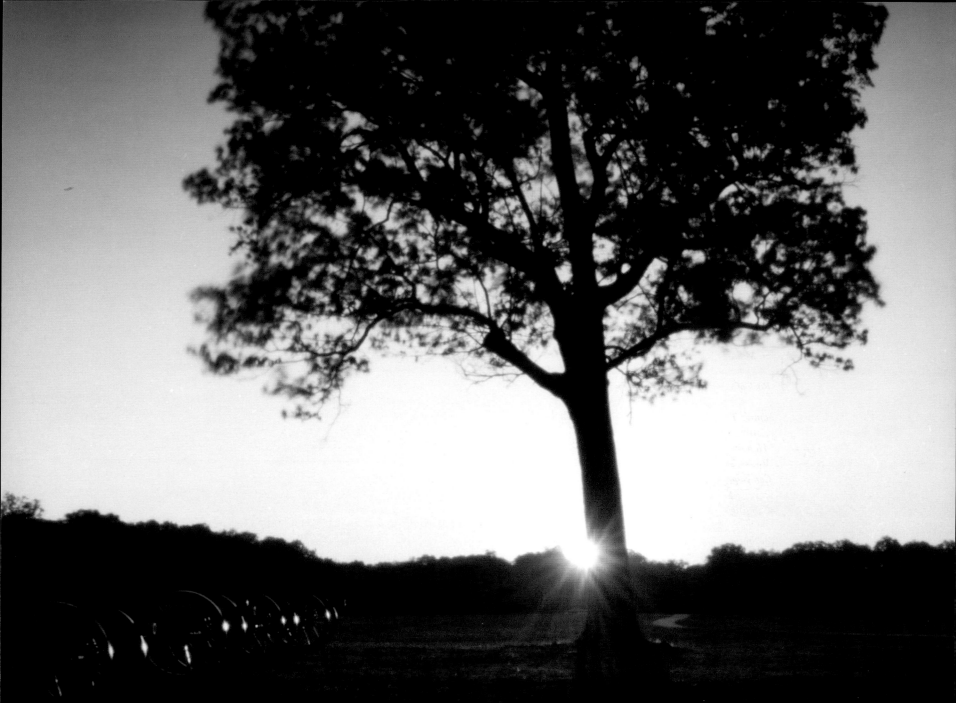

Bibliography and Source Books

Alexander, Edward Porter. *Military Memoirs of a Confederate*. New York: Skyhorse Publishing, 2014.

Altsheler, Joseph A. *The Rock of Chickamauga: A Story of the Western Crisis*. IndyPublish, 2004.

Ballard, Michael B. *Vicksburg: The Campaign That Opened the Mississippi*. Chapel Hill, NC: UNC Press, 2010.

Bearss, Edwin. *Fields of Honor: Pivotal Battles of the Civil War*. Washington, DC: National Geographic Books, 2007.

———. *The Five Forks Campaign and the Fall of Petersburg*. El Dorado Hills, CA: Savas Beatie, 2014.

———. *The Petersburg Campaign: Vol 1 & 2*. El Dorado Hills, CA: Savas Beatie, 2012–2014.

Bierce, Ambrose. *Civil War Stories*. Mineola, NY: Dover Publications, 1994.

———. *The Devil's Dictionary*. New York: Oxford University Press, 1999.

Billings, John D. *Hardtack and Coffee: The Unwritten Story of Army Life*. New York, NY: Kessenger Publishing, 2009.

Bonds, Russell. *War Like a Thunderbolt: The Battle and Burning of Atlanta*. Yardley, PA: Westholme Publishing, 2009.

Burton, Brian K. *The Peninsula and Seven Days: A Battle Guide*. Lincoln, NE: Bison Books, 2007.

Cannan, John. *Bloody Angle: Hancock's Assault on the Mule Shoe Salient*. Boston, MA: Da Capo Press, 2002.

Carter, Robert. *The Fight for Snodgrass Hill and the Rock of Chickamauga*. Carrollton, GA: Bev Bruemmer Books, 2012.

Catton, Bruce. *The Coming Fury*. New York: Doubleday, 2013.

———. *Gettysburg: The Final Fury*. New York: Doubleday, 1974.

———. *Never Call Retreat*. New York: Doubleday, 1965.

———. *A Stillness at Appomattox*. New York: Anchor, 1953.

———. *Terrible Swift Sword*. New York: Doubleday, 1963.

Chamberlain, Joshua. *Appomattox: The Surrender of the Army of Northern Virginia*. Maine Book Barn Publishing, 1906.

———. *The Passing of the Armies; An Account of the Final Campaign of the Army of the Potomac*. New York: Bantam, 1992.

"The Report of Col. Joshua Chamberlain 20th Maine," Chamberlain, Joshua, http://www.civil-war.net/searchofficialrecords.asp.

Charles River Editors. *The Atlanta Campaign*. CreateSpace Independent Publishing Platform, 2014.

———. *The Appomattox Campaign*. CreateSpace Independent Publishing Platform, 2014.

———. *The Battle of Chancellorsville*. CreateSpace Independent Publishing Platform, 2013.

———. *The Battle of Chickamauga*. CreateSpace Independent Publishing Platform, 2013.

———. *The Battle of Lookout Mountain*. CreateSpace Independent Publishing Platform, 2013.

———. *The Battle of Missionary Ridge.* CreateSpace Independent Publishing Platform, 2013.

———. *The Battle of the Crater.* CreateSpace Independent Publishing Platform, 2013.

———. *Beauregard Saves Richmond.* CreateSpace Independent Publishing Platform, 2013.

———. *The End of the Civil War.* Charles River Editors, 2016.

———. *The Overland Campaign: The Battles of the Wilderness, Spotsylvania Court House, North Anna, and Cold Harbor.* CreateSpace Independent Publishing Platform, 2013.

———. *Sherman's March to the Sea: The History of the Savannah Campaign that Subdued Georgia.* CreateSpace Independent Publishing Platform, 2014.

"The Chancellorsville Campaign—Out Generaled by Lee," Couch, Darius, http://www.civilwarhome.com/battlechancellosville.htm.

Chestnut, Mary and Ben Ames Williams. *A Diary from Dixie.* New York: Gramercy, 1997.

Cozzens, Peter. *This Terrible Sound: The Battle of Chickamauga.* Champaign, IL: University of Illinois Press, 1992.

Crane, Stephen. *The Red Badge of Courage.* Hampshire, UK: Collector's Library, 2009.

Cunningham, O. Edward. *Shiloh and the Western Campaign of 1862.* El Dorado Hills, CA: Savas Beatie, 2009.

Dawes, Rufus R. *A Full-Blown Yankee of The Iron Brigade: Service with the Sixth Wisconsin Volunteers.* Lincoln, NE: University of Nebraska Press, 1999.

Dickerson, Nell. *Gone: A Photographic Plea for Preservation.* Memphis, TN: Belle-Books, Inc., 2011.

Donnell, Clayton and James. *Shenandoah Valley 1862: Stonewall Jackson Outmaneuvers the Union.* Oxford, U.K.: Osprey Publishing, 2013.

Durham, Roger S. *Fort McAllister.* Arcadia Publishing, 2004.

Eyewitness to Shiloh: Accounts of Union and Confederate Soldiers and Officers at the Battle of Shiloh, April 1862. Cherry Lane Books, 2011.

Field, Ron. *Petersburg 1864-65: The Longest Siege.* Oxford, MS: Osprey Publishing, 2009.

Fletcher, William Andrew. *Rebel Private: Front and Rear.* New York: Dutton Adult, 1995.

Foner, Eric. *Reconstruction: America's Unfinished Revolution 1863–1877.* New York: Harper Perennial Modern Classics, 2014.

Foote, Shelby. *The Beleaguered City: The Vicksburg Campaign, December 1862–July 1863.* New York: Modern Library, 1995.

———. *Chickamauga.* Delta, 1993.

———. *The Civil War: A Narrative, Vol. 1–3.* New York: Vintage, 1986.

———. *Shiloh.* New York: Vintage, 1991.

———. *Stars in Their Courses: The Gettysburg Campaign.* New York: Modern Library, 1994.

Frassanito, William A. *Grant and Lee: The Virginia Campaigns 1864–1865.* New York: Macmillan Pub Co., 1986.

From Manassas to Appomattox: Memoirs of General James Longstreet. Andesite Press, 2015.

Gordon, General John. *Reminiscences of the Civil War.* Andesite Press, 2015.

Grant, Ulysses. *Personal Memoirs of Ulysses S. Grant.* New York: Cosimo Classics, 2006.

Guelzo, Allen. *Gettysburg: The Last Invasion.* New York: Alfred A. Knopf, 2013.

Haskell, Frank Aretas. *The Battle of Gettysburg.* Kessenger Publishing, LLC, 2010.

Heisey, Chris E. and Gordon Rhea. *In the Footsteps of Grant and Lee:* The Wilderness through Cold Harbor. Baton Rouge, LA: LSU Press, 2007.

Hennessy, John. *Return to Bull Run: The Campaign and Battle of Second Manassas.* Norman, OK: University of Oklahoma Press, 1999.

Hess, Earl J. *In the Trenches at Petersburg: Field Fortifications and Confederate Defeat.* Chapel Hill, NC: The University of North Carolina Press, 2013.

———. *Trench Warfare Under Grant and Lee: Field Fortifications in the Overland Campaign.* Chapel Hill, NC: The University of North Carolina Press, 2007.

Hitchcock, Henry. *Marching With Sherman: Passages from the Letters and Campaign Diaries of Henry Hitchcock, Major and Assistant Adjutant General of Volunteers, November 1864–May 1865.* Lincoln, NE: Bison Books, 1995.

Horwitz, Tony. *Confederates in the Attic.* New York: Vintage, 1999.

———. *Midnight Rising.* New York: Henry Holt and Co., 2011.

Howard, Blair. *The Seven Days.* Amazon Digital Services LLC, 2014.

Johnson, Skip. *A Charleston Primer for Yankees; History with a Southern Accent.* Meeting Street Press, 2010.

Johnston, Joseph E. *Narrative of Military Operations During the Civil War.* CreateSpace Independent Publishing Platform, 2014.

Jones, Robert C. *Retracing the Route of Sherman's Atlanta Campaign and the March to the Sea.* CreateSpace Independent Publishing Platform, 2010.

Kennett, Lee B. *Marching Through Georgia.* New York: Harpercollins 1995.

Konstam, Angus. *Seven Days Battles 1862.* Osprey Publishing, 2003.

Krick, Robert. *The Mortal Wounding of Stonewall Jackson.* Chapel Hill, NC: The University of North Carolina Press, 2012.

Lardas, Mark. *Shenandoah 1864: Sheridan's Valley Campaign.* Oxford, UK: Osprey Publishing, 2014.

Law, Evander M. *The Struggle for "Round Top," in Battles and Leaders of the Civil War, Volume 3: The Tide Shifts*, pp 318–330. Castle, a division of Book Sales, Secaucus, NJ.

Linderman, Gerald. *Embattled Courage: The Experience of Combat in the American Civil War.* Free Press, 1989.

Longacre, Edward. *The Early Morning of War: Bull Run 1861*. Norman, OK: University of Oklahoma Press, 2014.

Lyman, Theodore. *With Grant and Meade From the Wilderness to Appomattox*. CreateSpace Independent Publishing Platform, 2014.

Mackowski, Chris. *The Dark Close Wood: The Wilderness, Ellwood and the Battle that Redefined Both*. Gettysburg, VA: Thomas Publications, 2010.

————. *A Season of Slaughter: The Battle of Spotsylvania Court House*. El Dorado Hills, CA: Savas Beatie, 2013.

Masur, Louis P., ed. *The Real War Will Never Get in the Books: Selections from Writers During the Civil War*. New York: Oxford University Press, 1995.

McElroy, John. *Andersonville: A Story of Rebel Military Prisons*. Arkose Press, 2015.

McKim, Randolph H. *A Soldiers Reflections: Leaves from the Diary of a Young Confederate*. New York: Longmans, Green, and Co., 1910.

McPherson, James. *Battle Cry of Freedom: The Civil War Era*. New York: Oxford University Press, 1988.

McPherson, James. *Hallowed Ground: A Walk at Gettysburg*. New York: Crown, 2003.

Melville, Herman. *Battle-Pieces and Aspects of the War*. Paphos Publishers, 2015.

Miles, Jim. *Fields of Glory: A History and Tour Guide of the War in the West, the Atlanta Campaign, 1864*. Nashville, TN: Cumberland House Publishing, 2002.

Miles, Jim. *To the Sea: A History and Tour Guide of the War in the West, Sherman's March Across Georgia and Through the Carolinas, 1864–1865*. Nashville, TN: Cumberland House Publishing, 1964.

Northup, Solomon. *Twelve Years a Slave*. New Orleans, LA: Quid Pro, 2012.

Nosworthy, Brent. *The Bloody Crucible of Courage*. New York: Basic Books, 2005.

————. *Roll Call to Destiny: The Soldier's Eye View of Civil War Combat*. New York: Basic Books, 2008.

O'Reilly, Francis Augustin. *The Fredericksburg Campaign: Winter War on the Rappahannock*. Baton Rouge, LA: LSU Press, 2002.

Peters, Ralph. *Cain at Gettysburg*. New York: Forge Books, 2012.

Powell, David. *Maps of Chickamauga: An Atlas of the Chickamauga Campaign, Including the Tullahoma Operations, June 22–September 23, 1863*. El Dorado Hills, CA: Savas Beatie, 2009.

Rhea, Gordon. *The Battle of the Wilderness: May 5–6, 1864*. Baton Rouge, LA: LSU Press, 2004.

————. *The Battles for Spotsylvania Court House and the Road to Yellow Tavern: May 7–12, 186*. Baton Rouge, LA: LSU Press, 2005.

————. *Carrying the Flag: The Story of Private Charles Whilden, the Confederacy's Most Unlikely Hero*. New York: Basic Books, 2003.

————. *Cold Harbor: Grant and Lee, May 26–June 3, 1864*. Baton Rouge, LA: LSU Press, 2002.

————. *To the North Anna River: Grant and Lee, May 13–25, 1864* Baton Rouge, LA: LSU Press, 2000.

Sears, Stephen. *Chancellorsville*. Boston: Houghton Mifflin, 1996.

————. *Gettysburg*. Boston: Houghton Mifflin Company, 2004.

————. *Landscape Turned Red: The Battle of Antietam*. Boston: Mariner Books, 1993.

Shaara, Jeff. *Gods and Generals: A Novel of the Civil War*. New York: Ballantine Books, 1998.

————. *Jeff Shaara's Civil War Battlefields*. New York: Ballantine Books, 2006.

————. *The Killer Angels*. New York: Ballantine Books, 1987.

————. *The Last Full Measure*. New York: Ballantine Books, 1998.

Sherman, William Tecumseh. *The Memoirs of WT Sherman*. New York: Library of America, 1990.

Spruill, Matt. *Echoes of Thunder: A Guide to the Seven Days Battles*. Knoxville, TN: University of Tennessee Press, 2006.

Tanner, Robert. *Stonewall in the Valley: Thomas Stonewall Jackson's Shenandoah Valley Campaign Spring 1862*. New York: Doubleday, 1976.

Varon, Elizabeth R. *Appomattox: Victory, Defeat and Freedom at the End of the Civil War*. New York: Oxford University Press, 2013.

Warren, Robert Penn. *The Legacy of the Civil War*. New York: Random House, 1961.

Watkins, Sam. *Company Aytch*. New York: Plume, 1999.

Weeks, Michael. *The Complete Civil War Road Trip Guide: 10 Weekend Tours and More than 400 Sites, from Antietam to Zagonyi's Charge*. Woodstock, VT: Countryman Press, 2009.

Wert, Jeffry D. *From Winchester to Cedar Creek: The Shenandoah Campaign of 1864*. South Mountain Press, 1987.

Widney, Lyman. *Campaigning with Uncle Billy: The Civil War Memoirs of Sgt. Lyman S. Widney, 34th Illinois Volunteer Infantry*. Bloomington, IN: Trafford Publishing, 2008.

Willis, Charles. *Army Life of an Illinois Soldier*. Washington, D.C.: Globe Printing Company, 1906.

Winik, Jay. *April 1865: The Month That Saved America*. New York: Harper, 2001.

Wyeth, John Allen. *That Devil Forrest: Life of General Nathan Bedford Forrest*. Baton Rouge, LA: LSU Press, 1989.

Acknowledgments

Traveling through the country during the Civil War Sesquicentennial was an honor and a privilege.

When I began the project I had a sense that the specter of this period in our history was still all around us. But the specter of the war was actually much deeper than that. Legions of the country's reenactors are actual descendants of the soldiers who fought this war. They were on the same time schedule as me, and I would meet them time and again at different battle sites throughout the country.

When I decided to become a reenactor, these zealots for history took me under their wings. Of the hundreds of living historians I met, a few stand out for their extra efforts in helping me navigate through unknown territory. In the reenactment community, I need to thank, among others: George Alcox, Brian Gesuero, Jake Jennette, Geoffrey Spangler, Chris Anders, Bill Cross, Herb Coats, Tim Williams, Tom Burke, and Mark Way. I am also grateful to Lori Lockhart and the Tennessee Archivists for their early interest in this project.

I would also like to thank the National Park Service and the countless park rangers who continue to educate the public and maintain the battlefields. These landscapes are American treasures, and these individuals' devotion to them is exemplary.

I would like to thank Henry Falco for his woodworking expertise and help with design and construction of the pinhole cameras. Those homemade cameras withstood a lot of abuse over this four-year journey, and they're still working.

I would like to thank my friend and colleague, Jonathan Tilove, for his help in editing this work. Mr. Tilove and I collaborated on the book *Along Martin Luther King: Travels on Black America's Main Street*, published in 2003. Through that experience, I came to trust Jon's instincts, and I would have no one else decipher my writing.

I would like to thank Dan Tucker of Sideshow Media for his trust and guidance in seeking to have this work published and Dan Crissman at The Countryman Press for his vision.

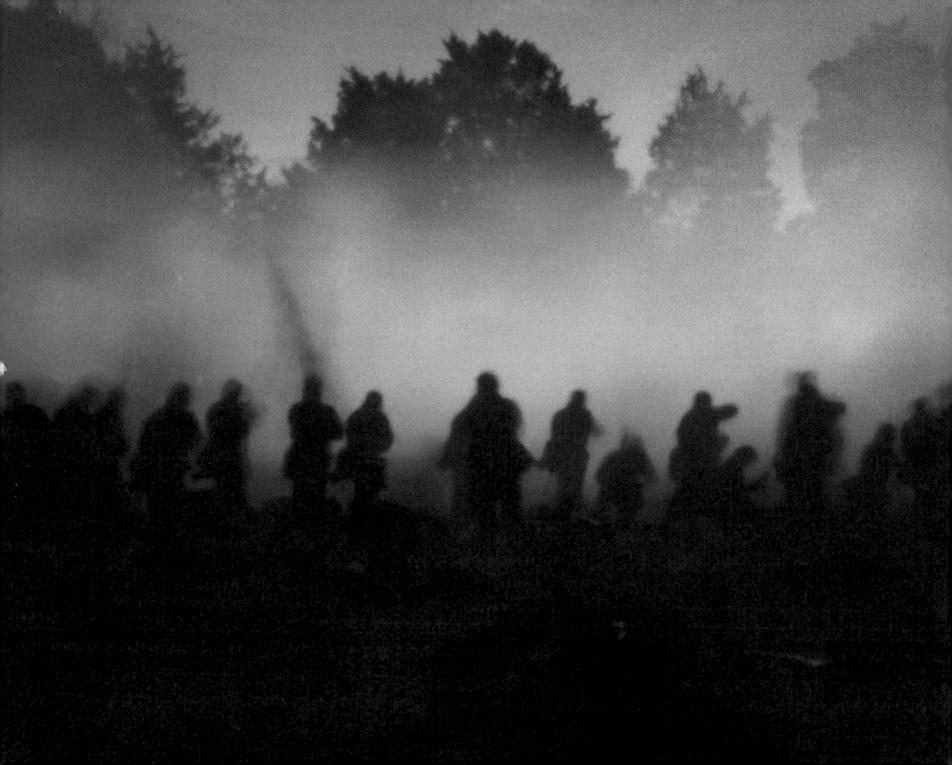